W9-ANV-840

WITHDRAWN

Fields of Vision

Essays in Film Studies, Visual
Anthropology, and Photography

EDITED BY

Leslie Devereaux and
Roger Hillman

UNIVERSITY OF CALIFORNIA PRESS

Berkeley / Los Angeles / London

University of California Press
Berkeley and Los Angeles, California

University of California Press, Ltd.
London, England

Chapter 3 of this book was previously published in *SVA Review* 6, no. 1 (Spring 1990). Reprinted by permission of the American Anthropological Association. Not for further reproduction.
An earlier version of chapter 6 was published in *New German Critique* 59 (Spring/Summer 1993).
An earlier version of chapter 12 was published as "Indigenous Media: Faustian Contract or Global Village?" *Cultural Anthropology* 6, no. 1 (Feb. 1991).
Chapter 14 was published as *"Rivers of Sand:* Versuch einer Neueinschätzung," in *Rituale von Leben und Tod: Robert Gardner und seine Filme,* edited by R. Kapfer, W. Petermann, and R. Thoms (Munich: Trickster Verlag, 1989).

Library of Congress Cataloging-in-Publication Data

Fields of vision : essays in film studies, visual anthropology, and photography / edited by Leslie Devereaux and Roger Hillman.
 p. cm.
Includes bibliographical references and index.
ISBN 0-520-08522-1 (alk. paper). — ISBN 0-520-08524-8 (pbk. : alk. paper)
 1. Motion pictures. 2. Motion pictures in ethnology. 3. Visual anthropology. 4. Photography. I. Devereaux, Leslie. II. Hillman, Roger.
PN1994.F433 1995
302.23'43 — dc20 94-646

Printed in the United States of America
9 8 7 6 5 4 3 2 1

The paper used in this publication meets the minimum requirements of American National Standard for Information Sciences — Permanence of Paper for Printed Library Materials, ANSI Z39.48–1984.

For Tim Asch

Contents

Illustrations

Acknowledgements

The papers in this volume spring from a year of scholarly activity sponsored by the Humanities Research Centre (Australian National University, Canberra) in 1989, a year devoted to considering the nature of film from different perspectives within the humanities. Two conferences, titled respectively "Coming to Terms with the Photographic Image" and "Film and Representations of Culture," as well as a festival of film, "Documentary: A Fiction (Un)like Any Other," were the focal points of that year, which brought together more than twenty speakers and large audiences from many disciplinary and national perspectives. This volume represents not only the contributions of the writers whose work appears here but the many scholars, filmmakers, critics, curators, and administrators whose efforts supported the work of the entire year and the conveners/editors in its aftermath.

We would like to mention for special thanks the generous and wise advice of the then Director of the Humanities Research Centre, Ian Donaldson, and the Deputy Director, Graeme Clarke. Bruce Hodsdon, curator of the Film Studies Collection of the National Library of Australia, gave us unstinting assistance (as well as part of his budget) in locating and acquiring many films needed for the festival and for other showings throughout the year. The National Film and Sound Archive hosted a festival of French cinema of the 1920s in the course of the year.

Bill Nichols curated the documentary festival, selecting a programme of key works in narrative nonfiction and providing a deeply enlightening set of contextualizing comments from which discussion contin-

ued throughout the year. In designing the activities of the year the conveners were informed and assisted by several people, special amongst whom were Gary Kildea, Judith and David MacDougall, and Andrew Pike.

The Humanities Research Centre's administrative staff are famous for their expertise and generosity, and the help we received from them, especially Jodi Parvey, Krystyna Szokalsi, Wendy Antoniak, and, in the final critical stages, Bernice Burrows, was vast. We thank all the visitors and fellows but in particular David Boyd of the University of Newcastle and Barbara Creed of La Trobe University for their consistently generous and collegial presence during their stays and Faye Ginsburg of New York University who provided energetic support in locating an appropriate publisher for this interdisciplinary volume.

The editors gratefully acknowledge financial assistance from the Editorial Committee, Faculty of Arts, Australian National University.

1

An Introductory Essay

LESLIE DEVEREAUX

The problematic power of photograph and film, in their apparently au-
thentic representation of what actually happened, in their capacity to be
highly constructed in inapparent ways, in their dependence upon con-
text for interpretation, is deeply present in the material culture of our
present era, lavishly exploited and celebrated in the pop rock video clip
as well as in presences and more significant absences of images in televi-
sion news. The way the photograph, once it exists, comes to have and
to exercise beyond full intentional control its own force was revealed in
the television and newspaper politics of the Vietnam War and may well
have led quite directly to Pentagon decisions to restrict access of journal-
ists and photographers to the Gulf ground war in 1991. The images that
were televised during the Gulf War were from the aerial war—almost
abstract, sanitised rocket trajectories viewed from the aircraft that
bombed Baghdad—and quite different from the disturbing, unambigu-
ously blood-and-guts images of the Vietnam ground war. The ideology
empowering the war images in 1991 yielded a visual sense of computer
games and favoured a similar detachment at the political level, rein-
forced by young airmen who spoke in relief and exhilaration of their
sense of participating in a form of football game. This interplay of the
profoundly real (in the sense of death, the actuality of the aftermath
of a bomb's explosion) with forms of representation, which also have
consequences, implications, and reality, was like an enactment of the
concerns of many of the papers in this volume.

The authors in this volume come to question how film and photogra-

1

phy work, both formally and contextually in society, from a variety of perspectives: as critics, as social scientists, as filmmakers, as literary scholars. The result is a collection of thoughtful essays on diverse, though related, subjects which are meant to be both instructive and enjoyable — edifying, in the true sense. The differing scholarly and intellectual backgrounds of the authors are evident in their vocabularies, their methodologies, and their approaches, and these, we feel, are the virtue of the collection, which presents some very serious writing about film from across the disciplines in a way which will allow access from many points to a consideration of the nature of film in culture and society today.

Themes

The essays have been grouped in such a way as to make clear their interconnections at a topical, thematic level. However, the volume begins with three papers (two from anthropology and one from critical cinema studies) that themselves set out the larger theoretical themes that the volume as a whole addresses: the interplay of film with aesthetic form, with economic and political structures, and with gendered and philosophical concerns embedded in the cultures that produce it.

It is extraordinary that in this final decade of the twentieth century, the century following the invention of moving pictures, the immense importance of visual technologies in the production and distribution of knowledge throughout the globe has still made so little impact on scholarly activity in the humanities. While cinema studies have begun to grow, largely as a form of literary or cultural theory, scholars in the humanities remain dedicated wordsmiths, whose representations and ruminations rarely include the visual, let alone the filmic. Among the realist disciplines of the humanities, anthropology has perhaps made the greatest excursion into filmic representations, and yet ethnographic film has still not yet been regarded with much intellectual rigour or trust. Despite promising beginnings anthropologists have not yet inquired very deeply into the reasons for their mistrust of visual representation. It is still the case that most scholars are far more practised at critically reading a written text than they are at understanding the discursive impact of a documentary film or television show. Visual literacy, outside of cinema studies courses, is not taught to university students, and yet

they will certainly come to know their world and to decide their place in it through the representations of the visual media, to which written texts and books will be at most a specialist corrective.

The realist disciplines of the humanities — history, sociology, anthropology, political science — need to debate their representational practices in much the same way as the literary canon has become contested ground in departments of literature. They are, after all, engaged in representing difference — different cultures whether distant in time, space, or concept, different experiences — to audiences composed of multiple positions and of multiply positioned people: Korean-Americans, Aboriginal Australians, West Indian–Britons. To write or to make films in the 1990s is to confront the twin facts of cultural dominance and robust cultural difference. How does the discourse shift when a different speaking voice asserts itself? How can representation, encrusted with its conventions, assume new audiences, accommodate new voices, express the suppressed experiences of groups new to self-representation in the dominant discourses of knowledge?

The three theme-setting papers in this volume (Willemen, Marcus, and Devereaux) deal both with issues of the tyranny of form and institution over the self-representation of the formerly silenced — women, indigenous populations, migrant populations — and with the dilemmas of scholarly, ethical representations of nondominant cultural realities; many of the other papers (Ginsburg, Creed, Studlar, MacDougall) carry these forward from a variety of disciplinary perspectives, addressing both cinema and documentary film.

All these writings are, in one sense or another, about coming to terms with the play of the real in film and photographic representation. Their audience could be anyone with a fascination for the unknown reality trapped in a filmic image: the snapshot, the home movie, the newsphoto, the documentary film, or fictional cinema. The singular virtue of a collection of papers emanating from disparate disciplines is that each discipline asks questions which the others, in their internal self-representing practices, would not have asked in quite that way, or in just that language, if they had posed the question at all.

Film, photography, cinema are all cultural products available as artifacts to be scrutinised for their form, their use, their origins, and their meaning. The contested critical space of the discovery of meaning contains many possible investigative manoeuvres: inquiry into the nature of the producers, as author, technician, artist, biographical subject; assessment of the conditions of production, those enabling structures and devices and constraints; interrogation of the receiving audience, as

viewer, reader, critic, dupe. The elastic and high-tech fibres that connect representation to our senses of reality are multiple, sheathed in relations of power that inhibit interference. They can be traced with difficulty.

A critique of representational practices can take a purely formalist position, but it will inevitably have political consequences since the un-problematic nature of a practice—its naturalness, its commonsen-sicalness, its objective inevitability—is itself the outcome of political processes. Many academic representational forms remain divorced from the implications of postcolonial cultural contestation, even in a world of technological simultaneity, where film, video, and photographic im-ages are ubiquitous. Third World cinemas are now attracting a growing critical literature among First World audiences, but the recent uses of media by encompassed, indigenous populations, such as those of the Kaiapo and Nambikwara peoples in Brazil, Navajo video self-representation, and Inuit and Aboriginal Australian television pro-duction, are all important aspects of self-representation as well as in-terventions in national cultural politics and their relationships to state bureaucracies. Not only is real contemplation of images underdevel-oped in traditional disciplines such as anthropology, history, and sociol-ogy, which often relegate them to contemptuously conceived categories such as popular culture, but the use of image, especially in video and film, as a means of serious intellectual discourse has, outside the arts, remained exceedingly rare.

Another theme which threads through the papers in this volume is the effects on all representational practices—"scientific" representations such as ethnographic and documentary film as much as locally produced indigenous children's television—of Hollywood cinematic conventions and production values. These conventions produce effects both on the aesthetic forms of representation—such as conventions about beauty, the nature of relationships—and on the exploration of culturally local meanings not shared by the mass audiences of Hollywood cinema. Competing for an audience, as well as for advertising, packaging, and distribution, all participate in forcing culturally specific film and video toward the conventions of Hollywood.

The filmic forms of knowledge produced in even so arcane and scien-tifically oriented a discipline as ethnographic film are necessarily en-twined with the fictional cinematic forms of Hollywood and television, because the narrative and compositional expectations that even univer-sity students bring to their viewing have been schooled by the movies, by TV, and by home videos. David MacDougall's essay here (as well as other writings by him) in part shows the historical development of

ethnographic film within this greater context. Ethnographic filmmakers have been very aware of this cultural and formal pressure of the conventions of our Euro-American mass media upon their work, precisely because they make representations of what is culturally unfamiliar, even though anthropology is an objectivist knowledge practice that brings back its information from "the field" in the form of notes, observations, and field recordings on audio tape, photograph, film, and video. Cross-cultural or historical documentary films are necessarily different from cinema, which works precisely through audiences' deep and nuanced cultural familiarity with gesture, prop, location, light, and sound. Audiences for ethnographic or historical film are like European cinemagoers encountering an Ozu film for the first time — they cannot necessarily trust their own suppositions about the meaning of most of what they see. At the same time, as otherwise accustomed movie and TV viewers, they cannot but attempt to make the same interpretive moves that work for them when looking at a Hollywood or television piece.

So ethnographic film participates in a medium whose conventions are drawn from Euro-American cultural forms of self-representation — theatre, cinema, photojournalism — and it uses this medium to document the practices and meanings of other cultures. It is not surprising, then, that anthropology's best filmmakers experience a genuine need for critical analysis of the film medium of representation as well as of the written genres of ethnography, scientific report, and intellectual argumentation. Several of the papers in this volume, in particular those by Ginsburg and Marcus, are written by anthropologists with these sorts of issues in mind and resonate with Willemen's concerns.

Those concerns are allied with consideration of more widespread and pervasive manifestations of the economically and culturally dominant nature of Euro-American cinematic form. Representation is always happening across the notional boundaries of psychological, social, or cultural specificities. Men represent women to audiences of men and to women themselves. The rich represent the poor and dominate the media so that few acts of self-representation ever penetrate the veil of bourgeois homogeneity within First World cultures. And the technologies of knowledge and representation in the First World continuously overwhelm the possibilities for non-Western cultures to represent themselves on a world stage, as Faye Ginsburg's essay demonstrates. Can these cultures ever succeed in parochializing Europe as it has rendered them parochial? This is a question less to be answered than to be explored for its implications about what such a project would entail.

Self-representation of indigenous peoples and of immigrant "ethnic"

populations within nation-states, not to mention class-derived subaltern cultures, also has to come to terms with the narrative structures, archetypal forms, and economic practices of international commercially viable cinema whose roots lie in Euro-America. At work here are formal and historical processes of cultural dominance which are outlined in Paul Willemen's essay on the concept of the national cinema. At one level Willemen's essay explores what is at stake in subsidising or not subsidising culturally specific cinema, which cannot, by its very nature, be commercially viable on an international or global scale. Cinema is a highly capitalised and now universally penetrating art form that has broad appeal but whose own "production values" are set by an industry designed to mass market its products and recoup its enormous investments. The mechanisms of mass marketing overwhelm cinemas with local meanings and smaller production budgets and threaten to expunge them. National governments are the entities with sufficient resources to subsidise culturally specific cinemas.

In thinking through this issue Willemen rigorously engages with the question of cultural boundaries and considers what is to be gained and lost by crossing them and in what state of mind the intellectual traveller can best do this. Indeed, even to think in "cross-" or "multi-" cultural terms sets up central and defining vantage points from which difference can only be perceived ethnocentrically. Willemen helps us to disentangle the issue of national specificity from the discourses of nationalism, and also from the discourses of universalising humanism, by which cultural specificity is doubly colonised. He carries out this project not merely in the name of a polycentric, multivocal world, which could hopelessly fragment (or deafen) itself, but in the service of the dialogism that Bakhtin termed "creative understanding" and that Raymond Williams called "diagnostic understanding" — both notions which are remarkably close to what the best anthropologists aim for in their own, also power-laden, context. Willemen quotes Bakhtin:

Creative understanding does not renounce itself. . . . We raise new questions for a foreign culture, ones it did not raise for itself; we seek answers to our own questions in it; and the foreign culture responds to us by revealing to us its new aspects and new semantic depths. Without *one's own* questions one cannot creatively understand anything other or foreign.

Carrying out creative understanding in the context of multinational industrial cinema regimes may be hard, but if we value the expression, self-representation, comment, and critique that is available through cin-

ema produced in nondominant cultural contexts, whether West Indian in Britain, Turkish in Berlin, or Aboriginal in Sydney, structural support for that cinema must be a priority of intellectual activity and arts funding.

One of the objects of this volume is to bring cinema into closer relation to the work of writing-based disciplines, not only as an object of critical scrutiny, but as an activity of relevance to the various disciplines themselves. George Marcus examines the literary possibilities of cinematic techniques demanded by the conditions of twentieth-century global forms in which no one can any longer live in self-contained and wholly knowable communities but in which filmmaker, ethnographer, and villagers are complexly linked in space-time contexts of simultaneity and difference through a multiplicity of homogenising technologies and appropriations. Devereaux and MacDougall both consider the possibilities of an expanded role for film in anthropological description and thought through considerations of objectivity, subjectivity, positionality, and voice as they have been taken up in cinema theory and practice.

Devereaux, in particular, further pursues the paradox posed by Mac-Dougall—that anthropologists want ever more "realistic" documentary while filmmakers are more interested in what cannot be seen, in seeking what lies behind the overexposed, foregrounded body, namely "the experience of existing in it." This hinge between the papers of MacDougall and Devereaux, in which the unforgettable image of a woman's belt imprinted upon her skin stands for a whole indelibility of culture, sentience, and her being as a woman, links up further with most of the essays in this volume in their concern with encompassing more adequate perceptions of the body.

Devereaux's paper, like Dermody's, seeks to reinstate the subjective voice, and also women's voices, to speak of their own experiences, to temper and to redirect male discourse, and both papers have implications for film aesthetics within the documentary and the ethnographic realms. And not just for film aesthetics; if there is, indeed, no (anthropological) discourse for the way woman's body feels to itself, then this is a gap that is the subtext, or perhaps the urtext, to many of the essays in this volume. The conclusion, "Female experience, like female desire, is absent in this record of male visual pleasure," is in fact Devereaux on chimpanzees but clearly reads as a gloss on Studlar's study of Barrymore films.

Case Studies: Film

Dialogism is a theme which is set in the initial papers and resonates through the entire volume. Bakhtin's recognition of the situated nature of every utterance has implications not only for the realist disciplines of the social sciences but for interpretive historians of cinema and for feminist and other theorists of spectatorship. Film is of interest to any theoretical approach to the interpersonal generation of meaning, since film, as text, has conditions for production, duration, and repetition that are unique to it. Aspects of this issue are touched on in all the papers but most particularly in Gaylyn Studlar's discussion of the relation of women to the "women's film" of the 1920s and in Barbara Creed's analysis of the carnivalesque functions of the horror film. And virtually all of the papers, especially those dealing with the documentary qualities of film and photograph, owe an unacknowledged debt to Bakhtin's commitment to realism not in mimesis but in the profoundly social nature and historicity of human life. This is most clearly evident in Willemen's essay but also echoes throughout the volume as the authors attempt to deal with the deep interpenetrations of form and meaning between different cultural positionings—woman and man, Aboriginal and Anglo-Australian—without reducing those positionings to issues of essential difference or sameness.

The body as the site and the icon of the construction of self and other is a key element of a culturally situated representational practice and occupies a central place in current theoretical debates. Once the debased term in many Western paired oppositions, it is now experiencing intellectual recuperation. Barbara Creed considers the body in popular discourse through the transmogrifying lens of the horror film, which she sets in its cultural history of the politics of symbolic inversion. Drawing on Bakhtin's analysis of the way symbolic inversion in European carnival works as a critique of high culture, Creed examines the grotesque and dismembered bodies of the horror film for their critical and constructing work in bourgeois culture. She discusses the processes by which the infant psyche enters culture, its body is ordered, and its body products contained. Creed shows how these processes are relived and disrupted by the representations of horror, where the expelled and rejected bodies are drawn back into consciousness. It is here that the pleasures of the horror genre lie for the spectator, in this challenge to the classical ordered body, as well as in its simultaneous confirmation, Creed claims.

The political possibilities of symbolic inversion, whether in public ritual or in popular cinema, are rebellious rather than revolutionary, but the cracks and gaps which they open in consciousness are not inconsequential.

The questionable power of the spectator to command the pleasures that cinema constructs for it in the manipulated economy of the mass market is under scrutiny in Gaylyn Studlar's essay on women's role in constructing the male body in Hollywood romances of the 1920s. She shows how these films, aimed at a female audience and speaking a discourse of romantic love, participated in an already conventionalised web of representations of the eroticised male body produced for women's sexual subjectivities. This very fact of female sexual desire was the focal point for male anxiety about blurring masculine and feminine in public culture. The New Woman who smoked and drank, and the feminised matinee idol like Valentino, created a terrain of cultural antagonisms successfully traversed by the vigorous body of John Barrymore when allied to scripts of romantic melodrama in which the hard indifference of the pure male gradually allows its repressed softness to emerge and envelop the heroine in its nurturant love.

Once again the ambiguities of gender and power are represented in a genre formula that fulfils a complex specular function, harnessing the disorder of male desire to the imperative of moral and tender love through the physical suffering of the heroic male body, a body which, moreover, must be wholly unaware of its own desirability in order to remain male. The pleasure of the image in narrative, then, lies in the play of partial inversions; what survives in the gender systems of popular culture and what is altered or inverted is the very stuff on which any understanding of representation's relationship to social process depends; we see the feminine in the masculine, and the masculine in the feminine, and acknowledge the utility of a gender analysis for understanding human life.

The concerns of these papers in citing the voyeuristic pleasures of the cinema spectator return like the repressed to haunt the more scientific representational practices. This is so especially, of course, with ethnographic film but also with the uses of archival film and photography in the construction of historical narratives, where we can usefully ask whether the intellectual pleasures of knowledge are voyeuristic and are newly reconstructing the power relations of the past. As an example, the republication of colonial photographs in a recent volume commissioned to critically review colonial representational practices was stopped by a

complaint that such reuse simply perpetuates the voyeuristic pleasures of old power relations, and, in fact, releases their constructing effects once again. Scholarly as well as popular imaging of others, whether conceptually distanced by space or by time, inevitably constructs self and other in the present, and it may well be that simply surrounding the images with a critical environment of words may not rescue those constructions from the work of the image. Indeed the recurrent question is whether any image can avoid the place of stereotype already prepared for it by the power relations of the past. Can films (such as Trinh Minh-ha's *Reassemblage*) show women's breasts without participating in the lascivious male gaze of Western cinema? Can films (such as Robert Gardner's *Rivers of Sand*) show Ethiopian tribal women laden with heavy brass bangles without participating in the misogyny it claims to critique? Under the weight of European representations, can any image of non-Western people, let alone nomadic herders dressed in skins, be other than stereotype? Can any film image of woman be other than made for man? These issues will reward attention as the impact of new representations accretes. Gaylyn Studlar's paper is a case study in the reception of film history, her assessment of the Barrymore films differing radically from the response of the contemporary critics.

Working another vein in the same seam, Gino Moliterno's essay on *The Name of the Rose* takes as its point of departure the phenomenon of a narrative multiply embedded in the form of the European book widely translated into languages that in some cases have only recently moved from orality to literacy as well as into the medium of film. The novel, a study in overt intertextuality, takes its narrative complexity from its structure as a multilayered palimpsest aquiver with the dialogic murmurings between all the parchments of the mediaeval canon, a palimpsest in which the desire of the text for itself becomes the story. Moliterno inquires into this dialogism of the novel and its condemnation of the monologic motivations of books, of knowledge, and of representation, especially as they fail to be taken up by the film version of *The Name of the Rose*. His critique shows how realism as a form of objectified mimesis (Bakhtin's rejected pseudo-realism) wholly misses its object when the subtleties of framing, perspective, and voice are ignored. The mediaeval authenticity so painstakingly produced in Annaud's film at the level of costume and prop becomes caricature when the dialogic and intertextual nature of the originating text are themselves not made operative in cinematic code. Far as this may seem from matters of realism in science and documentary film, it is nonetheless a persuasive example of the way

in which visual literalness inevitably becomes stereotype, a problem that yawns like the caverns of hell at the feet of all cross-cultural, cross-gender, and cross-positional representation when it seeks faithfully to repeat a cultural form rather than courageously to intersect with it. This is another point at which we hear the echo of the political extension of Bakhtin's thought in Paul Willemen's essay.

Taking some issues of adaptation between media a step further, Roger Hillman invites us to discard simplistic views of film music as emphasis and mood and to consider its work in creating an alternative or commenting narrative to the visual and verbal dimensions of plot. The narrative potentials of musical scores in films produce a capacity for polyphony, which is not always noticed overtly and represents a complex intertextuality between the arts to which film criticism has remained relatively impervious. The force of our Western urge toward realism in narrative is perhaps nowhere less challenged than in the non-verbal audio aspects of most Hollywood films. However, in the more crafted films of the European auteur tradition, music, as Hillman shows, can do the work of omniscient narration, which carries the shifting positioning of the audience from character to character. The question which the essay opens up is the intertextuality between works of different genres and the possibilities and limitations this creates. In a volume in which less problematic concepts of ethnography, representation, and indeed narrative itself are critiqued from feminist positions, the feminist restoration of sound beyond the privileged sense of sight finds some echo here, too.

Case Studies: Photography

Two papers take up the relationship between the photographic image (primarily the still image) and the practices of historical scholarship and popular history. Once again the issues of visual realism and its implications for cross-temporal representation, knowledge, and historical narratives emerge. The self-interested, now-interested production of historical narratives determines the nature of the use of photographs from the past.

Anne-Marie Willis's essay ironically deconstructs the phenomenon of historic theme parks, which some would place on a par with ethnographic film and TV nature series — captive re-creations of waning

worlds, or disappeared worlds, for purposes of lucrative spectacle. Willis calls on Thomas Elsaesser's work to elaborate the conditions which contributed to the rise of the visual in Western culture and the subsequent use of the figural in discursive attempts to come to terms with cultural process. She describes the use of photographs in the production and practices of historical theme parks and in the ellipsis between realism and actuality. We are entangled in the technologies of our recording mediums and cannot move hand or foot without setting in motion images of the distant or more recent past. And at the same time the rapidly receding past carries our nostalgia for stability of place and meaning. This nostalgia in turn produces a hall of mirrors of authentic recreations of absent places and times through the details of the once-real afforded by photographs stranded in albums, archives, and bureau drawers and revivified in the props and staged locations of historic theme parks.

The stories that we weave around the activity of war, stories that make it possible to wage and to endure, come out of many centuries of heroic narratives and are often incompatible with the documentary character of the photograph. Bernd Hüppauf's paper on photography in World War I explores the urges to retouch and make composite photographs of moments in combat in order to express the totality of both grandeur and desecration experienced by the photographer but not "captured" by the narrower focus of the camera lens. Hüppauf demonstrates how the particular and documentary nature of the photograph clashed with the morally committed reportage of war, and also with the aesthetic requirements of visualising a reality that, by its distance and overloaded meanings, had become highly abstract for the audience back home. He connects this observation to more mundane and present situations by pointing to the abstract, scientific, and disjointed nature of modern reality, which seems to require highly conceptual modes of representation rather than pictorial duplication of visible reality. Once again, the reality of the experiencing subject bears an uneasy relationship to the acts of representation for a distant and nonexperiencing viewer, precisely the problem that ethnographic film confronts in presenting a cultural reality different from the one in which the viewer has expertise. The technological mimesis of the photograph fails to create a "you were there" experience in the viewer because the meaning of the moment may lie visually, or auditorially, outside the frame; indeed it may lie in the juxtaposition of this moment with other moments in the mind of the experiencing subject, moments not available to the viewer

except through montage or through the multiple image created by means of composition and overlay. Frank Hurley's composite photographs of jungle savages, island paradises, and storm-ridden battlefields become, indeed, "more real" than the literal reality he could offer through unretouched documentary photography.

Subject(ive) Voice

David MacDougall's "concern with the portrayal of experience across cultural boundaries rather than cultural self-expression or reassertion" complements in terms of a geography of human experience the two essays with which this volume opens. But in its reinstatement of a subjective voice within the (human) scientific classifications of the ethnographic film it also bears on the way Gaylyn Studlar's paper addresses the suppression of experience via its unacknowledged channelling across gender boundaries. MacDougall provides a historic survey of ethnographic film's approach to its subjects through such devices as the glance into the camera, dramatisation — whether exterior, interior, or narrated — and the approaches of psychodrama, cultural reexpression, and ethnobiography. A title in a very early film he cites invites us to "see what the native sees" — MacDougall's article continually poses the question of the extent to which we can share not only the object of "the native's" gaze but the consciousness informing it, its manner, the subjectivity structuring and interpreting it. The magnitude of this issue of course goes beyond ethnographic film and indeed film itself among the arts, and so it is not surprising to find a close analysis of Epstein's *Finis terrae* (which MacDougall considers an ethnographic film) leading to a comparison with Antonioni. Between the lines of MacDougall's wide-ranging examination of techniques straddling both ethnographic and fiction films, intriguing questions are raised. He implies that the coming of sound was an irreversible turning point for documentary film, with the risk of the spoken word swamping the visual image as a vehicle of narrative. One is left with the possibility of an ethnographic film abandoning the spoken word and relying exclusively on imagery and a nonverbal sound track, something that Trinh Minh-ha's film *Reassemblage* approached, in fact. MacDougall registers a shift from representation to evocation, but this too is located in the domain of discourse.

One attempt to transcend the discursive, which though ultimately a failure seems to demand attention from ethnographic filmmakers, is Reggio's *Powaqqatsi*. With its stylized use of slow motion and its Third World images crying out for political contextualisation, this film relies on Philip Glass's sound track to carry the narrative beyond the visual level, a burden to which this particular music is not equal and which may ultimately have defied any music. It may be that unsourced music — music emitting from a source not visible on the screen — cannot replace the cognitive content of the spoken word, but natural sound (whether distant thunder or a musical instrument played by the subjects of the film) could possibly meet the challenge. And all three aspects — unsourced music, the spoken word, and natural sound — are certainly implicated in the issue of subjectivity in ethnographic film. They further that crossing of generic lines which George Marcus pursued from a different vantage point. A key figure, one important to MacDougall's essay and one taken up in detail by Peter Loizos, is the controversial Robert Gardner. His films seem to have crystallised for ethnography what John Berger has formulated for fiction films, namely the simultaneous presence within the filmed event of "something of the focus, the intentionality of art, and the unpredictability of reality." The very terms of the tension would perhaps be denied by the more positivist streams of ethnographic film, for whom the profilmic event can ultimately be made largely predictable.

Epistemology and form are questions with both political and economic roots, as Ginsburg's paper reveals in her discussion of what forces come into play when indigenous cultures are linked to metropolitan centres by satellite technology. Ginsburg takes up the emerging literature about the engagements of indigenous peoples with mass-mediated television and video technology. Her paper provides a striking case in point with a detailed discussion of the regional television produced by Aboriginal people in central Australia, work that demonstrates the complex range of Aboriginal responses to the introduction of media technology. These responses include informed consideration of what is at stake in using this technology to construct cultural identity and attempt to intervene in the dominant representations. Aboriginal writers and producers are aware of the trade-offs, traps, and possibilities that are bound up in the use of television to mediate culture. Ginsburg's paper opens these discussions and developments in Aboriginal broadcasting to the debates about representation taking place in the film and writing arenas that have been concerned with "the ethnographic." Ginsburg's contribu-

tion provides a link to wider political concerns about the subtle dominations inevitably arising from both institutional and technical/formal aspects of technologies of representation.

A different dilemma of self-representation is faced by the central figure in Alexander Kluge's *The Patriot,* a female history teacher seeking a positive history of her native Germany. Susan Dermody discusses a bizarre embodiment of a narrator in this film, namely the knee of a corporal killed at Stalingrad. Here we have the concretisation of an antiwar nonsense poem by Kluge's countryman Morgenstern in which a knee, no more nor less than a knee, walked alone through the world. Even the experience of existing in the body is transcended here by the disembodied consciousness of a key link in the body, a knee, which supplies a perspective on (German) history from below. The film's narrative progression is continually punctuated by photographs and paintings, all of them conjuring up stories that are the stuff of history and which function as allegory, an eclectic ancestral gallery of the German past. For the traditional ancestors are displaced, and yet the absent or alienated icons of the past are also the film's documentary foundation. The knee, and the knee's perspective, would not exist without the Battle of Stalingrad, a nadir in Germany's experience of World War II, and the death of Corporal Wieland the day before the lifting of the siege. Absurd history demands absurd or surrealistic imagery. Even were it less fertile as a nonauthoritarian voice from the wilderness of history from below, Kluge's narrator would yield more truth, as Dermody tells us, than the "factual" referents of documentary as reduced *ad absurdum* in Kluge's image with which Dermody's paper finishes. Not only is the distanced man unknowable, but a totally incidental detail eclipses him further — the flame of his cigarette, foregrounded by the conditions created by the documentary.

A comparable distancing from experience was addressed by both Willis and Hüppauf, particularly in the latter's examination of war photography from planes. The problems of distancing addressed by Dermody echo Devereaux's call for anthropology to take a less distanced perspective and to put "dailiness" and "embodiment" closer to the heart of its ethnographic documentation. The aim of reducing distance is to come closer to a view of other lives as they are experienced in their own terms and to recognise the interpenetration of those terms in the global connections of life in the twentieth century.

Here we come to the central dilemma of the politics of representation. Can an author or filmmaker, can a medium for that matter, rooted

in one culture, in one sex, ever produce a representation of another culture or sex that is not, to some extent, a stereotype? This question arises not only because of cultural limitations on the perceiving consciousness of the filmmaker but also because of the heavy weight of all the representations already in existence. Can an image of a rainforest tribesman in the 1990s ever fail to evoke the jungle dramas of safari films or the glorious photographs of the *National Geographic*?

Peter Loizos bridges ethnographic and aesthetic concerns in considering one of Robert Gardner's films, concerns that arise in several papers in this volume, in different vocabularies, each pointing to the tension between "realist" and aesthetic desires. Gardner's films have fascinated and infuriated anthropologists for many years, since they remain some of the most watchable of ethnographic footage while refusing to work within the genre of didactic film. Anthropological audiences often react with suspicion, fearing manipulation by "unexplained" images, and demanding more information and contextualisation than Gardner is willing to supply. His most recent film, *Forest of Bliss* with Akos Oster, indeed refuses any contextualisation and has given rise to intense debate about the effects its images have on Western audiences.

Loizos writes from a position of commitment to the possibility and the need for an objectivist social science, but he offers a filmic analysis of the way Gardner's *Rivers of Sand* works as film to produce its meaning. His analysis assists students of ethnography to inquire into their own responses to documentary films by examining the way a visual essay creates meanings, and he seeks to avoid drawing hard conclusions. In this Loizos demonstrates some of the significant differences between the rhetorics of image and text, especially in nonnarrative genres.

Representation and self-representation are equally caught in this web of image; there is a labyrinth here, from which there is no escape. We cannot transcend our relationships to observe, speak, and know from any wholly exterior point. At the same time, the exteriority of the other creates a continuous field of awareness in which knowledge is produced. This is the relationship of astonishment, whose ethics are respect.

Here the political stance of Bakhtin toward cultural knowledge points the way forward, and his work runs through much of this volume in recognisable but unstated ways. The ground of the encounter with the other is dialogue, in which the subject is herself brought forth. Each and both always — therefore, contextual. The culture that is in us and the culture that is in things, our products, point to the politics of difference — class, gender, national difference — which is at stake in cultural

production such as film. We can ally Bakhtin's ideas about dialogue to the interpersonal philosophy of Emmanuel Levinas's notion of alterity, in which Levinas invites us to regard each of ourselves not as the pre-existing axis around which all others circulate as subsidiary, outside (our) true consciousness, but as ourselves evoked by the prior existence of others. In an epistemology of alterity we are evoked by our social relationships; our apprehension of the other is embedded in it. Such an epistemology of alterity linked to the political notion of cultural dialogism can inform the critical work of understanding cultural production and the way it works to uphold or to subvert a given personal or political consciousness.

Studies that clarify the links between our own forms of representation (especially those forms such as movies in which we swim like so many fish in a sea) and the lines of continuity, interest, and force that structure the conditions of their production meet up with anthropology in two important ways. Cultural studies is a cultural anthropology of ourselves, and at the same time the radical, formal, critical theories of which it takes part lay bare, from historical and philosophical points of view, the conditions of anthropology and all other social sciences' knowledge production. That these structures of knowing have been entirely complicit with the rest of European relations of domination in no way alters the necessity for knowing beyond the confines of the self. Indeed self-scrutiny without regard for the field of alterity that precedes and surrounds the self is the very cultural autism that Eurocentric knowledges constantly become. The members of all the subaltern positions must know Europe to know themselves. Until now European thought, that egotistical sublimity, has in its imagined transcendence rendered other cultural thought inferior, lacking, truly other, existing only for European purposes of representation.

The beginning of this century saw a cluster of crises in representation in the humanities (the advent of film, tonality yielding to atonality, etc.). Something of the millenarian proportions of the current crisis is reflected in the contributions to this volume. History and ethnography are perhaps the disciplines most consciously affected, but they are not alone. Film is a fruitful base for interdisciplinary metarepresentation, just as it is a pedagogic link for humanities disciplines. Film, as it is discussed in this volume, is a focal point for concerns that have their analogues throughout the humanities, concerns that have been taken up in one form by film studies, in other forms by visual anthropology, and that require the release and the opening of the disciplinary shutter.

Through debates on postmodernism, postcolonial cultural identity, and globalisation, undermining traditional disciplinary boundaries leads to mining lodes under worked-out seams (semes), as film and the humanities find their way to dialogue.

Note

Many of the thoughts in this essay were developed in conversation with Roger Hillman, who also contributed the sections on the Devereaux, Dermody, and MacDougall papers.

Themes

2

The National

PAUL WILLEMEN

In the introduction to *The Archibald Paradox: A Strange Case of Author-ship,* Sylvia Lawson formulated the paradox besetting the central figure of her book, J. F. Archibald, the editor of *The Bulletin* at the turn of the century in Australia, in the following terms: "The Archibald paradox is simply the paradox of being colonial. . . . To know enough of the metropolitan world, colonials must, in limited ways at least, move and think internationally; to resist it strongly enough for the colony to cease to be colonial and become its own place, they must become national-ists."[1] I would like to approach this paradoxical tension between the national and the international from a slightly different perspective: that of multiculturalism and the concern with national specificity as it relates to film studies.

In each sociocultural formation, these tensions must, by definition, be played out in different ways. But the terms in which these tensions are presented will have a family resemblance. Consequently, some of my remarks may seem to rehearse well-worn lines of argument. Neverthe-less, the issues of the national and the international and indeed of the colonial and the imperial are present in film studies in specific ways, where those issues are not approached in the same way as, for instance, in anthropology or in comparative literature. Although the structural method of analysis migrated from linguistics into film theory via the anthropology of Claude Lévi-Strauss, it is only fairly recently that some anthropologists have begun to take on board questions of textual functioning and subjectivity, questions such as the constructed-and-

constructing nature of all discursive practices that have become commonplace in film theory.

And while the traumatic aspects of the relativist binge that followed from that recognition are mercifully beginning to recede in film theory (while still holding sway in television studies), vanguardist anthropology is still incapacitated by the discovery that anthropological discourse is also "discourse." As for comparative literature, regardless of its many historical deficiencies, it must be acknowledged that comparative studies in cinema do not as yet exist. What is worse, given the current insufferably ethnocentric bias of film theory, it may well be a while before this urgently needed discipline of comparative cinema studies will displace the kind of film studies currently being inflicted on university and college students.

Both the terms "cross-cultural" and "multicultural" already point to the first problem in the sense that they suggest the existence of discrete, bounded cultural zones separated by borders that can be crossed. The term "multicultural" in addition suggests that such discrete, bounded cultural zones continue to exist within a given country as small, self-contained pockets or islands, miniature replications of an alleged community's allegedly original national culture, as repositories of some cultural authenticity to be found elsewhere in time, in space, or in both.

In Ukania — Tom Nairn's suggestive term for the peculiarly ossified, incompletely modernised monarchical state known as the United Kingdom — one hears references to, say, the Bangladeshi or the Irish or indeed the Asian communities, as if a given "ethnic" community had simply transposed a national culture from "there" to "here." This multicultural ideology has some positive but also some exceedingly negative consequences for a country's cultural life and policies. The most negative result is that for instance "ethnic" groups will be imprisoned, by arts funding bodies and local government practices, within a restrictive and ossified notion of culture. In this way, they are condemned to repeat the rituals of ethnic authenticity regardless of how uncomfortable many members of those so-called communities may feel with such rituals. One of the political effects of such cultural policies is that administrators and local politicians will tend to recognise "community" spokespeople who represent the more conservative and nostalgically "traditionalist" sectors of "the communities" in question. A further, perhaps ironic, consequence of such "multiculturalism" is to encourage the practice of a "traditional" culture separated from the social conditions by and for which

cultural forms are shaped and, in so doing, to fetishise the separateness of the cultures thus called into being. In that respect, multiculturalist policies are in fact designed to create a kind of cultural apartheid.

By insisting on the discreteness and the separateness of the "other" cultures, the host culture conspires with the conservative upholders of an imagined "ethnicity" to draw lines around those "other" cultural practices, ghettoising them. And in that way, the host culture can re-affirm its own imaginary unity and the illusion of its own specialness and authenticity. In that context, I would like to draw attention to the brilliant work of the late Eric Michaels in relation to Australian Aboriginal cultures and particularly to his short talk entitled "Postmodernism, Appropriation and Western Desert Acrylics" reprinted in a pamphlet edited by Sue Cramer of Brisbane's Institute of Modern Art (1989). There, Eric Michaels argued against the idea that Aboriginal art should be locked into some ethnographic notion of authenticity and irremediable otherness. Instead he pointed to the modernity, indeed the critical postmodernity in some respects, of the work of many Aboriginal artists as they engage with their critics and the market and reflexively comment on their own contemporary production practices as Aboriginals living in a late twentieth-century Australia, which in its turn is part of broader cultural processes and institutions such as the international art market and its power centres.

Although we can all agree that cultural zones are far from unified, homogeneous spaces, this should not lead us to deny or unduly relativise the existence of borders. The existence of borders is very real, and although their meaning and function are changeable, their effectiveness has not diminished in the least.

At one level, it does indeed make sense to try to construct a notion of national culture by way of a spatial commutation test. The culture would then be defined in terms of the things that change in "the whole way of life" (R. Williams) or "the whole way of struggling" (E. P. Thompson) when a national frontier is crossed. For instance, abortion may be legal on one side of a border and not on the other. Similarly, legal and other institutional arrangements, such as those relating to film and television finance and censorship, may be vastly different as well. In federal structures such as in India, the United States, the former USSR, or Australia, there are different inflections to this problem because of the imbrication of national and state institutions, but the problem of the nation-state's borders remains, as is demonstrated by the importance

of passports for bestowing a national identity upon individuals, with the consequent legal regulation of immigration and the whole panoply of issues implied by the notion of citizenship.

On the other hand, the construction of a cultural matrix in such a geostructural way does not account for the sense of temporal continuity that is attributed to national cultural formations. The comparative study of, say, independent British cinema in the 1930s and the 1970s is not regarded as a form of cross-cultural studies. The intervention of World War II and of a host of other sociopolitical and economic changes apparently does not constitute a sufficient temporal boundary for us to be able to talk of different cultural formations. My question would then be: what model of social functioning is able to account for the differences as well as for the connections between temporal periodisations and geographical demarcations?

Perhaps we should begin by becoming more aware of the unholy complicity between periodisation in history and the drawing or the crossing of geographical boundaries. The invasion of Australia and the declaration of a bicentenary period is only one example of this complicity. The tendency to date "England" back to the invasion of 1066 is another, as is the tendency to regard World War II and its large-scale redrawing of the world map as THE temporal watershed of the twentieth century. It would be foolish to deny that World War II is indeed a very significant marker in all kinds of respects. The point is that in other respects, such as for instance the periodisation of capitalism, World War II is not such a significant marker. The liquidation of nineteenth-century absolutist empires took over fifty years and the triumphant consolidation of capitalism on a global scale happened sometime between the mid-1950s and the late 1960s, while the triumph of finance capital over industrial capital took even longer and was not consolidated until the 1980s. This point is worth making to show that there are temporal rhythms and periods that, although implicated in and affected by geographic changes, do not coincide with them. The synchronicity of geographical and temporal periods at work in most national histories has to be produced at some cost: the loss of perspective on the very forces that construct the vicissitudes of "the national" in the era of international dependency.

The notion of cultural specificity that may be deployed against the universalising ethnocentricity at work in film studies operates at the level of this geotemporal construction of the national. The question of

cultural specificity can be posed on other, social community levels (and these community levels may themselves be transnational, as are some constructions of gender and class-based politics). But in film studies, the issue of specificity is primarily a national one: the boundaries of cultural specificity in cinema are established by governmental actions implemented through institutions such as censorship and its legislative framework, industrial and financial measures on the economic level, the gearing of training institutions toward employment in national media structures, systems of licensing governed by aspects of corporate law, and so on.

For the purposes of film culture, specificity is a territorial-institutional matter and coincides with the boundaries of the nation-state: the terrain governed by the writ of a particular government.

As a rule, the effectiveness with which national sociocultural formations, that is to say, state-bound unities, determine particular signifying practices and regimes is not addressed. This is a problem for a number of reasons. One result is that it encourages confusion between, on the one hand, the discourses of nationalism as objects of study or as a political project and, on the other hand, the issue of national specificity. Compared to U.S. black films, black British films are strikingly British, and yet in no way can they be construed as nationalistic. They are part of a British specificity but not of a British nationalism, especially not if you remember that British nationalism is in fact an imperial identification rather than an identification with the British state. To complicate matters further, an identification with the British state is in fact English nationalism, as opposed to Welsh, Cornish, or Scottish nationalisms, which relate not to a state but to nations and are recognisable by their demand for autonomous governments, even if that autonomy may be qualified in various ways.

A second area of confusion is the relation between a concern with national identity and the specificity of a cultural formation. For instance, the concern with notions of Australianness and with national identity were a temporary component of the dominant registers of Australian cultural specificity. That concern started to decline since the so-called bicentennial celebrations. This simply means that the specificity of the Australian cultural formation has changed over the last decade and now generates other motifs and discourses. In that sense, the concern with sociocultural specificity is different from identity searches and debates. The specificity of a cultural formation may be marked by the presence

but also by the absence of preoccupations with national identity. Indeed, national specificity will determine which, if any, notions of identity are on the agenda.

So, the discourses of nationalism and those addressing or comprising national specificity are not identical. Similarly, the construction or the analysis of a specific cultural formation is different from preoccupations with national identity. I would go further and suggest that the construction of national specificity in fact encompasses and governs the articulation of both national identity and nationalist discourses. Nationalist ones forever try to colonise and extend themselves to cover, by repressively homogenising them, complex but nationally specific formations. Thankfully, they are also doomed to keep falling short of that target. In that sense, nationalism is the shadow side of imperialism: it is an ideology generated by imperialism as its own counterbody, and it is in some ways even more repressively homogenising than that of the empire it seeks to undo. Perhaps necessarily so if nationalism is to undo its imperial yoke successfully.

At the same time, in art- and media-oriented studies, insufficient attention is paid to the determining effects of the geographically bounded state unity, and this encourages a kind of promiscuous or random form of alleged internationalism that I would prefer to call an evasive cosmopolitanism masking imperial aspirations. Another, more polemical, way of putting this is to say that the discourse of universalist humanism is in fact an imperial and a colonising strategy. If we accept that national boundaries have a significant structuring impact on national sociocultural formations, this has to be accounted for in the way we approach and deal with cultural practices from "elsewhere." Otherwise, reading a Japanese film from within a British film studies framework may in fact be more like a cultural cross-border raid or, worse, an attempt to annex another culture in a subordinate position by requiring it to conform to the raider's cultural practices.

Such practices are an acute problem in film studies for three main reasons. The first one is that academic institutions are beginning to address the film cultures of non-Western countries. This expansion in academia's disciplinary field creates job and departmental expansion opportunities. The result is that scholars formed within the paradigm of Euro-American film theory are rushing to plant their flags on the terrain of, for instance, Chinese, Japanese, or Indian film studies. In that respect, those scholars and departments are actively delaying the advent of genuine comparative film studies by trying to impose the paradigms

of Euro-American film and aesthetic theories upon non-European cultural practices. In the process, the very questions concerning the production of specific sociocultural formations mentioned earlier are marginalised or ignored.

The second reason for film theoretical malpractice can be found in the assumed universality of film language. This illusion is promoted to ignore the specific knowledges that may be at work in a text: for instance, shorthand references to particular, historically accrued modes of making sense (often referred to as "cultural traditions"). As an example, we might remember the controversy generated by Antonioni's use of the close shot in his film on China or the different ways in which notions of realism are deployed in relation to various types of melodrama in Asia. Further examples can be found in films that engage with the connotations generated by particular landscapes within particular cultures or the differing meanings attached to images of industrialisation, for example. It is in this set of issues that notions of "third cinema" can most productively be deployed. Similarly, since the Hollywood model of character narration is accepted as the norm in Euro-American film studies, the modes of studying Hollywood narrative and its counter-cinemas have been presented as equally universal and normative, duplicating and confirming the position of the economic power enjoyed by Hollywood.

The third reason is the forced as well as the elective internationalism of film industries themselves. The capital-intensive nature of film production and of its necessary industrial, administrative, and technological infrastructures requires a fairly large market in which to amortise production costs, not to mention the generation of surplus for investment or profit. This means that a film industry — any film industry — must either address an international market or dispose of a very large domestic one. If the latter is available, then cinema requires large potential audience groups with the inevitable homogenising effects that follow from this, creating an industrial logic that if played out at a national level will benefit from the equally homogenising project of nationalism.

The economic facts of cinematic life dictate that an industrially viable cinema shall be multinational or, alternatively, that every citizen shall be made to contribute to the national film industry, regardless of whether they consume its films or not.

If the question of national specificity is posed in this context, it is at the level of national and governmental institutions, since they are the only ones in a position to inflect legislation and to redistribute tax reve-

nues. And that fact has unavoidable consequences for the social power relations that govern the kind of cinema that will thus be enabled.

Consequently, a cinema that seeks to engage with the questions of national specificity from a critical or non- or counterhegemonic position is by definition a minority and a poor cinema, dependent on the existence of a larger multinational or nationalised industrial sector (most national cinemas operate a mixed economic regime, but that does not alter the argument; it merely creates a little more breathing space for filmmakers). By the same token, a cinema addressing national specificity will be anti- or at least nonnationalistic since the more it is complicit with nationalism's homogenising project the less it will be able to engage critically with the complex, multidimensional, and multidirectional tensions that characterise and shape a social formation's cultural configurations.

This leads us to the ironic conclusion that a cinema positively yet critically seeking to engage with the multilayeredness of specific sociocultural formations is necessarily a marginal and a dependent cinema: a cinema dependent for its existence on the very dominant, export- and multinational-oriented cinema it seeks to criticise and displace. This too is a paradox worthy of Archibald, because this marginal and dependent cinema is simultaneously the only form of "national" cinema available: it is the only cinema that consciously and directly works with and addresses the materials at work within the national cultural constellation. The issue of national cinema is then primarily a question of address rather than a matter of the filmmakers' citizenship or even the production finance's country of origin.

Cultural Specificity as an Analytical Construct

For the Soviet cultural theorist Mikhail Bakhtin, there are three kinds of interpretation that correlate with three different ways of framing relations with "other" sociocultural networks. The first one is a kind of projective appropriation (my term). This happens when the reader/viewer projects him or herself, his or her belief world, onto the texts. The most common example of this practice happens when a theoretical or interpretive framework elaborated for and within one cultural sphere is projected onto the signifying practices of another cultural sphere. To project early twentieth-century Western novelistic criteria of

psychological verisimilitude onto 1940s commercial Indian films would be one such example. Another would be the assumption that Leavisite or Baudrillardian aesthetic ideologies are universally applicable norms. Projective appropriation accompanies efforts to internationalise a restrictive regime of making sense. It is concerned with conquering markets, eliminating competition, and securing monopolies.

The second type is what I would call ventriloquist identification. This is the obverse of projective identification and happens when someone presents him- or herself as the mouthpiece for others, as if the speaker were immersed in some ecstatic fusion with the others' voices and were speaking from within that other social or cultural space. The fantasy at play here, in the realm of film studies as well as in filmmaking, is that of the middle-class intellectual or entrepreneur who is so traumatised by a privileged education and access to expensive communications technology that she feels compelled to abdicate from intellectual responsibilities and pretend to be a mere hollow vessel through whom the voice of the oppressed, the voice of the "other" people, resonates. The attitude remains the same regardless of whether those "other" people are defined in terms of class, gender, ethnicity, religion, nationality, community, or whatever. Ventriloquism is the monopolist-imperialist's guilty conscience: it allows him to remain an authoritarian monopolist while masquerading in the clothes of "the oppressed."

The third type, predictably, avoids both those undesirable but very widespread attitudes. It does not appropriate the other's discourse, it does not subordinate itself to the other's discourse, and neither does it pretend to be fused with it. With increasing frequency, this third practice is described with the Bakhtinian phrase: the dialogic mode.

Unfortunately, this is a complete misunderstanding of Bakhtin's notion of dialogism, which is in fact an inherent characteristic of all language and of all communication. In other words, it is completely meaningless to try to distinguish one practice from another by calling one dialogic and the other, presumably, monologic. It is worth pointing out that Bakhtin revised his work on Dostoievsky in the light of this insight into the social nature of language itself and tried to distinguish between the way texts activated their inherently dialogic aspects.

More useful is Bakhtin's notion of creative understanding and the crucial concept of alterity, of otherness, which he introduces into his theories. Bakhtin argues for a necessary alterity, and this aspect of his argumentation is far more important, though usually overlooked, than the now fashionably inflated reference to The Dialogic.

To clarify this point, permit me to quote from Bakhtin on creative understanding or, as Raymond Williams called it, diagnostic understanding. The quote is taken from a short newspaper piece Bakhtin wrote in 1970:

There exists a very strong, but one-sided and thus untrustworthy, idea that in order better to understand a foreign culture, one must enter into it, forgetting one's own, and view the world through the eyes of this foreign culture [this is what I called ventriloquist identification — P.W.]. . . . Of course, . . . the possibility of seeing the world through its eyes is a necessary part of the process of understanding it; but if this were the only aspect . . . it would merely be duplication and would not entail anything new or enriching. *Creative understanding* does not renounce itself, its own place in time, its own culture; and it forgets nothing. In order to understand, it is immensely important . . . to be *located outside* the object of . . . creative understanding — in time, in space, in culture . . .

In the realm of culture, outsideness is a most powerful factor in understanding. . . . We raise new questions for a foreign culture, ones it did not raise for itself [this is worth stressing since it is almost always overlooked: film or video makers do not engage critically with, for instance, the community group they work with — P. W.]; we seek answers to our own questions in it; and the foreign culture responds to us by revealing to us its new aspects and new semantic depths. Without *one's own* questions one cannot creatively understand anything other or foreign. . . . Such a dialogic encounter of two cultures does not result in merging or mixing. Each retains its own unity and *open* totality, but they are mutually enriched.[2]

My own conclusion from Bakhtin's discussion of creative understanding is that one must be other oneself if anything is to be learned about the meanings of another culture, of its limits, the effectiveness of its borders, of the areas in which, in another memorable phrase of Bakhtin's, "the most intense and productive life of culture takes place." It must be stressed that, for Bakhtin, creative understanding requires a thorough knowledge of at least two cultural spheres. It is not simply a matter of engaging a "dialogue" with some other culture's products but of using one's understanding of another cultural practice to reperceive and rethink one's own cultural constellation at the same time. If the critical study of, say, Chinese or Indian cinemas is not also aimed at modifying our Euro-American notions of cinema, then why study these cultural practices at all? Simple curiosity does not sound like a persuasive answer to such a question.

Bakhtin and Film Studies

Bakhtin's three ways of relating to other cultural practices can be neatly illustrated by the way Western film critics and other film writers, including Indian ones, regrettably, approach commercial Indian cinema.

The first and most widespread approach is a demonstration of Bakhtin's first type of interpretation: projective identification. It deploys a scornful amusement at Indian commercial cinema, marvelling at the infantile eccentricities of an intellectually underdeveloped mass audience supplied with entertainment by a film industry that matches its quaintly simple-minded naivety. The criteria used to justify such a discourse invariably erect a mid-twentieth-century European bourgeoisie's notions of art into a self-evident, universally applicable norm against which to test the rest of humanity's degree of civilisation. Increasingly, a variant of this approach can be found in the writings of advocates of the postmodernist persuasion who project the modalities of finance capital's cultural forms (corporate raiding and short-term investments in diversified portfolios for quick profits) onto "the global culture."

The second approach mirrors this process of projective identification but simply operates an ethical inversion of the terms. Anglo-American notions of popular culture are projected onto the Indian cinema, and suddenly the products of the Indian film industry become examples of the people's culture in exactly the same way that, for instance, Hollywood is said to be a site of "the people's culture" in the West. Such an inversion of projective identification corresponds with Bakhtin's second type of relation, which I called ventriloquist identification. It validates the commercial Indian cinema by pointing to the vast box-office takings of its more lucrative products. Something that such large numbers of people want to pay for must be popular culture. To dismiss the cultural products involved is to dismiss those who derive pleasure from them. On the other hand, to validate the products is to identify with the downtrodden people who enjoy them.

An unfailing characteristic of this populist position is the constant reference to pleasure in its discourses. In fact, such a position equates units of pleasure with units of the local currency as they appear on the balance sheet of a business enterprise. It also fails to distinguish between the different types of pleasure that can be derived from cultural practices or objects: for example, the pleasures of mastery, of submission, of repe-

tition, of difference, of narcissism, and so on. Consequently, the populist position is also blind to the way in which particular cultural-economic practices seek to bind specific pleasures to specific types of product while ruling other pleasures out of order. In discussions of popular culture in Ukania and in the United States, the pleasures of understanding are nearly always outlawed or stigmatised by associating them with what are usually white middle-class male cultural values.

Before going on to talk about Bakhtin's third type, involving a necessary outsideness, a transitional subcategory has to be taken into account. This category corresponds to the traditional scholarly approach to the history of the Indian cinema, chronicling trends and formulating historical narratives while avoiding, to some extent at least, legitimising or instrumentalising positions. The value of this approach depends on the quality of the historiographic skills deployed. Admittedly, these narratives often are riddled with elements of the populist and of the projectivist tendencies, which does not make life any easier for the reader who has to disentangle the useful leads from a hopelessly tangled discursive web. However, this scholarly approach is still to be welcomed for its efforts to provide much needed information, even though its narratives must be treated with extreme caution.

This is a transitional moment in the process of engagement with otherness because it still maps the familiar Western reductive paradigms onto the development of Indian and other film industries. But to the extent that the effort is genuinely scholarly, this type of historiography is also bound to register areas of difference where the object of study resists the interpretive framework projected upon it. For instance, Barnouw and Coomaraswamy's history of the Indian cinema uses Lewis Jacobs's *The Rise of the American Film* as its main model. But whereas Jacobs offers a standard romantic version of the way the industry destroys individual genius (Chaplin, Stroheim, Welles, etc.), Barnouw and Coomaraswamy find themselves stuck for individual geniuses in the Western mould (until Satyajit Ray). Consequently, they promote powerful actors and studio bosses as the individuals of genius: genius-entrepreneurs rather than genius-artists. In this way, they have difficulty assessing the value of Guru Dutt or of Ritwik Ghatak, since both operated in relation to India's commercial and traditional (but already inflected by industrialisation) aesthetic practices.

Bakhtin's third type of encounter is only now beginning to be attempted. It is an approach that concentrates on the need to understand the dynamics of a particular cultural practice within its own social for-

mation. However, that social formation is simultaneously taken as a historical construct and thus an object of transformation rather than as a given essence hiding deep within the national soul. In this way, the analyst's own sociocultural formation is brought into focus as a historical construct equally in need of transformation. The engagement with other cultural practices can (and in my view must) thus be geared toward the unblocking or the transformation of aspects of the analyst's own cultural situation.

In a way, we are talking here about a double outsideness: the analyst must relate to his or her own situation as an other, refusing simple identifications with pregiven, essentialised sociocultural categories. At the same time, such identifications with group identities "elsewhere" must be resisted as well since the object of study is precisely the intricate, dynamic interconnections of processes that combine to form a social formation or, perhaps better, following Walter Benjamin's terminology, a sociocultural constellation. Some of the forces at work in such a constellation will tend toward the containment of elements likely to challenge its fragile and always provisional cohesion, others will tend toward the consolidation of unequal balances of power, others will promote collusion with or resistance to the reigning balance of power, and so forth. Identities, whether subjective or group identities, are riven as well as constituted by such processes-in-tension. Indeed, identities are the names we give to the more or less stable figures of condensation located at the intersection of psychosocial processes.

With such an approach, it becomes possible to ask questions outlawed by populist instrumentalism as well as by projectivist appropriation. In the case of the Indian cinema, it allows us to address questions regarding the mobilisation of precapitalist ideologies as well as capitalist but antiimperialist tendencies amongst urban workers and underclasses, about the operative differences between central and regional capitals, and so on. It allows us to envisage the possibility that in some circumstances (which ones?) bourgeois cultural trends may have a greater emancipatory potential than anticapitalist ones harking back to an idealised fantasy of precolonial innocence.

More important, the approach from the outside requires us to conceptualise texts and other practices as potentially comprising many different, even contradictory, strands. Some aspects of a text may pull in one direction while others will pull in a totally different direction, with yet others exerting pressure in diametrically opposite directions. For me, the fundamental question to ask of a film is: in which direction

does this particular bundle of discourses, on balance and in the present situation, seek to move its viewers or readers? Obviously, answers to that question will always be provisional and context-dependent — that is to say, dependent on the context within which these questions and answers are meant to achieve a degree of productivity.

Finally, a caveat may be in order. Although it is necessary for Western intellectuals to address Indian cinema with one eye on their own situation, their other eye must remain focussed on the potential effects of their discourses within the Indian situation. This uncomfortably cross-eyed mode of operation is absolutely vital if Western intellectuals, however well-intentioned, are to avoid obstructing the work of Indian comrades and their allies. The unfortunate facts of imperialism mean that the power relations between Indian and Western intellectuals are still uneven. This is clearly evident from the fact that Indian filmmakers can secure production finance at least partly on the strength of their reputation in the West.

Consequently, Western intellectuals, in their efforts to draw attention to particular aspects of cultural practices in India likely to assist desirable developments in Western cultural practices, must be careful not to lend inadvertent support to work that, in India, obstructs the very positions they are trying to support. Besides, the distinction does not have to be drawn as starkly as the differences between the situation in India and, say, Ukania in the late twentieth century. Differences between Ireland and Ukania require a similar approach, as do differences between the former East and West Germany. If this cross-eyed dialectic is forgotten, the term "specificity" loses any meaning, and with it any notion of "creative understanding" or of "diagnostic understanding" go out the window. That would be unfortunate since a position of double outsideness, hybridity, and in-betweenness is the precondition for an engagement with the national in film culture.

Notes

1. Sylvia Lawson, *The Archibald Paradox: A Strange Case of Authorship* (Ringwood, 1987), ix.

2. M. M. Bakhtin, *Speech Genres and Other Late Essays,* trans. Vern W. McGee, ed. Caryl Emerson and Michael Holquist (Austin, 1986), 6–7.

3

The Modernist Sensibility in Recent Ethnographic Writing and the Cinematic Metaphor of Montage

GEORGE E. MARCUS

This paper obliquely comments on ethnographic *film* through an argument about the cinematic imagination at work in contemporary experiments in ethnographic *writing*. Its offstage agenda is to stimulate a different relationship than has existed in the past between these two media of ethnographic representation in anthropology, given the favourable current conditions for such a project.

Most theoretical writing in anthropology has concentrated on the development of detailed classificatory schemes to assimilate and constitute the description of "the real." As such the stories of ethnographic film have been received and appreciated largely by anthropological scriveners, not for themselves, but as kinds of case studies of "nature" (messier and truer than writing) to be assimilated by the prior and essentially classificatory knowledge developed by written ethnography. For the realist ethnographic writer ethnographic films are somehow more natural than written texts, and their appreciation has lain in the confirmation and enrichment they provide for the local and global classifications by which anthropologists have created knowledge of others.

As written ethnography moves toward its repressed narrative dimension, it is more likely to appreciate new links with film. This shift toward constructing the real through narrative rather than through classification is stimulated, I believe, not by some aesthetic preference but rather by a shift in the historic conditions in terms of which anthropology must identify itself and is practicable at all. The shift affects the way anthropology constructs its object (certainly no longer the primitive

outside a modern world system) and how it argues for the authority of its own representations of otherness in a much more complex field of such representations. It is a field occupied by diverse others who aggressively and eloquently "speak for themselves" in the same media and to the same publics within which anthropologists once felt themselves to occupy a secure position.

In this paper I want to pursue the potential change in the relationship between ethnographic film and writing by making a strong claim about the cinematic basis of contemporary experiments in ethnographic writing. I am strongly committed to sustaining the empirical nature of the practice of ethnography as well as the claims to knowledge for its representations, consistent with the way anthropologists currently invent their disciplinary tradition, while incorporating what many have viewed as the threatening (narcissistic, nihilistic, and thus socially irresponsible) aspects of a form that, while representing others, now critically requires a calling of attention to itself. This is of course not the only position that can be argued from the critique of ethnography, and it may be viewed as a conservative (as well as an optimistic) position in thinking about the critique's implications for the practice of ethnography.

Anthropology is both addressing subjects new to it and recasting the space-time identity of its conventional ones. This is in response, I believe, to a fin de siècle phenomenon marked by an exhaustion of concepts and frameworks, or at least by an inability to choose critically and decisively among them. Thus, witness the symptomatic loss of authority of metanarratives, working paradigms, and foundations in most disciplines, and the consequent inability to make the kind of ethical judgements that have always policed the boundaries of knowledge to be pursued by discrete disciplinary communities of scholars. Contextualisation, historicisation, probing local variation, fragments, indeterminacies — these are the styles of inquiry generally in play. Thus, it is indeed a very appropriate time for the jeweller's eye gaze of ethnography. Yet the conceptual capital of ethnography is very much the realism of nineteenth-century social theory. While thus focussed appropriately, ethnography operates with concepts that cannot comprehend subtly enough the historic present of its subjects.

Interested in modernising, so to speak, ethnography's apparatus of representation, I could do no other than to relate myself to the complex debate over the nature of late twentieth-century aesthetics and culture regarded as postmodernism. In this discursive space, I side with those who seek to show that postmodernism is best understood as another

moment of modernism and who attempt to rethink or revise the history of this signature Western movement in line with certain global changes and repositionings of the West in a world that is decidedly not *only* Western. Whatever postmodernity may mean for artistic production, its critiques of the rhetorical and conceptual apparatus of ethnography are leading finally to the introduction of some of the problems and techniques of classic (primarily literary) modernism. The nature of an essentially nineteenth-century-derived social realism in anthropology (which it shares with other disciplines of the humanities and social sciences) is being modified through the influence of aspects of a classic modernist sensibility toward redefining the real, particularly when the prestige and sovereignty of Western cognitive frameworks of representation are diminished. It is thus no accident that a renewed affinity between the tribal (or the cross-cultural) and the modern should be so profoundly marked in the turbulence about anthropology's methods and practices of representing "others."

The self-conscious experimental moves away from realist representation in both history and anthropology have been undertaken sometimes in the name of montage. Montage lends technique to the desire to break with existing academic rhetorical conventions and narrative modes through exposing their artificiality and arbitrariness. How montage techniques in themselves establish an alternative coherence, or whether they can, is a major issue in experimentation.

Montage is a key theoretical cinematic concept whose influence upon classic literary modernism has been apparent since its appearance in the late nineteenth century. Reference to the way cinema establishes narrative through montage is the explicit self-advertisement of a writerly sensibility. Keith Cohen's study of the historic relation of film to fiction has been an important frame of reference for me in thinking about this cinematic basis of the changes in ethnography. As he concludes, "The cinematic precedence for the classic modern novel, therefore, deserves prominence as a primary example of one art technologically ahead of its time that shocked another art into the realization of how it could align itself with the times."[1] A similar event in the emergence of a modernist sensibility in ethnographic writing can be discerned. I want to suggest the potential of a modernist ethnography in writing, sensitive to its own cinematic basis, for sparking a different sort of relationship to ethnographic film.

In studying the Tongan diaspora during the 1970s, then in studying contemporary dynastic family fortunes in the United States, and now

in pursuing the related topic of the emergence of great public cultural institutions in the West, my own work came to focus upon the increasingly deterritorialised nature of cultural process and the implications of this for the practice of ethnography. If ethnographic description can no longer be circumscribed by the situated locale or community, *the* place where cultural process manifests itself and can be captured in the ethnographic present, what then? How to render a description of cultural process that occurs in transcultural space, in parallel, separate, but simultaneous worlds? This recalls a defining problem of literary modernism concerning representation in a linear form of simultaneity. In film parallel editing has been the basis for achieving an effect of simultaneity, a technique later adapted into writing. It is in extending the cinematic metaphor in experimental writing to actual filmmaking that the new relationship between ethnographic writing and film might be forged.

In the following sections I want to explore each of these strains of thought coming out of the mid-1980s' critique of ethnography. In the end, I return briefly to the possibility of an *ethnographics,* which depends upon stimulating underdeveloped tendencies in ethnographic film and upon a revision of its relationship to ethnographic writing. The possibility emerges from the way proposed shifts in conventions of ethnographic writing rely on essentially filmic concepts.

The Emergence of a Modernist Sensibility in Late Twentieth-Century Ethnographic Writing

Why there should be a so-called crisis of representation that has called theoretical and critical attention to the form and rhetoric of textmaking in so many disciplines of the human sciences has yet to be fully addressed or explained. How, or whether, such disciplines will find their way back to reasonably settled paradigms or working theories, away from the mood of self-critical reflexivity, is quite uncertain. One might argue, however, that the self-critical mood itself, in its most productive aspects, is evolving a working paradigm quite different from previous objectivist master frameworks that limit or exclude the possibility of calling critical attention to the ways in which they stimulate the production of knowledge. In cultural studies centres, humanities research centres, and so forth of largely English-speaking academia, where alternative working paradigms are being constructed, what is at

stake is a reevaluation of the intellectual fecundity of European and American modernisms of the past century and a half. The specific intellectual capital for this reevaluation, which has seeded the growth of the current interdisciplinary movement, has been the diffusion of the ideas of French poststructuralism through English-speaking countries along with the development of feminism as both a site of theory construction and a social movement itself. There seems to be a parallel between the keenly critical and modernist nature of the signature deconstructive mood of this interdisciplinary movement and a fin de siècle sense of the decline of the West, or at least of its social, political, and economic dissemination into a global order that it no longer can perceive itself as commanding.

Anthropology's own specific version of the more general crisis of representation may well be more keenly felt than most. By the nature of its enterprise it has always been more or less explicitly deconstructing the West, yet its means of continuing to do so now have to some degree been trumped. On the one hand, more powerful and complex notions of anthropology's key concepts of culture and society are coming out of literature, despite how frustratingly ethnocentric many of these might be. On the other, anthropological representations, as claims to knowledge, now exist in a complex matrix of dialogic engagement with diverse representations, interests, and claims to knowledge concerning the same objects of study. The critiques of the West that anthropological knowledge has offered in the past must now reposition themselves in a much more complex space in which critical ideas generally are produced. This makes it essential to relate anthropology to the current debate over modernity/postmodernity through giving its central practice of ethnography a genealogy and context in intellectual history beyond anthropology's own disciplinary history. To this purpose, I proffer two positions that place the current experimental mood in ethnographic writing at the intersection of the debate about modernism/postmodernism and changes in the world that most powerfully stimulate this mood and sensitivity to its own descriptive practices.

A core notion in the contemporary debates about postmodernism is the idea that the creative possibilities of modernism are exhausted, assimilated by popular culture, that the distinction between high and popular culture no longer holds, that the new can no longer be constituted by or recognized in avant-gardes. In this context, I appreciate most those who, like Marshall Berman,[2] try to reread and reinterpret classic modernism. In this reading, modernism was not a rejection of

nineteenth-century literary realism but a recasting of it in response to perceived changes in the conditions of society. Anthropology drew on the intellectual capital of nineteenth-century social theory that facilitated the objectification of such concepts as culture, society, community, and tradition. With reflexive issues absent or in the background, classifications and narrative frameworks of dispassionate observation produced representations of others with a distanced gaze. Literary modernism was a profound complication of the production of these modes of realism. Far from being exhausted, as appears to be the case for contemporary artists and aesthetic theorists, modernist techniques of representation in the ways that they problematically construct "the real" seem fresh and compelling in a discipline such as anthropology, with the act of realist description at its core. While postmodernism may be a proper subject of anthropological (or sociological) study as a techno-aesthetic movement in society, anthropology itself as a practice is merely becoming modernist in the classic literary sense.

Now, what stimulates this shift in cognitive/perceptual terms is an understanding that while the conceptual, rhetorical apparatus of producing ethnography may still do within the classic discursive frames for constituting theory in seminar rooms and the like, it will no longer do in most field situations — the other that we study is as embedded in conditions of modernity as we are. The acknowledgement of this has profound implications for the current formulation of anthropology's core puzzle, which is the relationship between similarity and difference and their differential attribution to peoples of the world. Positing the global pervasiveness of modernity undercuts the ability of anthropologists to tell stories of isolated settled communities, worlds unto themselves, both by establishing and then problematising global homogenisation processes and by denying the possibility of the distanced gaze on which the otherness of others depends for its construction. Thus the relationship between deeply entwined simultaneous processes of homogenisation and heterogeneity anywhere on the globe is what requires an ethnography with a historic sense of the present to move toward modernist techniques and strategies of representation.

Such a move rests on a premise of antilocalism, a premise that derives from the perception of a late twentieth-century globalism yet without the naive assumptions of universalism that accompanied similar perceptions at the end of the last century. The world in a cultural or humanistic sense is not becoming one, although it might be becoming more dialogic. Rather, difference, diversity, is generated not from the integrity

and authenticity of the local community — that is, rooted tradition — resisting and accommodating a modern world system ever more powerful in its force but paradoxically from the very conditions of globalising change. To show the entanglement of homogenisation and diversity without relying on notions about purer cultural states "before the deluge" of an exogenous modernity requires a shift in conventions for establishing the space-time in which ethnography can be narrated, a fundamental change in the allegory of the pastoral — capturing worlds on the wane, endlessly studying them before their demise — on which much of its framing has depended.

A key ethnographic analytic problem is to explain the process of how cultural identity is constituted among peoples (virtually all peoples now) who are hyperaware of their own history and situation in a world system. Once irony is introduced as a factor in cultural analysis, then the process of identity formation against and in line with homogenising technologies becomes the focal problem, not only for the subjects of ethnography, but for the ethnographer too in producing knowledge of others.

I will briefly and schematically lay out a set of requirements for shifting the space-time framework of ethnography toward modernist assumptions about the organization of contemporary social reality. This will involve both changing certain parameters in the way that ethnographic subjects are analytically constructed as subjects as well as altering the nature of the theoretical intervention of the ethnographer in the text he or she creates. This duality of alteration encompassing both the observer and the observed is fully consistent with the simultaneous levels on which modernist perspectives work — the writer shares conditions of modernity, and at least some identities, with his or her subjects, and no text can be developed without some registering of this.

Thus, three requirements deal with the construction of the subjects of ethnography through problematising the construction of the spatial, of the temporal, and of perspective or voice in realist ethnography. And a further three requirements will concern strategies for establishing the analytic presence of the ethnographer in his or her text: the dialogic appropriation of analytic concepts, bifocality, and the critical juxtaposition of possibilities. These requirements are by no means exhaustive, nor are there necessarily any existing ethnographies that satisfactorily enact any or all of them. I am particularly interested in how a distinctly modernist text is created in each work in which it is shown how distinctive identities are created from turbulence, fragments, intercultural

reference, and the localised intensification of global possibilities and association.

Briefly the requirements are these:

1. Problematising the spatial—a break with the trope of settled community in realist ethnography. A recognition of the contemporary deterritorialisation of culture: its production in many different locales at the same time, each of differing character; thus, the disseminating character of cultural identities; and the need for the effect of simultaneity in ethnographic representation.

2. Problematising the temporal. A break with the trope of history in realist ethnography. Not a break with historical consciousness or sensitivity in sites of ethnographic probing, but an escape from explanatory attachment to historical metanarratives that weaken the ability of ethnography to probe the present moving toward the future in particular sites. Against historical narrative, the modernist ethnography is interested in the constitution of collective memory and its expressions—remembering discourses are critical responses to emergent, not yet fully articulated conditions in a way that the assimilation of ethnography to historical narrative is not.

3. Problematising perspective/voice. A break with the trope of structure in realist ethnography. Ethnography has opened to the understanding of perspective as voice, or polyphony, just as the distinctly visual, controlling metaphor of structure has come into question. The modernist text is open to registering indigenous voices without preemptive assumptions about how they might be located through the conventional correlates (notions of class, gender, or hierarchy) that constitute structure in realist descriptions.

4. The dialogic appropriation of concepts and narrative devices. This replaces exegesis as the acknowledgement of the intellectual worth or equivalence of the other in standard ethnography. Realist ethnography has often been built on the intensive exegesis of a key indigenous symbol or concept pulled from its contexts of discourse and then reinserted in them but according to the dictates of the ethnographer's authoritative analytic scheme. In one sense, exegesis at the centre of ethnography is a gesture toward recognizing and privileging indigenous concepts over anthropology's own. In modernist ethnography the usually authoritative structure of narrative is being replaced by the anthropologist's in-

corporation of the other's discursive framework into his or her own. Short of some idyllic collaboration, this is done through the undeniably colonial character of ethnography, whereby the ethnographer uses her power to speak for the other. She attempts to do so partly in the other's terms by a therapeutic and imaginative appropriation of the other's concepts into her own framework.

5. Bifocality. This involves effacing the distance of "otherness," a distance that has been so important in constituting the ethnographic gaze. One assumes and demonstrates the observer's constant connectedness to the observed and thus works against exoticism based on distance between "us" and "them," on which much ethnography is predicated. The most defensible and necessary justification of a display of reflexivity in the modernist text is provided by this requirement: bifocality demands looking for the kinds of connections that allow one to construct difference in full recognition of the already constituted relationship that exists between observer and observed and that historically or personally precedes the moment of fieldwork and ethnography.

6. Critical juxtapositions and contemplation of alternative possibilities. The function of modernist ethnography is primarily one of cultural critique, not only of one's disciplinary apparatus through an intellectual alliance with the alternative cosmologies and practices of one's subject, or of one's own society (à la Margaret Mead), but also of conditions within the site of ethnographic focus itself—the local world that it treats. This involves critical thought experiments whereby the ethnographer poses alternative possibilities—the roads not taken, repressed possibilities documentable on the margins of cultures studied—to those that seem to be dominant and explores their implications in dialogue with her subjects. Indeed, this kind of critical thought experiment incorporated within ethnography, in which juxtaposed actualities and possibilities are put analytically in dialogue with one another, might be thought to border on the utopian or the nostalgic if it did not depend on documentation showing that these traces do have a life of their own. Such clarification of possibilities, against the objective, defining conditions within the limits of discourse "that matter" in any setting, is the one critical intervention and contribution unique to the ethnographer.

Now, I want to argue that each of the above strategems is more easily achieved in a cinematic medium than in a written one and that indeed

their realization in written texts involves the quite difficult translation of essentially cinematic narrative techniques — especially montage — into the linearity of the written text. The modernist revision of ethnography changes the understanding of the general character of what ethnography is about. In the past, ethnography has been associated with discovery, particularly by describing specific groups of people who had not been treated before. Restudies have been oddities in anthropology, and the full matrix of existing representations (missionaries, travellers, journalists, the people's own, etc.) in which an ethnographer produces a text has always been downplayed. "One tribe, one ethnographer" is the persisting romantic ethic of the way research is organized long after the European age of exploration and discovery has ended. And there is a careful and sensitive etiquette in force about not working on another anthropologist's people or at least group. Against this, the kind of ethnography I have outlined above is supremely aware that it operates in a complex matrix of already existing alternative representations and indeed derives its critical power and insight from this awareness. Of a deconstructive bent, modernist ethnography counts on not being first, on not discovering. It remakes, re-presents other representations. Experimental ethnography thus depends on preexisting, more conventional narrative treatments and is parasitic on them. Such ethnography is a comment, a remaking of a more standard realist account. Therefore, I would suggest the best subjects of modernist ethnography are those that have been heavily represented, narrated, and made mythic by the conventions of previous discourse. Part of the experimentation is in revealing the intertextual nature of any contemporary ethnography; it works through already constituted representations by both the observed and previous observers. There is no sense of discovery in the classic sense in modernist ethnography. It forgoes the nostalgic idea that there are literally completely unknown worlds to be discovered. Rather, in full awareness of the historical connections that constitute bifocality, it makes historically sensitive revisions of the ethnographic archive with eyes fully open to the present and the emergent in any context of work.

Simultaneity in ethnographic description would replace discovery of unknown subjects or cultural worlds with an acknowledgement of the complexity of our already known subjects. It creates a new vision and ear against the existing narrative myths in our analytic discourses. In my work with dynastic families, for example, I found that to understand these organizations only as families[3] — in the way that family stories are pervasively narrated in our culture, by my dynastic informants as well

as by my own family, in the popular media, and by scholars, for that matter — was inadequate. Such families are produced by many different agencies, differently located in space and social categorisation. What I needed in order to see this, and to contemplate the possibility of an alternative representation of these dynastic entities against their domestication in standard stories of family, was a sort of cinematic imagination geared to writing, to which I now turn.

The Emblematic Use of Montage to Signal Self-Conscious Breaks with Past Practices in Historic and Ethnographic Narrative

Mundane montage — the technical condition of the juxtaposition of images in the production of film and the associated task of editing — is at the heart of the possibility of narrative in film. In the complex theorisation of the concept of montage by Eisenstein, and others since, the potential for its development as an aesthetic and critical technique of communication still remains undeveloped. In particular, the notion of an intellectual montage, which Eisenstein distinguished from mundane montage and exemplified daringly (but by contemporary standards crudely) in certain sequences of *October* and *Potemkin*, is a possibility that is only now being literally explored in the writing of social scientists and historians responding to the crisis of representation already mentioned. They frequently refer to their manipulations and ruptures of conventional forms of exposition as montage. To quote at length again from Cohen:

For the cinematic experience included, among its most significant effects for the novelists, a spatial configuration of the flow of time, an innate relativity and perpetual shifting of point of view, and a vivid discontinuity of the narrating material by means of montage. Consequently, the most dynamic aspects of the new novel form were simultaneity, or the depiction of two separate points in space at a single instant of time, multiperspectivism, or the depiction of a single event from radically distinct points of view, and montage, or the discontinuous disposition in the narrative of diverse story elements. . . . The straining of the limits of literary expression is a sign of the indelible mark left by the cinema's spatial narration. No other art had ever before been capable of narrating so completely through images, and never before had these images corresponded so completely to the mimetic objects they were modeled on. It is this narrative space, intrinsically discontinuous yet externally timed with electric

regularity, constantly in development yet essentially no more of a "procession" than a three-ring circus, that determines a pronounced tendency in the early twentieth century toward the image and elicits in the novel a decidedly visual response.[4]

Something very similar to this is now occurring in experiments with modernist ethnography. Indeed, the defining aspects of the classic modernist novel that can be traced to cinematic influence — simultaneity, multiperspectivism, and discontinuous narrative — are precisely the defining moves announced and practised by experimental ethnography in the name of polyphony, fragmentation, and reflexivity.

Usually, a critical intellectual montage becomes, in the contemporary idiom, a deconstruction in action, and its aim is to decompose categories that construct basic ideological concepts of common sense such as the individual, gender, or class. As Teresa de Lauretis has written, "The usual view of the political or aesthetic import of subverting narrative, that is to say, of anti-narrative or abstract film practices, is to decentre the individualist or bourgeois subject, to work against or to destroy the coherence of narrativity which both constructs and confirms the coherence of that subject in its imaginary unity."[5] Interestingly, in the same paper (on strategies of coherence in feminist cinema), de Lauretis questions the value of extreme montage as a critical form for what it loses in coherence and thus audience. Feminist cinema, like modernist ethnography, works by retextualising existing cultural images and narratives, doing so by rupturing the strategies of coherence — usually linearity — by which these analytic or cultural myths have been achieved. But perhaps the sacrifice of coherence in the alternative is too great, especially given de Lauretis's argument for feminist poetics. So the larger problem becomes how to retain the equivalent of a storytelling coherence while retaining the powerful critical advantages of montage.

In work on the cross-cultural, the critical use of montage in ethnography or historical writing is somewhat different from its use in the subversion ideology realized through conventions of form in its own society. Montage calls attention, I would suggest, to the essentially oral conventions and techniques of other cultures, or to the different ways that literacy has established itself elsewhere, as a protest against what Jack Goody has called the domestication of the savage mind by the conventions of Western literacy and narrative production. Not to crack, by schematic representation of its structure, another culture's cognitive or symbolic code but to give voice to the qualities of oral genres of communication in performance through the visual medium of film or writ-

ing is perhaps the main purpose of the resort to montage techniques in ethnography that seeks to represent otherness. Perhaps the most explicit example of this in recent ethnography is Michael Taussig's *Colonialism, Shamanism, and the Wild Man*. While he makes no claim to a montage structure to the work itself (although it often does work cinematically) he does claim that the indigenous discourse of shamanism must be understood as montage. He makes quite explicit the connection between montage as the key form of modernist critical discourse in the West and also the form of shamanic discourse:

As a form of epic theatre these yage nights succeed not by suffusing the participants in relived fantasies. Instead their effect lies in juxtaposing to a heightened sense of reality, one of fantasy — thereby encouraging among the participants speculation into the whys and wherefores of representation itself. In a similar vein Stanley Mitchell (introduction to *Understanding Brecht*) delineates Benjamin's preoccupation with montage:

> For fruitful antecedents, he looked back beyond German baroque to those forms of drama where the montage principle first made its appearance. He finds it wherever a critical intelligence intervenes to comment upon the representation. In other words where the representation is never complete in itself, but is openly and continually compared with the life represented, where the actors can at any moment stand outside themselves and show themselves to be actors.

The technique of criticism and of discovery imputed here is not bound to an image of truth as something deep and general hidden under layers of superficial and perhaps illusory particulars. Rather, what is at work here is an image of truth as experiment, laden with particularity, now in this guise, now in that one, stalking the stage whose shadowy light conjures only to deconjure. It is this image of truth that flickers through the yage nights of which I write.[6]

In his interest to see the critical (against the grain of history) sides of discourses in other cultures — discourses that anthropologists have usually probed antiseptically and apolitically through one form or another of structural(ist) analysis — Taussig might be fairly criticized for trying to make modernists out of shamans and peasants. Yet, in the concern not to domesticate the savage mind to our literacy, there is something exciting in introducing the notion of montage as an analytic characterisation of voice in non-Western cultural settings. For Taussig, montage is the ultimate reflexive operation that ruptures the narrative of straight, monological storytelling. The operation of reflexivity and disorderly, thus critical, narrative are bound together. Further, the appeal of montage for Taussig is both in its capacity to disrupt the orderly narrative of social science writing and in its capacity as a performative discourse of healing in response to the history of terror and genocide, which is the

present legacy of a colonial past in Colombia. Montage thus works as counterdiscourse on two parallel levels at once and unites the ethnographer with those he studies. As I noted, this parallelism is one of the key marks of the modernist ethnography.

I would argue that the complexity of an essentially cinematic imagination at work in Taussig's written ethnography — toying with intellectual montage on dual levels — could have been more economically and clearly achieved in film. In a sense, his book is a scenario for such an experimental film in ethnography. Here I am reminded of Eisenstein's famous characterisation of montage as a special form of emotional speech that operates through the imagistic value of words. This well suits both Taussig's own discourse and that of his subjects. The Conradian horror of which he writes and which his contemporary subjects address is not communicable otherwise, except in what would be the parodic form of dispassionate classic ethnographic narrative, with which his work breaks sharply.

Another movement in experimental ethnography is the use of montage to radically disrupt and reconceive the way social and cultural process as action is represented in ethnography — how milieu, or the space-time framework, is constructed. Objectification in ethnographic representation has been effectively critiqued, but the need for setting the scene, even in the most radical attempts to use a montage of consciousness, requires some revision, but also a preservation, of an objectifying discourse about process and structure. This is what the use of montage technique in the service of representing the simultaneity and spatial dispersion of the contemporary production of cultural identity achieves.

Experiments in the Representation of the Simultaneity of Complexly Connected Knowable Locales

David Lodge's popular and very clever academic novel *Small World* is a good introduction to the problem of simultaneity in the contemporary representation of process within ethnography. It touches on the deterritorialisation of culture and the adjustments that ethnographic description must make to it. The world to which the title refers is the peculiarly late twentieth-century one in which academic

gamesmanship must play out. As Morris Zapp, leading professor of English, and master of the game, describes it:

Information is much more portable in the modern world than it used to be. So are people. *Ergo,* it's no longer necessary to hoard your information in one building, or keep your top scholars corralled in one campus. There are three things which have revolutionized academic life in the last twenty years, though very few people have woken up to the fact: jet travel, direct-dialling telephones and the Xerox machine [obviously Lodge was a bit behind the computer revolution when he wrote this]. Scholars don't have to work in the same institution to interact, nowadays: they call each other up, or they meet at international conferences. And they don't have to grub about in library stacks for data: any book or article that sounds interesting they have Xeroxed and read it at home. Or on the plane going to the next conference. I work mostly at home or on planes these days. I seldom go into the university except to teach my courses.[7]

Lodge makes brilliant but straightforward use of montage and cross-cutting to represent this world in the novel's action, focussed on preparation for a conference at which academics from several different places around the globe come together at the end of the novel. Part 2 of the novel is a tour de force in the creation of the effect of simultaneity. It is anchored to Morris Zapp and his watch and a very limited set of actions as he awakens and prepares to leave for the airport:

At 5 a. m., precisely, Morris Zapp is woken by the bleeping of his digital wristwatch, a sophisticated piece of miniaturised technology which can inform him, at the touch of a button, of the exact time anywhere in the world. In Cooktown, Queensland, Australia, for instance, it is 3 p. m., a fact of no interest to Morris Zapp, as he yawns and gropes for the bedside lamp switch — though as it happens, at this very moment in Cooktown, Queensland, Rodney Wainwright, of the University of North Queensland, is labouring over a paper for Morris Zapp's Jerusalem conference on the Future of Criticism.

The rest of the chapter introduces new characters in simultaneity with Zapp's commonplace temporally compressed movements of awakening and preparing to leave the apartment to catch a plane. We have the global in the very specific and we see their intimate, necessary connection. The chapter ends in a crescendo of montage:

Big Ben strikes nine o'clock. Other clocks, in other parts of the world, strike ten, eleven, four, seven, two.

And then one long paragraph cascades to a conclusion:

Morris Zapp belches, Rodney Wainwright sighs, Désirée Zapp snores. Fulvia Morgana yawns, . . . Arthur Kingfisher mutters German in his sleep, . . . Michel Tardieu sits at his desk and resumes work on a complex equation representing in algebraic terms the plot of *War and Peace,* . . . Ronald Frobisher looks up "spare" in the *Oxford English Dictionary,* . . . and Joy Simpson, who Philip thinks is dead, but who is alive, somewhere on this spinning globe, stands at an open window, and draws the air deep into her lungs, and shades her eyes against the sun, and smiles.[8]

The historic background for this cinematic performance in literature is once again provided by Cohen in his discussion of the cinematic influence on literary modernism. As he says and demonstrates with interesting commentaries on *Ulysses* and *To the Lighthouse:*

Simultaneity embraces both time and space: temporal coincidence and spatial disjunction. In so doing, it poses many problems at once: the nature of present time in narrative, priority of point of view, and textual decoupage. Cinema presents an image that is plastic, mobile, and perceivable at a glance. Consequently, a single shot can conglomerate two or more separate actions taking place at the same time. This generalised effect of simultaneity may be seen to earmark cinema as an essential precedent to colliding narratives and multiple presentations attempted in the novel, which is, strictly speaking, confined to a single focus, a single effect at a time.

Parallel editing or cross-cutting refers to the juxtaposition of two or more spatially noncontiguous sequences by alternating segments cut from each one [the most celebrated example of parallel editing is Griffith's *Intolerance* of 1916]. Under ordinary circumstances, cinema cannot, any more than literature, present simultaneously two noncontiguous, noncoterminous events. Parallel editing, however, is the technique that most nearly achieves this effect (most dissimilar from literature, where narrativity was for ages considered in mainly linear terms, the cinema seems to have arrived at narrativity through the concept of simultaneity).[9]

In the novel, it is in realizing such parallel editing as Lodge's exhibits that writing can produce cinematic effects. Yet there is an irony that should be well marked for the argument of this paper. *Small World* was made into a BBC film, but as the *TLS* reviewer of it noted, it failed to capture any of the cinematic qualities of the novel:

The novel employs a variety of cinematic techniques (cross-cutting, montage, the rapid succession of vignette-like scenes) to create an impression of hectic simultaneity. The filmed version is much less inventive, full of plodding and mechanical flash-backs, voice-overs, and dream sequences. What is missing, for all the excellence of individual performance, is precisely that sense of forward movement, of a rush of convergence and interlacings, which is the novel's distinguishing narrative feature.[10]

The film version seems to have substituted apparently more conventional aspects of a montage of consciousness (flashbacks, dream sequences) for a much more cogent montage of action and lost what I see as the broader import of the novel for ethnographic representations of cultural and social process in the late twentieth century. Tellingly, film in this case has failed to accomplish what the novel has been able to accomplish cinematically, not because it is not able to do so (in fact it probably could have done what the novel did more easily) but because, unlike the novel, it did not appreciate the central problem of realist representation in late modernity.

Shifting ground a bit, what indeed is this problem of representation in ethnography, for which experimentation with creating the effect of real time or simultaneity through montage, cross-cutting, and the like is, if not a solution, at least a response? One might present the argument point by point.

1. Begin with the proposition that in the late twentieth-century world, cultural events and processes anywhere cannot be comprehended as primarily localised phenomena or are only superficially so. In the full mapping of a cultural identity, its production, and variant representations, one must come to terms with multiple agencies in varying locales. The connections among these are sometimes readily apparent, sometimes not, and a matter for ethnographic discovery and argument. In short, culture is increasingly deterritorialised and is the product of parallel diverse and simultaneous worlds operating consciously and blindly with regard to each other. What "relationship" is in this configuration becomes a matter of focal interest for ethnography, which presents itself initially as a problem of form, of representation. The "small world" of peripatetic academics that Lodge evokes is paradigmatic of one sort of such production of culture.

 Life goes on in place A and place B, for example. In the more difficult case, there is very little contact between the two, yet they are intimately or powerfully related to one another in that they have mutual unintended consequences for each other. How does one explore this kind of complex relationship without dramatic resolutions? How is one to give a cultural account of this structure, or represent it ethnographically?

2. The ethnographic grasp of many cultural phenomena and processes can no longer be contained by the conventions that fix *place*

as the most distinctive dimension of culture. Merely historicising local culture — connecting the village community to a particular historical narration — or describing the depth and richness of tradition fails to capture the side of culture that travels, its production in multiple, parallel, and simultaneous worlds of variant connection.

3. This problem of description and theoretical construction is nothing new in anthropology. In the 1960s, anthropologists came to terms with the forms of social/cultural organization of modernity (so-called nongroups) through formalist techniques of modelling and the imagery of network and systems analysis from cybernetics. Models of course had their advantages, in dealing abstractly and linearly with relationships, but for the kinds of contemporary questions being asked about distinctly cultural processes within social organizations or *as* social organizations, they are descriptively impoverished. Models of networks, for example, are linear in space and time: A moves to B, A causes B. There is no sense of the simultaneity of process and action that provides a profoundly different and more ambiguous sort of analytic experience of organization that allows one to understand content as well as form or rather form as content and vice versa.

I see the attempt to achieve the effect of simultaneity as a revision of the spatial-temporal plane on which ethnography has worked. Experiments with it posit three kinds of organizational situations:

a. simultaneous operations, spatially dispersed within a conventional single institutional frame as a representation of process within it — academic small worlds is an example;

b. the operation of institutionally diverse agencies to constitute an entity and organization that they all fragmentally share — the dynastic family, an object of interest to me, is an example;

c. independent worlds, operating blindly in relationships of unintended consequences for each other. These are the most exciting and controversial objects for this kind of experiment in anthropology. The kinds of relationships posited in the 1960s project of cultural ecology in anthropology would offer examples. So would the ethnographic study of markets, especially highly speculative commodity markets (see, for example, Stephen Fay's account of the attempt of the Hunt brothers to corner the world silver market).[11]

4. In my own research projects, I have time and again come upon the multilocale determination of the identity of subjects upon whom I at first focussed as occupying a situated place. This necessitated a reconceptualization toward a broader and more complex understanding of the dimensions of the phenomena that I was addressing. Often this shift has occurred in the middle or at the end of work on subjects represented in conventional ways and whose lives seemed to be encompassed in knowable communities (to use Raymond Williams's term for the space-time framework of the pre-Industrial Revolution English novel). My realization of the partiality of this kind of knowledge stimulated me to look for an ethnography of different horizons.

My original work in the Polynesian Kingdom of Tonga during the 1970s was located in a number of different Tongan villages. This was a time of massive domestic migration and emigration. Virtually nothing that happened in a village, from kava ceremonies to church collections, could be understood only in terms of the life of the village. What was happening in the village was always being experienced vicariously elsewhere — for example, in San Francisco, Sydney, Auckland, Honolulu — and vice versa. I tried to follow and map migration networks to understand this internationalised dimension of Tongan culture, in which the home islands were becoming just one site, among others, in which contemporary Tongan identity was being constructed. From a cultural perspective, network/systems modelling takes one only so far; rather, one needs a sense of parallel existences through juxtapositions of everyday life in different locales. Models, perhaps too literally and linearly, imagine the connecting lines between such locales without fully describing life within them. Cultural description demands an account of ongoing, simultaneous activity in locales for which connections are posited (that is, the linkages are secondary to a description of life in the locales linked). At the time I had no clear sense that the problem was one of representation rather than one of method. Now I understand problems of representation *as* the distinctive medium of theoretical and methodological discourse in contemporary anthropology.

This sense came through to me in the other project with which I was concerned and which I have pursued with more energy, especially as a vehicle for enacting some of the experimental strategies and problems that have derived from the critique of ethnographic conventions of the early to mid-1980s. This is the project on American dynastic families

of the late twentieth century—how self-involved individualists sustain themselves as lineages in capitalist society. Eventually, I broke with the family narrative in terms of which accounts of such organizations have been pervasively recounted in Western societies. I found that a particular family was the complex construction of a number of different kinds of agencies—lawyers, bankers, politicians, scholars, servants, workers, journalists, and family members themselves who were only one such agency. I confronted myself with diverse parallel worlds that must be accommodated by my account. Otherwise, my ethnography would just be repeating the mythic narrative of the family in the guise of scholarly production. But I had no model for representing such multiple and diverse representations of a phenomenon that I at first thought commonsensically was quite unified and localised.

The Possibility of Ethnographics: A New Relationship between Anthropological Writing and Film

The argument of this paper is that an ethnographics, involving integrations of visual and written media in common projects, on the initiative of either writers or filmmakers but ideally in close cooperation and exchange, is not just a good idea but a necessity given the problems of ethnographic textmaking shaped by modernist requirements. Film has its own special domain of interest different from writing, but what they potentially share are projects that take full responsibility for mimetically confronting difference in a powerfully homogenising world. Clear visions concerning how such difference emerges are needed more than ever. The route to these visions is through the complex problems of representing the real that modernism has posed for us, and through a response to these problems, which lies in the hand extended by the cinematically sensitive ethnographic writer to the one that controls the camera. Textmaking in the face of the complex realities of late modernity and modernism is what the ethnographic writer and filmmaker share—a recognition on which they might base a collaboration that would have regard for past genre boundaries as starting points for conversation but would not submit to their policings.

Notes

1. Keith Cohen, *Film and Fiction: The Dynamics of Exchange* (New Haven, 1979), 219.

2. Marshall Berman, *All That Is Solid Melts into Air* (New York, 1982), 8.

3. George E. Marcus, "The Constructive Uses of Deconstruction in the Ethnographic Study of Notable American Families," *Anthropological Quarterly* 68 (1988): 3–16.

4. Cohen, *Film and Fiction*, 208–9.

5. Teresa de Lauretis, *Technologies of Gender: Essays on Theory Film and Fiction* (Bloomington, Ind., 1987), 122.

6. Michael Taussig, *Colonialism, Shamanism, and the Wild Man: A Study in Terror and Healing* (Chicago, 1987), 444–45.

7. David Lodge, *Small World* (Harmondsworth, 1985) 43–44.

8. Ibid., 83–113.

9. Cohen, *Film and Fiction*, 141.

10. Zachary Leader, Review of the BBC production of *Small World, Times Literary Supplement* (March 1988): 280.

11. Stephen Fay, *Beyond Greed* (New York, 1981).

4

Experience, Re-presentation, and Film

LESLIE DEVEREAUX

Knot and Web

Figure 1 shows a Zinacanteca woman's belt. It is woven of somewhat degraded Merino wool, which was dyed with a local vegetable green and with German chemical red imported from Guatemala. It is supposed to be one finger-width broader than it is, but I wove it to be narrower to suit myself.

Her belt is the piece of a Zinacanteca woman's clothing most emblematic of femininity. She wears it throughout her life, cinched very tightly around her middle. The belt holds her skirt smoothed closely across her body, delineating her hips, which are the part of her body sexually fetishised by men. Because of the way her skirt folds over the top of it, the belt itself is virtually invisible when she is wearing it. Its breadth supports her back and stomach when she carries heavy loads. She hangs it over the rafters and it supports her weight when she kneels in the labour of childbirth. Usually a woman loosens her belt at night when she's sleeping, but she unties it fully only when she's changing her skirt or when she invites someone inside her skirt to make love.

As soon as an infant girl is born in Zinacantan she is wrapped in a skirt-like cloth for a nappy, which is cinched in place with a miniature belt just like this one. She will wear a woollen belt bound around her waist for the rest of her life. Until she is two years old, she will experience life from a place on her mother's body, to which she is bound

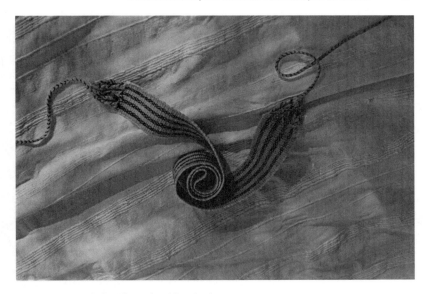

1. Zinacantec belt. Photo by Alex Asch.

snugly with a special cotton cloth. Her mother will also cover her head whenever she is sleeping or strangers are around.

Zinacantan is a community of Mayan villages in the far south of Mexico. I lived in the village of Nabenchauk. Figure 2 shows the courtyard of my house in the compound of the family who are godparents to my elder daughter. I think I have spent something close to a thousand days in this courtyard, talking, dreaming, working. When I see this photograph I supply to this image a memory of the smell of woodsmoke, the ruckus of turkeys and baaing lambs, voices carrying up the mountain slope from neighbours' courtyards, truck horns, and scratchy *cantina* music. The feel of dawn frost under my bare foot.

You, who have likely never been there, can supply none of this. What meanings and associations extrinsic to this image do you supply? If this were the opening image of a film I were to make, what connections from within this image would I need to carry beyond it to establish this place in its social and historic context? What connections would I make to situate this belt within this frame?

Without the frost under my foot, the grassy patches between forest and cornfield would not be good pasturage for sheep. Without the baaing of the sheep, the wool in the belt would be gone. Without the truck

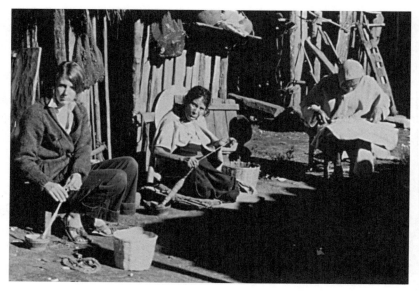

2. The late Mal Vaskis, her late husband Mol Shun Vaskis, and me, in their end of our common courtyard, January 1974. Photo by John Haviland.

horns the colourfast red dye from German companies in Guatemala would have to come by muletrain, and would be too costly and scarce. Without the woodsmoke from the disappearing oak forests, how would the weaver cook her corn into tortillas? So it is clear that this belt is actually composed of an infinitude of non-belt elements. It has no separate existence apart from this web of non-belt elements.

Similarly, it has already expanded into a web of non-belt meanings, as it takes its place wrapped tightly around a woman's waist, where belts have always held her fast throughout her life, loosened only in her most private moments. In fact this belt is present even in its absence.

My daughter's great godmother Me' Mal died in 1982, but nearly half of the days I've spent in this courtyard were in her company, as she taught me to spin and told me stories about the past. In 1974, it was arranged for Me' Mal to have the cataracts that were blinding her removed at a clinic in the state capital. I learned there (as I would not otherwise have done, as women never take off their clothes, not even in the sweatbath) that the flesh of Mal's waist was permanently indented about half an inch deep, the width of her belt, all the way around. For me, as I washed her and felt that indentation, the presence of that belt

in its absence was profound. But for Mal the absence of that belt at her waist was deeply meaningful throughout her stay in the clinic, a part of her estrangement, her weakness, her aloneness among strangers, a lack of support, her body unwrapped, loose and vulnerable.

Any text, this text, any film must select, from among these meanings and connections, some to articulate, to trace, to call into play. The whole context can never be elucidated fully. This, of course, is true of every moment of our lives. An exercise often given to students of phenomenology is to have them go home and write out the background knowledge needed to elucidate fully the meanings in this exchange between two people preparing dinner:

Tom: By the way, how much did the shoe repair cost?
Mary: I didn't have any change for the parking meter.

We live at all times in embedded, contingent ways in our minds and in our physicality. The interactions of our lifeworld continuously tweak strands in the web, strands which resonate through many nodes and intersections and through the structures of capital, macropolitical, and economic conditions that lie beyond the horizon of direct experience and impinge in constitutive ways on the lifeworld. So we have both the specificity and the embeddedness: the node and the web; the thing and the relationship. And we have somehow, in order to live and to understand living, to keep both these aspects in view. The practice of anthropology is especially about the specific and the particular: the detailed account of how these particular people inhabit, embody, and invest the world. We owe it to them and to ourselves not to close that world off from its historical and social contexts by supplying system where there is chaos, closure where there is penetration, stasis where there is movement.

Self and Other

How can we help in the project of validating the plurality of human experience without imposing false separation? How do we keep human understanding open to the possibility of radical difference while tracing out the connections which hold us all within a single woven world?

In this context I hold the work of the Uruguayan writer Eduardo Galeano as a model. His trilogy *Memory of Fire* ranges over the whole continent of Latin America and juxtaposes pieces of historical documents with voices from indigenous legends and with bits of fictional writing about historical actors, a mixture that creates an account of great specificity and subversive of narrative explanation. We can learn a lot from Third World writers, whose position does not offer them the hubris that they alone can tell it like it is. But I have, in a way, digressed, and I want to return to the problems of presenting experience, and to question who is doing the experiencing.

Anthropology is a discipline devoted to the encounter with others. Historically we are the children of rationalism, caught in hierarchy and duality, handmaidens of colonialism, trappers of romantic illusion.

The "self" and the "other" are ideas inseparable from each other. When we encounter the other we are inclined to project onto it those aspects of ourselves that we cannot own or even acknowledge — we make our most elementally frightening desires into the desires of the other. And so the encounter with the other is also the encounter with the self, and to know, amid this projection and difference, what is what is perhaps the heart of human difficulty.

Objectivism — the act of radical separation of the knower from the known, of mind from its object — expunges the self from the scene of encounter and impedes the possibility of distinguishing "other" from projection. Only the self-knowing self can withdraw its projections and leave the other free. Self-knowing, which is the condition for knowing the other, is not an achievable state but a process within the act of knowing and perception, a process that accomplishes itself through encounter with the other. An anthropology of difference begins with that attitude of openness to self within the conditions of encounter.

The Said and the Unsaid

Carol Gilligan, rewriting the extensive work on the social psychology of moral reasoning, has demonstrated that in our culture (or at least my subculture) men and boys tend to evaluate situations in terms of positions, often hierarchically understood, and in terms of the application of universalising rules. Women and girls, on the other hand, evaluate situations in terms of relationship, specificities of context, and contingency.

Is this why I could find little place for Mal's belt in anthropology? The web of meaning enmeshing Mal's belt leads into women's daily work, the thumping of weaving looms, the tending of sheep. And it leads into women's bodies, into the way they feel to women — the significance of the way a woman's body feels to her as she cinches in her belt of a morning or as she labours in childbirth. There is no anthropological discourse for this. The strands of Mal's belt do not lead readily into words anywhere, unless you count dreams. Dreams are told around the fire in the sleepy dawn, and there are lots of dreams in Zinacantan about losing one's clothes, finding oneself naked. The absence of the belt. Other words we can hear at the end of Mal's belt are the stories, news, and speculations women exchange as they sit in the courtyard and weave, watching the paths and listening to the voices that carry on the mountain air. But most anthropologists don't hear them. They are down at the courthouse with the men, settling debates about village politics.

So most of the words that Mal's belt leads to are mine. I could really spin a yarn about that belt. Right over here in the shade, we could just sit down and talk about it together while we feed the chickens.

But this isn't really how we do things in the academy. As Father Walter Ong has explained in his book titled, significantly, *Fighting for Life,* in the academy talk is contention, and academic practice is descended from a long tradition of what he calls male ceremonial combat, which doesn't go on in the shade but takes place in special arenas, lecture theatres, and conference halls. Ong has a good deal to say about the history of thought under conditions of literacy. Literacy, he contends, is a process whereby the thinker becomes aware of his own thought as an entity, as an abstraction. Writing fixes the idea, "transforming the evanescent world of sound to the quiescent, quasi-permanent world of space."[1] It allows analysis to free itself from context and to develop generalising and universalising tendencies. And print, far more than mere writing, completes the separation of the knower from the known and creates finality and closure in the manufacture and discourse of the text.

No conversation here.

And a long way from context and experience, too. The human lifeworld is not at home in the discourses of the academy; what belongs there is analytical abstraction. Outside the academy people stick closer to experience.

One way anthropologists have tried to stick close to experience has been, in fact, to stick close to the text, by recording and carefully

translating exactly what people have said to them. This relieves the ethnographer from some of the danger that his or her own rhetorical agenda will overwhelm local meanings. Ivo Strecker's *Conversations in Dambaiti* is a case in point.

Another, more literarily constructed book in this vein is Marjorie Shostak's *Nisa,* in which she transcribes and edits the life story of a San woman, elicited in the course of her fieldwork there. The account of Nisa is restructured for the reader into segments that correspond with our expectations of connection and analysis, and each segment is introduced by the ethnographer. *Nisa* restores personhood, as we see it, to the ethnographic subject and allows her own account and words, in some measure, to weave the map of meanings in her life for us. The ethnographer reduces her own presence in the text to our guide, an interpreting voice, speaking, as it were, over our shoulder just when we need it to understand the context of what Nisa is telling us. And what Nisa tells us holds our attention, because she is doubly displaced — an illiterate and a woman. And even more, a bit of an oddball, we're told. From her we hear the profoundly rare, a woman talking about her life in her body.

This book is an exemplar of the effort in anthropology to let the subjects of ethnography speak for themselves. This is the reflex in our discipline of the impulse in the Latin American literary genre of "testimonio," in which the account of a person ill-placed to inscribe her own words on the public record is transformed into print and translated into the national language by a writer who makes of herself a conduit. The intention here is political, to render less flagrant the relations of hegemony that are in play and to allow someone who otherwise could not to speak to "us" — members of the national or international literate culture.

Still, people know more than what they hear, they are more than what they say (more, even, than what they think), and books such as *Nisa* hold us in the thrall of words, which is our lot in the culture of academia. As if all meaning were contained in talk, in our ideas about living. Like a character in a Godard film in his Maoist period, we miss the living itself. The book *Nisa* resonates with the film by John Marshall called *!Nai,* a compilation of footage shot over many years, now rendered into a form of coherent life through the subject's translated comments looking back on herself in a voice-over commentary spoken by an African English speaker. In contrast with Marshall's early innovative sequence films, which, while edited, appear to let a moment in life (like coming upon a wasp's nest) unfold on its own, *!Nai* is highly con-

structed, and the images of this film have the quality of providing illustration for the speaking voice, which carries the burden of what we are meant to learn.

Accounts by ethnographers who attempt to enter into their subjects' experience of living and to render it as experience are relatively few. Bateson's *Naven,* a complex book with several agendas, is nonetheless inspired in part by this impulse, and it directly addresses his own engagement with the observed lifeworld and his efforts to understand it. In this decade we have Stephen Feld's *Sound and Sentiment,* written about the Kaluli and how they perceive and express feeling. This is part of a highly experientially oriented set of researches by Feld and his colleagues Buck Schieffelin and Bambi Schieffelin, often working simultaneously but in quite different ways. Jean Briggs's book *Never in Anger* is still perhaps the most thoroughgoing experiential account, one in which the ethnographer comes to terms with the embodiment of feeling in an Inuit community through the outcomes of her own emotional and bodily engagement. Some films that, while not reflexive, render the experience of the subjects in ways accessible to the viewer are Tim Asch's short sequence films from the Yanomamö: *A Man and His Wife Weave a Hammock; Weeding the Garden; Children Playing in the Rain, Climbing the Rasha Palm.* These films take no narrative authority and develop from Marshall's idea of the sequence film.

In most feature cinema the viewer shares large swathes of the lived world with the makers of the film. The viewer already knows, in a way, everything. The meanings and significances of a shadow or an ashtray exist within both cinematic and extracinematic codes in which the viewer is expert. Even the plot, with its expected movements, is only partially yet-to-be-revealed. In ethnographic film it may be the case that very few of the elements in the image, or in the sequences of images, carry much extracinematic meaning for the viewer at all or that through the work of cinematic representational codes the viewer may, in fact, misrecognise the apparently familiar and construe objects, faces, and events in ways extraneous to the culture represented.

As we know, a text cannot be created simply out of lived experience; a form — that is, the textual organization of experience — must preexist. And in the case of anthropology that form of the text can even work in advance to shape the lived experience itself. In anthropological fieldwork, certainly, there are procedures to be followed, questions to be addressed. Until recently we have been inattentive to this work of the text.

We have preferred to explore human culture as something thought

rather than felt, embodied, and experienced. We have found it difficult to acknowledge that culture is as inscribed in everyday interaction and in ordinary glance and gesture as it is in spectacle and performance, as articulated in gossip as in legend. Cultural meaning is theorised as if suspended between minds, referred to and enacted, rather than renewed and modified as it reciprocally modifies each consciousness. This is the consequence of resorting too quickly to abstraction, in search of generalisation, rather than sticking close to experience. Sticking close to experience is not the same as empiricism; it requires looking closely at one's own experience, at the process of engaging with social reality, to discover how it is that we know what we know as well as how others know it and work with it.

The conventions of scientific writing work against the portrayal of experience in favour of elicited systems of thought and observed regularities of public behaviour, usually reported as behaviour — that is, with the emphasis on action rather than interaction and on prescription rather than on contingency. This amounts to a grave distortion of human actuality. In this rhetorical form it becomes hard not to render people homogeneous and rule-following, no matter the disavowals we utter about this. Our scientised standards of evidence privilege speech over feeling and bodily sensation, which is assimilated to the personal. The personal, the putatively private, is an indistinct category of well-defined suspicious character.

The private is the realm of the idiosyncratic, the disordered, the unaccountable, the unreplicable. "Public" event, as in ritual, oratory, and ceremonial, is the realm to which anthropology has most comfortably turned to locate the cultural discourses of emotion, sentiment, and the endowment of meaning upon experience. As the indisputably symbolic, this is the realm of the "said" as opposed to that of the "unsaid." And so anthropology has turned away from the bulk of human experience and away from the tacit understandings of everyday life. Perhaps this is also a reflex of the conditions of living for most First World writers. In the twentieth century we have virtually no direct experience of the unmediated world. Our world comes to us not merely endowed with cultural meanings but air conditioned, filmed, recorded, amplified, mixed, packaged, and printed. Experience may be a concept whose day has passed for us, and we may be ill positioned to grasp it directly, to inquire into it as it passes. What is actually happening to us, in us, and through us is rarely an object of our attention: we live primarily through the instant replay. Daily life is what happens to us during the commercials, and it's highly untrustworthy.

Anthropology's interest in the formal and in spectacle has also meant that it has turned away from women's lives (not a new insight) until the past decade. The absence of women as social actors in ethnographic writing is unsurprising, especially to feminist theory. Our cultural stories and narratives are men's stories, in which women figure as complements. Any absence of the cherished collaboration of hero and his complement is regarded as evidence of hostility. Any power in women that is not harnessed to the interests of the male, or the male group, is demonic; any action by her in and for her own right is unrepresented. These conventions are no different in ethnography.

One of the most influential theoreticians of the Anthropological Imaginary is Claude Lévi-Strauss. In 1949 he described humanity's arrival at the doorstep of culture as that moment when woman, in her character as sign, was exchanged between two groups of desiring men. I would like to quote his words, which entrap women in an especially dense net:

As far as women are concerned reciprocity has maintained its fundamental function on the one hand because women are the most precious possession, but above all because women are not primarily a sign of social value but a natural stimulant; and the stimulant of the only instinct the satisfaction of which can be deferred and consequently the only one for which in the act of exchange and via awareness of reciprocity the transformation from stimulant to sign can take place, and, defining by this fundamental process the transformation from nature to culture, assume the character of an institution.[2]

Woman as sign and as stimulant pretty much covers ethnography up to the 1980s. There is, then, a double absence in ethnography: the daily and personal arenas in which women's lives take place — the gardens, the cooking fires, the menstrual retreats, the lily ponds, the oyster beds — are rarely represented, and so women's social action in their own terms appears scarce. The public worlds of men and the discourses that belong to them are the primary subjects of ethnography, and so those women who appear do so in the role of complements, the "muted" women written about by Edwin and Shirley Ardener.

The Daily and the Spectacular

In our culture it has been the feminist project to begin, through consciousness-raising activity and through women's writing, to

share and to celebrate women's knowledge that life is lived in its daili-
ness—weeding these plants, spinning this wool, cooking these beans.
All that which is encoded in public spectacle, and much more, is already
inscribed in the actions and interactions of daily life. Public spectacle
may reinforce the hierarchies of value by expressing the relations of he-
gemony and by coding them as desirable and as natural in the language
of the dominant discourse, but it never creates them. This creativity lies
in the ten thousand interactions and significations of daily living,
through which people witness, experience, discover, and express their
existences, in this particular place, this language, this group.

Perhaps what I'm saying about dailiness amounts for anthropology
to what Ursula LeGuin was saying to writers in her essay titled "The
Carrier-bag Theory of Fiction." Since Ursula LeGuin is the daughter of
two anthropologists, perhaps that is not so surprising. She notices the
similarity between men's stories in literature and their stories in science
and contrasts these with women's writing. In particular she muses on
the theories of "Man the Hunter," in which man's invention of a
weapon was regarded as the first act of material culture and has since
become the engine of man's heroic progress in the struggle of life. This
story began to lose its evidential base in the 1970s and has been replaced
with the carrier-bag theory, according to which someone, probably a
woman, but who knows, figured out how to carry food back to camp.
LeGuin celebrates being able to see herself in the story, while in the old
heroic tale she could not.

If it is a human thing to do to put something you want, because it's useful,
edible, or beautiful, into a bag, or a bit of rolled bark or a leaf, or a net woven
of your own hair, or what have you, and take it home with you . . . and then
later on take it out and eat it or share it or store it up for the winter in a
solider container or put it in the medicine bundle or the shrine or the museum
or the holy place, the area that contains what is sacred, and then the next day
you probably do much the same again—if to do that is human, if that's what
it takes, then I am a human being after all. Fully, freely, gladly, for the first
time.[3]

This dailiness is one of the things we want in ethnography, and an-
other thing is embodiment, the representation of experience of the body
as felt by its inhabiting consciousness and not as it exists for someone
else and by cultural dictate—as the ground of being, not as "stimulant."

In our culture a piece of clothing that bears a few of the meanings
that Mal's belt bears in hers is the high-heeled shoe. It has many mean-
ings for men, often analysed in popular and scholarly places, in part as

something they look at as it encases a woman's foot. Something else they look at is the sway it imparts to a woman's back, lifting her rump, making her hips more prominent and emphasised when she walks. Among nonhuman primates this postural change is a signal of sexual solicitation — sexual lordosis, it's called in the literature — and a female adopts this posture when she swings her rump past the noses of possible sexual partners. Some women are comfortable enough to note that they like the feeling of wearing high heels, but there has not until recently been much discourse, scholarly or otherwise, about the sexual feelings of women concerning high heels. A good deal of medical and physical hygiene debate has existed throughout this century, but it took the frank self-interest of the era of power dressing to acknowledge the personal confidence involved for an executive woman in a condition of discreet arousal.

An analogue to this in biological anthropology and its influential theories of human evolution is worth repeating. For many years the large and colourful sexual swellings of female chimpanzees during estrus were regarded as visual signals of sexual readiness to males. In the 1970s, when pheromonal (or scent) cues had been discovered as major modes of communication in many species, experiments were carried out to discover their possible role among primates, and it was revealed that male chimpanzees were indifferent to the visual signal of sexual swelling and aroused only by the pheromones that females gave off during estrus. Ho ho! Consternation and befuddlement. What could these gross and disfiguring swellings be for, in that case? It truly awaited clarity until women in biology intuited that these swellings might incite the female herself to the frenzy of sexual activity in which she engages at these times. It had not been asked, this most obvious of questions: what do these swellings feel like for the swellee? Female experience, like female desire, is absent in this record of male visual pleasure.

As Pierre Bourdieu has pointed out, every society treats the body as a memory in which to store the basic principles of its culture in mnemonic form. When we enter the field without attention to our own body's experience, when we give only a looking and not a seeing, comprehending gaze to the bodies of others, when we don't inquire into the experience of those bodies for themselves, we engage in a process of forgetting which is intrinsic to our own society before we have even begun to know.

So what I specify, or allude to, which I term "experience," is not a notion of some idiosyncratic thing that belongs to someone and to

which we might compare similar things belonging to other people. It is not, after all, the personal in that inaccessible and disordered sense to which I have referred. I mean experience in a much more general sense, as the process by which one enters or places oneself in social reality, a process of engagement through which one perceives as subjective the material, economic, and interpersonal relations of social and historical life. Who one is is continuously constructed, not a fixed place from which one interacts with the world. Action, in this sense (or interaction) is not a repetition of the already meaningful but a creative response to continuously unfolding contingency. Who we are at a given moment is the outcome of that interaction. Our "self" and the position from which we act in time is the product not of culture, conceived of as some external set of available ideas and values, but of our own personal engagement in the practices that give significance to the things and events of the world.

In trying to understand meaning and experience, I have found C. S. Peirce useful, as have many before me, as he outlines how it is that meaning is conveyed, received, and modified even as it modifies the consciousness that receives it. As he conceives of it, this process contains space and movement insofar as the sign that a receiving consciousness actually lays hold of is not necessarily the sign that was "sent." Peirce says, "A sign addresses somebody, that is, it creates in the mind of that person an equivalent sign, or perhaps a more developed sign. The sign which it creates I call the interpretant of the first sign."[4]

He goes on to consider the events, as it were, set off in the consciousness of the receiver of the sign. "The first proper effect of a sign is a feeling produced by it." The second effect that may be produced is mediated by the first and is energetic, in the form of physical, or more usually mental, effort. The third, which may be produced by the mediation of the previous two, is what Peirce calls "a habit-change, a modification of one's tendencies toward action, resulting from previous experiences or from previous exertions."[5] This third interpretant is self-analysing and makes sense by providing a conceptual representation of the (previous) effort.

Here we have a view of cultural meaning in which significances pass through persons, embodied consciousnesses, changing in the process and also altering the person, who then may effect change in the world through action, which may be inaction or a form of being. Peirce's delicate little mechanism provides theoretical room for us to conceive of experience as a nodal point, as it were, in a web, a node or nexus which

inheres in a person as a "complex of habits resulting from the semiotic interaction of 'outer world' and 'inner world', the continuous engagement of a self . . . in social reality."[6]

Teresa de Lauretis, from whom I have taken that last phrase, goes on to link this view of semiosis to the specific quality of feminist theory in a way that resonates wonderfully with her countryman Gramsci's insights into the conditions for intervention in structures of hegemony, which has found its particular elaboration in Ranajit Guha's theory of the consciousness of subalternity. She says:

> This is where the specificity of feminist theory may be sought: not in femininity as a privileged nearness to nature, the body, or the unconscious, an essence which inheres in woman but to which males too now lay a claim; not in a female tradition simply understood as private, marginal yet intact, outside of history but fully there to be discovered or recovered; not, finally, in the chinks and cracks of masculinity, the fissures of male identity or the repressed of phallic discourse; but rather in that political, theoretical, self-analysing practice by which the relations of the subject in social reality can be rearticulated from the historical experience of women.[7]

And, we might add with only the slightest shift in perspective, the subjects of ethnography.

This is about reinserting the experiencing self into the practice of ethnography, which means attending to the phenomena of the ethnographic experience as it is happening. Theoretically we must put our attention in the moment of the transformation of self and sign. As the sign is received it effects a habit-change, and as it is produced, spoken, it proceeds from an experienced and experiencing person and is itself transformed by that passage — residues of embodied habit encrust on it, into it; barnacles of the person.

One way we can do this work in practice is by weaving the belt ourselves and wearing it. Participation in the lifeworld to which we come as relative strangers involves us in mimicry, trying out ways of being till we begin to do it well enough to pass. This practice provides constant information, in the sense that Bateson means: news of difference. The close-matched acts of mimicry with my own habits of mind and body create "news of difference," which is the principle source of change in any system, in this case, my thought.

The canonised description of anthropological practice is participant observation, of which we willingly own only the latter term. Observation is good and standard science, not without certain phenomenological difficulties rising obscurely out of particle physics, but still pretty

respectable. Participation is an embarrassment. Its analogue in the non-human sciences is experimental manipulation, and we don't want to be associated with that. So participation in anthropology becomes a sort of ritual requirement that we actually go there and learn the language. In fact, being there is so existentially involving that even the most intro-verted ethnographer engages in a great deal of learning by being and doing. But we have not been able to take much epistemological advan-tage of this, to actually examine our own human practice and expand it into a way of knowing.

If we can shake off a preoccupation with the text — a preoccupation that has been so productive, if infuriating, in cultural studies — and re-new some of its roots in phenomenology and pragmatism, some parts of the semiotic project can be very useful to an anthropology of expe-rience.

Reinserting the experiencing self is not the same as the recent move-ment in anthropology to reinsert the ethnographer into the text. I wel-come the new attention to ethnographic writing, and it seems clear that it is opening the way to reconsidering ethnographic practice. However, we don't want anthropology to become like a version of the movie *Broadcast News,* a piece of entertainment about the process of creating entertainment, and to turn our writing to the project of considering writing.

I wouldn't want to be misinterpreted as suggesting that ethnography should be a form of confessional literature. Nor would I prescribe in-creasing self-description and the use of the "I" pronoun as a sop to sci-entific objectivity, as if the embodied personhood of the observing intel-ligence and the speaking or writing subject needed apologetic specifying in hope of regaining some neutrality of perfect objectivism. I'm just talking about the practice of experiential learning undertaken in the spirit of true presence to the encounter. And about keeping that pres-ence in the text — what we might call, in the idiom of this paper, "writ-ing with the belt on" and not removing that presence by distilling it into disembodied generalities in the text. This is where I come at last to ethnographic film, which has the potential to carry out this project more immediately perhaps than does writing. I also hope to define a space in ethnography for film which is more than illustration.

One of the efforts I see in some current ethnographic film, sensitive to the intrusiveness of the film apparatus and to the ease with which stereotypical images can be created, is the effort to transform "looking" into "seeing." "Looking" preserves the ontological separation of beings

into viewer and viewed. "Seeing," on the other hand, begins the project of traversing that gap, acknowledging the incorporation of the sign into the subject, acknowledging habit-change, and preparing for the possibility that the subject's action arises out of the ground of meaning. Filmmakers are doing this in the first instance by transforming their own practice, in a number of ways: by becoming ethnographers themselves and living as participants in the societies in which they film by engaging with their subjects in the moment of filming, talking with them, with and without the camera, so that when the subjects speak on film they are speaking to the filmmaker, a person whose own perspective they understand in some sense, with whom they are comfortable and who gives them room to move within any agenda of their own.

I am thinking here of Judith MacDougall's film *The House Opening,* in which the widow sits in the shade of a tree, talking to David, who is behind the camera. It is a quiet, unhurried, ruminative conversation in which the subject is fully free to speak or not to speak. The MacDougalls achieve an alert, fully present, and allowing quality in their interviews, which gives the subjects moral space in which to say what is on their minds. There is no pretence, however, that the film is not constructed by the considering minds and techniques of the filmmakers.

The space between human bodies is not only physical space, culturally specified, but also moral and ethical space, to do with the nature of relations between persons. The camera, as a technology extending the eye, is a great potential violator of that space. And visual anthropology, which traded in the past on the power relations of colonialism and today often trades on the personal relations of face-to-face social worlds to which the gross exploitation of the personal so common to our civilization of advertising is still a surprise, can be a tactless practice, worming its way into close spaces that it then exposes in ways unimaginable to its hapless subjects.

This is the underbelly of the camera's special virtue, which is its direct relation to the personal and the particular. Whatever its claims or disclaimers about its relation to the real, the ethnographic film cannot escape its ties to the specific. The specific can be made to stand for the general; there is no ontological imperative toward nor guarantee of the actual in ethnographic film, but there is the opportunity for a visual immersion in the particular, which is the condition for its affinity with anthropology. Writing, especially academic writing, flees the particular and takes hold of the abstract, that enemy of experience. The expository project, extrapolating from the particular to the general, explaining, is

not impossible in documentary film. But sticking with the particular, sticking close to experience, is, if anything, more possible in anthropological film than in writing. Writing takes place after the experience. It revises in the light of the intervening moments. Each take in film is constructed in the moment of filming. Its contingency is the contingency of the experiencing filmmaker. Editing, narrative, or expository construction are still to come, of course; this possibility of sticking with the moment is easily lost, but it can be preserved or built upon.

This sticking with experience, with the moment, is only partial, only what was seen or heard; it does not contain what was felt, or silently thought. And film, like ethnographic writing, can construct itself so fully around speech that the possibility of experience gets turned, like "testimonio," into merely an image as the conduit of the words of the subject. The richness of the image, the context in which the utterance was made, is often far more illuminating than is transcribed speech in text, as gesture and aspects of context can be present for the viewer. But film is no guarantee of veracity, as witness the documentary *Some of These Stories Are True,* or Mitchell Block's *No Lies.*

Film can also allow the viewer a degree of autonomy different from that of the reader's. When documentary film refrains from forcing the viewer's gaze, and attention, to follow it through fast cutting and short takes, the viewer can look at leisure at the image and through looking this way perhaps see something. At the moment of filming, the decision to place the camera at a distance, showing subjects in their contexts within the image the viewer sees, and to hold the camera still for long takes, long takes that remain in the film, allows the viewer to trust in the camera's stillness enough to look for herself, to move her eyes around in the image, and to move her thoughts without fear that she will miss something, a fear which is the hallmark of the viewer's experience of mainstream cinematography. I think here of the pleasure of seeing that comes from the exceedingly slow pans around the subject's room in Laura Mulvey's films or in Gillian Leahey's *Life without Steve.* In a fictional context, the trust we have in the camera in Chantal Akerman's *Meetings with Anna* allows us to consider what we are seeing, and we find ourselves trying out her experience, of lying in reverie on a hotel bed, of staring out a window, by substituting moments of our own experiences rather than by making her experience ours. Ozu also comes to mind. The long takes and length of the films themselves in Ian Dunlop's *Baruya Manhood* series bring us poignant and unsensationalised experiential knowledge of an initiation process that a shorter, more managed

film would not do. I think, perhaps, what is happening is that with a relatively still camera, the distance and angle of viewing held constant, the viewer can find her own position not wholly dominated by the camera, and she can choose to change that position and take up another. This is what, if anything, I would prescribe for film in the ethnographic project: a cinematography that allows the viewer agency and self-knowledge in the act of spectatorship. I will close with some words from Thomas Merton:

We are always aware of ourselves as spectators. This spectatorship is like a wound in our nature . . . for which healing is required. Yet we refuse healing because we insist on preserving our status as spectators. This is the only identity we understand. Once we cease to "stand against" the world, we think we cease to exist. . . . We can never really believe ourselves fully at home in the world that is ours since we are condemned to live in it as spectators, to create for ourselves the distance that establishes us as subjects fully conscious of our subjectivity.[8]

Notes

1. Walter Ong, *Orality and Literacy: The Technologizing of the Word* (London, 1982), 91.

2. Claude Lévi-Strauss, *Elementary Structures of Kinship*, trans. James Harle Bell, John Richard von Sturmer, and Rodney Needham (Boston, 1969), 62–63.

3. Ursula LeGuin, "The Carrier-bag Theory of Fiction," in *Dancing at the Edge of the World: Thoughts on Words, Women, Places* (London, 1989), 168.

4. Charles Sanders Peirce, *Collected Papers* (Cambridge, Mass., 1931–58), 2: 228.

5. Peirce, *Collected Papers,* 5: 476.

6. Teresa de Lauretis, *Alice Doesn't: Feminism, Semiotics, Cinema* (London, 1984), 184.

7. Ibid., 186.

8. Thomas Merton, "The Zen Koan," in *Thomas Merton on Zen* (London, 1976), 79.

Case Studies: Photography

5

Photography and Film

Figures in/of History

ANNE-MARIE WILLIS

Film and photographic history appear to have different agendas and to be sealed off from one another, yet they have many functional relations as interconnected cultural forms. Both media have been implicated in the late twentieth-century condition of hypervisuality, which has seen the rise of the figural over discourse. The real has collapsed into credibility of appearance, authenticity has become a matter of convincing detail. With the loss of the notion of a referent lodged in an allegedly pristine real, no first instance in the generation of imagery can be identified. Film, photography, video, and "the real" intertwine. Photography has certain advantages; it is mobile, diverse, and ubiquitous compared to the more fixed form of film. Sometimes the photographic image precedes and is generational of film, seen for instance in the use of "historic" photos as reference material for set and costume design in "period" films and TV miniseries. In other cases photography functions as the image "after-life" of film. Conversely, film acts back on photography, memories of film recoding our encounters with "historic" photos.

In this figural world, history becomes a genre of representation: to say this is to do more than simply name the historical film as a genre. The photograph is used unproblematically as a "window on the past," which then is translated into the details, and often the whole aesthetic, of fiction and nonfiction films. Historical reconstruction projects (such as the theme parks I will discuss in this essay) are similarly based on photographs and in turn are often used as sets for films. Experiencing

such "themed" historical spaces, despite their claims of authenticity, can be like encountering a film set.

The textual relations between film, photography, and "reconstructions" of history — as well as the work of these interconnecting representations in constructing popular knowledges of history — will be examined in this paper. A major consideration will be the production of a social imaginary of a "picturesque past." There is a need for new knowledges that can come to terms with the dissolved boundaries between the filmic and the photographic as they have colluded and continue to collude in deepening crises of representation.

Disciplinary Circumscription: Within and Beyond

Film and photography are often thought of as intimately connected because of their shared technologies of representation; thus the inadequate term "photographic image" is used to refer to all visual imagery, still and moving, that is produced through the registration of reflected light onto a recording medium (film stock, videotape) via the agency of a camera. Thus "photographic image" can refer to still photographs, films, or video. Yet it is an awkward term precisely because it seems to privilege the still image. It is significant that the disciplinary fields of film and photographic history have not come up with an adequate means of naming the system of representation that unites them. This has been partly due to the separate entry points at which film and photography have entered into the academy and in which each has made its own claims to be worthy of study under the umbrella of the humanities. It has been left to those without an investment in the establishment of the fields of photographic and film history to name the larger whole, hence terminology such as the society of the spectacle (Debord), simulacra (Baudrillard), and the hyper-real (Umberto Eco). What is of particular value is that such terms name film and photography as cultural forms, not just as systems of representation.

To simplify then, film has entered into the humanities via literature and photography via art history. There has therefore been a disciplinary separation that is at odds with their interconnection as material cultural forms. It also needs to be noted that they have developed unevenly; film studies has gained a stronger claim than has photographic history/the-

ory to be regarded as a field in its own right. The academic legitimation of both media has also coincided with crises within the traditional disciplines. Just as film and photography history came to be recognised as serious fields of study, there were movements to break out of the disciplinary moulds they might have occupied in the first place. Photographic history, for example, became legitimised by taking on the methods of art history, thus constituting photographic history as a parade of significant creative individuals, movements, styles, genres. This was because art history *colonised* photography; the medium didn't enter art history departments of its own accord but rather came to be seen by art historians as an untouched field of visual imagery to which they could apply their methods and thus expand their field of influence. However, photographic history arrived and began to settle in comfortably at the same moment that art history as a discipline was beginning to go through a crisis, one element of which was to question its predominant concentration on the "high arts" and on painting in particular. Ironically then, the ubiquitous popular medium of photography, with its multiplicity of uses and its consequent potential to blow art history apart, was incorporated into its mould. The social history of art, advocating contextualism and the study of popular imagery (including photography), acted back on the freshly established canon of photographic history with projects of rereading the work of canonised masters. For example, the work of French photographer Eugène Atget has been reassessed by a careful excavation of the uses to which his photographs were put at the time they were made, which has fueled more informed speculations on this enigmatic photographer's intentions.[1] But this example shows the narrow focus of discipline-based investigations, for it draws on the impoverished internal critique of art history, which still centres the creative individual as the moving force of its historical account and simply tries to paint a more filled-out picture of the individual artist and his/her historical context.

There is a long tradition of histories of photographic technologies. More recently these have taken a social historical approach that extends to projects of writing photographic history as the history of an industry. This problematically assumes that there are singular coherent stories to be told about technology or about industry. Critically reflective photographic history writing is a rare genre, confined mainly to the work of two writers based in the United States, Alan Sekula and John Tagg.

In a useful article in *Cinema Histories Cinema Practices,* Thomas Elsaesser acknowledges the slipperiness of the historical boundaries of

photography and film.[2] He points to a nonhierarchical field of inter-
acting discourses — of power, of pleasure, of knowledge, of sexuality, of
representation — within the social formation and says, "it would then
simply be a matter of choosing a particular vantage-point and unravel-
ling articulations and intensities with a particular strategy in mind, say
that of pleasure and subject positions."[3] But to me there's still something
missing. I'm quite happy to abandon medium-centred histories, but
"simply choosing" is no solution, for that leaves the gaping question of
what then is to guide that choice. Choice cannot be wholly determined
by political questions internal to the disciplinary field but must be con-
nected to a politics beyond. Choice has the significant critical potential
of articulating internal and external imperatives. Elsaesser's argument
moves back and forth between decentring and recentring film history
as he analyses Kracauer's study of German silent cinema, *From Caligari
to Hitler.* Elsaesser's allegiance to film history as such is revealed in his
comment that Kracauer's objective is social history, not film history. He
makes the following point:

But what if it turned out that the cinema was not the outcome of the histories
of the optics, chemistry, technology and so forth that make up its "apparatus"
or its "institutions"? Suppose instead that cinema was the beginning of the
end of history, the apparatus that would contribute decisively to the suspen-
sion of history?[4]

He goes on to suppose that a homology between films and a given
society, a relation of reflection or crystallisation, cannot accurately seize
the phenomenon. Then we would have to conceive of a disjunctive
change, or leap, "where the appearance and semblance of identity con-
ceal . . . a radical nonidentity or break."[5] Later he takes this up in a
different way when he refers to "the emphasis that our society places on
vision and the eye for mastery and control of our everyday environ-
ment" and proposes that the cinema's historical task has been to "in-
scribe itself in an ensemble of discourses and social practices that trans-
lated particular forms of industrial organisation and the mastery of space
and time into a sensory perceptual discourse." "Its effect," he says, "has
been to restructure both subjectivity and signification in the light of the
changes that capitalism has brought to all social relations."[6]

Elsaesser is pointing to a process that didn't begin and end in the
cinema of the Weimar Republic but also to something that cannot be
confined to cinema. This rise of the visual has historically incorporated
all the reproductive media that have been part of the making of the

world of late modernity, increasingly dominated by spectacle, and for this the mobility of still photography has been particularly significant. This relates also to what Scott Lash has named "the rise of the figural" — that is, that which comes to displace narrative and discourse when the rationalist explanations upon which they are founded have become deconstructed.[7]

What becomes significant then are not the issues of how to "do" film and photographic history or how to account for the specificity of each medium and thereby identify appropriate methodologies. Such exclusive foci are too inward looking, too hermetically sealed within gatekeeping concerns of the academy. What Elsaesser and Lash are pointing to instead is the *historical process* in which photography, film, and video have been implicated. These media have been agencies in that disjunctive change or leap of Elsaesser's "where the appearance and semblance of identity . . . conceal a radical nonidentity." I understand this as a nonidentity between appearance and that to which appearance claims to refer, a manifestation of the more general crisis of representation as it is embedded in a broader crisis of the foundation of reason. This becomes particularly apparent if we consider what the rise of film and photography have done to history. A double movement has occurred: while serving as agencies in the historical transformation of culture (into mass culture), these reproductive media have also reinvented history as visual, as a genre of representation that has in its turn acted to obscure the visibility of the historical process at work.

Figural History: Two Dimensional/ Four Dimensional

Photography, film, and video act separately and together to produce history as visual spectacle. As media they have also become increasingly significant modes of transmission of historical knowledge beyond the textbook and the classroom. Because of its flexibility, photography operates at many levels both visibly and invisibly in constructing historical knowledge. Film's narrativity is a more powerful device of historical telling than the discrete and bounded imagery of still photography, but still photography often has a presence, sometimes visible, sometimes not, in the historical film. Photographs are believed to be "windows on the past," so they are used as reference material by

researchers as the basis for set and costume design and sometimes for the whole aesthetic of a film. One of the major points in the *Screen* debate on film and history in relation to the TV miniseries *Days of Hope* was the collapse that occurred between truth and appearance, so that the credibility of the account of historical events became reduced to the accuracy of historical detail—the clothing people wore, the furniture, and so on. The authority of the historical photograph was of course the ultimate reference point.[8] A particular photographic style—sepia tone, soft focus, certain arrangements of characters in interiors—is also used to evoke a sense of pastness, by the imitation of early twentieth-century studio photography for instance. In this way a movie/TV version of history can be powerfully connected with a viewer's own personal history as it is deposited in family albums. Photographic technology and conventions of photographic representation have moved through such marked changes over the last 150 years that portraits are immediately locatable within designated time periods. When the subject of the portrait is unknown, style comes to the fore and is rich in connotation. Codes of clothing, pose (formal or informal), and colour (black and white, coloured, or hand-coloured) have an uncanny ability to evoke particular genres of pastness. This is something used by makers of documentaries. As soon as the narrative shifts to the past, up pop the close-ups and montage sequences of family snapshots, school photos, or official group portraits, usually accompanied by appropriate music to evoke the era—for example, the Charleston for the 1920s, the sound of gunfire for World War I. Thus through music and narration particular styles of photography become even more firmly fixed as signifiers of an era. The very dividing up of history into eras—the Elizabethan, the Victorian, the Colonial period—or into decades has been very much the work of filmic and televisual popular history. Events and larger historical processes become subsumed to a regime of appearances—the era of Garbo, of glamour portraiture, or of black-and-white newsreel footage. A first instance cannot be located in this generation of history as visual spectacle. Still photography, film, and video echo and refer to one another. A photographic aesthetic is appropriated for a film, which can then recode our perceptions of historic photographs, investing them with a certain kind of theatricality.

Many writers have pointed to this boundlessness of the filmic text. Elsaesser says "a film today is as much constructed 'outside'—in the discourses of financing and spin-offs and residuals, in promotional campaigns and journalistic or critical reviews—as it is constructed within

the length and duration of its celluloid strip and the space of its projection."[9] Photography is significant in this prefiguration and afterlife of the film with specialists such as stills, publicity, and portrait photographers employed exclusively to give the film an extratextual life.

Figural History: Three Dimensional

If the filmic and the photographic dissolve in these ways, both also participate in the construction of a hyper-real space of history in real space and time, space and time that audiences can walk into and experience. Here I am referring specifically to restored, reconstructed, and newly constructed themed historical spaces. Film and photography are implicated in the construction and the experiencing of such places on a number of levels:

- Vintage photographs are used as the source for designing appearance and layout and are used to verify architectural details.

- The constructed historical spaces are often used as film sets.

- Such places look like the film sets of historical dramas; the ubiquitous frontier town recalls the sets of innumerable cowboy movies.

- Live people are employed to act out historical roles in costume; sometimes these are unemployed actors.

- An imitation nineteenth-century photo studio in which people are photographed in old-fashioned clothes is often featured. A "special effect" here is that still photography gets recoded as quaintly "historical."

- For the visitor the experience can be something like being on a film set and encountering characters that can be captured on film, taken home, and put in an album. Thus public history as spectacle enters private histories as a memory of leisure.

- Photography is used in colour brochures, postcards, and souvenir books, thus extending the life of the representation beyond the immediate encounter with the site of simulated history.

Without going into a typology of re-created historical spaces it could be noted that they range from collections of restored buildings to full-scale

historical theme parks, which attempt to re-create a particular past time and place, its appearance and social life, down to the smallest detail.

These historical hyper-spaces are symptomatic of a mutation that has occurred in the discursive field of history as it has now moved beyond the textbook and classroom. It is produced as an ensemble of representations, re-creations, reenactments, restorations, and artefacts that are encountered almost anywhere, from shopping centres to theme parks or open-air museums, in souvenir shops, advertisements, picture books, movies, and TV series. History then has become a spectacularised cultural commodity, a genre and an instrument of the manufacture of brands. History as theme enables commodity differentiation and hence proliferation. It becomes an element in the sign-powered economy of late modernity, operational in the cultural field that drives production and that has finally annihilated the workability of theoretical models of base-superstructure and economic determinism. History as a commodity intersects with a number of discursive fields — those of leisure, tourism, education, nation, and history. History as commodity may present itself unashamedly as spectacle or entertainment, as historical fantasy, but at other times commodified history claims authority, in such instances as the expertly researched documentary or the authentically restored historic house, which can be just as fantasy-like in its selection and, more significant, its exclusions.

Both the serious historical film/TV series and the serious historical theme park claim truth on the basis of authenticity of detail. Realism stands in for truth; realism conceals what it cannot show.

I'll take a specific example: Sovereign Hill is a facsimile nineteenth-century gold mining town that has been built on the outskirts of Ballarat, one of Victoria's gold rush towns of the 1850s (see fig. 3). It is like an animated photographic history book, one that can be stepped into and in which you are invited to play. The reference point is not so much the visitors' assumed historical knowledge of the area or of gold mining but their mental storehouses of historical visual imagery. Encounter with the site activates traces of pictorial, filmic, and televisual history rather than history as event or process. It claims to be a re-creation of early Ballarat but in fact telescopes some fifty years of history into one site so that different phases of gold mining from small claim and alluvial through to large-scale deep shaft mining all co-exist in a flow. The main street with shops and businesses is also a composite of simulations from different moments of Ballarat's history. The overall spectacle does not betray the disjunctive time. The different structures

3. Photography's history as aestheticised historicism. Photo by Tony Fry.

and areas of activity blend into one another, and visitors are guided along the designed spaces of roads and paths that give them the impression that they are walking through a contained place that existed in a single time frame. It is an experience of history that is guided by the gaze; visitors experience a carefully managed scenario, a seamless text. The activities presented, the businesses on the main street, obey the logic of the spectacle.

Visitors are inducted into a flow, but it is not like the narrative binding of film. It is more mobile; there is some choice of direction of bodily movement, of the sequence in which one will look at things. There is the possibility of activity — panning for gold, going down a mine shaft. A visit to somewhere like Sovereign Hill is not a singular act of consumption such as purchasing a ticket and watching a movie. After you have paid your entrance fee, other activities and further acts of consumption become possible — for example, buying souvenirs or having a meal. Desire then is driven not by narrative but by a less structured process, which I call theme-ing. The subject is not moved through a tight story of gold mining in Ballarat but through a series of figural appearances that are united by the theme of "gold town." This theme acts as an operational (that is, instrumentally applied) discourse that

4. The film-set appearance of commodified history animating the history of commodification as nostalgia ("life was simple then"). Photo by Tony Fry.

appropriates and knits together fragments from other discourses. So the ensemble of appearances at Sovereign Hill has been put together according to unquestioned notions of the history of gold mining, Australian history, appropriate forms of family entertainment, saleable commodities, the expectations of tourism, and so on. Although it may seem less binding than a narrative, it is in fact just as powerful because it is a totality of sensory experience, as its promotional brochure emphasises:

As you walk along Main Street *feel* the atmosphere of the 1850s all around you. *Hear* the ring of hammer on anvil at the blacksmith's forge . . . *smell* the ground coffee, the spices and sawdust at Clarke Brothers Grocery [fig. 4] . . . *taste* the freshly made humbugs, butter balls and other boiled sweets made at Brown's Confectionery Manufactory . . .

As is the case with many historical films the truth claim of the account is based on the notion of authenticity of detail. At Sovereign Hill the tangibility of multisensory experience is another dimension of this realist and empiricist regime of truth. Because it has the appearance of being "live" — buildings seem to be re-created exactly as they were in the 1850s, functioning as they did then, peopled with authentically cos-

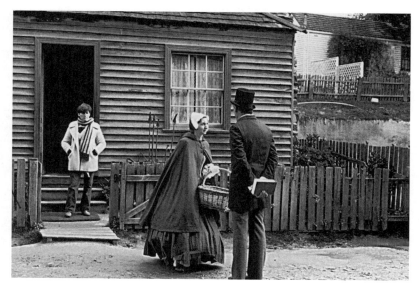

5. Labour as mobile figures of spectacle. Photo by Tony Fry.

tumed workers — Sovereign Hill appears as history come to life (fig. 5). Living history then is equated with the visual, the tangible, the animated, in other words the figural. But this simulacrum refers to an original that never existed. Its detail and accuracy claim historical truth, but this truth can work only at the level of the ahistorical gaze. It operates as spectacle.

The content of Sovereign Hill has been assembled according to assumptions of visitors' fragmentary knowledge, which the spectacle seeks to reinforce and knit into something coherent. This comprises a jumble of knowledge including some recognition of the significance of the gold rushes in Australia's history, but also familiarity with romantic notions of gold mining gleaned from film, TV, comics, fiction — figures such as "gold fever," "striking it rich," giant nuggets, eccentric prospectors, wild frontier towns.

There is no directive ideological program, though ideological values come through as subtext of what is taken for granted. The Sovereign Hill complex is subtended by two privileged themes in Australian historiography: egalitarianism and embourgeoisement. The myth of an egalitarian society is replayed, the "ordinary man" is centre stage. The goldfields of the 1850s represent the birth of this myth. For a very brief

period, in the early alluvial gold rushes, class and capital were not so significant in making fortunes; rather stamina, ingenuity, and luck were the factors. The moment was brief indeed, as the alluvial gold was exhausted within a few years. Companies then formed to finance the technology and equipment that was needed to extract gold from deep-lying seams and miners became wage earners. Yet the egalitarian myth of the goldfields remains enshrined in many historical accounts.

Sovereign Hill presents a sanitised history. Free enterprise, the prosperity and respectability delivered by gold, is celebrated. What is presented is the embourgeoisement of Ballarat. In its first ten years the town in fact developed on two separate sites. The west became the more upmarket commercial centre with respectable shops and neatly laid-out streets. The east was chaotic, squalid, with mud roads and a network of backstreets, brothels, hotels, and grog tents. The simulacrum of Sovereign Hill is not structured by any such division. There is no disease, shortage, poverty, or accidents. Squalor is limited to horse manure and the mud of the gold diggings.

If the history of Ballarat is laundered squeaky clean at Sovereign Hill, so too is the larger history of gold mining. The story of gold mining in one place is not connected to other histories in other places. A narrative could be constructed around the cultural history of gold, the story of how gold came to acquire its status and role as what is virtually a transcendent signifier of ultimate value. Another could be told of the history of the extraction technology, in which the individual prospector represents a very brief moment, not only in Australia, but everywhere. However, the prospector is always placed at the centre of narratives; he is the hero of Sovereign Hill's theme of gold. In symbolising individual initiative he represents the romance of capitalism.

There are innumerable other absences in the history presented by Sovereign Hill's spectacle — significant absences of class, gender, and race conflicts that were very much to the fore in early Ballarat.

So, what exactly has happened to history at Sovereign Hill? What does this historical rise of the figural do to history? Clearly it transforms it. There is an illusion that one can step back into the past and engage history. Panning for gold or riding in a stage coach make history seem tangible (fig. 6). But this illusion of involvement masks the truly passive nature of the outdoor museum. The visitor is invited to step *back* in time, to revel in the vivid experience of a *bygone* era, through a range of acts of consumption. The living history museum spells death, a nonusable past is animated, nonusable because it is not connected to the present. The meaning of the word "history" becomes subtly transformed.

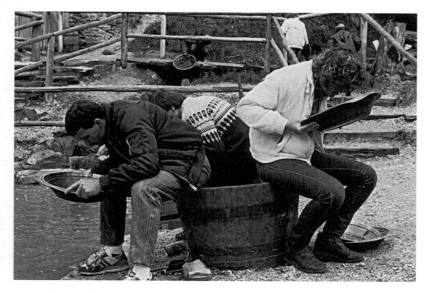

6. Having an historical experience at Sovereign Hill. Photo by Tony Fry.

The notion of history pervades tourism in Victoria, with brochures proclaiming "Kyneton — Gateway to History," "Bendigo — Riding through History," "Beechworth — come inside Victoria's most historic town." History becomes an empirical entity of the present, tangible, capable of being experienced through the visual and by moving through space. This is history as style, as a genre of leisure. History is the obsolete artefact, the past architectural style, weathered stone, conspicuous craft and ornamentation, obsolete technologies and modes of transport, "olde worlde charm." Thus history is capable of being quantified. Certain buildings "have a lot of history in them," a commonplace phrase that contains the wish "if only the stones could speak" (they never will) but is primarily an aesthetic response.[10] Sovereign Hill in fact represents the leading edge of Victoria's cultural tourism. It is a point of entry and mechanism of induction into this new field of cultural consumption in which place, film, photography, and costume are all elements.[11]

Figural History: The Fifth Dimension

This discussion of the themed historical space of Sovereign Hill may seem a long way from questions of film, photography,

and history, yet what ties all of it together is the rise of the figural. All three cultural forms have contributed to a process that has transformed history into a spectacularised commodity form. The existence of history as panorama on the screen legitimises the next step into realism that the three-dimensional, experiential themed historical space represents. There are also cultural and technological developments that bring together the filmic and photographic space and the hyper-real space of simulated environments. To take one example: there are now travel companies in the United Kingdom and the United States that specialise in arranging themed holidays for executives in which the emphasis is on participation in a managed spectacle. Groups of businessmen, paid for by their companies, act out fictional roles with themes such as Chicago gangsters, a medieval banquet, a pirate ship, an Edwardian hot-air balloon adventure, a Sherlock Holmes mystery, a Zulu war. These themes are drawn randomly from history as it has been constructed through filmic narratives, and the players act out fantasies, not of imagining themselves and acting as "original" historical characters, but of playing heroes and heroines as they have encountered them in films. This might all sound trivial or like harmless fun, but the corporations who pay for these holidays for their workers do not think so. Japanese and German firms offer them as a reward for performance and as structured excitement to break the monotony of corporate life. Some of the companies that organise these theme breaks also offer services in psychological assessment of workers' participation for recruitment and promotion purposes.[12] These controlled and simulated adventures provide the space in which transgression can be played out and resistance can be rendered symbolic and ineffectual; they are part of an attempted pacification of the corporate subject. In this way historical fantasy is constituted according to requirements of colour, variety (consumer choice), and potential for psychological revelation. History is made to obey the logic of commodification and the requirements of the maximisation of the labour power of the corporate subject.

Such cultural forms are already becoming bound to new technologies. And here we need to acknowledge the computerised imagery that is annihilating film as projected image and photograph as material object. Digitised editing and interactive multimedia allow the operator the same freedom as an artist with a tube of paints to alter, colour, combine, re-create, and then animate imagery, all by electronic methods, imagery that after all this manipulation appears as convincing as filmed footage. Another development is virtual reality, which is indicative of a new level

of sophistication of potential human interaction with computers, going well beyond the videogame. This is how it works. A user wears a special helmet that contains two small television screens, one for each eye, so that the image appears to be three-dimensional. This by itself already sounds like the memorable scene from the sci-fi film *Robocop,* in which the new hybridised human-machine awakes after the operation that has created it by welding computer and mechanical parts to the dead body of a policeman in order to view the world through a videoscreen— Robocop's eyes are the eyes of a television camera monitor. In the virtual environment the helmet that the user wears prevents anything except the image from being seen, immersing him or her in the simulated scene. A sensor mounted on the helmet keeps track of the position of the user's head, and as the head turns the computerised scene shifts accordingly. To interact with objects in this simulated world the user wears a thin lycra glove with optical fibre sensors that detect how the hand is bending. Another sensor determines the hand's position in space, then a computer-drawn image of a hand appears in the scene, allowing the user to guide the hand to objects in the simulation.[13] Virtual reality's potential application for themed narrativised fantasy is in fact already being realised.

To conclude, the disciplinary separation of film and photographic history has been misleading because of the ways in which the two media interweave as material cultural forms. The significant questions to ask are not those internal to fledgling and not so fledgling disciplines, such as how to "do" film and photographic history, but the larger questions of what have been the many historical consequences of the arrival and proliferation of these media, and then how to get a grip on these. Both media have been implicated in the rise of the spectacular as part of modernity, and in an increasing dominance of particular forms of visuality and the figural, and both have driven this development further. One aspect of the reproductive media's historical mission has been to radically alter modes of transmission of historical knowledge and to produce history as style, as genre, as a range of visual appearances. The movement toward greater degrees of simulated realism is both driven by and annihilates the traditional reproductive media of film and photography. So in one sense we could say that film and photographic history are ending only just after they have begun and what we need now are histories of the hyper-real. But there are larger challenges for film and photographic history, and these need to be directed toward the future. The rise of the figural, which has come to displace narrative and discourse,

is symptomatic of the crisis of representation. A kind of mute technological sublimity is generated as a response to the mounting failure of representation in face of the forces of contemporary crisis — political, economic, ecological, psychological, social. Representation then does not exist as something separate to be observed; it is inseparable from its conditions of existence and thus needs to be considered together with them.

Notes

This paper is based on work done by myself and Tony Fry on theming, history, leisure, and cultural tourism.

1. For example, see Margaret Nesbit, "Atget's *Intérieurs parisiens:* The Point of Difference," in Eugène Atget, *Intérieurs parisiens: Photographies* (Paris, 1982).

2. Thomas Elsaesser, "Film History and Visual Pleasure," in P. Mellencamp and P. Rosen, eds., *Cinema Histories Cinema Practices,* American Film Institute Monograph Series (Los Angeles, 1984), 47–84.

3. Ibid., 55.

4. Ibid., 56.

5. Ibid.

6. Ibid., 75.

7. Scott Lash, "Discourse or Figure? Postmodernism as a 'Regime of Signification,'" *Theory, Culture, and Society,* 5, nos. 2–3 (June 1988): 311–36.

8. The debate is reproduced in Tony Bennett et al., eds., *Popular TV and Film* (London, 1981).

9. Elsaesser, "Film History and Visual Pleasure," 52.

10. One kind of reaction to my analysis of Sovereign Hill (and thus similar cultural forms) is that it assumes a passive, uncritical consumer and that I have not sufficiently acknowledged the variety of responses (some oppositional) that different visitors may have. I would reject such a criticism. While a totalised, uniform reading of any cultural text (even the most carefully constructed) cannot be assumed, advocating "difference" or "resistance" in such instances can often immobilise critical responsibility by placing faith in oppositional potentialities *when no agency for such can be identified or no actual sign of opposition — cultural or economic — can be discerned.* Such views, I would argue, declare a desire for resistance rather than its actuality.

11. My discussion of Sovereign Hill is based on research done there in early 1987. Since then there has been an expansion of the site, but the central complex remains substantially unchanged. An interesting series of developments occurred in relation to the Chinese village, opened in mid-1987 and intended to present the role of Chinese miners in the gold rushes. The following sequence of events instances the collapse of the orders of representation, the limits of

cultural translation, and the revenge of the real as simulacrum: a reproduction of an original goldfield temple was included, but the present-day Chinese inhabitants of Ballarat were not happy for it to be simply a replica. It has recently been dedicated and now operates as a fully functional temple with restricted visitor access.

12. Helen Chappell, "Playtime with the Boss," *Guardian* (9 April 1989), 24. My thanks to Geoff Batchen for this reference.

13. Andrew Pollack, "Advanced Simulation: A Vision of the Future," *Sydney Morning Herald* (8 May 1989), 24.

6

Modernism and the Photographic Representation of War and Destruction

BERND HÜPPAUF

Theoretical approaches to film and photography developed after World War II can be read as both a radicalisation of traditional positions and a turning point leading away from them. Prior to the emergence of the semiological approach, André Bazin used the term "ontology" for his attempt to define the unique character of the photographic image.

> Originality in photography as distinct from originality in painting lies in the essentially objective character of photography. For the first time, between the originating object and its reproduction there intervenes only the instrumentality of a nonliving agent. . . . All the arts are based on the presence of man, only photography derives an advantage from his absence. . . . This production by automatic means has radically affected our psychology of the image. . . . In spite of any objections our critical spirit may offer, we are forced to accept as real the existence of the object reproduced, actually re-presented, set before us, that is to say, in time and space. Photography enjoys a certain advantage in virtue of this transference of reality from the thing to its reproduction. . . . The photographic image is the object itself, the object freed from the conditions of time and space that govern it.[1]

His position could be understood as an extension of the traditional belief in the objectivity of the photographic image. But what made it a real turning point in the debate was its radical separation of this "ontological" position from all previous ideological contexts of realism, mimesis, and truth claims. In his view, it is not only the mechanical process itself but also the viewer's knowledge of its nature that have changed the character of the image and its perception through a "transference of reality from the thing to its reproduction." Problems of representing

modern warfare were instrumental in the development of radically new approaches to film and photography.

That pictorial representation should not only mirror the represented object is how Rudolf Arnheim summarised an aesthetic position that gained considerable prominence with the "ontological" debate unfolding. In the age of film and photography, he argued, the onus was on the medium itself to make evident that the representation is a product of the object itself, mechanically produced in the way objects of the physical world imprint their image onto the photographic plate.[2] From its early days onward, photography commonly has been seen as a technique capable of duplicating visible reality. But with intensifying reflection on the new medium, the focus moved away from the mechanical character of reproduction. It was realised that photography created its own category of visual images resulting from the "independent" role played by the object in the process of reproducing and, more particularly, from the fact that the viewer is constantly aware of this "independence" of the object in its relation to both photographer and medium.

In a period increasingly dominated by ideals of "objective" sciences, photography was considered superior to all other forms of representation precisely because of the apparent absence of a consciousness mediating between the object and its representation. Photography therefore seemed to be the "medium of immediacy." The importance this medium gained in various scientific disciplines, as forensic evidence and in everyday life, supported the common association of the photographic image and truth. Yet it is precisely its "documentary" character and the seeming absence of subjectivity from photography that placed it at the centre of the crisis of representation. The specific object-medium relationship made photography particularly sensitive in relation to changes in the object — that is, the physical and the imagined reality. It was soon observed that, while they do not lie, photographs do not tell the truth either. Rather, they have to be seen as elements in a highly complex process into which both photographic techniques and the concept of reality have been dissolved. At one stage in this process of disillusionment photography was all but equated with falsification.[3] However, while falsifications of photographs is an important issue, this close association of political and ideological doctrines with the distortion of reality in photographic representation tends to misconstrue the fundamental issue.

To the degree to which modern reality has become the product of science and technology, is disjointed, opaque, and characterised by ab-

stract mediation, the relationship between pictorial representation and linguistic accounts has become highly problematic. It is the abstract nature of modernity that seems to require conceptual modes of representation rather than a pictorial duplication of visible reality. Such a requirement does not easily correspond to the character and predominantly documentary image of photography and more often than not has led to an uneasy relationship. The representation in photography and film of modern warfare provides us with a disturbing example of the fading link between experience and knowledge and an asymmetrical relation between abstract and pictorial representation based upon an unresolved contradiction between images and structures.

This essay is based on the hypothesis that representations of modern warfare in film and photography are faced with a structural dilemma: their moral commitment more often than not is linked to a visual code that clashes with aesthetic requirements of visualising a reality that has become highly abstract. Juxtapositions of the human face and images of the destructive technological violence of modern warfare suffer in film and photography from an intrinsic contradiction. Such representation of modern wars aims at maintaining a dichotomy between war and civilization. It is based on a concept of humanity and nature that is being eroded by the very condition of modern civilization, a condition that is only more exposed, accelerated, and condensed in warfare. An iconography based on an opposition between the human face and inhuman technology is inevitably in danger of oversimplifying complex structures, and consequently films based upon these opposed elements suffer from an anachronistic attempt to ignore basic constitutive elements of modernity.[4] The landscape of modern war is largely determined by communications technologies of the electronic age. At the same time structures of modern warfare are constitutive elements in modern technology to the extent that the aesthetic of a morally construed discourse, in contrast to one that is outside morality and technologically induced, is in danger of rendering itself obsolete. This is a process in which photography, film, and the electronic media themselves have played a significant role.[5] War films with a moral commitment face the problem that the nature of their images and indeed their very structure of representation contradict the subject of their representation — that is, the destruction of humanity by modern technological-scientific warfare. The origin of this process of abstraction, which finally led to images of the Gulf War devoid of the space necessary for human experience, but highly fantastic and playful, can be traced back to the late nineteenth century.

Its period of consolidation and first culmination was World War I, particularly in aerial photography.

The first war recorded in photographs was the Crimean War.[6] The era of photography was fifteen years old when England and France intervened in the conflict between Russia and Turkey and invaded the Crimean Peninsula (1854). Although this was neither a war in which photography played a significant role nor one in which the modern battlefield had emerged, the few photographs taken during that military campaign already reveal central issues of war photography, in particular questions as to what *can* and what *should* be represented in photographic images of warfare. While the possibilities of photography during the Crimean War were to a considerable extent limited by undeveloped photographic techniques, bulky equipment, and long exposure times, these photographs are at the same time a reflection of the aesthetics of the time. Photography's competition with painting and its striving for recognition as a new form of art within the system of established visual arts becomes even more exposed in war photography. The crisis of the concept of mimesis deeply affected war photography, and, above all, the problematic relationship between ethics and aesthetics was at the centre of war photography. Is the aesthetic thrill associated with images of ruins, a field of destruction, of violence and death amoral, or would it have to be seen as part of an aesthetic sphere divorced from that of moral value judgement?

While these tendencies emerged in the photography of the Crimean War, it was during the American Civil War that they gained momentum before fully unfolding in World War I. The American Civil War made war photography popular.[7] Stereographic photography and albums with collections of photographic views of the war provided the means for an unprecedented presence of war imagery in the contemporary public mind. Alexander Gardner, "author" of a *Photographic Sketchbook of the War* (1866), gives expression to his view that "verbal representations" of places and events of the war "may or may not have the merit of accuracy; but photographic presentations of them will be accepted by posterity with an undoubting faith."[8] Gardner was not wrong, and examples of a continuation of his view are numerous. Yet it was the American Civil War when, in spite of the large number of photographs of heroes and dead bodies, the invisible structure of the landscape of destruction constituted the reality of war. An industrialised battlefield, new armour, and modern forms of telecommunication spelt the end of traditional warfare. The economic, social, and cultural process of ratio-

nalisation now also began to determine the structures of the battlefield. Here for the first time a tension between images of warfare and the abstract technological structure of the battlefield became constitutive for the creation of a code of pictorial representation.

In an essay on three albums of the Civil War, Alan Trachtenberg denounces as a myth the view that the true Civil War was captured in photographs. He carefully places the pictures and their collections within the social and cultural contexts of their production and reception. From the history of the reception of photography and film it seems obvious that Trachtenberg's position cannot only be applied to the photographic documents of the Civil War but also to those of later wars. To the extent to which the social and cultural contexts of making and seeing those "documents" remain out of sight, "to that extent photographs more easily seem unmediated, innocent representations — their seeming to be without mediation being precisely the message of an ideology: that they present a pure capture of nature by marriage of science and art. In the very act of seeming to make the world visible the photograph as such vanished from sight."[9] It is this faculty of the photograph to vanish behind a reality it appears merely to re-create that contributed to its huge ideological success.

Apart from creating a pool of seemingly natural war images, which soon became familiar to everyone, the Civil War albums went a step further and created a certain code for the representation of the war that enabled things to fall in place: North and South, black and white, right and wrong, success and failure were linked together by a range of images of combat, death, and various battle-related activities. Combined with an "overtly ideological rhetoric" and a "display of that traditional flamboyance of the officer corps,"[10] these photographs contributed to the emergence of a morally charged discourse of the Civil War. Its code, communicated and reinforced through the political and social subtext of the photographs, needs a penetrating reader to be deconstructed. Once it is removed from its moral confines, a hidden code emerges that, in one of the albums (Haupt-Russell) particularly, reveals the mentality of industrial production, of calculation and measurement, that would radically change American society after the war. Trachtenberg argues that the combination of picture and text in the Haupt-Russell album made manifest the association between military regimentation and industrialisation. Haupt-Russell's album can be read as a document not so much of the war but of the mentality of economic and social modernisation of the years that followed it. With surprising consistency the album

concedes the construction, through the photographic medium, of the modernity of the war, thus harnessing it to the technological, social, and cultural structures of the North. "Indeed photography proved a not inconsiderable element in the war's modernity, in what made that event such a profound watershed in the transformation of America into a modern nation-state and military-industrial power: the camera's endowment of visibility, in images virtually simultaneous with the event, sealing the final stamp of modernity on the war."[11]

While the emergence of the machine gun, modern forms of communication, and photography in the American Civil War were indicative of the beginning of the industrialisation of warfare, the "ouvriers de la destruction," as Barbusse called the soldiers of World War I, had not yet arrived. It was indeed World War I that in the full meaning of the word became the first modern technological war, marked by a disproportion between political ends and technological innovations for destruction. While the beginnings of such tendencies might have emerged in the American Civil War, the problems of representation that are associated with modernism and go in tandem with the crisis of experience and the emptying of time and space are characteristic of twentieth-century warfare. In a seemingly never-ending war that appeared to have emancipated itself from human control and whose killing and destruction continued on a scale out of proportion to any conceivable political aim and with no moral justification, it was the experience of absurdity that made World War I the threshold in the crisis of representation of modern warfare.

In World War I film and photography gained a significant role both in military strategy[12] and as the collective image of the war. The sheer number of photographs left behind by this war is remarkable. Tens of thousands in public and private archives seem to provide the historian with complete documentary records of every phase and aspect of that war:[13] proud soldiers in their new uniforms and the enthusiastic masses of August 1914, the first weeks of traditional warfare, the trenches, technological innovations such as zeppelins and planes, tanks, gas, new artillery, the battles of Verdun, the Somme, Flanders, casualties, hospitals, exotic parts of the front, the home front, PO camps, and so forth. In France and Germany during the war, photos that had passed the censor were published in papers and periodicals, often in special issues edited to commemorate anniversaries or other special occasions, or as postcards and collectible small pictures or illustrations of war calendars and albums of the "Great War." Many of these collections also used repro-

ductions of drawings and paintings, sometimes because photos of par-
ticular events, in particular of battles and fast actions, were unavailable
and sometimes because of the desired perspective that photography was
unable to provide. Despite such limitations, there was no real competi-
tion between photography and traditional forms of the visual arts.[14] The
dominant position of photography in relation to actuality and reliability
was now unquestioned, and paintings, etchings, and drawings often im-
itated the accuracy and realism of photography. The spheres left for art-
ists were satire and caricature (certainly of the enemy's activities and
armies) and certain areas of propaganda where symbols and allegories
were considered powerful means of persuasion.

After 1918, photographs and films shot during the war did not disap-
pear in archives and chests of drawers but became strong elements in
the image-riddled reality of this century. Photographs had been taken
by the armies and official reporters, newspaper and agency reporters,
and private individuals.[15] After the end of formal censorship, photos
from all sources began to appear publicly and to be collected. They ap-
peared as illustrations and as source materials in history books for stu-
dents and in the flood of military literature published after 1919; they
were used by the military for the training of young soldiers; in Germany
several albums of war photography collected by editors with either paci-
fist or militant intentions began to appear after 1920; a few films with
original footage were publicly shown; there was Friedrich's unique anti-
war museum based on his private collection of gruesome photos, also
published as a book (1924) with captions in four languages;[16] and, fi-
nally, there were the millions of private collections of postcards, collect-
ible prints, and snapshots stored in albums or proudly displayed on the
book shelves in (predominantly boys') nursery rooms, lounge rooms,
and hallways. Prior to the invention of the electronic media, new photo-
graphic techniques had made possible the omnipresence of war imagery
in the "peaceful" societies after 1918–19. This unprecedented massive
presence of war images contributed to shaping the collective memory
and determining the nature of public discourse on war. Photography
helped establish a tension between the collective memory and the struc-
ture of modern warfare, a tension that was already potentially present
in the photography of the American Civil War but that unfolded only
under the conditions of a shaken Europe after 1919.

As a result of the industrialised war the concept of man had changed,
time and space had been emptied of experience,[17] and photography it-
self had become functional in creating a technological perception. But

the abstract and mediated reality of modern warfare, itself a product and reflection of the structures of modern and rational society, remained separate from and — with a few notable exceptions — alien to public imagery of modern warfare. Despite common knowledge regarding many details of this war of mass armies, technology, and economic strength, the images associated with it remained predominantly archaic images of individual suffering and heroism.[18]

Photography of this war, and this includes its later phases, tends to present the battles as extensions of traditional warfare with modern armour added. The archaic war that had come to an end in 1915 was maintained in the world of photographic representation even when images of early enthusiasm were replaced by those of suffering, exhaustion, or despair. The structural changes of the battlefield, which led to the artificial creation of a new reality for which only the traditional word "front" was available, were lost in a type of photography that maintained as its central object the fighting, running, resting, eating, laughing, dying soldier.

Everyone is now familiar with those "typical" films of the time, shot with static cameras and poor lighting, showing shadowy figures of soldiers in their long coats with helmets, rifles in their arms, and grenades dangling from their belts, going over the top, then through openings in barbed wire, running over black ground, which we know to be the wet grey mud of No-Man's-Land, and then throwing up their arms, knees buckling, tumbling, and finally collapsing backwards in what we know to be the machine-gun and rifle fire from the enemy trench. These images have been popularised through films and TV series, and their documentary character is beyond doubt, in particular when they appear on television accompanied by comments of veterans, who tell their stories of fighting and surviving those attacks, and historians, who explain the political background and strategic importance of that particular battle. Cinema films, often combining original footage and modern acting, made a considerable contribution to popularising this image of the war *as it really was*. Yet, these "documentary" films tend to convey an image of a war that no longer existed. By focussing on a surface that had remained visible but was no longer identical with the reality of a war that had turned soldiers into fighting machines, they provided a powerful contribution to popular cultural discourse on warfare. Tendencies to reduce soldiers to appendages of anonymous huge structures remained largely invisible to the documentary lens and were subsequently "forgotten" in the stories told about this first modern war. The impact that

popular photography and most films of this war had on public discourse is characterised by an intrinsic contradiction. They contributed to the postwar social and political project of inventing a code for the creation of an imaginary reality by negating the experience that the very war that photography and films intended to capture had destroyed the basis for their representations.

One of the photographers who made a considerable contribution to the particular image in collective memory associated with World War I was Frank Hurley. His photography is historically situated on the dividing line between traditional and modernist modes of representation. His famous *Over the Top*, taken at Zonnebeke in October 1917 and exhibited in London in 1918 as a 6.5 x 4.5 metre large print, presents us with the archetypical image of this war. There is the trench system, barbed wire, the emptiness, mud and debris of No-Man's-Land, detonating grenades and fountains of earth, aeroplanes and shrapnel, and, most prominent, soldiers in steel helmets captured in the moment of an attack that we know to have been another senseless attempt at achieving the generals' great aim in this war, the "break through." This archetypical image is not a documentary photograph in the traditional sense but the result of Hurley's careful work in the darkroom: it is based on twelve different negatives.

Hurley was concerned about the limitations created by the photographic equipment and the conditions of battles (he often barely escaped injury) that made it impossible to capture the war fully. He wrote: "I have tried and tried to include events on a single negative, but the results were hopeless. Everything was on such a vast scale. Figures were scattered — the atmosphere was dense with haze and smoke — shells would not burst where required — yet all the elements of a picture were there could they but be brought together and condensed . . . on developing my plate, there was disappointment! All I found was a record of a few figures advancing from the trenches — and a background of haze. Nothing could have been more unlike a battle."[19] Without any theoretical reflection on Hurley's part, his observations revealed the gap between the "reality" of the war and expectations concerning the mimetic capacity of documentary photography. He maintained the view of an integrated, complete, and continuous reality, a view that he developed in peaceful Australia and Antarctica and that conditioned his perception of the modern battlefield even under the most devastating conditions. The Biblical image of God's creation remained the model of his photographic images, which represent scenes of extreme cruelty with a techni-

cal perfection that creates its own aesthetic beauty. In his photographs the senseless destruction of the modern front and extreme fragmentation of reality experienced by soldiers are hardly ever visible, as an aesthetically created coherence makes them disappear in a display of beauty borrowed from a world of the past. While a nimbus of beauty surrounding many of his images can easily be criticised as tricks of misrepresentation played upon viewers ready to be deceived, it is surprising to note how close his work in the darkroom came to the opposite and modernist approach to photography, namely that of montage.

While it was Hurley's aim to hide from the viewer his technical manipulations with negatives, the technique of montage, based on a theory of modernity, exposed its artificial processes in a provocative manner. The camera's inability to capture reality was not seen as merely accidental but as a result of the nature of modern reality, which was disjointed, abstract, complex, and the product of technical, including photographic, constructions. In the underlying philosophy of this image of modernity, God's creation has lost its cohesion, meaning, and completeness. It appears amorphous, and its perceived order is the product of a continuous process of scientific-technological change and cultural construction, accessible only to a perception that is guided by theory. This philosophical problem of apperception, constitutive for the highly theoretical and political concept of montage,[20] was alien to Hurley's aesthetic approach to photography, which was based upon his pragmatic belief in "observation" and sought a cohesive image unwittingly modelled on theories of the nineteenth century.

Today, the heated debate between Hurley and the official Australian war historian Bean, supported by English and Australian officers, has lost its challenge. We find the question no longer interesting whether the technique Hurley called "combination printing"[21] can be justified, and Bean's naturalist concept of representation seems naive and hopelessly outdated. But it is of considerable historical interest to understand this debate as a reflection of a decisive turning point in the conception of photography. Although Hurley had personally observed the nature of modern warfare, his representation of this war was still conditioned by prewar images of beauty, cohesion, and harmony. Montage, however, incorporated into its technical processes and forms of representation the experience of the destructive qualities of modernity. War was then no longer the mere object of the lens; it reconstituted the very position of the camera and the photographic process within reality. It was this type of observation made by Hurley that provided support for

theories concerned with the disintegration of the concept of reality and the related emergence of new theories and practices of photography. Anton Giulio Bragaglia was one of the first to define the camera as a machine for the production of a visual reality independent of a mimesis of the visible. This machine, he writes in 1911, must be manipulated by the photographer so that it perceives that which transcends its mechanical nature.[22] Although his *Fotodinamismo futuristica* was still conceived within the framework of the art debate in relation to photography, it opened new ground for human apperception. Combining insights into the instability and constant deformation of modern reality with techniques of using the camera for extending human perception, Bragaglia had approached Hurley's problem in both practical and theoretical terms. The tension between an aesthetic and a moral, a realist and a modernist concept of photography, was never acknowledged by Hurley, and consequently he failed to develop aesthetic means radical enough to deal with the new reality that he was forced to witness and could not resist harmonising at the same time. As a result, the pacifist intentions of his war photography are lost in the beautiful appearance of his images. His moral realism turns into an iconographic apologia of a philosophy of harmony in the face of total destruction. His attempt to preserve a concept of photographic mimesis by manipulating negatives is an early example of a tendency that photographic realism has great difficulty in escaping: its images unwittingly turn a moral antiwar attitude into a mythology of modern wars. The dividing line between a photographic realism, in which the intention to make visible the destructive might of modern reality is involuntarily consumed by the coherence and consistency of the surface, and an aesthetic beautification of the battlefield becomes easily blurred.

In World War I a recent invention, the aeroplane, was combined with the camera, thereby initiating one of the most powerful innovations of war technology of this century. This combination also had far-reaching implications for the history of perception and the modern mentality. Numerous letters and diaries of soldiers refer to the sight of planes, and it seems safe to suggest that every soldier on the western front who wrote letters would have written about planes. War planes and air fights became the object of literary imagination, wild speculations, and fantasy, of admiration and hopes as well as fear, of feelings of exposure and extreme helplessness. Planes had a profound impact on the perception of the environment. They became an object of identification and of dreams about flying away from the unbearable conditions, the mud and

stench of a life that had gone underground. At the same time they were a constant reminder that this war had also conquered the third dimension, turning Daedalus's dream of escaping from the labyrinth into the nightmare of a complete system of surveillance and threat, which used even this materialisation of an old dream for its own purposes. Soldiers knew that kites, balloons, and planes were used to direct the enemy's artillery and take photographs of their lines. Indeed, aerial photographs of the front demonstrate pointedly the new perception and experience of a "landscape" hitherto unknown: a landscape of complete destruction and high artificiality in terms of its system of dugouts, trenches, communication lines, supply routes, and so forth.

This "landscape," emptied of its traditional points of orientation and its potential for experience visibly reduced to barren functional space, is preserved in thousands of aerial photographs, some of which were even edited in collectors' albums. Indeed, the eye of the observer had changed and, as Jünger argued, had become like a lens, hard, distanced, with no emotion or sentimentality interfering with the act of registering the almost geometrically structured contours of a soulless area. Scenes of destruction may be seen as grandiose spectres but no longer arouse feelings of empathy, pity, or sorrow. There are examples of this in Jünger's own works, when scenes are presented as if they had been seen through reversed binoculars.[23] There are also much more trivial and less stylised accounts of the effect on perception of the destruction of the landscape and the war's technological means of achieving and observing it. It is the landscape of destruction that was particularly likely to revitalise the discourse of the sublime. While their humanist education led young officers in their small planes into experiences of the sublime that followed Kant's definition in almost every respect, the landscape before or rather beneath their eyes could be read in different terms. In a dramatic and patriotic report from 1915 we read about the view from a plane: "We quickly climbed to 1800 m. The view became ever clearer, ever more distinctly we could see the atrocities of the war. A sensation of sublime horror welled up as we now for the first time moved over this vast battlefield. Like a huge relief everything was spread out before us."[24]

This "relief" map seems identical to the photographs that from late 1915 onwards were systematically taken of the battlefields. Cameras had been installed on board planes known for their stable flying performance. Those planes were particularly vulnerable, as it was necessary for them to fly at the same speed and altitude for the entire time it would take to shoot a sequence of photographs. Only then was it possible for

trained personnel to interpret the photographs properly. These photographs in many respects resemble abstract landscape paintings, which also reduce the profusion of details of a "natural" landscape to a "rationally" structured order.

Compared to traditional battle paintings or stylised images of battle formations, a fundamental difference in this new technique of representing the "reality" of war becomes obvious. Aerial shots do not represent sensuous or moral experiences of space, nor is the prescription for or analysis of military movements part of their iconic content. They are silent without careful analysis and are symptoms of new modes of mediated perception and organisation of battlefields made up of huge concentrations of material and masses of soldiers in a vast space that no individual would be capable of surveying. The war killed the natural landscape and replaced it with highly artificial and, within its own parameters, functional spatial arrangements. Aerial photography, then, creating a metalevel of artificiality, further abstracts from the "reality" of this artificial landscape. It not only eliminates smells, noises, and all other stimuli directed at the senses but also projects an order into an amorphous space by reducing its own abundance of detail to restricted patterns of a surface texture. On photographs taken from a certain altitude, only objects of a certain minimum size will be represented; smaller objects, in particular human bodies, will not be there and cannot be made visible even with magnifying glasses or through extreme enlargements.[25] The morphology of the landscape of destruction, photographed from a plane, was transformed into the visual order of an abstract pattern.

Aerial photographs also developed an aesthetic in their own right beyond their tactical and strategic functions. A cloud of mustard gas may produce aesthetically attractive light grey shades on a darker grey background, and regular patterns of dark circles with sharp edges may result from the last long-range bombardment. But the sufferings inflicted on soldiers as a result of those gas attacks or bombardments are completely outside the frame of the photograph. While their picturesque qualities contributed to the popularity of these photographs, their structure seems more like a modern version of abstract representations of warfare in primitive art. There, too, knowledge was required for the deciphering of shapes and colours associated with events, demons, totems or tribes, and their actions in tribal warfare. Visual representation of the modern battlefield in aerial photography is another example of the frequently observed return of archaic structures in the world of

modern technology. Similar to the return of protective armour such as helmets and shields, and their association with magic protection, aerial photography led to a resurrection of primitive images disguised as high technology. Wilhelm Worringer based his reflections on "Abstraction and Empathy" on the opposition between an aesthetic that revolves around the psychological desire for empathy—part of the European classical and romantic traditions—and the tendency toward abstraction, characteristic of the great majority of works of art both from primitive civilizations and from modernity. He approaches the tendency toward abstraction in terms directly applicable to the aesthetic of aerial war photography: "While the desire for empathy as the precondition for aesthetic experience finds its satisfaction in the beauty of the organic world, the desire for abstraction sees its beauty in the life-denying inorganic, crystalline world, generally speaking, in an abstract system of laws and needs."[26]

Combined with these "purely aesthetic" effects is a level of invisible "information" that can be deduced only from the represented topography and changes of its elements over time. On this level what is immediately visible is less important than the inferences that can be drawn from it. The code of the visible landscape of destruction has to be decodified and recodified in military terms. Only then will it be possible to decipher its geometrical symmetries and read information hidden within the visible surface in terms of logistics, ballistic paths, strategic plans behind changes of shapes, and so on. This type of information is characterised by factors contributing to the indirectness and abstraction of images, of which the following are examples:

- long-term developments that have to be monitored in order to become visible

- indirect forces of change, such as strategic decisions taken at headquarters, the speed of transportation systems, etc.

- wide spaces that transcend the perspective of an individual

- absence of an individual focus, which is replaced by technical constructions

Aerial photographs are symptoms of and at the same time forces in the process of changing the mode of perception by fusing aesthetic effects and highly functional military information. Their space is emptied of moral content and experience. A reconstitution of the soldiers' self went

hand in hand with the destruction of experienced and morally charged space and its reconstitution in technical terms. The new landscape, a "dreamlike landscape like a furnace," as Ernst Jünger called it, provided no source for empathy. Identity, seen as a complex and continuous process of identifying with or rejecting other individuals, values, and social and natural surroundings, became critical very soon after soldiers experienced the conditions of "the front." There was very little with which to identify or to which to relate. Soldiers felt cut off from real life.[27] Often no connection seemed possible between their lives in the trenches and the life they remembered back home. At first, looking at photographs of their family, wives, children, and girlfriends maintained connections and established a sense of spatial and temporal orientation in their emotional landscape. After a while, they stared at these photos, and they remained silent. Soldiers' imaginations were no longer able to create the context necessary for these photos to become suggestive parts in personal memories and stories. Often a few days' break and the environment of the base would enable them to regenerate these contexts of emotional orientation. But after a certain period of time spent in the landscape of destruction they tended to lose this ability.

There are numerous reports of this disintegration of the culturally conditioned self, all from years after the end of the war, looking back at a period in life when the awareness and self-reflection necessary to write about this disintegration had been lost. The decomposition of soldiers' selves was marked by the end of narratives. The silence that surrounded the images both photographic and immediate was often recalled for many years after the end of the war and made the imagination of ex-soldiers wander back to this disturbing experience. Shortly before his death, Edmund Blunden, commenting on his own experiences as a young man in World War I, could still write: "My experiences in World War I have haunted me all my life and for many days I have, it seemed, lived in that world rather than this."[28] The disintegration of subjectivity, a central theme in Nietzschean philosophical reflection on the modern condition and in Freud's psychoanalysis, now definitely left the confines of the upper middle class and the framework of philosophical reflection or psychoanalysis and was turned into a mass experience. Under the conditions of technological warfare, the destructive elements of modernity were condensed to the extreme and forcefully imprinted on the modern mind.

It is against this background that the heroic images of this war reveal their ideological character as propaganda. It is not surprising that it was

the most advanced technology of this war, the aeroplane, that gave rise to an imagery of heroes for the new times. Through mass distribution of photos, faces of young pilots came to be associated with the glory and splendour of warfare and gave visible expression to the desire to maintain an image of war that had gone out of existence in trench warfare. Planes and aerial combat more than any other modern system of arms, including submarines and tanks (not to speak of gas units), were considered ideal for the creation of images of heroes who, in a war of mass armies and increasing abstraction, represented the ideal of the pure knight, the strong individual and master of both nature and the machine. A cult of young pilots emerged, based on portraits of the "aces" often photographed with symbols of their "nobility," — for example, a leather cap, a piece of equipment, or a part of a plane — and made these lieutenants more prominent than generals, marshals, and chiefs of staff. At public occasions this star cult would lead to outbursts of emotion and identification. In 1916, German papers reported on their front pages about the "triumphant burial" of one of these heroes, Max Immelmann, and printed photographs of the endless funeral procession curling through the streets of Dresden. The myth of the "Red Baron" Manfred von Richthoven may have been even more powerful. In England and France enthusiasm for the heroes of the sky was equally strong and equally linked to reproduced images of the pure face of the modern hero. In public imagination the world of aerial combat was made up of the idealised face of the young hero, images of open duels, with the place of the seconds taken by whole nations, and a reinterpretation of the empty space of aerial photography in terms of individual experience and collective mythology. This anachronistic imagery, which used photography's power to create illusions for concealing the power of photography, played a significant role in the process of maintaining a moral framework for war propaganda. More than that, it was the mass reproduction of images of the human face that successfully contributed to the mystifications of modern warfare in modern memory.

In contrast to this "humanist" vision of modern warfare, one of the faceless, grey warrior emerged. Linked to the process of disintegrating the bourgeois ego and its meaningful psychological construction was the reconstitution of man as a fighting machine. The hardened man with his steel helmet, emotionless, experienced, with no morality apart from the value of comradeship and no obligation and attachment other than to his immediate group of warriors, fitted the imagery of futurism and soon degenerated into the fascist myth of a new man.[29] However,

this ideological straightjacket and its threatening deformation into fascist attitudes and the Nazi killer mentality was only the most openly menacing political materialisation of this experience.

The experience of the dissolution of subjectivity and its traditional patterns of orientation and values, the transformation of modes of perception, the destruction of vast areas of landscape and experienced time and space have become constitutive elements in modern consciousness. While this destructiveness of modernity did not originate in World War I, this war was clearly experienced as a gigantic rite of passage into the modern condition. Once Western civilization had undergone this experience, the binary oppositions between war and peace, production and destruction became obsolete, and, as Blunden puts it, modern memory has been haunted with this experience ever since. It seemed impossible to restore the human face after it had been mutilated beyond recognition in the outburst of destruction after 1914. Ernst Friedrich's collection of photographs, for all his humanist and socialist commitment, captured this inability to forget and restore the human face to its once God-like image, the inability to bridge this gap that separated a happier past from a disillusioned present. The photograph to which he gave the caption "The 'image of God' with a gas mask"[30] clearly illustrates not only his satirical intentions but also despair.

How could a civilization that was not only prepared to enter into such carnage but also determined to continue it for years ever regain its human face? In Remarque's novel *All Quiet on the Western Front* (1929), in the only conversation that philosophically reflects upon the war, Paul Bäumer remarks that after having gone through two years of killing, devastation, and psychological regression, these young men will never again be the same as before. These sentences are literally repeated in the film that Louis Milestone based on Remarque's novel (*All Quiet on the Western Front*, 1930). The antiwar message of this film is only too obvious, but its images fail to reflect Paul Bäumer's simple observation concerning the irreversible changes brought about by the experience of this war.

It is this type of failure that underlies the structural contradiction in common antiwar discourse. Traditional metaphors, although they had become obsolete, were revitalised and maintained a language that was morally justified but largely incapable of reflecting the structural modernity of the war experience. Milestone's film, as well as *Westfront 1918* (G. W. Pabst, 1930), initiated a pictorial discourse on war by creating a particular imagery and language for film, the new medium that was de-

signed to contribute to the international pacifist movement. By creating on the screen images of increasingly brutal conditions of the war and juxtaposing them with the human face, they established a visual code of a political and humanist commitment. It seems beyond doubt that this emotionally powerful iconography of motion pictures differed from previous representations of wars, in which violence and destruction were embedded in images of heroism and purpose. Yet the moral framework within which these images are created and received largely excludes a representation of the structurally inhuman battlefield of modern warfare. Moral imperatives continue to shape the majority of war films up to the present.

In morally underpinned iconography the camera lens has adopted the position of the suffering soldier as a victim of war rather than exposing the structure of violence and presenting soldiers as elements of it. As a result of this perspective a clear spatial and temporal distinction is maintained between home and front, peace and war, and the destruction of the first by the latter can be reversed at any time — that is, after the armistice. The spatial or temporal distance is marked by emotional images, such as photographs of a happy past, dreams, flowers, city streets (back at the base), or various forms of representations of mothers, sisters, girlfriends.[31] These images are associated with emotions and the longing to bridge the distance between the presence of madness and senseless destruction and the past or future of happiness, reason, and sanity. When in Milestone's adaptation of Remarque's book German soldiers spend a night with French girls, it is made obvious that their happiness is not to last. However, far from being presented as a mere illusion, the scene visually represents the continued presence of this other world as one unaffected by the war despite the devastation of the surrounding tranquil countryside and the soldiers' experience of continuous destruction.

From Milestone's and Pabst's films on, this sharp caesura between two distinct realities has remained a central element in the construction of narratives in many war films. The affectionate scenes and slow action when Paul Bäumer meets his mother during his home leave similarly set up the separate worlds of peace and war, as do the final shots, which juxtapose the peaceful flight of a butterfly with the fatal action of a sniper. The two love scenes in Pabst's film or the shot of soldiers in front of a poster depicting an elegant couple in an urban environment are similarly based on this binary opposition of two worlds separated from each other by exclusive values and imperatives for action. The clear sepa-

ration of a world of senseless destruction, discontinuity, and disintegration of identity from one of emotion, meaning, and purpose established an emotionally powerful code for commercial war films. Bridging this distance through imagination, dream, and memories adds an imaginary dimension of hope to the otherwise hopeless life on the battlefield by cutting through the apparently inseparable and all-encompassing combination of technology and war, hopelessness and destruction.

The Spanish Civil War occupies in many respects an exceptional position within these complex tendencies. On the one hand it was a war of modern technology, but on the other hand it re-created a premodern constellation of moral oppositions and became the last war of heroic imagery. Poetry, songs, novels, films, and photography contributed to the creation of a heroic discourse unparalleled in any other modern war. Despite its many characteristics of a modern industrialised war, the Spanish Civil War is remembered for its resurrection of archaic images of individual endurance, suffering, commitment, and fighting morale. More than in the memory of all other twentieth-century wars, a sentimental mixture of enthusiasm and melancholy is at the centre of its legacy. As a result of the unique moral commitment on the part of the volunteers in the International Brigades, the Spanish Civil War exposed clearly and on an international scale the dilemma of antiwar photography caught between a moral commitment and the aesthetic requirements of representing a technological war. After the French and English governments refused to be drawn into the conflict, the intelligentsia of the Western world defined this war as a model of their international attempt to push back the emergence of the modern form of destructive barbarism and banish, by conquering fascism, the challenge to civilization. Thus the complex situation was simplified, as there seemed to be no alternative to a broad alliance between all forces and groupings who fought in the name of life and civilization while the enemy was identified with cold technology and inhumanity. A moral commitment was transformed into an aesthetic perspective, thereby creating an emotionally powerful imagery of a confrontation between good and bad — an imagery that survived numerous attempts to deconstruct it (Orwell, Koestler, Sperber, and many others). The opposition between the human face and images of suffering, between a peaceful life and the brutality of wars, was now extended and modern technology included within the moral framework of representation. In contrast to images of the American Civil War, which required a penetrating eye for the code of rationalisation to be deciphered, images of fragmentation, anonymity,

and the reign of cold purposeless functionalism were now made explicit. They are, however, exclusively associated with the amorality of a brutal enemy with no aim other than killing and destruction. The fascist enemy remained faceless and was represented by anonymous images of destruction, modern armour, war planes, fast movements, and empty space. While this imagery identified brutality and technology, steel and death, the moral framework of representation required an equally simplistic identification of the image of the individual fighter with the good and just. The fusion of technology and fascism with images of barbarism and their juxtaposition with images of the genuine and simple life, represented by expressive faces of peasants and soldiers with rifles and flower-decorated caps, creates a moral opposition that had become obsolete and, for all its powerful emotional imagery, remained powerless in relation to the technological structure of modern warfare. In a recent discussion of photographic representations of the Spanish Civil War, Malraux's film *L'Espoir* served as an example of the humanist qualities of the imagery. It was credited with the power of the human, which transcends the political, so that in almost every sequence of this film "what appears most obvious is Malraux's sensitivity to a suffering humanity in confrontation with a vast, mechanised, highly technological force."[32]

In a debate concerning aesthetic problems of representing the Spanish Civil War, a prominent position was based on a concept of realism that attributes to photographic images the power of revealing the truth. Linked to the doctrine of "Socialist Realism," which emerged in the late 1920s and was consolidated in the "Expressionism debate" staged in Moscow during the years of the Spanish Civil War, this position charged photographic representation with the justification of the war in the name of humanity. The role of photography was defined by its contribution to the image of a *bellum iustum*. In their attempt to combine a political message with a personalised approach to the war, directors such as Joris Ivens and Herbert Kline referred to codes of the documentary film simultaneously developed in the United States and in early Soviet film production. However, in reality a commitment to the preservation of the human face of modern civilization was not easily reconciled with the insight into the destructive forces this very civilization revealed most strikingly in its design of the modern form of warfare. In the photographic representation of modern war, moral commitment and the pursuit of truth seemed to exclude each other in a more fundamental way than in most other genres. On a personal level, even Ernest Hemingway, who was fairly unconcerned with the discrepancy between the structure

of modern warfare and its representation in realist images, had uneasy feelings about *Spanish Earth,* a film on which he collaborated with its director, Joris Ivens. "Afterwards when it is all over, you have a picture. You see it on the screen; you hear the noises and the music. . . . But what you see in motion on the screen is not what you remember. The first thing you remember is how cold it was; how early you got up in the morning; how you were always so tired; . . . and how we were always hungry. . . . Nothing of that shows on the screen."[33] By insisting on the identity of the human experience and the reality of the war, Hemingway is at odds with the mediated character of both modern warfare and the film. Although it is his film on his war, his frustration is obvious: in watching the film he realises that he has lost both.

While Stephen Spender, a keen observer of the Spanish Civil War and its reflections in the arts, referred to the ever-increasing abstraction and mediation of modern warfare in which, he claims, even the experience of horror calls for every "device of expressionism, abstractionism and effects learnt from collage" to be appropriately represented,[34] Hemingway's image of the war remained closely related to highly individual sensations. He therefore deplores the lack of sensuousness of the medium, which, he feels, by its very nature is unable to do justice to the war as it really was. Since for him the reality of the war is identical with individual experiences, he aims to make visible on the screen the memories imprinted in his body. Thus he distinguishes between a cold and a hot picture. "What I really remember clearest about that, the cold part of the picture, is that I always carried raw onions in the pocket of my lumberman's jacket. . . . [But] in the hot part you ran with cameras, sweating, taking cover on the folds of the terrain on the bare hills. There was dust in your nose, and dust in your hair, and in your eyes, and you had the great thirst for water, the real dry-mouth that only battle brings . . . so now when it is all over you sit in a theatre and suddenly the music comes and then you see a tank come riding like a ship and clanking in the well remembered dust and your mouth dries again."[35] To Hemingway, his dry mouth proves the authenticity of his experience of the war. But what he recalls is only his experience, and it is not the experience of the war but of private sensations on the occasion of a war. The "hero" expects the film to re-create in the cinema those great sensations that create heroes on the battlefield and to enable him to live repeatedly through scenes of heroism.[36]

Hemingway's fascination with fighting and violence is well known. It is hardly surprising that his ideals of heroism, glamour, and male ad-

venture would create a particular image of the horrors and destruction of the war, namely one celebrating the heroic male warrior. To a certain degree this can be attributed to his personal idiosyncrasies. Yet the film by Joris Ivens is also paradigmatic for the many antiwar films that, in spite of the omnipresence of modern technology both in war and peace-time, preserve an image of man outside of the war machine, an image that makes him either a victim or the master of modern destructiveness but not an element in or a product of its technological structure. Ivens's film has been interpreted as a model for the dichotomy between an ico-nography of social construction and peace — bread, water, blood, and earth — and one of war and destruction — the war machine — one of "flesh versus steel, rifles versus planes, the earth below versus the sky above. The high technology of a developed industrial culture imposes economic and political hegemony upon the muscle and grit of a tradi-tional culture defending its livelihood."[37] Through these binary opposi-tions, the film provided an influential contribution to the maintenance of a visual code centred on simple moral values and based upon clear demarcations between life and death, war and peace, destruction and production. Vis-à-vis the destructive character of modern warfare, the simple and clear face of a human being represents the truth of life[38] and its innate strength, which will, finally, always overcome the menace of modern times.

In this sense Joris Ivens's "objective" concept of documentary film with the aim of "agitating and mobilising" the audience by involving them "in the problems demonstrated in the film"[39] provides a surprising theoretical basis for Hemingway's extremely "subjective" approach to war. The chapter on the Spanish Civil War in Ivens's autobiography clearly shows that he is aware of the problem. But he defends his posi-tion by asserting that there is no gap between the images that he creates as a documentary filmmaker and what he knows about the social and political reality. "Had I the feeling that this unity was lost, I would change my profession. A documentary film maker has to have the feel-ing of participating directly in the essential problems of the world."[40] In the Spanish Civil War, Ivens felt, "right and wrong were clear cut" and neatly distributed on the two sides of the battle, because it was obvious that here "fascism was preparing a second world war."[41] There is no mention of details that would not fit the image — for example, execu-tions of "anarchists" or "left extremists" behind the Republican lines or the fact that availability of technology and modern fighting techniques were of equal importance for either side. Among the many wars that

were fought in Spain between 1936 and 1939 it is that of the technolog-
ical war machine against the human face that shaped public memory and
reinforced a visual code for the perception of modern wars. Without
addressing the issue as such, a contemporary critic recorded his feelings
of unease concerning these juxtapositions: "There were good shots of
air-raids and troops training on the march; but we continually cut back
to one of those impassive peasant faces, the backbone of propaganda
films all the world over. This particular old-timer was engaged in mak-
ing a gully to bring water to Madrid. Like all his kind, he just got it
fixed in time. Then there was a boy writing home."[42]

A debate concerning the appropriate mode of representing the Span-
ish Civil War in the visual arts and modern media was conducted in
the newspaper *The Spectator* in the October–November issue of 1937.[43]
Anthony Blunt's short comments associated a modernist approach to
the problem with Picasso's mural *Guernica*, of which he was highly criti-
cal. In his view such modernist images lack realism and therefore fail to
represent the war as it really was. Instead they distort it as a mere experi-
ence of horror and use "circumlocution so abstruse" that the chance of
providing an insight into the position of this war in history — which
is, according to Blunt, "a tragic part" in the continuing progression of
civilization toward a just society — is lost. He denounced this art as elit-
ist and esoteric and called Picasso's painting a "highly specialised prod-
uct, an essentially private art."[44] This position was opposed by Herbert
Read and Roland Penrose. They maintain that Picasso and modern art
in general are not separated from the people in any more radical sense
than artists of earlier centuries had been and suspected Blunt of having
adopted an ideological position in which the term "contact with life"
really means something like "contact with a political party" and was a
code word for propaganda.[45]

In opposition to this concept of realism, which was inseparably en-
twined with moral value judgements, techniques developed in the edit-
ing of films — the reduction of reality to disjointed news items and views
of the world developed in Cubism — were considered much more pro-
ductive for attempts to come to terms with the reality of modern war
than images of photographic accuracy could ever be. Reality and its rep-
resentation have become inseparably entwined and, Spender claimed:

secondhand experience, from the newspapers, the news-reel, the wireless, is
one of the dominating realities of our time. The many people who are not in
direct contact with the disasters falling on civilization live in a waking night-
mare of secondhand experiences which in a way are more terrible than real ex-

periences because the person overtaken by a disaster has at least a more limited vision than the camera's wide, cold, recording eye, and at least has no opportunity to imagine horrors worse than what he is seeing and experiencing. The flickering black, white and grey lights of Picasso's picture suggest a moving picture stretched across an elongated screen; the flatness of the shapes again suggest the photographic image, even the reported paper words. The center of this picture is like a painting of a *collage* in which strips of newspaper have been pasted across the canvas.[46]

In this perspective modern reality denies photographic realism its claim to represent war as it really is, because what is visible is only a small and often insignificant aspect of that reality. What has a photograph of the chemical corporation IG Farben to say about the reality of IG Farben, Brecht asked polemically, and added that under the conditions of capitalism reality had been shifted into the "realm of the functional."

The formal weakness and oversimplifying images of *Spanish Earth* only marginally obscure the fact that its structure is identical with many examples of antiwar photography. Their "propaganda for peace" is based on a more or less explicit opposition between the human face and the menace of war, peaceful production, and martial destruction. Robert Capa's well-known photographs provide numerous examples of this juxtaposition. The narrative in which his photography is embedded creates the conditions necessary for a pacifist reading of his images of war and leads to an illusion that the photographic lens itself has adopted the emotional position of empathy. Some of Capa's best-known photographs, such as the running soldier who is hit by a bullet and photographed in the fraction of the second when his knees collapse and the body tumbles backward, or the young woman collaborator, her hair shaven, led through the streets of Lyon, reveal horror and violence in such a way that human bodies expose the sensuousness of the experience that Hemingway missed in his own film. For those who are familiar with Capa's biography and stories, the lens of his camera, far from being cold or remaining outside of the picture, creates an emotional dimension that invites empathy with the victims and antipathy to the conditions that make them suffer. This is the photographic language of the "propaganda for peace" introduced into public discourse about war shortly after the end of World War I and most prominently associated with the Spanish Civil War. It would not seriously compromise Capa's moral position should he have faked his best-known photo, the *Falling Militiaman* — and there seems to be some evidence that this shot was indeed carefully arranged. The moral cause of this discourse is beyond

doubt. The question has to be asked, however, whether a position based on empathy and moral value judgements in relation to the nature of technology will find a space in the discourse on modern warfare that would enable it to unfold political power, which is its prime objective.

Deviations from this pattern have been rare and happen mostly in films of limited distribution such as Alexander Kluge's films on World War II. They have become more prominent only in recent films on Vietnam, in particular Stanley Kubrick's *Full Metal Jacket* (1987). An example of the other photographic discourse on war and destruction in which the characteristics of "modern" warfare are visualised but not idealised is *War Is Hell* (dir. Robert Nelson, 1960). This film creates disturbing images of war based precisely on the absence of a distance between here and there, the front and home, war and peace. The peaceful images of meadows in the sun, girls in bright dresses, mothers, and white beds are denounced as illusory. A war invalid in a hospital tries to rape his caring nurse, the dead comrade receives attention only because of the money in his pockets, the beautiful girl turns out a prostitute and love is quick sex in a dugout. In the end, the soldier discovers Sleeping Beauty on the battlefield, picks her up, turns around, and carries her in his arms, away from the battle, and into the world of peace and happiness where they will live ever after. But there is a final sequence in which the sights of a machine gun are being adjusted to point at the couple, and in the very last frame they have walked into the centre of the aiming device directed at them from the world of peace and happiness. The turning round and running away from the frontline does not lead into a world of a different nature. The killing devices have created a simultaneity of worlds of destruction no longer separated by spatial distances either. Some other films add a political dimension to the images of destruction as a characteristic of the modern world of war and of peace.

Milestone and Pabst created images of suffering and terror in order to counterbalance the demoralisation and dehumanisation crucial for the abstraction and calculated mediation of the war. An attempt to charge again with human emotions and images of a dignified life the empty structures of the aerial photographs of the war was their contribution to a pacifist discourse on war. In the light of later experience it seems doubtful whether the moral code of these attempts, for all their good intentions, is capable of coming to terms with modern technology. The domination of abstract and mediated constructions made possible strategic operations with modern armies of millions of soldiers and long-term planning involving huge spaces. In opposition to abstraction

as the precondition of modern warfare, the antiwar film of the late 1920s created a visual code that emphasised the closeness and concreteness of the experience of individuals and groups. The structural dilemma seems inevitable: the ethical motivation of these films required an aesthetic regression behind the modes and techniques of production and destruction practised in modern warfare. A filmic visualisation of the level of strategic-technological abstraction achieved in World War I would have led to abandoning depictions of the human face unaffected by the destruction of the war. This dilemma between the modernity of the war and the archaic quality of each and every individual death — even if repeated millions of times — had to be faced by film and photography to a much greater extent than by traditional media, partly because of the intrinsic nature of each medium and partly because of the commercial conditions under which it is produced and distributed.

Photographic imagery that aims at translating the "poverty of experience" into visual images is rare, usually associated with attempts to glamorise the grand world of technological innovations created by engineers (and computer technicians) and moved to a distant space — for example, a theatre of war in a remote part of the world. The Gulf War was the first example of an uncompromising presentation in mass media of the technological character of modern warfare. Cold images of military hardware and precise operations directed from distant power centres connected via satellite appealed to a sense of admiration for technological progress and unprecedented precision. The moral framework considered necessary for legitimising the distribution through mass media of these cold images of advanced technology was provided by linking them with the moral superiority of the nation most exposed in this war, the United States. Demonstrated technological supremacy of the West was identified with a moral nobility of its position in opposition to that of a dark, inhumane, and morally inferior enemy who also proved incapable of handling its own sophisticated military equipment. The distribution of right and wrong was straightforward and provided an ideal basis for a presentation of the aesthetic nature of abstract images of a war in which modern technology demonstrated its purity and efficiency. The beauty of a complex technological apparatus in full swing unfolded splendidly through its confrontation with images of an enemy characterised by backwardness, cowardice, and inhumanity. In moral terms, the constellation of the Spanish Civil War was now reversed. Technological progress and modernity were not associated with fascism and aggression but were strongly identified with the ideals of humanity

and moral superiority. There was no need to provide a space for the suffering individual in the imagery of this war.

The construction of war by analogy with aerial photographs would now have to be linked to the conception of nonemotional and basically empty space.[47] It is this geometrical and abstract space that makes strategic mobility of mass armies and related gigantic logistics possible. The effectiveness of the moral antiwar film, however, is based on the creation of a space of experience. In such a space, constituted through human action, emotion, and evaluation, no modern war could be conducted. While, from the Trojan War through to the wars of the turn of this century, interaction with structured space formed part of the warrior's identity, this is no longer required in modern warfare when — as World War I after 1916 illustrated — complete devastation of an environment creates ideal conditions for the operation of modern armour, communication, and surveillance devices and is linked to a technologically induced desert of the mind. It was the antiwar film and photography that maintained an emotionally laden space, thereby involuntarily contributing to the maintenance of obsolete images of war, because the space of suffering is also the space in which images of heroism have survived the end of its period. The representations are separated by political associations, but they are also part of the dual structure of a moral space. Only mathematical space emptied of human experience but structured in abstract detail will provide the smooth sphere for the "pure" war of technology.

Attempts to develop an image of warfare that simultaneously reflects the human ideal are linked to the imperative of creating a space within which suffering and terror can be experienced by the victim and located and spatially assessed by the viewer. These images are based on the assumption that an antiwar mentality will never emerge without such an anachronistic framework. The modern technological definition of warfare, however, has no room for experience and reduces time, space, and motion to abstract mathematical and physical quantities that enter into calculable operations. For missiles and their distant launchers or for fighter pilots who have contact with their environment only through electronic screens, the space they need for movement is empty and completely void of objects fit for stimulating emotional reactions. Compared with this mathematic-strategic construction, the image that most antiwar films create of a space constituted by fighting, suffering, and dying soldiers is an anachronistic image designed as a life support system for a threatened moral position.

Laser beams, neutron bombs, and star war games threaten to turn empty space into a space that, while structured, is completely devoid of life. There seems little room left for moral resistance apart from deliberately maintaining an anachronistic image of a space filled with the cries and groans and the flesh of the dying. But a radical negativity in relation to advanced war technology seems bound to remain equally inconclusive. Current projections of a possible war to come are ever more fantastic and playful: flight paths of beams and missiles and electronic shields in space, without actors and victims. Displaced into empty interstellar space, SDI appears as the provisionally final version of abstraction in a life-denying crystalline world, to use Worringer's words. In World War I soldiers disappeared in their dugouts and an empty battlefield appeared on many aerial photographs. In the conception of warfare of the electronic age, human beings seem to have even less of a place, and a concept of experience seems to become ever more atavistic. It might therefore remain the task of film and the electronic media to fill in the empty space and counterbalance the technological vision of pure war. In the apparent absence of any justification other than that of an anachronistic morality it seems unlikely, however, that the image of the human face will have an impact on the self-regulating system of technology. Attempts aimed at an education of the senses have remained marginal, and a more powerful project of a new aesthetic seems unlikely to emerge.

Notes

1. André Bazin, "The Ontology of the Photographic Image," in *What Is Cinema?*, ed. and trans. Hugh Gray (Berkeley: 1967), 13–14.
2. Rudolf Arnheim, "Systematik der frühen kinematographischen Erfindungen," in Helmut Dieterichs, ed., *Kritiken und Aufsätze zum Film* (München, 1977).
3. Alain Jaubert, *Fotos die Lügen: Politik mit gefälschten Bildern* (Frankfurt, 1989).
4. Sigmund Freud in a letter to Albert Einstein (1932) raises the radical question whether war might not be an inevitable implication of the particular constitution of culture: "Warum Krieg?" in *Studienausgabe,* vol. 9 (Frankfurt, 1974), 272–86.
5. Based on the experience of World War II, essays and films by Alexander Kluge have consistently emphasised the close links between perception and war: "Schlachtbeschreibung," *Die Patriotin;* see also Oskar Negt and Alexander Kluge, *Geschichte und Eigensinn* (Frankfurt, 1981), 797–866. Cf. also Paul Viri-

lio and Sylvère Lotringer, *Pure War* (New York, 1983), and Paul Virilio, *La machine de vision* (Paris, 1988).

6. Lawrence James, ed., *Crimea, 1854–1856: The War with Russia from Contemporary Photographs* (New York, 1981).

7. Cf. among others: *The Photographic History of the Civil War*, 5 vols. (1911; reprint, Secaucus, N.J., 1987); Alfred Hudson Guernsey, *Harper's Pictorial History of the Civil War* (New York, 1978), 1.

8. Alan Trachtenberg, "Albums of War: On Reading Civil War Photographs," *Representations* 9 (1985): 13.

9. Ibid., 12.

10. Ibid., 27.

11. Ibid.

12. The "miracle of the Marne" of September 1914 seems to have been the result of General Gallieni's correct interpretation of aerial photographs covering the movements of the German Fifth Army.

13. My comments are based on examinations of photographic collections and personal files of the following archives: Imperial War Museum, London; Bundesarchiv, Koblenz and Freiburg; Bayerisches Armeemuseum, Ingolstadt; Military Archives, Prague; Zentrales Staatsarchiv, Potsdam; Archives Militaires, Vincennes.

14. It has been argued that, due to the introduction of fast shutters, more sensitive filmstock, and 35mm cameras, modern war photography emerged only during the Spanish Civil War. While photojournalism was certainly a product of the post–World War I period, all elements of representing modern war and destruction are present in the photography of the years after 1916. Cf. Bernd Hüppauf, "Kriegsfotografie an der Schwelle zum neuen Sehen," in B. Loewenstein, ed., *Geschichte und Psychologie: Annäherungsversuche* (Pfaffenweiler, 1991), 205–33.

15. In contrast to the German army, in which a considerable number of officers and soldiers had their own cameras and films were often processed in the trenches, cameras in the English army appear to have been rare.

16. Ernst Friedrich, *Krieg dem Kriege [War against War]* (1924; reprint Frankfurt, 1981).

17. Cf. Walter Benjamin, "Erfahrung und Armut," *Gesammelte Schriften*, vol. 2, pt. 1 (Frankfurt, 1972), 213–19.

18. Walter Benjamin, "Theorien des deutschen Faschismus," *Gesammelte Schriften*, vol. 3, 238–50.

19. Hurley's diary is located in the State library of New South Wales. Quotations are from Daniel O'Keefe, ed., *Hurley at War: The Photography and Diaries of Frank Hurley in Two World Wars* (Sydney, 1986), 6.

20. Ansgar Hillach, "Allegorie, Bildraum, Montage: Versuch, einen avantgardistischen Begriff aus Benjamins Schriften zu begründen," in Martin Lüdke, ed., *Theorie der Avantgarde: Antworten auf Peter Bürgers Bestimmung von Kunst und bürgerlicher Gesellschaft* (Frankfurt, 1976), 105–42. For further discussion cf. Bernd Hüppauf, "Kriegsfotografie an der Schwelle zum neuen Sehen."

21. The term was first used by Galton for his technique of creating typified faces: Sir Francis Galton, *Inquiries into Human Faculty and Its Development* (Lon-

don, 1889). Regarding Hurley's photography see Bernd Hüppauf, "Hurleys Optik: Über den Wandel von Wahrnehmung," in Knut Hickethier and S. Zielinski, eds., *Medien/Kultur: Für Friedrich Knilli zum Sechzigsten* (Berlin, 1991), 113–30.

22. Anton Giulio Bragaglia, *Fotodinamismo futuristica,* ed. A. V. Bragaglia et al. (1913; reprint Turin, 1970), quoted from Wolfgang Kemp, *Theorie der Fotografie,* vol. 2 (München, 1979), 50–54. Kemp's three volumes of texts on photography are an invaluable source of information.

23. A striking example is provided by Ernst Jünger, *Feuer und Blut: Ein kleiner Ausschnitt aus einer grossen Schlacht* (Berlin, 1929).

24. Emil Ferdinand Malkowsky, *Vom Heldenkampf der deutschen Flieger: Ein Ruhmesbuch der deutschen Tapferkeit* (Berlin, 1916), 74.

25. Paul Virilio argues that aerial photography led to a new interplay of the human senses and their extensions: engine, eye, and armour are intricately linked to each other and form a collage of instruments vis-à-vis an equally functional and aestheticised reality (*Esthétique de la disparition* [Paris, 1980]).

26. Wilhelm Worringer, *Abstraktion und Einfühlung* (1908; reprint, München, 1959), 36.

27. Cf. Ulrich's recent observations in relation to the concept of "nerves" under the conditions of the front: Bernd Ulrich, "Nerven und Krieg," in B. Lowenstein, ed., *Geschichte und Psychologie,* 163–92.

28. Edmund Blunden, quoted in Paul Fussell, *The Great War and Modern Memory* (Oxford, 1975), 256.

29. Cf. Bernd Hüppauf, "The Birth of Fascist Man from the Spirit of the Front," in John Milfull, ed., *The Attractions of Fascism* (New York, 1990), 45–76.

30. Friedrich, *Krieg dem Kriege,* 131, n. 16.

31. In his reading of *Spanish Earth* Thomas Waugh refers to an iconography of "water, blood and soil" and their oppositions such as "steel, planes, the sky." "Water, Blood and War: Documentary Imagery of Spain from the North American Popular Front," in Kathleen Vernon, ed., *The Spanish Civil War and the Visual Arts,* Cornell University Western Societies Program, Occasional Paper No. 24 (Ithaca, 1990), 20.

32. John J. Michalczyk, "Malraux's Film *Espoir:* The Aesthetic Mind and Political Context," in Kathleen Vernon, ed., *The Spanish Civil War,* 9, n. 32.

33. Ernest Hemingway, "The Heat and the Cold: Remembering Turning the Spanish Earth," in *Verve* (Paris, Spring 1938), reprinted in Valentine Cunningham, ed., *Spanish Front: Writers on the Civil War* (Oxford, 1986), 206–8.

34. Stephen Spender, *"Guernica,"* in *New Statesman and Nation* (15 October 1938), reprinted in Cunningham, ed., *Spanish Front,* 221, n. 34.

35. Hemingway, "The Heat and the Cold," 207–8, n. 34.

36. In his critique of a collection of essays on World War I, Benjamin associates with fascism a tendency to create heroic images of a war of mass armies that spelt the end of heroism (Benjamin, "Theorien des deutschen Faschismus," 238–50).

37. Waugh, "Water, Blood and War," 19, n. 32.

38. Vertov contributed a number of penetrating essays to this debate. Dziga

Vertov, *Schriften zum Film,* ed. Wolfgang Beilenhoff (München, 1973); see in particular his essays "Man with the Movie Camera" and "On Love for the Living Human Being."

39. Joris Ivens, *Die Kamera und ich* (Reinbek, 1974), 105.

40. Ibid., 106.

41. Ibid., 77.

42. Anthony Powell, "A Reporter in Los Angeles: Hemingway's Spanish Film," *Night and Day* (19 August 1937), reprinted in Cunningham, ed., *Spanish Front,* 208–11.

43. Anthony Blunt, "Picasso Unfrocked." He elaborates on his view in two subsequent contributions to the debate. See Cunningham, ed., *Spanish Front,* 213–20.

44. *The Spectator* (21 October 1937), 216. In a letter of 22 October 1937 to the editor, William Coldstream supported this view.

45. *The Spectator,* (29 October 1937), 218.

46. Stephen Spender, "*Guernica,*" 220–22.

47. For a detailed discussion of specific aspects of the relationship between film and the technology of modern war see Paul Virilio, *Guerre et cinéma: Logistique de la perception* (Paris, 1984).

Case Studies: Film

7

Horror and the Carnivalesque

The Body-monstrous

BARBARA CREED

The body — that which is prey to the exigencies of desire; the opponent of reason; host to invisible signs of decay; physical barometer of approaching death; seat of earthly pleasures; signifier of feminine evil; site of repression; writing surface; postmodern text.

Notions of the body occupy a central place in current theoretical debates. As Jean Starobinski points out, writings about the body have "almost become the official religion."[1] It is not that the body has been forgotten over the preceding centuries — rather, it has functioned as the debased "other" within a series of binary oppositions that have been central to Western thought: mind/body; spirit/flesh; culture/nature; immortality/mortality. Significantly, in philosophical and religious discourses, the body is linked to the feminine — woman is emotional and more "of the body," whereas man is usually positioned on the side of logic and rationality.

In recent theoretical works, however, the body is no longer viewed as a negative term in a series of paired oppositions.[2] Nor is it reduced to a material or biological object known primarily through physical sensations and feelings. One of the most influential modern theorists of the body, Michel Foucault, argues that the body is analogous to a writing surface on which "messages" are inscribed. He is not alone in holding this view. Foucault sees the body as a social text marked by a society's regulatory systems (forms of discipline and punishment) as well as by

127

self-regulation. Most important, he also sees the body as a site of resis-
tance.[3] Michel Feher talks about the importance of outlining a picture
of the contemporary body in order to acquire what Foucault has called
"a thickened perception of the present" or "of the body we construct
for ourselves."[4]

In its symbolism the horror film constitutes a particularly interesting
popular discourse on the body. Yet very little has been written on the
body's overall symbolic significance in horror and how that relates to
other cultural discourses about the body. First, there have been various
analyses[5] that look at body symbolism in those texts in which the
boundary between human and animal is collapsed. Second, feminist
critics[6] have examined the representation of women's bodies in those
texts in which woman is positioned as victim. More recently, theorists[7]
have turned their attention to the changing representation of the body
in the postmodern horror film.

Two of the most interesting of these analyses examine the way in
which representations of the body in contemporary horror are primarily
concerned with the materiality of the body and the visual display of its
destruction. According to Phillip Brophy, the "contemporary Horror
film tends to play not so much on the broad fear of Death, but more
precisely on the fear of one's own body, of how one controls and relates
to it. . . . It is this mode of *showing* as opposed to *telling* that is strongly
connected to the destruction of the Body" (fig. 7).[8] The modern horror
film is able to depict in graphic detail the various metamorphoses that
the body undergoes when attacked. "Veins ripple up the arms, eyes turn
white and pop out, hair stands on end, blood trickles from all facial
cavities, heads swell and contract."[9] Brophy argues that the contempo-
rary horror film is "more interested in the body's exhibition of surface
form than its disclosure of spiritual depths. . . . If there is any mysticism
left in the genre, it is in the idea that our own insides constitute a fifth
dimension; an unknowable world, an incomprehensible darkness."[10]

Pete Boss also argues that the modern horror film is obsessed with
the destruction of the human body. The major preoccupation of the
special effects artist is "the lifelike creation of human tissue in torment,
of the body in profuse disarray." He sees this development as an indica-
tor of the modern horror film's "reduction of identity to its corporeal
horizons. A concern with the self as body." Boss also argues that there
is evidence of a new dispassionate tone with which the destruction of
the body is narrated. Whereas the representation of bodily destruction

7. Metamorphosis. *An American Werewolf in London* (1981). The Kobal Collection, London.

was once presented in relation to moral questions, destruction in the modern horror film is, "by contrast, often casual to the point of randomness; devoid of metaphysical import . . . mechanically routine." He describes this as a "peculiarly post-modern sense of dread"[11] that has partly been brought about by an increasing sense of individual helplessness in relation to the growing powers of medical technology and institutionalised bureaucracy, particularly in the areas of medicine and problems related to death and dying.

What is the body-monstrous? How many "faces" does horror wear? What does the representation of the body-monstrous tell us about our immediate fears and fantasies? What are the social and cultural functions of the cinema of horror? Here, I propose to draw on the work of Peter Stallybrass and Allon White, whose fascinating book *The Politics and Poetics of Transgression*[12] brings the ideas of Bakhtin together with a Freudian perspective to understand the "other" of bourgeois identity. The ideas they explore — particularly Bakhtin's notion of the carnivalesque and the grotesque body — are of particular relevance.

The Carnivalesque

Inspired by Mikhail Bakhtin's important study *Rabelais and His World*, recent work on the carnivalesque sees European carnival not simply as a ritual festival but as a means of popular perception of society and culture.

For Bakhtin, carnival — through its politics of inversion — is essentially a populist critique of high culture. In its most obvious meaning, carnival was a time of fairs, processions, feasts, dancing, costumes, mummery, masks, human freaks, trained animals, practical jokes, and trickery. Carnival was a time of laughter, of what Bakhtin describes as "festive laughter . . . the laughter of all the people"[13] that is universal, directed at the world. In the festive practices of carnival, the social hierarchies of daily life are turned upside down. Nothing is spared — normal proprieties, beliefs, etiquettes, and relations of power are deliberately profaned by those who are normally silent, by those whose voices are usually suppressed. A well-known reversal practised during carnival was known as "woman on top." In this enactment the man lies on the bottom and a woman sits astride him; her position and pose indicate she is in power not only sexually but in all areas of their relationship. Woman on top also provided a popular subject for woodcut artists. Bakhtin defines carnival in this way:

As opposed to the official feast, one might say that carnival celebrates temporary liberation from the prevailing truth and from the established order; it marks the suspension of all hierarchical rank, privileges, norms and prohibitions. Carnival was the true feast of time, the feast of becoming, change, and renewal. It was hostile to all that was immortalised and completed.[14]

Bakhtin argues that after the Renaissance carnival itself was given a new face; it was cleaned up and incorporated into middle class, commercial events. Stallybrass and White trace the various repressive measures that, from the seventeenth to the late nineteenth centuries, were introduced in order to suppress carnival and its various practices. In 1871, as a result of pressure from the London City Missions Society, the Fairs Act was passed, and in the following decade over 700 fairs, wakes, and mops were abolished. Stallybrass and White argue that carnival stood for everything despised by the newly emerging middle classes, who attempted to give definition to their newfound identity by slowly withdrawing from all existing forms of popular culture. In order

to establish themselves as clean, upright, civilised, and sanitised, the bourgeois gradually began to separate themselves out from the ordinary folk — the common, low, disgusting mass of people.

Despite these repressive measures, carnivalesque practices gradually reemerged. Stallybrass and White trace the reappearance of the "other" of bourgeois identity into new sites. These included the slum, the fairground, and prostitution as well as certain symbolic representations of the body. They also suggest that many aspects of carnival did not simply disappear but were displaced into middle class discourses such as art and psychoanalysis. "It is striking how the thematics of carnival pleasure — eating, inversion, mess, dirt, sex and stylised body movements — find their neurasthenic, unstable and mimicked counterparts in the discourse of hysteria."[15]

In their struggle to construct their own cultural Imaginary, the newly emerging middle classes inadvertently created a new form of the grotesque. Stallybrass and White explore the way in which the concept of the grotesque took on two related but separate meanings: (1) the grotesque as the "other" of the middle class imaginary and (2) the grotesque as a kind of hybrid form in which the boundary between self and other is blurred. This view of the grotesque has much in common with Julia Kristeva's notion of the abject[16] — a theory on which I will draw in my discussion of the body in the horror film.

The Carnivalesque and the Cinema

The concept of the carnivalesque as a practice of symbolic inversion and transgression provides us with a framework for the study of a range of cultural practices and political and social discourses. Following on from the proposition that aspects of carnival were displaced into middle class discourses, it is possible to argue that the horror cinema constitutes an arena into which aspects of carnival practices have been displaced. Certainly we can trace the horror discourse itself through other cultural and social practices, from the gothic novel, to the shilling shockers, through Grand Guignol theatre, to dada and surrealism. (Some critics of course argue that the origins of horror are as old as the human race itself.) Certainly there are striking similarities between the practices of carnival and the cinema of horror, particularly in relation to the following forms and concepts: (1) transgression; (2)

the world turned upside down; (3) grotesque humour; (4) the monstrous body; (5) spectatorship and the classical body.

My intention in this comparison is not to claim an identity between carnival and horror cinema but to draw out some similarities and differences to arrive at a better understanding of the cultural and symbolic function of the cinema, particularly in relation to representations of the body and to the question of transgression.

TRANSGRESSION

Like carnival, the horror film mocks and derides all established values and proprieties: the clean and proper body, the desire for immortality, the law and the institutions of church and family, the sanctity of life. It is this aspect of the horror film that offers immense pleasure to the spectator — particularly the youthful audience. Recent publications, such as those of Robin Wood,[17] clearly indicate that the horror film presents a critique of the symbolic order — particularly the institutions of the couple, family, church, law, medicine, and corporate capitalism. The postmodern argument[18] about the collapse in the West of the master narratives of imperialism and progress also points to a massive failure within the domain of the symbolic. Like the practices of carnival, the cinema of horror is hostile to all that is sanctioned by the official culture, specifically to the norms and values of patriarchal culture. Wood argues that the modern horror film in particular celebrates the destruction of the nuclear family and the heterosexual couple. He pays little attention, however, to the representation of the body.

THE WORLD TURNED UPSIDE DOWN

Woman on Top

Like carnival, the horror film also presents its version of "woman on top." Although woman is the central victim of the slasher subgenre, there are many other instances when woman takes on the role of the monster. The various forms of the monstrous-feminine represent woman in a variety of powerful roles.[19] Woman as the monstrous-feminine is represented as witch (*Carrie* and *Suspiria*); vampire (*The Hunger, Vampire Lovers*); monstrous womb (*Lifeforce, The Brood, Aliens*); creature (*Cat People, The Leech Woman, The Wasp Woman*); homicidal killer (*Fatal Attraction, Sisters*). There is also a subgenre that I have called the woman's revenge film in which woman takes revenge — either be-

cause she has been raped or because her sister or best friend has been raped (*Violated, Savage Streets, I Spit on Your Grave, Angel of Vengeance*). In virtually all of these films, the most savage form of revenge is castration. The male victims of these women are dispatched in scenes of bloody gore.

Man-as-Mother: Couvade and Horror

The theme of birth, linked to monstrosity, is also played out in relation to man and suggests a fundamental change in gender role — a world completely turned upside down. The theme of couvade — or the male mother — has always been central to the horror film. In earlier decades, we witnessed the mad scientist in his laboratory hatching a plot to create life from his test tubes or to give birth to himself as the other (*Dr Jekyll and Mr Hyde, Wolfman, Frankenstein*). In the modern horror film the couvade theme has been given new emphasis. In *Altered States* the scientist takes himself back to his beginnings and gives birth to himself as an apeman. In *Xtro* man emerges fully formed — that is, as an adult — from the womb of woman; he births himself, cuts his own umbilical chord, and walks away. In *Alien* we have that now infamous scene where the male astronaut is raped by an alien creature and gives birth through his stomach. In films such as *Starman* the alien-man clones himself in the image of an earth man. In *The Thing* the alien creature compulsively clones itself in the image of an entire male group stationed at the South Pole. Werewolf films show man rebirthing himself as a creature. The male scientist of *The Fly* develops a mode of transportation known as a teleporter, which consists of two womb-like chambers. The teleporter is designed to revolutionise travel by deconstructing living organisms in one place and then reconstructing them in another. A fly is caught in the teleporter just when the scientist is attempting to deconstruct himself; he is reborn as a monstrous fly. The metamorphosis takes place gradually and provides most of the film's shocking scenes as well as black humour.

In all of these films, the male who gives birth or rebirths himself is asked to take up the position of woman. Clearly, a male desire to give birth, to take up a feminine position in relation to reproduction, suggests a form of hysteria in the Freudian sense of behaviour resulting from an inability to come to terms with one's ordained gender role. The monstrous changes wrought on the body of the male in these films (he transforms into an animal, his stomach is torn open, etc.) could, at one level, be interpreted as a form of conversion hysteria brought about by man's terror at actually having to take up a feminine place as "mother."

Male hysteria in this context also represents a repudiation of the symbolic order and man's destiny as it is set out within the symbolic. The couvade theme has also been explored recently in various comedies such as *Three Men and a Baby* and *Three Fugitives;* hysteria in these texts is displaced onto narrative movement, which is generated by mounting confusion, mistaken identity, loss of bodily control, female impersonation, and scenes of male pregnancy. At the centre of this confusion is the male body—distorted, out of control.

GROTESQUE HUMOUR

Like the grotesque body of carnival, the monstrous body of contemporary horror has become a source of obscene humour. Think for instance of Reagan's body in *The Exorcist*—it urinates on the carpet (before guests), belches green bile, utters filthy jokes, mocks all forms of propriety—its head even rotates in full circle on its neck. Or think of the laughing hag in *The Shining* or the dance of the skeleton in *The Evil Dead*. Here the headless body of the murdered woman rises from the grave and begins to dance grotesquely in the moonlight; realising her head is off, she retrieves it and puts it back on her neck before continuing her dance, in which she deliberately mocks the gestures associated with romance and courtship rituals (fig. 8). One of the most humorous moments in horror occurs in *The Thing* when the thing—a small tentacle—attaches itself to a human head in order to clone itself into a living image of the dead man. In what is one of the most amazing technical feats of modern horror, the head turns upside down while eight spidery feet tear through the skull and use the head as a body. As the head "walks" to the door one of the crew remarks: "You've got to be fucking kidding!" But unfortunately it isn't, and the thing proceeds with its murderous attacks. Humour is generated from the way in which, like a magician, the thing is able to make the human body do absolutely anything—change shape, defy gravity, parody life itself. The self-reflexive nature of the horror film, particularly of the postmodern horror film, combined with its deliberate use of parody and excess indicate the importance of grotesque humour to the success of the genre.

THE GROTESQUE BODY

The main concept around which Bakhtin formulates his discussion of Rabelais as a carnivalesque text is that of "grotesque

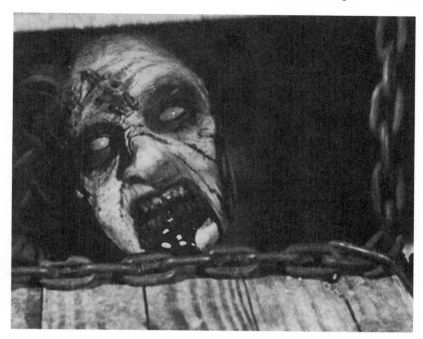

8. The abject witch. *The Evil Dead* (1983). The Kobul Collection, London.

realism" with specific emphasis on the "grotesque body." According to Stallybrass and White:

> Grotesque realism images the human body as multiple, bulging, over- or under-sized, protuberant and incomplete. The opening and orifices of this carnival body are emphasised, not its closure and finish. It is an image of impure corporeal bulk with its orifices (mouth, flared nostrils, anus) yawning wide and its lower regions (belly, legs, feet, buttocks and genitals) given priority over its upper regions (head, 'spirit,' reason). . . .
> To complete the image of grotesque realism one must add that it is always in process, it is always becoming, it is a mobile and hybrid creature, disproportionate, exorbitant, outgrowing all limits, obscenely decentred and off-balance, a figural and symbolic resource for parodic exaggeration and inversion. All of these grotesque qualities have a positive force in Bakhtin.[20]

In his discussion of the carnivalesque, Bakhtin refers to the grotesque body in relation to woman's body, specifically to the Kerch terra-cotta figurines of three pregnant, ageing hags:

This is a typical and very strongly expressed grotesque. It is ambivalent. It is pregnant death, a death that gives birth. There is nothing completed, nothing calm and stable in the bodies of these old hags. They combine a senile, decaying and deformed flesh with the flesh of new life, conceived but as yet unformed.[21]

The grotesque body lacks boundaries; it is not "completed," "calm," or "stable." Instead the flesh is decaying and deformed, presumably falling from the bodies, connecting them to the earth. What is most disturbing is that the decaying flesh of the pregnant hags intermingles with the unformed flesh of the living foetus. Here the abject is created in the collapsing of boundaries between the living and the decaying or putrefying flesh. The pregnant female body is also an important figure in the modern pantheon of female grotesques.

Bakhtin's notion of the "grotesque body" is particularly relevant to the horror film; indeed if one word can be used to describe all manifestations of the body found in this genre it is "grotesque." The grotesque body of horror is — like Bakhtin's grotesque — always in a process of change and alteration. However, the emphasis is different. Whereas the grotesque body of carnival privileges the lower regions of the body over the upper, the monstrous body of horror draws on the bodily categories of inside and outside in order to shock and horrify. Julia Kristeva draws particular attention to the collapse of boundaries between inside and outside as a major cause of abjection.[22]

Twelve "Faces" of the Body-monstrous

The concept of a border is central to the construction of the body-monstrous of horror. Although the specific nature of the border may change from film to film, the function of the border remains constant — to bring about a conflict between the whole and the proper body (the symbolic body, the body politic) and that which threatens its integrity, the abject body, the body-monstrous. The abject is produced when a body crosses the boundary between the human and nonhuman or takes up a borderline position in relation to a definition of what it means to be human. The categories I have drawn up define the body as monstrous in relation to the border between the abject and symbolic bodies. By using the *symbolic* body as the norm, the taxonomy can allow for different cultural definitions of the monstrous. In the past, the monster has provided the focus of a number of taxonomies. The general assumption has been that the monster is almost always male, the victim

female. By focussing on the body, we can see more clearly how the feminine body is constructed as monstrous in the horror genre.

The monstrous body of horror falls into one of at least twelve categories with at least eighteen subdivisions. There is much overlap between these categories, but for the purposes of this study I will discuss them individually.

THE METAMORPHOSING, TRANSFORMING BODY. The image of the transforming body is central to the horror genre; its main symbolic function is to challenge definitions of what it means to be human. The proper body of the symbolic does not metamorphose; it is recognisable, fixed, trustworthy. It is made "in God's image" — a sacred vessel, a divine temple. In some discourses, particularly that of Christianity, the male body is seen as the norm, the female body as an inferior version. Bodies which change shape physically, particularly if they adopt animal or insect forms, conjure up notions of degeneration, devolution, deformity, loss of control, magic, satanism, and witchcraft. The possibility of bodily metamorphosis attacks the foundations of the symbolic order which signifies law, rationality, logic, truth. By signifying these qualities, the human body is seen to represent or reflect the ideals of the body politic. It too should be upright and consistent, conforming to the laws of biology and physics. Human beings who deviate physically from the norm (dwarfs, bearded women, hermaphrodites, Siamese twins) have always been socially stigmatised; they are the "freaks" of the circus and sideshow.

Images of the changing body are found within various subgenres of the horror film, particularly those dealing with the werewolf, vampire, creature, or animal. Change always leads to the emergence of a different life form; its difference is the sign of its monstrousness. Emphasis is on the process of change as well as the outcome. What will it become? How much will it change? What will be produced? Films dealing with the metamorphosing body take many forms.

The Animal/Insect/Reptile Body. Many films in this category belong to the werewolf subgenre — *The Wolf Man, The Curse of the Werewolf, I Was a Teenage Werewolf, An American Werewolf in London.* In other metamorphosis films, man changes into a monkey (*Altered States*) and a fly (*The Fly*); and woman into a wolf (*The Howling*), a leopard (*The Cat People, Cat Girl*), a snake (*The Reptile, The Snake Woman, Cult of the Cobra*), an orang-utan (*Captive Wild Woman*), a wasp (*The Wasp Woman*), or a

fish monster (*The She Creature*). In earlier horror films the association between human and other is not represented in terms of a visible metamorphosis but rather is suggested through the convention of the doppelgänger, the double or the alter ego, as in *King Kong* and *Tarantula*. In the latter woman and spider are linked through various filmic codes. With the renaissance in special effects technology, scenes of metamorphosis (*The Fly, An American Werewolf in London*) now take place before our very eyes.

Gender appears to play a part in determining the nature of the metamorphosis. In the werewolf film, it is man who usually becomes the beast, although there are a small number of werewolf films that represent female metamorphosis, such as the Mexican horror film *La Loba* and *The Howling*. Woman, however, is more likely to transform into a cat, reptile, or a spider — a phobic object with which woman continues to be linked in modern myth and superstition. In the majority of films involving metamorphosis, the body is neither fully (once and for all) animal or human. Transformation films point to an anxiety about what it means to be human. When the human transforms into a wolf, the body appears literally to be turned inside out. Teeth, nails, and hair sprout without warning and at such speed that it is clear the process cannot be stopped. It is as if these bestial characteristics were lying hidden beneath the skin's surface waiting for the opportunity to burst forth in order to attest to man's nonhuman self. The inside of the body becomes the outside. In a few texts, such as *The Fly*, the metamorphosis is irreversible. The remake of *The Fly* also contains a landmark scene of horror in which a monkey is literally turned inside out during the scientist's preliminary experiments with teleportation of the body.

The Vampiric Body. The films in this category belong to the ever-popular vampire genre — *Nosferatu, Dracula, Dracula Has Risen from the Grave, The Lost Boys*. Here the body is erect, pointed, phallic. Several critics have stressed the phallic nature of Dracula's body and stance — his stiff posture; his pointed face, ears, nails, and fangs; his penetrating look; the blood rushing to his eyes as if his whole body were having an erection. On the other hand, Dracula is also coded as feminine. He is always dressed beautifully in silk and satin, his face is white, his lips red, and he appears on the night of the full moon, associated in myth and legend with witches and menstruation. He also loses blood periodically and seeks to replace it. He appears to be a curious mixture of hermaphrodite, transvestite, and androgyne. The female vampire is also represented in sexually ambiguous terms. She is aggressive, phallic, and often

a lesbian. In many films about lesbian vampires, the queen vampire is dedicated to the seduction and recruitment of uninitiated women, often young virgins, as in *Vampire Lovers, Daughters of Darkness, Vampyros Lesbos,* and *The Hunger.* The vampiric body is sexually ambiguous, male and female vampires taking on the gender characteristics of the opposite sex. In general, however, only the female vampire is homosexual.

THE SUPERNATURAL BODY

The Possessed Body. In films about possession, the body — usually female — is capable of a range of amazing feats; it changes shape, performs amazing tricks, or assumes supernatural powers (*The Evil Dead, Evil Dead 2*). Often the supernatural powers of this body, when female, are linked to menstruation, the arousal of the girl's sexual desires, or the onset of puberty. For instance, Reagan in *The Exorcist* is possessed by the Devil when she reaches puberty. In *Rosemary's Baby,* sexual possession is taken to its logical consequence and Rosemary becomes pregnant with the Devil's child. The possessed body defies all known laws governing bodily powers; it is horrifying precisely because possession desecrates the body (its own or the bodies of others) in its presentation as grotesque, engorged, disgusting, or abject. The permutations are arbitrary and seemingly endless.

The Psychokinetic Body. Like the possessed body, the psychic body is also capable of amazing feats, but these are related to acts of paranormal power such as telekinesis (*Carrie*) and the ability to kill from a distance (*The Omen*) or to transmit visions to receptive bystanders (*The Sender*). Whereas the possessed body is usually taken over and rendered powerless to resist, the psychokinetic body is powerful and potentially dangerous. These films usually explore a wish-fulfilment fantasy in that the character with paranormal powers has been hurt, humiliated, or pushed beyond endurance, whereupon she or he takes revenge. Some films about characters with psychic powers (*Carrie, Firestarter*) also emphasise the body of the adolescent about to discover sexuality. Carrie, for instance, develops her powers of telekinesis at the same time as she begins to menstruate. Other films in this category include *Ruby, The Fury, Jennifer, Scanners, The Medusa Touch, Psychic Killer, The Shout.*

The Demonic and Ghostly Body. Surprisingly, films about pagan practices have drawn very little on H. P. Lovecraft's mythology of Elder Gods in which these divinities have been held somewhere in a state of limbo

waiting to return to take over Earth. The closest approximation of this scenario is found in *Ghostbusters*, in which a horde of Sumerian demons, agents of Gozer, try to take over New York. *Gremlins* and *Gremlins 2* also explore the possibility of demons trying to take control of or destroy the world. The "bodies" of ghosts and demons have much in common with the protagonists of films about possession. The bodies can assume any shape, defy the laws of gravity, and resist most lethal weapons.

The Pagan Body. Films about covens and devil worship usually draw on pagan depictions of the body, particularly in scenes of fertility worship where coven members dance naked or seminaked in order to harmonise with nature. If the Devil is present, she/he usually sprouts horns at some point (*The Wicker Man, Children of the Corn, Blood Orgy of the She-Devils*).

THE BESTIAL BODY. In one sense films about transformation into a creature/insect/reptile also belong to this category. However, the monsters of this category do not usually change from a human into a nonhuman life form. Their form is fixed; they are either creatures who resemble humans or humans who resemble creatures. The creatures of this category are horrifying because their bodies symbolise dark desires, desires which specifically threaten the symbolic order.

The creature represents the darker side of sexual desire in its animalistic, sadistic, and incestuous forms. For instance, the Claude Rains version of *The Phantom of the Opera* generates horror through the suggestion of an incestuous father-daughter relationship. The Phantom's scarred face points symbolically to such perverted desires. *King Kong* and *Creature from the Black Lagoon* (both films have sympathetic monsters) explore the animalistic nature of sexual desire. Sometimes, the creature represents the doppelgänger or alter ego of another character. In these films there are usually two main characters: the scientist/doctor and his creation or creature, the monster — *Frankenstein, The Phantom of Rue Morgue*. Again, the creature is often more sympathetic than its master. It is almost always male.

THE BODY OF NATURE. In these films, the natural world turns against the human. Nature's "revolt" often symbolises the appearance of something "unnatural" or rotten in the human world. Nature terrifies because she is no longer controllable and hence threatens the very fabric

of civilisation. Films include: *Jaws, The Swarm, The Savage Bees, The Giant Spider Invasion, The Blob, The Birds.*

THE GENERATIVE BODY

The Female Body. In many of these films, woman's body becomes capable of amazing feats and her womb assumes new powers — it is able to conceive alien life forms and is capable of assuming enormous proportions and of coming to full-term pregnancy in a matter of hours. Woman is monstrous because she is able to copulate with and give birth to the other; for instance, in *Rosemary's Baby* she gives birth to the Devil's child. Woman's most monstrous feature is her womb. In order to accommodate the womb's changing shape, her outer skin stretches to new limits, changes texture and colour, while also pointing to its potential for further transformation. This process is represented vividly in *Xtro.* In *The Brood,* her birth sac is attached to the outside of her body so we can see in clear detail what normally remains hidden. Her mutant offspring are born of her rage. The schizoid heroine of *Possession* gives birth to a tentacled pseudo-human (it is born of her fury) which finally metamorphoses into a double of her husband. Her womb not only contains this creature but also all manner of abject wastes such as gore and pus. In *The Manitou* the foetus of an evil witch doctor, about to reincarnate himself, grows from a tumour/womb on the heroine's neck. In *The Fly,* the heroine dreams that she gives birth to a giant maggot. Although at the mercy of alien birth processes, the generative female body is not usually depicted as if it were hostile to these forces. Instead, the female body is acquiescent and receptive. Woman and her monstrous-womb stand less on the side of humanity and more on the side of the inhuman and the alien. It is woman's alliance with nature that constitutes her monstrousness in these films. In *Dead Ringers,* the womb with its triple cervix is literally represented as a monstrous thing.

In films dealing with the generative body, the house is often used as a symbol of the womb and woman's reproductive powers, as in *The Amityville Horror, Amityville 2: The Possession, House, The Shining.* Usually, the house is constructed as a place of horror. Its walls and hallways bleed, its cellar fills with blood. Freud's theory of the uncanny provides us with a working hypothesis by which we can understand how the house functions symbolically as that original, first house — the womb. The house becomes monstrous because of the uncanny likeness it bears to the womb in the eyes of the protagonist. Sometimes female characters who inhabit the house are also represented in an uncanny form, as

are the dead female twins of *The Shining,* who appear as twin ghosts to haunt the young boy, Danny.

The Male Body. The classical horror film played on the theme of couvade in those films in which the mad scientist tried to create new life forms in his laboratory, as in *Metropolis* and *Frankenstein.* This theme has been explored in a variety of ways in the horror film. We see man give life to another creature (*Frankenstein*), create life in the form of a robot (*Metropolis*), create mutant life forms in experiments with humans and animals (*Island of Lost Souls*), or discover a vaginal opening in his stomach (*Videodrome*). In *Alien,* man is raped orally and later gives birth through his stomach. In *The Beast Within,* he is raped by a swamp creature and eighteen years later gives birth to a mutated flesh-eating insect which erupts out of his body. In these films the male body, which does not possess a womb, is not distorted in the same way as woman's body. However, the hysteria generated by man's attempt to take up a feminine position, by giving birth or creating life, is played out across the male body in a variety of horrific ways. In some films the male body takes up a feminine position. In others, it is impregnated and torn apart (*Alien*), or else the newly created life form itself is represented as monstrous (*Frankenstein, The Fly*).

Although primarily metamorphosis films, *Dr Jekyll and Mr Hyde* and *Altered States* also play on the theme of couvade. The laboratories of these scientists, with their winding tubes and womb-like structures, suggest the female reproductive system. There is also a suggestion of couvade in the wereman transformations in that the wolf appears to emerge from the inside of the man. However, wereman films belong primarily to the metamorphosis category.

THE INFANT BODY. In these films, the monster takes the form of a foetus or infant which is misshapen or deformed in some way. It is the mutant, partially formed nature of the body which is exploited to create scenarios of horror. The monstrous infant films also present a critique of the nuclear family, with the infant itself symbolic of a canker eating at the heart of the family. Films include *It's Alive, It Lives Again, Alien, The Kindred, Eraserhead, Basket Case, Gremlins.*

THE MORTAL BODY. The bleeding body is usually the victim's body and as such it does not constitute a monster in conventional terms. As I have argued, however, the bleeding body, particularly the female, is repre-

sented as a sight of monstrosity. This characteristic has become a feature of the contemporary splatter film. Prior to the mid-1960s, when the splatter film first appeared, the dying or dead body was depicted with little emphasis on scenes of blood and gore. With the advent of the splatter film, whose roots can be traced back to Grand Guignol theatre, the representation of the body in contemporary horror changed. The body and its parts have become the locus for various forms of physical transgression. The body is cut, slashed, dismembered, infested, skinned, and cannibalised. The destruction of the body is emphasized with close-up shots of gore, blood, body parts, torsos, limbs, eyeballs, offal. Everything and every part of the body has become horrifying. Special effects technology can create realistic images of human tissue in a variety of states of disintegration and destruction.

I would argue that the contemporary horror film's obsession with the materiality of the body points to another, more complex concern—an obsession with the nature of the "self." Images of the dismembered, mutilated, disintegrating body suggest that the body is invested with fears and anxieties which are actually felt about the self. Is the self like a fortress, impregnable, inviolable? Or is it, as Lacan would argue, like the body, a construct which is capable of fragmenting, disintegrating, even disappearing?

Here we see the ego, in its essential resistance to the elusive process of Becoming, to the variations of Desire. This illusion of unity, in which a human being is always looking forward to self-mastery, entails a constant danger of sliding back again into the chaos from which he started.[23]

For Lacan the autonomy of the ego is only an illusion, and the subject will draw on various symbols, particularly in dreams, to displace anxiety about the fragmented ego onto the body. He refers to "images of castration, mutilation, dismemberment, dislocation, evisceration, devouring, bursting open of the body. . . . The works of Bosch," he writes, "are an atlas of all the aggressive images that torment mankind."[24] The monstrous body of horror may appear to be only flesh, bones, and sinew, but I would argue that the destruction of the physical body is used as a metaphor to point to the possibility that the self is also transitory, fragile, and fragmented.

The Bleeding Body. The body that bleeds is invariably the one that has been cut open by an axe, knife, ice pick, hammer, or chainsaw. (Guns are pointedly absent in the horror film.) The bleeding body is most evi-

dent in the slasher film. The rise of the slasher film was no doubt aided by the revolution in special effects technology, which enabled an audience to see with its own eyes what the body would look like if cut open. Blood flows from wounds and orifices, linking the inside and outside of the body. Images of the bleeding body also point symbolically to the fragile nature of the self, its lack of secure boundaries, the ease with which it might lose definition, fall apart, or bleed into nothingness. Films include *Suspiria, Psycho, Dressed to Kill, Hell Night, Slumber Party Massacre, He Knows You're Alone, Texas Chainsaw Massacre, My Bloody Valentine.*

The Hysterical Body. This is almost always the body of the female victim, the woman who runs and screams as she is pursued by the monster, whether human or animal. The victim we remember most is the one who survives, the one who has usually seen the butchered bodies of her friends and who is relentlessly pursued by the killer for the long final sequence, as in *Halloween, Friday the Thirteenth, Texas Chainsaw Massacre.* Her flight often follows a predictable pattern whereby she falls or stumbles, picks herself up again, loses her only weapon, and continues on her frantic journey. Her arms and legs appear out of control. She thrashes frantically in the dark; her mouth is usually opened wide and emits piercing screams. Male victims rarely scream or allow their arms and legs to flail in the air in hysterical movements. It is the female body which is used to express (on behalf of men?) terror at its most abject level. As she loses bodily control, she also loses her powers of coherent speech and her sense of her "self" as a coherent whole. Close-up shots of her open mouth frequently fade into blackness; the black hole of her mouth appears to signify the letter "O" — zero, the void, the final obliteration.

The Dismembered Body. The dismembered body is central to several subgenres of the horror film: the ghoul film, the slasher film, and the vampire film in which the vampire is killed through decapitation. Perversely, the appeal of some of these films is that we are denied an actual glimpse of the dismembered corpse, as in the Jack the Ripper films. Severed hands feature as a monstrous image in a number of horror films (*Un Chien Andalou, Mad Love, The Beast with Five Fingers, The Exterminating Angel*). This may be partly explained because of the link in mythology between severed hands and spiders. Minerva punished Arachne by turning her into a hand, which then changed into a spider.

Images of bodily dismemberment fracture our sense of bodily unity and, by extension, of the self as a coherent whole. Images of bodily dismemberment represent a particularly strong expression of the abject. Such images also point to the contemporary horror film's desire to explore all forms of material transgression, in succumbing to the lure of abjection and the pleasures of perversity.

The Disintegrating/Exploding Body. Here the body disintegrates or explodes from within. Emphasis is frequently on the spectacular, operatic nature of these scenes of destruction. Bodily mutilation and fragmentation are taken to extremes — the entire body is constructed as a battlefield. These scenarios of bodily destruction frequently assume the proportions of a spectacle, suggesting that the total annihilation of the body and self is experienced as an explosion into nothingness. Films include *Scanners, The Hunger, Lifeforce.*

The Invaded Body. Here the body has been invaded by an alien life form, disease, parasite, insect, or creature. Horror is aroused because the presence of the creature in the body is not known. In one group of these films, the creature/alien either uses the existing body or makes an exact duplicate of it in order to hide its presence among "normal" human beings. These films play on paranoid fears about the body of other people, suggesting that as aliens they cannot be trusted (*The Thing, Invasion of the Body Snatchers*).

In other body-invasion films, the body acts as a host to some form of infestation. Again, the body is a traitor because it acts as a host to the infestation and rarely gives any warning until it is too late. Images of the infested body suggest an underlying paranoia directed at the self where self-betrayal is experienced as bodily infestation. In other films the body is invaded by disease which renders the body either treacherous (*Rabid*) or grotesque (*The Elephant Man*).

In these films the monster or alien is not only able to inhabit human bodies at will but also able to evacuate itself from these bodies when necessary. The body becomes a nest. The imperialised body also collapses boundaries between human and alien, making it impossible to distinguish one from the other. Again horror is generated because of an inability to distinguish the human from the "thing."

The Body as Living Corpse. There are many monsters who have returned from the dead: Dracula, Frankenstein, the zombie, and the mummy.

Whereas Frankenstein was created by science and Dracula is reanimated from his grave at night, zombies are revived from the dead by black magic. In the zombie film (*White Zombie, I Walked with a Zombie*) the self exists in a state of suspended animation; having been revived from the dead, it is simply "undead." The zombie films play on the fear of being buried alive. Not all zombies are cannibalistic. However, the zombies of *Night of the Living Dead* do feast on human flesh. Driven by a terrible need to feast on the flesh of the living, these zombies point symbolically to the incorporative, cannibalistic aspect of the self. In this context, the self exists in a trance; it is will-less and indistinguishable from the body itself. The cannibalistic zombie is similar to the ghoul— a spirit in Muslim stories that robs graves and devours the corpses in them.

The mummy is also one of the living dead, but unlike the zombie it does have a will. In the mummy films, Hollywood's response to the discovery of Tutankhamen's tomb in 1922, the semi-preserved shell of a man, buried thousands of years ago, is brought to life by incantation or the imbibing of a secret potion. He usually finds the presence of his ancient love in a modern woman whom he wants to take back to eternity with him (*The Mummy, The Mummy's Hand, The Mummy's Ghost, The Curse of the Mummy's Tomb, The Mummy's Shroud*). The mummy's body, preserved in a state of semidecay, is neither fully alive nor dead. The body, covered in earth mould and decaying bandages, is horrifying because of its liminal state. Parallels between woman, eternity, and death suggest these films are also exploring the subject's desire for reunion with the maternal body.

The Corpse. The corpse figures in all horror films. It represents the body at its most abject. It is a body evacuated by the "self"—but worse still, it is a body which has become a "waste."

THE MECHANICAL BODY. Many science fiction horror films use the body of the robot (machine that resembles a person) and the android (artificially created person) to explore definitions of the "human" (*Metropolis*). Whereas earlier films in this genre usually drew a clear distinction between the human and robotic body, contemporary films tend to collapse the two in relation to the figure of the android. The android is neither fully human nor fully machine. It is an immensely attractive figure because it is self-regenerating; it also repels because it observes no moral code and is able to kill without sentiment. In some recent films,

however, the android is depicted as being more "moral" than its human counterparts (*Bladerunner, Aliens, Robocop*). Such films present an interesting critique of the nature of the "self." In some films the robot or android is monstrous because it is perfect (*The Stepford Wives, The Terminator*).

Theorists of postmodernity such as Jean Baudrillard have pointed to a collapse in the once clearly understood boundaries between subject and object. The revolution in communications and systems of representation means that the individual can no longer clearly distinguish the real from the hyper-real, original from the copy, human from simulacra. In the horror film this failure of perception in relation to the body is linked to scenes of monstrosity.

THE SEXUALLY DEVIANT BODY. In this category the body is represented as monstrous in terms of a confusion about gender and sexual desire. The monster is either a girl raised as a boy, as in *Homicidal!* and *Private Parts,* or a boy raised as a girl, as in *A Reflection of Fear* and *Deadly Blessing.* Related to these films about gender confusion, we have the monstrous transsexual of *Dressed to Kill* and the son-mother of *Psycho.* Horror is generated by the sexually ambiguous and indeterminate nature of these figures. They are usually represented as psychotics.

THE BODY OF THE SLASHER. The slasher is usually male — a shadowy, terrifying figure who remains in the background, despatching victims with alarming regularity (*Halloween*). Films in which the slasher is female include *Sisters, Friday the Thirteenth, Play Misty for Me.* When the slasher is a psychotic female, she sometimes castrates her male victims. When victims are of both sexes, the film usually represents the deaths of the women in more detail and at greater length. The slasher is a figure associated with knives and other sharp instruments. Freddy Kreuger, the indestructible nightmare "hero" of the *Nightmare on Elm Street* series, literally is a lethal blade; he has knives for fingers. His body is a mutation of flesh and steel. He also frequently takes on a female form when he kills. The slasher is a figure who threatens castration; his/her victims are stabbed, mutilated, and dismembered. The body of the slasher is associated with the unknown, death, blood, sexual difference. The male slasher is almost always destroyed by a young woman who sometimes castrates him. These themes of the slasher film have recently been represented as a source of pathos mixed with horror in the film *Edward Scissorhands.*

The woman who castrates for revenge — usually the crime is rape — is also a slasher figure, but she is not depicted as psychotic. Her revenge is presented as justified and audiences are encouraged to sympathise with her. Sometimes she is represented as a temptress who kills during coition (*I Spit on Your Grave, Naked Vengeance*). In these films death for the male victim is eroticised, suggesting a link between sexuality and masochistic desire.

THE MATERNAL BODY. There are also a number of films that represent the female psychopath as a woman who clings possessively to others, particularly family members (*Psycho, Carrie, Fanatic, The Psychopath, Friday the Thirteenth, Deep Red, What's the Matter with Helen?, Sunset Boulevard*). It is her possessiveness which is represented as the source of horror. In some films she is an ageing female psychopath. Her appearance is usually disturbing in that it suggests either a decaying or frustrated sexual desire. Unlike films which deal with male psychopaths, her reasons for killing are almost always linked to perverted familial relations and her desire to suffocate her loved ones. (A recent exception to this is *The Stepfather,* in which the suffocating parent is male.) The male psychopath kills as a form of symbolic rape. His victims are usually teenagers who are unknown to him.

THE BODY OF THE ARCHAIC MOTHER. The bad imago of the archaic mother exists in the horror film as a background oceanic presence or what Roger Dadoun refers to as an "omnipresent totality."[25] Signs of the archaic mother are cobwebs, dust, hair, dried blood, damp cellars, earth, empty chambers, creaking noises, steep stairs, and dark empty tunnels. Everything associated with the archaic mother belongs to (a) the idea of an empty forgotten house, that first mansion or dwelling place, and (b) the image of that last resting place, the grave, Mother Earth. The archaic mother is not the same as the phallic mother, the mother of the pre-oedipal. The archaic mother pre-dates the phallic mother; she is a totalising presence known or apprehended only through the senses and through specific signs such as those listed above. Her presence constitutes the background of the horror film, particularly those films which involve a haunted house, decaying mansion, or empty grave. Films include *Dracula, Aliens, Psycho, The Psychopath, The Hunger.*

Abjection and the Body-in-Process

Like the carnivalesque body, the monstrous body of the horror film is always in a process of change. It is the body of becoming,

of process, of metamorphosis—from human to animal, from animal to human, from living to dead, dead to living, human to machine, machine to human—but always the process turns on the definition of what it means to be human. What distinguishes this body of becoming? How are the processes of change and alteration linked to the monstrous?

Representations of the monstrous body in the horror film do not in general draw on symbolic oppositions of high and low as expressed in relation to the grotesque body of carnival. Instead the horror genre mainly puts into play those oppositions that take place between the *inside* and *outside* of the body. This interplay between inside and outside implicates the entire body in the processes of destruction. Whereas carnival celebrated a temporary liberation from prevailing values and norms of behaviour, the cinema of horror celebrates the complete destruction of all values and accepted practices through the symbolic destruction of the body, the symbolic counterpart of the social body. Julia Kristeva's theory of abjection provides a particularly useful basis for an analysis of these issues—particularly the relationship of inside and outside to the representation of abjection and the body.

In *Powers of Horror* Kristeva argues that the constitution of the self is intimately bound up with the constitution of a sense of stable subjectivity, coherent speech, and the clean and proper body.[26] The child gains access to the symbolic order only when it has come to understand the rules governing the constitution of the clean and proper body—the boundaries of the body and the boundaries between its body and the bodies of others. Everything that threatens the subject's identity as human is defined as abject. As I have explained in a previous article,

the place of the abject is "the place where meaning collapses," . . . the place where "I" am not. The abject threatens life; it must be "radically excluded" . . . from the place of the living subject, propelled away from the body and deposited on the other side of an imaginary border which separates the self from that which threatens the self. . . . The abject can be experienced in various ways—one of which relates to biological body functions, the other of which has been inscribed in a symbolic (religious) economy. . . . The ultimate in abjection is the corpse. The body protects itself from bodily wastes such as shit, blood, urine, and pus by ejecting these substances just as it expels food that, for whatever reason, the subject finds loathsome. The body extricates itself from them and from the place where they fall, so that it might continue to live.[27]

Kristeva draws on her notion of the abject to explain the way in which cultures establish themselves by expelling everything that threatens their existence and naming it as abject, that which must be located

on the other side of the border. In patriarchal cultures, those objects that are related to woman and her procreative and mothering functions (menstrual blood, faeces, urine), and hence to the maternal body, are defined as abject. Many cultures erect elaborate rituals of defilement and purity to safeguard the group from the contaminating presence of these "wastes."

The existence of the abject points always to the subject's precarious hold on what it means to be human. For the abject can never be fully excluded; it beckons from the boundaries, seeking to upset the already unstable nature of subjectivity, waiting to claim victory over the "human." Fear of the abject inspires the human subject to deny the corporeal, material, animalistic nature of existence. Abjection gives rise to an impossible desire — bodily transcendence. Wastes that the body expels in order to protect the self include faeces, blood, tears, urine, vomit. These emit from zones forming a surface on the body, a point of entry that links inside and outside. Hence there is a place on the body's surface at which bodily wastes leave the body; as they are expelled they link the inside to the outside of the body. In the horror film a number of these zones and bodily wastes are drawn upon to represent and exploit the relation between abjection and the inside and outside of the body — in particular the mouth, eyes, vagina, womb, skin, and blood. A closer examination of the representation of these wastes and bodily zones will tell us more about the way in which the inside and outside of the body are constructed in relation to abjection and sexual difference.

Blood

Blood taboos of course are central to all cultures — frequently taboos on woman's blood or menstrual blood. Blood is still used in this context in some horror films, with menarche being linked to witchcraft. In *The Exorcist* Reagan is possessed by the Devil at the same time as she begins to bleed. In the slasher film the prime target for the knife-wielding homicidal maniac is the young girl on the brink of womanhood. A dominant image in the slasher film is the body of the young girl cut and covered in blood. One could argue that her whole body has been transformed into a bleeding wound signifying the horror of menstruation. She is threatening precisely because she is a liminal figure, at the threshold of womanhood. She represents female power associated with bodily change — a change that may also serve to reawaken castration anxiety in the unconscious of the male protagonist. Finally, she becomes monstrous because she literally represents the bleeding wound.

In the horror film, blood is the most visible of bodily wastes, the one that seems to evoke the most terror in the protagonists and, through the mechanisms of identification, in the spectator. Blood flows from inflicted wounds and from all of the bodily orifices. Blood also flows between individuals, the blood from victims covering the living. Blood signifies another liminal state — the state between life and death. Many contemporary films depict images of blood as it gushes forth from the body in close, realistic detail.

The Skin

The representation of the skin in horror is particularly relevant to a discussion of the abject. The skin, which normally guarantees the integrity of one's clean and proper body,[28] acts as a border between the inside and outside of the body. Bodily wastes that pollute the skin are usually quickly wiped away. But in the horror film, the skin is always there to be cut, penetrated, to permit the inside to stream forth and cover the outside. The horror film abounds in images of cut and marked skin, skin erupting from within into pustules, skin infested with parasites, skin covered with blood, skin bubbling and transforming itself as the beast from within erupts, skin that expands to permit the creature inside room to grow. The representation of skin as mobile, fluid, and fragile reinforces an image of the grotesque body as constantly in a state of becoming.

The Mouth

The horror film's obsession with the body, where identity is defined in corporeal terms, represents a self no longer defined in relation to language. Language can no longer be trusted as a defining characteristic of subjectivity. Language has betrayed the self; the self has taken refuge in the body, has become one with the body. It is the scream — particularly the scream of woman — that epitomises the failure of the symbolic order. In the slasher subgenre of the horror film, the most dominant iconographical image is that of woman's terrified face and her open mouth, lips rimmed with blood, from which her terrified scream rises to pierce the night air. (An image that immediately comes to mind in this context is Munch's painting *The Scream*.) The mouth, particularly the open mouth, represents another aspect of the abject. The mouth represents an inside and outside plane of the body; its lips are on the outside, the other side of the lips leads into the body's inner recesses. Blood that flows from the mouth links the inside to the out-

side. The body's boundaries are violated by the open bleeding mouth. Parallels with woman's other mouth and lips, which also bleed and also link the inside with the outside, are obvious and are frequently underlined in the horror film — particularly the vampire film.

The mouth, normally the portal of speech, has become in the horror film an image that signifies the most unspeakable of terrors. First, the mouth that can only scream or groan signifies a renunciation of speech and a blurring of boundaries between animal and human. Second, the mouth that bleeds or becomes a portal through which spills the guts of the human body suggests that the loss of language leads only to death. The third (and perhaps most terrifying) function of the mouth in the horror film is that of traitor — the body's traitor. For the mouth of woman (and sometimes man) is used more and more as a displaced vagina — the opening through which woman is raped and inseminated by alien creatures.

The Womb

Bakhtin's discussion of the Kerch figurines of three pregnant hags that suggest pregnant death is an example of a very strongly expressed form of the grotesque. Images such as this are central to many horror films. In *The Shining* the character played by Jack Nicholson walks toward a beautiful young woman who steps from her bath; the scene suggests Botticelli's *Birth of Venus*. He embraces her lustfully and then watches in horror as she suddenly transforms into a hideous laughing hag whose flesh is already in an advanced state of decay.

The theme of woman as pregnant grotesque is central to many horror films (sci-fi horror) where woman is depicted as monstrous because she is capable of breeding and giving birth in abnormal ways. For instance, in *The Brood* she has a large birth sac attached to her side and is able to conceive parthenogenetically. Horrified, her husband watches as she tears the birth sac with her teeth. He is revolted by the sight of the birth process, which, because it takes place on the outside of her body, is rendered in full view. In *Inseminoid* and *Xtro* woman is impregnated by an alien, while in *Demon Seed* she is raped and impregnated by the household computer. In *Alien* and *Aliens* both women and men are orally raped and impregnated by aliens. In one sense these films could be interpreted as fantastic representations of the primal scene as defined by Freud.[29] In another sense, scenes such as these draw connections between woman's reproductive capabilities and the abject. The fact that woman's body is represented as that which is capable of receiving the

alien is a sign of the truly monstrous nature of her body and being. Possibly one reason why reproduction has become a dominant theme in horror may be found in the current anxieties surrounding developments in reproductive technology.

In all of these films, pregnancy is also linked to death. The very fact that woman has conceived abnormally—particularly where she has been raped by an alien of some kind—suggests that the act of giving birth will lead to death. In *Alien* and *Aliens* this is taken to extremes in that the victims' bodies are transformed into wombs and they die as the creature gnaws its way through the stomach. While the notion of a pregnant death is important, these images suggest the grotesque more because of the conjoining of human and alien.

It is possible that the modern horror film's obsession not only with the body and with bodily wastes such as blood, putrefying flesh, crumbling bones, vomit, tears, and so forth but also with the "limits of the body" represents a retreat from the symbolic, the domain of the father, and a return to the imaginary, the domain of the body and of the mother. Consider *Psycho*, for instance—its emphasis on the toilet bowl, blood, the bog, tears, cut flesh, and the need to halt the process of decay by embalming dead birds and the body of mother. The father of course has already been murdered and his body removed from the scene. The film's attitude to the world of the mother, her authority as the one who authorises the clean and proper body, what Kristeva calls the "semiotic chora," is highly ambivalent—there is a wallowing in the taboo as well as an attempt to shore up the authority of the mother. There is no doubt, however, that the domain of the father, the word of the law, is spurned, derided, banished.

SPECTATORSHIP AND THE CLASSICAL BODY

Stallybrass and White's argument that carnivalesque practices gradually reemerged in displaced and distorted form as objects of phobic disgust and repressed desire in various nineteenth-century cultural discourses is clearly of relevance to a discussion of the horror film. I have attempted to show that there are marked similarities between carnivalesque practices, particularly in relation to inversion, grotesque humour, and the representation of the monstrous body. What is of particular interest is the way in which these practices continue and the changes that have taken place in their representation, for instance

the change from a high/low body binarism to one characterised by an inside/outside opposition.

Stallybrass and White argue that carnival practices also mounted an attack on the classical notion of an ideal ego. "The carnivalesque inversion mounts a coordinated *double* attack upon the 'ideal-Ich,' calling the bluff on foreclosure: it denies with a laugh the ludicrous pose of autonomy adopted by the subject within the hierarchical arrangements of the symbolic at the same moment as it reopens the body boundary, the closed orifices of which normally guarantee the repressive mechanism itself."[30]

In her important discussion of carnival, Mary Russo points out that the "grotesque body is opposed to the classical body, which is monumental, static, closed, and sleek, corresponding to the aspirations of bourgeois individualism."[31] At one level the subject matter of this paper is a carnivalistic inversion of Gaylyn Studlar's. The important question that arises here concerns the relationship between carnival practices and their displaced counterparts and the bourgeois spectator. Is bourgeois identity at all shaken by its encounter with the "other" or is it reconfirmed? Or both? And to what extent might female spectators view the feminised body-monstrous differently from male spectators?

Earlier Stallybrass and White stressed the importance of recognising that "the classificatory body of a culture is always double, always structured in relation to its negation, its inverse." "What is socially peripheral is often symbolically central."[32] In her article "Myth, Narrative and Historical Perspective,"[33] Laura Mulvey makes a similar point. She argues that the definition of carnival as the opposite of official culture does not guarantee that carnival therefore challenges the system or poses a radical threat to its continuation. The horror film is also a discursive practice that inverts and attacks the official world order and its values. The horror film addresses a classic body — the body of the audience. The horror film is also licensed, a legitimate practice. To what extent, then, does the horror film seek to unsettle and alienate the viewer?

Drawing in part on the Lacanian theory of the subject, film theory of the last decade has presented a radical critique of existing notions of the screen-spectator relationship. Central to this view of the screen-spectator relationship is the idea that the spectator does not sit in the cinema in isolation from the events unfolding on the screen. The spectator is then constructed, through the ideological workings of the filmic process, in a comforting but illusory sense that she/he is a coherent, rational subject. This view argues that the classic Hollywood realist text,

through the very nature of the viewing process and the deployment of conventional narrative structures, works to construct the spectator in a position where she/he (mistakenly) thinks herself/himself to be a unified, rational subject.[34] This process is particularly reinforced by the conventional happy ending of the classic realist text in which all loose ends are usually neatly tied up and the values of the status quo confirmed — the couple, family, society, and the law. Recent critical articles[35] have, however, argued that this theory of the screen-spectatorship relationship and the classic text is too reductive. A close study of many popular texts will reveal that there are moments of contradiction, gaps and dislocations, that allow for subversive readings.

How does the horror film construct its viewer? What values are brought to bear in the interrelationship of screen and spectator? Robin Wood's view, discussed earlier, holds that the subject matter of the horror film, particularly its attack on the status quo, does have a subversive potential. But what of the viewing process itself? In general, it seems that the above theory of spectatorship is not relevant to the processes involved in the viewing of horror. It seems clear that the horror film, with its emphasis on the death, temporality, bodily destruction, and ambiguous nature of the monster, cannot construct in the viewer a comforting or lasting sense of unity and coherence in relation to the ideal ego and the symbolic body.

The experience of viewing most horror films is extremely complex. On the one hand, the horror film invariably employs filmic codes such as lighting, music, camera angles, and tight editing to elicit maximum identification. On the other hand, no clear answer can be given to explain the nature of identification. The spectator may identify with the monster or psychopath or else with the victim — or switch identification throughout. Possibly, the spectator may not identify with any of the protagonists — although the audible response of most audiences to the horror film suggests that identification with the victim is extremely important. The spectator may be made aware of her/his voyeurism and punished for looking. Clearly, a detailed study of modes of identification and viewing in relation to the horror film would have to draw on both sadistic and masochistic theories of the gaze.[36]

What of the gendered spectator? In her article "When a Woman Looks," Linda Williams argues that there is a clear difference. She claims that there is "a surprising and at times subversive affinity" between the female heroine of the text and the monster in that, like woman, he is also "a biological freak with impossible and threatening appetites" —

particularly sexual appetites.[37] In her view the female spectator in the auditorium — unlike the male — is punished for looking at the male monster because she realises that its freakishness is not unlike her own. Williams's thesis is important, although it does not take into account the possibility that the monster might be female. What happens when the male spectator looks at the female monster, particularly the castrating female monster? Isn't he also punished? Nor does Williams consider the differences between the abject and symbolic bodies in relation to death and the natural world. (She is primarily concerned with the question of bodily appetites.) But insofar as all monsters are feminised, as a result of changes that transform the body from symbolic form into an abject thing, it would seem that the female spectator is positioned differently from the male. On the one hand, through identification with the abject and feminised body she is better placed to confront the abject nature of life and the fine line separating the human from the animal world; but, on the other hand, she alone is made to bear, through the processes of representation, mankind's debt to nature precisely because of this association of the feminine with the monstrous.

What are the underpinnings of the modern cinema of horror and its representation of the abject body? On the one hand we could argue that a central function of the horror film is to mount an attack, through scenarios of bodily destruction, on the notion of the unified rational self. One of the major changes in the modern horror film is to address the viewer directly, to construct scenarios of bodily destruction that ask the viewer to imagine that the body displayed on the screen could be her/his body. One of the most pronounced features of the contemporary horror film is the realistic creation of human bodies, limbs, organs, and tissues in states of torment and destruction.

The modern horror film now, with perverse pleasure, shows everything that was once only alluded to. The grotesque body of the horror film is the spectator's body — for the duration of the narrative. Furthermore, the horror film's attack on the symbolic order and its repressive institutions denies the autonomy and validity of the subject within that order. This attack coincides with an attack on the body, particularly the boundaries of the body, which normally work to confirm the validity of the ideal self within the symbolic.

On the other hand, it could be argued that one of the major functions of the horror film is to reconstruct in the viewer a definite sense of her/his body as clean, whole, impregnable, living, inviolate. The images of the human body in various stages of dismemberment and disarray must

work also to create in the viewer a sense of separateness from the screen. The scenarios of bodily destruction are too horrifying to sustain indefinitely the mechanisms of identification. Clearly, identification must be weakened or broken at the point at which the abject living body becomes a corpse. Finally, the experience of viewing horror, the subject's encounter with abjection, might also serve to reinforce in the viewer a sense of bodily purity, wholeness, and selfhood.

It is important to remember that carnival was a licensed, authorised practice. The horror cinema is also a licensed practice. As Juliet Mitchell points out:

You cannot choose the imaginary, the semiotic, the carnival as an alternative to the symbolic, as an alternative to the law. It is set up by the law precisely in its own ludic space, its own area of imaginary alternative, but not as a symbolic alternative. So that politically speaking, it is only the symbolic, a new symbolism, a new law, that can challenge the dominant law.[38]

The kinds of pleasure that horror offers (the permitted breaking of taboos, a safe confrontation with the abject, black humour) also point to one aspect of the ideological work of horror — a separation of the pure body from its abject other and a reaffirmation of a comforting but illusory sense of a unified, coherent, authentic body and self. However, this is not the whole story. For if the horror film does function as a kind of safety valve for the forces of protest and rebellion, it must equally work to construct a space that gives rise to, permits the utterance of, a language of protest and revolt, not only in relation to the sociopolitical arena but also in terms of the constitution of subjectivity. The audience's encounter with abjection as it is represented in the horror text cannot be ignored or dismissed. For if abjection is the condition of the proper body and unified subjectivity, abjection as it is represented in the horror text may well function to remind the viewing subject of the fragile nature of all limits and all boundaries, particularly those of the symbolic (masculine) self. Like the practices of carnival, the cinema of horror serves to mark out those boundaries and those limits. Yet again we find, as with other patriarchal forms of representation, that it is the feminine that signifies the outer limits of those boundaries.

Notes

Many thanks to William D. Routt for his particularly helpful comments and suggestions.

1. Jean Starobinski, "The Natural and Literary History of Bodily Sensations," in Michel Feher, ed., *Zone: Fragments for a History of the Human Body* (London, 1989), 2:350–93.

2. For a detailed discussion, see Elizabeth Grosz, "Desire, the Body and Recent French Feminism," in *Flesh, Intervention* 21–22 (1988): 28–33.

3. Michel Foucault, *Discipline and Punish* (Victoria, 1977).

4. Michel Feher, "Introduction," in Feher, ed., *Zone: Fragments for a History of the Human Body,* 1:12.

5. James Twitchell, *Dreadful Pleasures: An Anatomy of Modern Pleasure* (Oxford, 1985), is a good example.

6. The representation of woman in horror is discussed in the following: Linda Williams, "When the Woman Looks," in Mary Anne Doane, Patricia Mellencamp, and Linda Williams, eds., *Re-Vision,* American Film Institute Monograph Series, vol. 3, University Publications of America (1984); Carol J. Clover, "Her Body, Himself: Gender in the Slasher Film," in James Donald, ed., *Fantasy and the Cinema* (London, 1989), 91–133.

7. There is an interesting collection of articles on this theme in the "Body Horror" edition of *Screen* 27, no. 1 (Jan.–Feb. 1986). For a humorous reverie on the dead, see Bill Routt, "Dead Is My Dancing Partner," *Flesh, Intervention* 21–22 (1988): 68–69.

8. Philip Brophy, "Horrality: The Textuality of Contemporary Horror Films," *Screen* 27, no. 1 (Jan.–Feb. 1986): 8.

9. Ibid., 9.

10. Philip Brophy, "The Body Horrible," *Flesh, Intervention* 21–22 (1988): 60.

11. Pete Boss, "Vile Bodies and Bad Medicine," *Screen* 27, no. 1 (Jan.–Feb. 1986): 15; 16; 16; 15.

12. Peter Stallybrass and Allon White, *The Politics and Poetics of Transgression* (London, 1986).

13. Mikhail M. Bakhtin, *Rabelais and His World,* trans. Helene Iswolsky (Bloomington, Ind., 1984), 11.

14. Ibid., 10.

15. Stallybrass and White, *Politics and Poetics of Transgression,* 182.

16. Julia Kristeva, *Powers of Horror: An Essay on Abjection* (New York, 1982).

17. Robin Wood, "The American Nightmare: Horror in the 70s," *Hollywood from Vietnam to Reagan* (New York, 1986), 70–94.

18. Barbara Creed, "From Here to Modernity," *Postmodern Screen* 28, no. 2 (Spring 1987): 47–67.

19. Barbara Creed, "Horror and the Monstrous-Feminine: An Imaginary Abjection," *Screen* 27, no. 1 (Jan.–Feb. 1986): 44–70.

20. Stallybrass and White, *Politics and Poetics of Transgression,* 9.

21. Bakhtin, *Rabelais and His World,* 25–26.

22. Kristeva, *Powers of Horror,* 3–4.

23. Jacques Lacan, "Some Reflections on the Ego," *International Journal of Psychoanalysis* 24 (1953): 12.

24. Jacques Lacan, *Ecrits: A Selection,* trans. Alan Sheridan (London, 1977), 11.

25. Roger Dadoun, "Fetishism in the Horror Film," in James Donald, ed., *Fantasy and the Cinema* (London, 1989), 43.

26. Kristeva, *Powers of Horror,* 113–15.

27. Creed, "Horror and the Monstrous-Feminine," 46–47.

28. For a discussion of the clean and proper body see Kristeva, *Powers of Horror.*

29. Jean Laplanche and Jean-Bertrand Pontalis, "Fantasy and the Origins of Sexuality," in Victor Burgin, James Donald, and Cora Kaplan, eds., *Formations of Fantasy* (London, 1986), 335–36.

30. Stallybrass and White, *Politics and Poetics of Transgression,* 183–84.

31. Mary Russo, "Female Grotesques: Carnival and Theory," in Teresa de Lauretis, ed., *Feminist Studies: Critical Studies* (Bloomington, Ind., 1986), 219.

32. Stallybrass and White, *Politics and Poetics of Transgression,* 20.

33. Laura Mulvey, "Changes: Thoughts on Myth, Narrative and Historical Experience" in *Visual and Other Pleasures* (London, 1989), 159–76.

34. See Christian Metz, *Psychoanalysis and the Cinema: The Imaginary Signifier* (London, 1983); Annette Kuhn, *Women's Pictures: Feminism and the Cinema* (London, 1982), 21–65.

35. Kuhn, "Rereading Dominant Cinema," in *Women's Pictures,* 69–128. For a sustained critique of contemporary theory in relation to the films of Alfred Hitchcock see Tania Modleski, *The Women Who Knew Too Much* (New York, 1988).

36. For a discussion of these issues see Laura Mulvey, "Visual Pleasures and Narrative Cinema," in *Visual and Other Pleasures,* 14–18; Gaylyn Studlar, "Masochism and the Perverse Pleasures of the Cinema," *Quarterly Review of Film Studies* 9, no. 4 (1984): 267–82.

37. Linda Williams, "When a Woman Looks," *Re-Vision,* University Publications of America (Los Angeles, 1984), 85; 87.

38. Juliet Mitchell, "Psychoanalysis, Narrative and Femininity," in *Woman, the Longest Revolution* (London, 1984), 291.

8

Barrymore, the Body, and Bliss

Issues of Male Representation and Female Spectatorship in the 1920s

GAYLYN STUDLAR

In November 1922 *Motion Picture Magazine* featured a poem, "The Movie Fan." "She may live in Pinochle, Wisconsin," the poem declared, "but she holds the whip on Hollywood."[1] The poem was accompanied by two cartoons. One depicts the aftermath of a woman taking a hammer to the bust of her favourite male film star. She stands with a hammer in one hand and a newspaper in the other. The newspaper headline reads: "FLOYD PHILMSTAR HAS WIFE AND CHILDREN."

In spite of the real and metaphoric violence attributed to female film spectators by the poem, the Hollywood film industry in the 1920s rarely bemoaned the fact that women were regarded as a formidable box office force, both in its own estimation and that of the popular press. Although box office records of the time are untrustworthy and studies of the gender differentiation of the audience nonexistent, the female portion of the American film audience was estimated by exhibitors' trade journals, fan magazines, and numerous casual observers as being between 75 and 83 percent.[2] For example, in 1925 *Exhibitors Trade Herald* warned its readers: "DON'T FORGET HER! In every exploitation campaign, it would be financial suicide to leave the women folk out of consideration. They are the ones who go to the movies the most, and they are the ones that give the youngsters the pennies needed to attend your matinees."[3] An ad recommending tie-up exploitation schemes for a 1925 comedy likewise warned exhibitors: "You must never lose track of the fact that the majority of your business comes to you because Mrs or Miss So-and-So says to the other half of the party, 'I would like to

see a picture tonight.'"[4] In *Photoplay* of 1924, Frederick James Smith offered another view: "the great motion picture audience . . . is mostly feminine. Probably it is at least 75–25 in its percentage of femininity. Woman, through moral restrictions dating back through the ages has had to seek vicarious experience . . . to gain adventure second hand."[5] Like the poem "The Movie Fan," Smith pursues the obvious, the link between women's desire for vicarious experience and their relationship to the opposite sex. "Sex appeal" in actresses, he concludes, can easily offend women, but "it is impossible for it to be too blatant in an actor."[6]

These examples in trade and fan magazines of the 1920s are but a part of the industry discourse that agreed from the beginning of the new, postwar decade that women spectators most enjoyed the vicarious adventure of heterosexual courtship — of "romance." A November 1919 front page *Photoplay* editorial encouraged its readers to consider movie romance in positive social and personal terms and its power at the box office as a direct and decisive influence on the medium. It lyrically extolled, "If it were not for you the photoplay would not exist. There might be motion pictures of events and industries, but there would be no romance. Romance is what the photoplay is made of. . . . Any photoplay which calls up that frank, healthy laugh of yours . . . one which bares to you the tenderness and strength, the helplessness and power of a real man's love — photoplays like these are more than mere entertainment. They will actually help you in realising the vital and splendid womanhood which lies at the end of every American girl's rainbow of youth."[7] To many, *Photoplay*'s editorial optimism about both the movies' moral power and America's "vital and splendid womanhood" would seem increasingly antiquated as the decade of the 1920s became marked by numerous Hollywood sex scandals and "real" men and splendid women were eclipsed in the popular imagination by pervasive cultural images of eroding gender boundaries.

Women were becoming masculine and men feminine, so much so that philosopher Will Durant remarked: "Within a generation it will be necessary to mark them [the sexes] with badges to distinguish them, and to prevent regrettable complications."[8] In the wake of reliable birth control, petting parties, and hot jazz, romance had turned to licentiousness, and licentiousness, social commentators agreed, had become the preoccupation of the fairer sex. One reviewer saw screen romance as having a new didactic function within this changing social climate: "The girls get a great kick out of the heavy love stuff. They come out of these pictures with their male escorts and an 'I wonder if he's learned

anything' expression. They claim the screen's the closest they can get to it. But pity the modern lover. He's so tired from holding up a raccoon coat he can't compete."[9]

In spite of the variety of films aimed at women in the 1920s, including classic "women's films" with suffering heroines stuck in unrequited office romances, the moral quagmire of flapperism, or the social quicksand of unwed motherhood, the biggest box office successes of the decade were frequently less "sophisticated," more escapist fare. These love stories, often referred to as "romantic melodramas," were frequently drawn from literary source material aimed at women or were based on screenplays penned by some of the numerous women screenwriters of the era such as Bess Meredyth, Dorothy Farnum, and June Mathis. Constructed according to the familiar terms of address established in women's fiction and set in imaginary historical landscapes or improbable exotic locales, films such as *Night of Love, The Cossacks, Beloved Rogue, The Sheik, Son of the Sheik, The Arab, Tempest, Monsieur Beaucaire, Bardeleys the Magnificent, Don Juan,* and *Morals* initially may appear to be little more than historical curiosities, remnants of a Victorian sensibility out of step with an era clamouring with contradictory discourses about the changing sexual mores of a so-called jazz age. Populated with pure damsels, dashing Don Juans, sheiks and shebas, dancing girls, and gypsy chieftains, they are costume dramas, swashbucklers, and generically hybrid romantic-adventure films seemingly united by their one indisputable element of commonality: the male matinee idol — whether he is Rudolph Valentino, John Gilbert, John Barrymore, George Walsh, Wallace Reid, Ramon Navarro, Lew Cody, or Ronald Colman (fig. 9).

These were "women's films" in the important sense of being aimed at women and speaking a familiar "feminine" discourse of romantic love, but they have been neglected by feminist film criticism, perhaps because they do not fit comfortably into the established definition of the "woman's film" attached to films of the 1930s, 1940s, and 1950s. The spectacle of female suffering, made virtually synonymous with the woman's film, is "de-eroticised." The focus in these films is displaced from a contemporary heroine as a spectacle for imitation in a commodifiable world to an eroticised male spectacle fixed within an uncommodifiable or exotic fantasy world.

The most famous (or infamous) representative of the palpable influence of this male-centred "discourse of love" on female movie fans in the 1920s was, of course, Rudolph Valentino. In one of the few articles to address women's films of this era, Miriam Hansen claimed that Val-

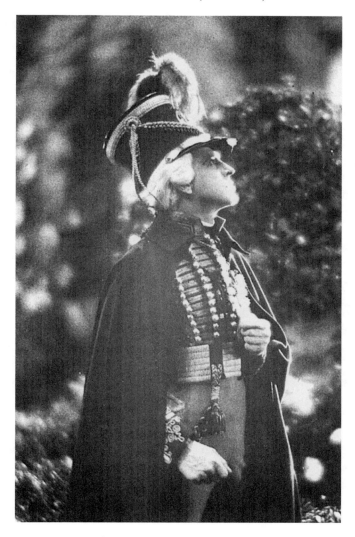

9. *Beau Brummel* (1924).

entino was the first major star whose films were primarily addressed to a female audience.[10] However, commentators of the era saw Valentino as the mere successor to numerous other "matinee idols," male stars including Francis X. Bushman and Maurice Costello[11] whose careers had been made and unmade by their female audiences.[12]

Of more direct importance to the goals of my paper is Hansen's claim

that Valentino "inaugurated an explicitly sexual discourse on male beauty" that worked to destabilise "standards of masculinity . . . with connotations of sexual ambiguity, social marginality, and ethnic/racial otherness."[13] Her statement provides a useful starting point to demonstrate the need to begin with an exploration of coexistent cultural forms at the historical moment under consideration. The intertextual web of discourses of the era reveals that the eroticised inscription of the male body as a textual and extratextual lure was already conventionalised in theatrical and literary fictions aimed at women, and even in advertising. Yet what had previously gone unnoticed as part of the subterranean critical field of women's culture gained enormous public attention in the 1920s as it became symbolic of the perceived tumultuous changes in the gender system governing American sexual relations. The male body no longer could escape attention as middle class social discourses became obsessed with the cultural ramifications of women's sexual subjectivity. If, as Adela Rogers St Johns suggested in 1924, men hated Valentino because, in her words, "the lure of Valentino is wholly, entirely, obviously the lure of the flesh,"[14] they were also reacting to women's perceived susceptibility to that lure. By arguing that Valentino was a unique demonstration, a sudden unprecedented outburst of women's box office power in response to a more explicitly depicted male sexuality, Hansen inadvertently echoes the numerous tracts that mark the era's "surprised" discovery of female heterosexual desire.

In the 1920s, it was no longer fashionable for doctors, psychologists, anthropologists, and philosophers to confidently echo (as they had a few short years before) the Victorian belief that woman's passion was, in the words of one prewar newspaper editorial, "mainly a pretence."[15] Conservatives, progressives, and even arch-feminists such as Charlotte Perkins Gilman deplored women's "shallow self-indulgence in appetite and impulse." Women had forgotten that they were made to be mothers, said Gilman, "and not, as seems to be widely supposed, for the enjoyable preliminaries."[16] Countless articles with memorable titles such as "Should Men Be Protected?" and "Are Women Inferior or Are They Trying to Side Track Nature?" agreed that women were trying to imitate men and that, even as they were masculinising themselves, they were remodelling men, creating "woman-made men."[17] Universal suffrage and female employment were not blamed for this masculinisation of women, but sexual desire. In the attempt to be "equal partners in all marital ideals including sexuality," wrote Lorine Pruette in *The Nation*, women were causing the "decline of the male." American men were los-

ing their "financial and sexual dominance," she continued; they "still hold the big jobs and get the big rewards, but their confidence is going and for the most intelligent ones it is already gone."[18]

The "new woman" who demanded the right to smoke, drink, vote, and wear short skirts was going too far in daring to demand the same promiscuity society tacitly granted the male. She was ruining herself. Allan Leigh's popular novel *Women Like Men* warned its heroine and its readers in no uncertain terms: "Women are not like men. Men can do it, but women can't. You'll go down. . . . Look at you now. Why . . . your face is changing!"[19] Psychologist Beatrice Hinkle was one of the few to see the negation of the old double standard of "sexual morality" as a positive step toward women's equality. She acknowledged that as women were becoming the "active agents in the field of sexual morality," American men were reacting as "the passive, almost bewildered accessories to the overthrow of their long and firmly organised control of women's sexual conduct."[20]

Most expert commentators, however, offered less than passive responses to gender role changes they perceived in decidedly more pessimistic terms than Hinkle. Typical was the response of Anthony Ludovici's *Woman: A Vindication*. Industrialism and urbanism might be implicated in the masculinisation of women and the "degeneration of man," declared Ludovici, but so too were the pernicious fictional ideals of manhood promoted by a publishing industry that, he asserted, was controlled by women readers. As a consequence, the country was being overrun by men who were athletic, "breezy and fond of games," but who were a "womanly ideal of man" rather than being manly. Such a man was an ineffectual, harmless creature who knew "nothing about women." "Real men" who would control women's desire for "petty power" were, by contrast, being vilified everywhere as the "prig." "This," Ludovici concludes, is "what we have had to pay for woman's point of view becoming paramount."[21]

It might be expected that Hollywood would gingerly attempt to negotiate the path of least resistance and most popular appeal between this cultural antagonism toward "womanly ideals" of masculinity and the desire of its female audience for male screen idols. Although the notorious *Chicago Herald Tribune* condemnation of Valentino as a "pink powder puff," representing Hollywood's "national school of masculinity," singled out the star for attack, the codes of representing masculinity[22] in his films were actually not unique to him but a highly conventionalised element of many romantic melodramas of the 1920s. To investigate the

cinematic sexual discourse on the male body in the 1920s, I am using the example of John Barrymore—more specifically—John Barrymore's body.

In part, my choice of Barrymore is purely for argumentative purposes since Hansen dismisses his screen appeal (along with that of Richard Barthelmess) as not being attributable to his body. These two stars she says "seemed to owe their good looks to a transcendent spirituality rather than anything related to their bodies and sexuality."[23] Within the discursive web of debates centring on masculinity and female desire, the filmic exhibition of John Barrymore's body is doubly "revealing" since he was a well-known matinee idol of the theatre before his desertion of the stage for screen in 1926. At the end of his stage career in the 1920s, he was the country's "great tragedian," but he had previously been known as a matinee idol, one of a number of male actors whose careers depended heavily, if not exclusively in some cases, on the devotion of their female audiences.

Beginning in the 1870s, the "matinee idol" was a theatrical phenomenon regarded as peculiarly American.[24] Coincidentally emerging when American society was first hearing of the spectre of cultural "feminisation," the matinee idol and his fans, the "matinee girls," flourished well into the next century, in spite of occasional denunciations (not of the poor besieged actor, but of his audience). In 1903, the magazine *Theatre* rebuked the young women whose spectatorship was taking annoyingly active forms: "The matinee girl who makes herself conspicuous is to be seen at all the theatres. . . . Usually she is in bunches . . . and invariably she is noisy. All through the play one hears such snatches of conversation as: 'Isn't he just darling'; 'I think he's the most handsome man I ever saw.'"[25]

As a matinee idol, Barrymore's romantic good looks elicited a discourse of fan behaviour predating Valentino and every bit as strongly marked by sexual difference. His appearance in the touring production of *Peter Ibbetson* in 1917 prompted sighs from women all over the nation. A New York woman announced that she had seen the play forty-five times;[26] another was rushed from the theatre to the hospital because of "an unaccountable weeping hysteria."[27] These incidents were but the overture to "New York's biggest riot" (the response to Valentino's death), but Barrymore's stage career, like Valentino's film persona, was also marked by an intense female response to a male frequently portrayed as sexually ambiguous. However, unlike the male response to Valentino, Barrymore's masculinity was always defended by critics, one

of whom praised Barrymore's portrayal of Peter Ibbetson as a revelation of "the unlit red fires of an unfired manhood."[28] This almost incomprehensible poetic praise contrasts with Barrymore's own straightforward repudiation of the dreamy, love-obsessed character as "a marshmallow in a blond wig."[29] In the next year, 1918, Barrymore essayed the role of Giannetto, the foppish, cowardly, adolescent Renaissance painter in the hoary stage melodrama *The Jest*. Giannetto had been played on the European stage by women, including Sarah Bernhardt. Barrymore's interpretation of the role was said to have suggested more than a measure of effeminacy. Nevertheless, his second wife also recalled that the Renaissance tights he wore "left no faint fragment of his anatomy to the imagination."[30] With virility so visibly displayed, his entrance was regularly greeted by the sighs and gasps of women in his audience.

When Barrymore left the stage to become a Warner Brothers star, he was promoted as "the greatest living actor," but his reputation and representation as a matinee idol also followed him to the silver screen. As a measure of the studio's financial respect for women's box office power and Barrymore's ability to attract it, Warner's entrusted the feature film debut of its sound-on-disk process to *Don Juan*, written by Bess Meredyth and starring Barrymore (fig. 10). The film was immediately perceived as addressing women. *Variety* noted in its review, "As a box office winner *Don Juan* is sure fire — it aims directly at the women for pulling power and that takes in everything."[31] Both publicity and advertising assumed that even though Barrymore was known as "the prince of profiles," female film audiences, like the matinee girls, were interested in more than his nose. *Screen Secrets* alludes to this as late as 1928: "How could a story about this Don Juan be complete without at least one picture showing the famous Barrymore figure?"[32] Movie exhibitors reconfirmed the industry's perception that the male body was what attracted women audiences. Even in the heartland of America — i.e., Ann Arbor, Michigan — advertisements for Barrymore's *Tempest*, like those for Valentino's *Monsieur Beaucaire*, featured Barrymore in a pose from the film in which he is stripped down naked to the waist.

The display of Barrymore's body, like that of Valentino's, was not a spontaneous creation emanating from women's sudden libidinous curiosity. It involved a complex adaptation of existing male discourse on the body to meet two probable, concurrent demands: (1) female fantasy elicited through a formula based on successful preexisting fictional models and (2) Hollywood's assessment of women's sexual subjectivity. Existing male discourses were tied to the emergence of the "cult of the

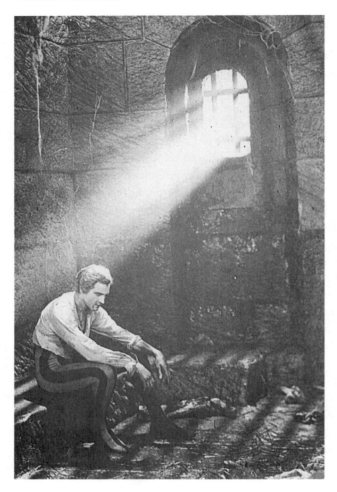

10. *Don Juan* (1926).

body" in late nineteenth-century America. This cult promoted the ideals of the "masculine primitive," a constellation of behaviours that came into vogue in response to the perceived feminisation of society throughout the private and public spheres.[33] In the institutionalised public sphere, more bureaucratic and sedentary middle-class jobs were increasingly tainted with a "feminine aura."[34] In the private sphere, women's perceived dominance of the home and the attempt to bring female morality into politics was producing, in the words of Michael Monahan, a "generation of feminised men ('sissies' in the dialect of real boys)

who will be fit only to escort women to poll or public office and to render such other puppy attentions as may be demanded by the Superior Sex"![135]

The feminine threat to American male identity was answered by the inscription of masculinity in newly idealised traits: vigour, forcefulness, and mastery. These traits were personified by heroes such as Theodore Roosevelt and John L. Sullivan. By revalidating masculinity through re-definition, a new emphasis on man-as-body began to emerge in the 1880s.[36] Heroes were described in physical terms evoking the popular misunderstanding of Darwinism; "brute nature" and "instincts" were believed to be the primary shapers of manliness. Size, strength, vigour, and energy defined manliness as the physical ideal of muscularity was achieved, not through physical labour, but through leisure activities pre-viously considered unfit for gentlemen.[37]

In women's print fiction in the early 1920s, the middle class Ameri-can male body is rarely described in any detail, but the beauty of the male body is made more explicit — within a narrative context of ethnic, racial, national, and historical otherness and the appeal of "the romance of a life we know not."[38] In women's magazines, home decorating styles and myriad beauty products worked to evoke the languid luxury of the Mid- and Far East even as stories of Persian marriage markets and the conflict between female slaves and their despotically attractive Oriental masters found an enthusiastic audience.[39] These images reverse male sexual ideology's long-standing fascination with culturally taboo (i.e., darker) woman, but they can also be regarded as evidence of a rebellious reworking of the prevailing model of American masculinity — of the "cult of the body" and the "masculine primitive."

Contemporary observers of the Valentino phenomenon read wom-en's fascination with women as a complete rejection of the "native" Anglo-Saxon/Nordic American male. Nevertheless, women's fictional search for a new model of masculinity in the 1920s did not threaten American manhood by simply rejecting it but by co-opting aspects of a privileged model that was already destabilised, that was, in actuality, cracking apart at the seams.[40]

Within this context, the fantasy formula of Barrymore's romance films of the 1920s, including *Beloved Rogue, Beau Brummel, When a Man Loves, Sea Beast, Tempest,* and *Don Juan,* use the materiality of the male body as a crucial yet paradoxical vehicle that both proclaims the "natu-ral" attraction of sexual difference and disavows that difference in a pat-tern of textual inscription that bears a remarkable similarity to the strate-

gies employed in the modern romance novels described by Janice Radway in *Reading the Romance*.

Radway argues that ideal romances of the Harlequin type play out a predictable pattern of male representation that functions to displace the female as the erotic centre of the story. Instead, the narrative works to reconcile the heroine (and the reader) to the patriarchal construction of masculinity through the transformation of the hero. Like his counterpart in the romance novels of the 1980s described by Radway, the hero of Barrymore's (as well as Valentino's) romantic melodramas asserts "the purity of his maleness" through his muscular physique and attitude marked by indifference and misogyny. The formula requires, however, that the "hardness" of his attitude be mediated by the suggestion of a repressed softness that tells the reader, usually well before the heroine, that the hero is capable of a transformation into a utopian lover who can nurture her with a maternal, effeminate love.[41]

Radway believes that such a fictional, female-defined maleness reflects the wish to overcome the relational poverty of heterosexuality as it also reflects a deeper need, the reader's pre-Oedipally driven psychological demand to re-create the total symbiotic attachment with the mother. Radway speculates that this re-creation of a relationship in which the subject's demands are all passively met is particularly appealing to women who do not want to take responsibility for their sexuality and are unsure that "equality is a fact or that . . . [they] might want to assent to it."[42] This situation is reflected in popular discourses' inscriptions of femininity and certainly would have been a predictable response of women to the changing sociopolitical circumstances of the 1920s.

In Barrymore's films (like Valentino's), the softness of the hero is literal as well as figurative, as shimmering soft-focus cinematography transforms the hero as an exemplar of spectacular physicality into what one fan magazine writer dubbed "the soft focus boys."[43] The display of the athletic, "virile" male body is mediated by soft-focus photography that offers up the male star to the female spectator in sustained moments of static two-dimensionality — the visual terms of address usually associated with the filmic "fetishisation" of the female.

One explanation of such a contradictory visual treatment may be found in Steven Neale's "Masculinity as Spectacle." In briefly discussing the "feminisation" of Rock Hudson in Douglas Sirk's *All That Heaven Allows*, Neale argues that in the patriarchy "only women can function as the object of an explicitly erotic gaze"; therefore, males who are sexually

displayed are "feminised with the same conventions that govern the eroticisation of women." Most Hollywood films, he claims, anticipate their ideal spectator as male and so must leave the cinematic male body "unmarked as [an object] of erotic display to stifle the homoerotic possibilities of men looking at men." Refusing to acknowledge that the bodies are on display for this ideal spectator's gaze, "mutilation and sadism," says Neale, become the "marks of repression" through which "the male body may be disqualified, so to speak, as an object of erotic contemplation and desire."[44]

Neale's argument, as persuasive as it may be, ignores the Hollywood films in which men looking at men is inscribed with a decidedly unrepressed erotic component, such as some films of Howard Hawks (*Paul*). His remarks also raise the question of exactly how "mutilation" and "sadism" in films always manage to "disqualify" the male body from erotic contemplation in a culture in which the intensity of sexual feeling, especially that of homosexual erotic feeling, is regularly conflated with violence.

While Neale argues that ritualised "sadistic" violence against the male body represses eroticism for male spectators, Miriam Hansen argues that Valentino's films use ritualised, "sadistic" violence to evoke eroticism for their female audiences. Working from Freud's 1913 essay "A Child Is Being Beaten," Hansen identifies a sado-masochistic structure in Valentino's films. The "sadistic appeal," she says, is "articulated in point of view structures on the one hand and the masochistic pleasure in the identification with the object on the other." The female spectator oscillates between being "perpetrator and victim" and regarding Valentino as the "whipping boy" who represents one of the anonymous male children of the last phase of a three-phase Oedipal fantasy. In this, he substitutes for the woman herself in the fantasy formula: "I am being beaten and therefore loved by my father." Hansen argues that the Valentino films revive and resexualise the repressed fantasy by offering the female spectator "a position that entails enjoying the tortures inflicted on Valentino and others."[45]

But in order to create a much coveted, nonmasochistic space for female spectatorship, Hansen is forced to diverge from Freud's own conclusions regarding the beating fantasies. Freud concluded that the "whipping boy" phase was sadistic "only" in its form; the gratification derived from it remained "masochistic."[46] One might also ask whether, in the notion of an easily reversible chain of sadism and masochism,

Hansen's theory inadvertently reproduces what Charles Affron has referred to as silent melodrama's tendency to revert to a "simple-minded sexuality."[47]

Hansen treats the presence of erotic violence in Valentino's films as unique to the era, but the association of the eroticised male body with suffering is present in most of these male-centred women's films of the 1920s and is neither a phenomenon initiated by Valentino's films nor exclusive to them, as Hansen appears to claim. Rather, the linkage between the male body and suffering appears to have at least some precedent in the theatrical construction of the late nineteenth-century matinee idol, as well as in the requirements of melodrama in that era. It can also be explained as a textual remnant, a holdover from the generically hybrid origins of these films — that is, from their roots in "male" genres.

Nevertheless, within these films, this representational formula does fulfil a complex specular function. In Barrymore's romantic melodramas, the male body serves as the visual vehicle through which the order of "feminine" love is constructed from the moral disorder of "masculine" sexual desire. Under the imperative of love, ritualised scenes of violence against the male body serve a "higher" purpose than just the spectator's sexual arousal: they serve as reaffirmation, as proof — in suffering — of a "lasting form of love,"[48] of a feminine, maternal tenderness that transcends the transitory pleasure of sex, the stereotyped masculine pleasure.

Even the rhetoric of extrafilmic publicity pushed the angle of male suffering. The original program for the premiere of Barrymore's *When a Man Loves* (1927) described the end of the film, an adaptation of *Manon Lescaut:* "While the battle rages on the swaying deck, Fabien bears Manon to the boat. . . . 'All for me, Fabien,' Manon sighs. 'For me you have suffered, suffered.' He draws her to him with ineffable tenderness. 'What matters suffering, Manon, when a man loves?'" The de-eroticised victimisation of the heroine that feminist film criticism expects of the "woman's film" is displaced here by the eroticised victimisation of the male, who thus occupies a "feminine" role. Suffering serves yet another function as well. If, as Bataille suggests, "suffering alone reveals the total significance of the beloved object,"[49] then female worth is also confirmed through male suffering. Last, suffering substitutes for sex, and sexuality becomes equated with the swoon, the moment of shared sensation in keeling over in the mortal bliss of pleasure and anguish. Such moments are illustrated again and again in Barrymore's films such as *Beloved Rogue* and *Tempest.*

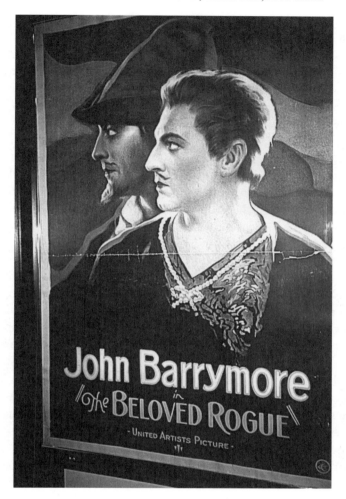

11. *The Beloved Rogue* (1927).

This convergence of violence and the unveiled male body serves yet another purpose within an era in which traditional standards of feminine behaviour and women's expression of sexuality were at odds. The hero's unveiling in *Beloved Rogue* (fig. 11), and his flaying and frying, must be coded as decent since it is for love. Writhing under the blows proves that it is violence and not the hero's body that is indecent and, more important, not the woman spectator who has paid to gaze in fascination at that body. Hence, what we have here is not a straightforward,

simple, "sadistic" pleasure but a detached masquerade of looking in which punishment functions to remove the taboo from the female look as well as from the male body under scrutiny. With ample precedent in traditional Christian iconography, the taboo of suffering and the taboo of (semi-) nudity cancel each other out. By imitating the familiar structures of aggression against the male body described by Neale, the film permits the woman spectator to use an ostensibly male, ostensibly sadistic form as cover so that she may quietly violate the taboo against women scrutinizing, objectifying, and therefore threatening to commodify men. We might further suggest that the spectator is also detached from a "masochistic" identification with the hero; this dialectic possibility also masks the taboo status of her own sensual visual pleasure through an ostensibly sentimental, "feminine" (conventionally masochistic) act.

Male exhibitionism is permitted in these films, but the male object of the woman's vision must be purged of self-awareness. To indulge in a heightened awareness of his own desirability would "feminise" him and throw him into one of the categories of disreputable modes of masculinity, much discussed and derided during the 1920s. These were men who lived off their looks and catered to feminine sexual indulgence: the "flapperooster," the "male butterfly," and the "lounge lizard."[50] To keep from becoming one of these species of "woman-made man," Barrymore's sexual exhibition for the female spectator must be disavowed through the hateful gaze of his enemies or normalised through the presence of other, inevitably less attractive men in a similar state of indecency (*Tempest*). When the hero's physical perfection has little purpose except the seduction of women, he must be rejected by the heroine. In Valentino's *Monsieur Beaucaire,* Princess Henrietta (Bebe Daniels) admiringly observes Valentino in court performance until she overhears that he is an ally and probable lover of Madame Pompadour. She turns away and thus gains his interest. The intertitle tells us, "Shock of his life . . . a woman not looking at him." He is mistaken, of course; she has looked at him, but, as she later tells him, he "has made such an art of lovemaking" that he "no longer knows what love means." In *Beloved Rogue,* François Villon discovers that he has a fan. He finds the king's ward, Charlotte, worshipping *him* at an altar. She adores Villon's poetry but is visibly disappointed with Villon the man, who is a dirty, dishevelled, romantically undesirable coward and clown. They are, in the tradition of melodrama, a most improbable couple, but the audience and

Charlotte need only wait for the transformation of Villon's body as well as of his spirit. The signal comes when Villon tells Charlotte, "You have swept my heart clean," and he appears transformed into a conventional groomed courtier, but, as in *Monsieur Beaucaire*, the heroine rejects him.

This momentary failure of male transformation foregrounds the fantasy appeal of the hero's association with rebelliousness and social marginality. If the heroine rescues him from sexuality without emotional commitment, he will rescue her from social and sexual conventionality. Valentino's marginality was inscribed in unmistakable racial and ethnic terms that were difficult to recuperate within a wildly xenophobic and racist culture; with Barrymore, the appeal of social and sexual marginality is inscribed as class difference. The opening title of *Tempest* announces the film as "The storm tossed romance of a poor dragoon and a princess." As in *Beloved Rogue,* class difference displaces the more unsolvable dilemmas of gender difference: difference takes a social, hierarchical form that reverses normative sexual ideology — prince and beggar girl are replaced by princess and beggar boy — and rather than marriage marking the social elevation of the poor female, in these films marriage marks the woman's acceptance of the male's social marginality. The woman rejects the conventional, "safe" life and chooses the physically attractive, socially inappropriate male who sexually fascinates.

As simple as this romance formula may appear, Barrymore's romantic melodramas of the 1920s use this strategy to create a complex relationship between the female viewer and heroine through the inscription of the gaze. The heroine serves as the moral anchor of traditional feminine sexual purity, but she is not precluded from exhibiting a sexual interest in the hero not unlike that of the female spectator. When the heroine appraises the male body, the act does not always mark the presence of a vamp as in Valentino's *Blood and Sand*. The good girl is also allowed to look, but with qualifications. For example, in *Tempest,* the heroine, Princess Tamara, gives the poor hero, Sergeant Ivan Markov (Barrymore), the once-over when she sees him before the military review board in his quest for an officer's commission. But when he looks back, she stops looking, and what started as a playful interchange leads to a tragic misunderstanding, one not shared by the audience. The Princess, unaware that earlier in this scene Markov almost swooned at the sight of her, thinks he is merely in lust. The audience, armed with the privileged sight of Barrymore virtually fainting from bliss after his first glimpse of Tamara, knows Markov is in love. Consequently, the audience can wait

patiently for the unification of the couple, which will necessitate the Bolshevik revolution to level the class differences between them and reveal his compassionate and noble nature to her.

In *Loving with a Vengeance,* Tania Modleski suggests that the superior position of knowledge possessed by readers of Harlequins vis-à-vis the books' heroines results in a "schizophrenic" or "apersonal" reading analogous to the symptoms of hysteria.[51] I would argue instead that this particular example from *Tempest,* and Barrymore's romances in general, are similar in their "authorial voice" to Harlequins but that they suggest another function for this technique. The "splitting" of the spectator/reader allows her partially to identify with the heroine but also to cross readily the boundaries of gender and identify with the hero, whose emotional transformation is so crucial to her fantasy of a reconciliation between masculinity and femininity. The spectator/reader can revel in the superiority of her "reading" of patriarchal masculinity over that of the heroine since she sees the full range of compassion, kindness, and tenderness present in the hero's basic nature long before the heroine.

According to Radway, the revelation of the hero's hidden "feminine" sensibility means that modern ideal romances avoid addressing the cultural construction of masculinity: the desired transformation of the hero is an already accomplished fact from the beginning.[52] Conforming to Radway's description, Barrymore's *Beloved Rogue* and Valentino's *Blood and Sand* share a noteworthy strategy for inscribing the hero's motherly capabilities. The heroine's first gaze of attraction coincides with the appearance of the hero's mother. Hansen reads this moment in *Blood and Sand* as one that serves to sanction Carmen (Lila Lee) as "the legitimate companion" for Valentino,[53] but the audience's gaze at mother and son, and likewise the following close-up of the heroine's face and the trajectory of her gaze at the same loving couple, strongly figure in the process of sanctioning him to the audience as an appropriate partner for her. In *Beloved Rogue* a similar pattern occurs with humorous play on the improbability of the couple and the mother's expectations for her son. Villon and Charlotte slide down a snowy embankment into his mother's apartment. Mother and son greet each other with elation. He kisses her all over her face and rocks her back and forth in his arms. A reverse close-up shows a smiling Charlotte as she watches them. The loving interaction of the hero and his mother affirms his unusual ability to retain a close identification with a woman and shows he has not completely rejected his "feminine" side. He can be counted on, then, to

reconstruct the intensity of the blissful symbiotic ideal of the early mother-daughter bond in his relationship with the heroine.

If "women-made men" such as these recall the wish for the total love of the mother-child bond, the hero is not completely "feminised." Through emphasis on his association with adventure, with excitement, and playful masquerades, he may also stimulate a memory trace of the paternal imago of the "exuberant, exciting father" who, according to Jessica Benjamin, symbolises the young child's "own sense of activity and desire" as he also provides the child with a psychological barrier against the fear of being overwhelmed by the mother.[54] Even if these romances do, perhaps, articulate fragments of archaic fantasy and attempt to reconcile patriarchal norms of motherhood and fatherhood into one impossible feminised man, they are also important articulations of the social discontent of their historical female audience. Providing a secure context for indulging in a fantasy of mutual romance and sexual interest, their mythologised settings and marginalised heroes signal a rejection of a middle class life style. In doing so they may register a measure of feminine social discontent with the normative model of American courtship and marriage. However, we must not forget that they still work to calm women's anxieties about masculinity, and the films neither redress the inequality of male-female relations nor question the heterosexual presumption. In this respect, they are entirely consistent with other culturally transmitted messages to women in an era obsessed with the possible sexual empowerment of women. The escapist textual regime of the films would certainly make imitation difficult outside the text. The "woman-made" masculine ideal promoted by the films would make imitation more difficult for men than for women. Perhaps a sense of that is evidenced in the numerous letters of protest from men who told the film industry to "quit kidding the girls" about love.

If they are read as models for female imitation, these films can easily be dismissed as being profoundly reactionary; however, if we assume that female spectators possessed a measure of psychic autonomy preventing passive identification with the heroine, then the films pose a number of questions about film reception, the inscription of female looking, and cultural context that may broaden our view of the "woman's film" and its use by female audiences. As a domain of representation inseparable from coextensive cultural forms addressed to women, such films, we must remember, would not be read in a representational vacuum but be interpreted as one of a number of fictions, of fantasies recognised as such and also appreciated for their sensuous textures, imagi-

native excesses, and pleasurable freedom of appropriating a gaze at once voyeuristic and intimate. While the female spectator of Barrymore's films enjoys the male star in his eroticising function as an image constructed for her pleasure, she is not fixed into one position of identification but enjoys a certain freedom. But that freedom in objectifying the male and also identifying with him is only a temporary liberation and, I must admit, a suspect one. She may visually appropriate the male body for her own pleasure, she may hold the whip on Hollywood, but, as always in the patriarchy, the female spectator must watch out for the backlash.

Notes

The research for this paper was funded, in part, by an award from the University Research Council of Emory University.

1. Helen Carlisle, "The Movie Fan," *Motion Picture Magazine* (Nov. 1922): 50–51.

2. Adela Rogers St Johns, "What Kind of Men Attract Women Most?" *Photoplay* (April 1924): 40–41; 112–13. Beth Brown, "Making Movies for Women," *Moving Picture World* (26 March 1927): 342.

3. "The Scarlet Streak," *Exhibitors Trade Herald* (5 Dec. 1925): 29.

4. "Dresses-Hats-Jewels," *Exhibitors Trade Herald* (28 Nov. 1925): 18.

5. Frederick James Smith, "Does Decency Help or Hinder?" *Photoplay* (Nov. 1924): 36.

6. Ibid.

7. "To a Young Girl Going to a Photoplay," *Photoplay* (Feb. 1919): 1.

8. Will Durant, "The Modern Woman," *Century Magazine* 113 (Feb. 1927): 422.

9. "Love," review of *Love, Variety* (15 Aug. 1927): 17.

10. Miriam Hansen, "Pleasure, Ambivalence, Identification: Valentino and Female Spectatorship," *Cinema Journal* 25, no. 4 (Summer 1986): 6–32. Since my writing of this article Hansen has corrected her claims regarding Valentino's status as "the first major star" for a female film audience. See her book *Babel and Babylon* (Cambridge, Mass., 1991).

11. Herbert Howe, "Close Ups and Long Shots," *Photoplay* (Feb. 1926): 52.

12. Smith, "Does Decency Help or Hinder?" 36.

13. Hansen, "Pleasure, Ambivalence, Identification," 23, 7.

14. St Johns, "What Kind of Men Attract Women Most?" 112.

15. James F. Clark, quoted in "Sex O'Clock in America," *Current Opinion* 55 (August 1913): 113.

16. Charlotte Perkins Gilman, "Vanguard, Rear-Guard and Mud-Guard," *Century Magazine* 104 (July 1922): 351.

17. Louis Bisch, "Are Women Inferior or Are They Trying to Side Track Nature?" *Century Magazine* 113 (Feb. 1927): 674–81; and Lorine Pruette, "Should Men Be Protected?" *The Nation* 125 (31 Aug. 1927): 200–1.

18. Pruette, "Should Men Be Protected?" 200, 201.

19. Allan Leigh, *Women Like Men* (New York, 1926), 214–15.

20. Beatrice Hinkle, "Women and the New Morality," *The Nation* 119 (19 Nov. 1927): 541.

21. Anthony Ludovici, *Woman: A Vindication* (New York, 1923); all quotations are from pp. 290–91.

22. "Pink Powder Puff," *Chicago Herald Tribune*, 18 July 1926, 10.

23. Hansen, "Pleasure, Ambivalence, Identification," 23.

24. John Carroll, *The Matinee Idols* (New York, 1972), 42.

25. Ibid., 15–16.

26. John Barrymore, *Confessions of an Actor* (1926; reprint, New York, 1971), n.p.

27. Carroll, *Matinee Idols*, 147.

28. Julian Johnson, "The Art of John Barrymore," *Photoplay* 15 (Feb. 1919): 55.

29. John Kobel, *Damned in Paradise: The Life of John Barrymore* (New York, 1977), 126.

30. Ibid., 145.

31. "Don Juan," *Variety* (11 Aug. 1926): 12.

32. Charles Darnton, "They Love Barrymore," *Screen Secrets* (28 Nov. 1925): 40.

33. Joseph Hantover, "The Boy Scouts and the Validation of Masculinity," in Elizabeth Pleck and Joseph H. Pleck, eds., *The American Male* (Englewood Cliffs, N. J., 1980), 287–88.

34. Elizabeth Pleck and Joseph H. Pleck, introduction to Pleck and Pleck, eds., *American Male*, 28.

35. Michael Monahan, "The American Peril," *Forum* 51 (1914): 878.

36. E. Anthony Rotundo, "Manhood in America: The Northern Middle Class, 1770–1920" (Ph.D. diss., Brandeis University, 1982), 302.

37. Hantover, "Boy Scouts and the Validation of Masculinity," 208.

38. Chester Fernald Bailey, "The White Umbrella," *Ladies Home Journal* (Sept. 1919): 12.

39. Emma Lindsay Squire, "But Once an Emperor," *Ladies Home Journal* (May 1923): 10ff.; also idem., "The Trembling God," *Good Housekeeping* (Feb. 1925): 48ff.; and idem., "The Ungrateful Gate," *Good Housekeeping* (May 1925): 38ff.

40. Peter Filene, *Him/Her Self: Sex Roles in Modern America*, 2d ed. (Baltimore, 1986), 138–39.

41. Janice Radway, *Reading the Romance* (Chapel Hill, 1984), 128, 168.

42. Ibid., 136, 145–51, 78.

43. Nancy Pryor, "The Sheik Stuff Is Out: Hugh Allen Says It Leaves Him Cold," *Motion Picture Classic* (June 1928): 26, 87.

44. Steven Neale, "Masculinity as Spectacle," *Screen* 24 (Nov.–Dec. 1983): 14–15, 8.

45. Hansen, "Pleasure, Ambivalence, Identification," 20, 19.

46. Sigmund Freud, "A Child Is Being Beaten," in Phillip Rieff, ed., *Sexuality and the Psychology of Love* (New York, 1963), 119.

47. Charles Affron, *Star Acting: Gish, Garbo, Davis* (New York, 1977), 116.

48. Georges Bataille, *Eroticism* (San Francisco, 1986), 24.

49. Ibid., 2.

50. Freeman Tilden, "Flapperdames and Flapperoosters," *Ladies Home Journal* (May 1923): 16ff.

51. Tania Modleski, *Loving with a Vengeance* (New York, 1984), 57.

52. Radway, *Reading the Romance*, 148–49.

53. Hansen, "Pleasure, Ambivalence, Identification," 12.

54. Jessica Benjamin, *The Bonds of Love* (New York, 1988), 131, 119.

9

Narrative, Sound, and Film

Fassbinder's The Marriage of Maria Braun

ROGER HILLMAN

Narrative beyond the Novel

Narrative is more basic to living than is its presence in the novel or other forms of art. The philosopher Alasdair MacIntyre claims: "Man is in his actions and practices, as well as in his fictions, essentially a story-telling animal." In this view there is a narrative pattern in life; human actions are enacted narratives. Shrouding art in moral dubiousness — as does Thomas Mann, whose works centre on a dichotomy between art and life — impoverishes for MacIntyre "any narrative understanding of our-selves. Yet . . . such an understanding . . . continuously recurs within art: in the realistic novels of the nineteenth century, in the movies of the twentieth century."[1] In Wim Wenders's *Wings of Desire,* storytelling has just such an existential role, with the venerable Curt Bois seeking to preserve with his youthful gaze the stories through which his city has constituted itself, his roving across the centuries matching the same de-materialized capacity in the angels of the film.

In film, either intertitles or voice-overs not originating from any of the characters on screen can approximate the omniscient narrator of a novel, as in Tony Richardson's *Tom Jones* or Fassbinder's *Effi Briest,* or have a similar stamp of narrative authority — an authority problematised elsewhere in this volume — in a documentary. But the visual, dramatic side of film frequently confines narration to images and dialogue — and, as I shall argue, to sound beyond the dialogue. A slanting to one charac-

181

ter's point of view can nonetheless be achieved when that character takes up a verbal narration. Otherwise, a personalised narrator (as distinct from a "Camera I" as narrator through length of shots, lighting, etc.) is less usual in film than in the novel. Certainly it is possible to signal the unreliability of such a narrative perspective (e.g., the young girl in Malick's *Days of Heaven*) through dialogue and visuals. Leaving aside for the moment any qualification at the level of sound, the visuals are perceived as either the ultimate narrative instance or the honest, if misguided, point of view of a character. Challenges to this particular stability of audience expectations verge on the anarchic.

Seymour Chatman writes of the sequel to a murder in Hitchcock's 1950 film *Stage Fright*, when "there is a dissolve to the 'events themselves.'"[2] Only at the end do we become aware that this account, with the camera as accomplice, is the true murderer's false testimony and that even "the images lie as well as the words."[3] Hitchcock himself defended the procedure of telling "a lie through a flashback,"[4] which certainly undermines the viewer's position and the assumed consistency of the camera eye. However, the visually unreliable aspect of a narrative can be conveyed by music. *The New Grove Dictionary of Music and Musicians* gives the example of David Lean's *Ryan's Daughter:* "At one point . . . events seen on the screen take place only in the schoolmaster's imagination, and this is made clear by the accompanying use of Beethoven's 'Eroica' Symphony, earlier associated specifically with the man's thoughts."[5] Music here signals that the visual images are externalizing processes of the mind.

Narrative in Music

The visual aspect of film still holds most critics in thrall, and the dimension of sound, including music, frequently receives token mention, if any. As long ago as 1945 Vaughan Williams made the bold claim: "I still believe that the film contains potentialities for the combination of all the arts such as Wagner never dreamt of."[6] It is a potential that has remained largely unrealised through the virtual preoccupation of the film industry and film criticism with functional and realistic music, whereas the possibilities are in fact richer.

But before these are explored, music itself needs to be approached as narrative. As a generally nonrepresentational art, instrumental music is

rarely viewed in this light, not figuring for instance in the lengthy list Roland Barthes makes of forms of narrative.[7] Yet music can certainly seek to represent in sound a written text, as with *Peter and the Wolf* or a Schubert setting of a poem. A specific, often more abstract instance of this representation is programme music, which in turn can lead to a "programme film" such as *Fantasia* using the music as a further text. Beyond the level of a kind of musical onomatopoeia—the drums invoking thunder in Beethoven's "Pastoral" Symphony or cuckoo imitations across the centuries of musical history—the rendering of ideas in nonvocal music is problematic. But inasmuch as music can express a narrative line, it qualifies as one of the transferable aspects of narrative.

The whole process can be far subtler than the simultaneous expression in the orchestra or piano of emotions conveyed by a vocal rendition of a text. In Schubert's song cycles the piano accompaniment frequently provides a commentary on the action, just as in Mozart and Verdi operas the orchestra can function as onlooker. Music also abounds with conventions that yield rich possibilities for symbolism, a narrative embedded in the text. One such example is Berg's use of open fifths in his opera *Wozzeck,* the interval from C to G, for instance, without an intervening E or E♭, which would be expected in Classical tonality to define major or minor key and hence convey that sense of direction that underlies Classical harmony. Berg later explained his intentional use of the ambiguous, more expansive interval for situations when Marie is confronted by or "open" to the unknown. This figure in conjunction with a carousel-like two-note alternation links the conclusions of Acts I and III of *Wozzeck,* in each case as an orchestrated commentary on the tragedy of the title figure and Marie. The music is in each case a postlude to a verbal text, not a parallel accompaniment, so that its narrative function depends on the text for substance but does not directly refer to it. In the final bars of the opera the two-note figure simply stops on the upbeat, with no contrasts in tempo or dynamics and hence no sense of the cadence to which even music of the Romantic period finally found its way. Through discarding this basic musical convention a telling narrative effect is created. With the sense of endlessness in the final bars— no musical logic dictates just when they should trail off—Berg creates an open-ended opera, with the perpetual motion of the quaver rhythm conveying more eloquently than any words or setting of words the changeless, cyclic quality of human life. In turn the open fifths supplement this effect with their archaic implications, recalling music before the development of Classical harmony. With its musical sense of a time-

less society, not a particular historical phase of Western music, this narrative device raises the tragedy of the one individual, Wozzeck, to a universal context, a pattern not localised in history. All this demonstrates music as a powerful narrative tool going well beyond any word-painting function.

As a bridge to the use of music in film I should like to give a further example from opera to illustrate the narrative force of musical idiom. It comes from the final stages of Richard Meale's *Voss,* the first full-length opera commissioned by the Australian Opera and hence largely without precedents. With its libretto by David Malouf based on Patrick White's novel, it faces the question so frequently encountered in film of the adaptation of subject matter from one art form to another. Malouf saw the communion between Voss and Laura Trevelyan as existing "in some spiritual dimension where space, time and the barriers of the individual soul are immediately dissolved. I call this daring because it is, in fictional terms, non-realistic and challenging of the normative narrative conventions. But music is itself such a dimension." He then formulates the challenge in terms that are wholly relevant to a discussion of film techniques, citing opera's "ability to give voice simultaneously, in vertical ensemble, to characters who may be speaking out of different worlds and different world views, and from different places."[8]

In Meale's *Voss* various European composers of the early twentieth century are called to mind; there is little trace of a distinctive sound to convey the Australian wilderness, such as composers like Antill and Sculthorpe had attempted. In the final bars preceding the cadence we hear music strongly reminiscent of Mahler's *Song of the Earth.* It sets the last words of Malouf's text, "The air will tell us," and is clearly designed to evoke a dissolving of human individuality into the elements such as occurs in Mahler's work. But this musical reference in its exposed position works against the overall conception of composer and librettist. While aiming at universality, resorting to Mahler for want of any clearly developed idiom of its own sounds like a musical return to Voss's European roots, and hence it diminishes the narrative to one strand. This is a Voss who has throughout been heavily accented; in places he actually speaks German and in Act II utters the words "I am a desert that no man can enter." The conclusion of the opera privatises the desert to the inner expanses of Voss's mind and capitulates in terms of musical narrative before the broader spaces coexisting in the text. What the *music* says destabilises what the *text* says by involuntarily reducing it. In film the

converse is probably more frequently encountered; the screen context of music can diminish the source. The *Elvira Madigan* theme, with the music dripping with associations from the film, sentimentalises the Mozart original. When film gets the idiom right, music can however be a singularly effective narrative tool.

Beyond Realistic and Functional Film Music

Realistic music in this context means music that "is written into the scenario as an integral part of the action."[9] Hence music can be dramatically foregrounded in the life of a composer, from Cornel Wilde as Chopin (*A Song to Remember*) through to *Amadeus* or the more complex *Death in Venice*. It can be present on a smaller scale in scenes set in jazz dives, concert halls, and open-air festivals (*Woodstock*) but also just with a piano playing out the back. In Percy Adlon's *Bagdad Café* the pianist labours over and over at a mechanical rendition of Bach until the transforming presence of Jasmin creates magic with the music, too. Such use of realistic music advances the narrative in telling us about the player and the listener and in no sense reeks of an arbitrary insertion to lend tone to the film or seek self-legitimation as an art form. Realistic music can also emit from a record player or a radio and, in the latter case, locate an era, as in the young boys' passion for jazz in Bo Widerberg's *Adalen 31*.

These possibilities can easily be trivialised, the presence of music appear incidental, the choice of music lack narrative logic. But it *can* exert a powerful narrative force, as in Ingmar Bergman's *The Silence*. This film featured silence at many levels, with two sisters, already failing to communicate with each other, in a country whose language they do not understand, attended to in a hotel by a mute waiter. Apart from a few snatches of dance rhythms the only music comes in a scene when Bach's *Goldberg Variations* are played on Ester's radio. For a few moments the Bergman bleakness is dispelled, the door between the sisters' rooms is opened, they exchange cigarettes, and the waiter's face is transfigured. Briefly the self-perpetuating silence at all levels is banished. The Bach excerpt is technically realistic, and it pivots the film's narrative, briefly exposing possibilities that are not pursued and intimating another narrative world. Beyond Bergman's film silence is in fact the alternative

narrative possibility for conveying what transcends words. More pervasive is the Romantic perception of music as an expression of the ineffable.

Nonrealistic or functional music is what we probably most readily think of in connection with film, music designed to further effects and mood and in some cases overdetermined to the point where it is meant to create them. Such an illustrating role was present in the era of silent films, where music already commented on the action. A host of original scores have this function, but to lend narrative point it is also possible for a well-known, even hackneyed theme to be effectively alienated. The *New Grove* tells us that "for Hitchcock's *Shadow of a Doubt* (1943) Tiomkin embellished the Merry Widow waltz with what he described as 'horror harmonies and orchestration'; this was . . . justified, for the story concerned a homicidal maniac with a penchant for wealthy widows."[10] At its best, functional music can carry far more weight than merely underlining a mood. The Philip Glass score for *The Thin Blue Line* matches perfectly the characteristic style of the composer and the theme of Errol Morris's film. The repetitive, disembodied quality of the music keeps suggesting the same qualities in the system of justice that confronts Randall Adams. This music pulls no heartstrings, but its motion and its texture keep reinforcing, not the visual images themselves, but what those images imply. In Peter Weir's *Picnic at Hanging Rock* the musical theme, in conjunction with some stylised photography, is foregrounded *as* the mood. It functions virtually as a component of the plot, not in the same sense as realistic music, but as vehicle of the action — music, without the visual image of its performance, *as* narrative. Without it the pull exerted by Hanging Rock would only be posited. The music itself seems to draw the children, the pagan lure of the panpipes and the swells of the organ sound (with atavistic associations of a theatre organ in a silent film?) create a compelling atmosphere that is crucial for the film to sustain the narrative weight attached to the girls' disappearance. Their vanishing can remain mysterious but must not seem implausible. The music suspends rationality while simultaneously heightening the element of mystery and making the latter credible through its intensity.

Even the established uses of music in realistic and functional veins in film are often overlooked. When they are not, as in an extensive work by Roger Manvell and John Huntley, *The Technique of Film Music*, functional music is treated under such headings as "Music and Action," "Scenic and Place Music," "Period and Pageant Music," "Music for Dramatic

Tension," "Comedy Music," and "Music for Human Emotion."[11] This catalogue is reminiscent of the set pieces prescribed for certain moods and situations in silent films. But it seems to exclude subtler musical possibilities that are neither realistic nor functional in the above senses. Music used in film can convey a cultural code whose presence is more important to the film than any emotive qualities of the melody used. By definition this involves preexisting music and not original film scores, since the whole effect is based on resonances already attached to the work. As Adenoid Hynkel, Charlie Chaplin (*The Great Dictator*) playfully toys with a globe of the world to the strains of shimmering strings, which might seem hopelessly misplaced in terms of conventional film music stereotypes. But this is not romantic music in a Hollywood sense; this is what Thomas Mann called the quintessence of German Romanticism, the Prelude to Act I of Wagner's *Lohengrin*. Debased in the Nazis' cult of the antirational, Romanticism is represented by a composer who was Hitler's favourite and strongly anti-Semitic. This gives Chaplin's other role of a Jewish barber a further macabre twist. The use of this music in this film scene is patently nonrealistic and by conventional criteria seems dysfunctional, but it demonstrates music as cultural code, the coding in this case being highly political. In a film parodying Hitler, the use of Wagner's music has to have pan-Germanic overtones.

However, the *Lohengrin* reference recurs in the final frames of the film, with Paulette Goddard's Hannah in the fields and Chaplin's Jewish barber who has been mistaken for Hynkel delivering his extended message to humanity. The parallel in action is clear: first the supposed but false Great Dictator, whose balloon world bursts, and ultimately the truly Great Dictator, the visionary. But, unwittingly perhaps, using the Wagner excerpt to reflect the parallel is problematic, because in the German context on which Chaplin is drawing it has particular cultural connotations such as those mentioned above. Yet these recede when it is also required to herald the final vision that transcends contemporary history. In fact Hannah says "Listen," and all we hear is this Wagnerian music as the final sound effect. Is this the true Romantic spirit? Is the secrecy surrounding the legendary Lohengrin's name a springboard for the truly great dictator, eclipsed for the moment by the look-alike historical aberration? Chaplin dictated the shape of his musical sound tracks, saying he wanted more Chopin here or more Wagner there, and it is hard to imagine this particular choice being arbitrary or else dictated by a purely emotional response to culturally loaded music. This film is an

interesting test case for film music as narrative, and its ending is painful not only because of its didacticism but also because of the undoing of an initially brilliant musical commentary.

The Marriage of Maria Braun

A virtuosic, sovereign control of music and indeed sound in general is to be found in Fassbinder's *The Marriage of Maria Braun*. The film is framed visually by an image of Hitler, dislodged from its mounting inside the registry office as the marriage of the title is formalised in ludicrous fashion. Public then frames private, and history dwarfs all. But the overbearing impression is made by the sound track, above all the cacophony of bomb raid sound effects. These find an echo throughout the film in the many scenes in which buildings are being reconstructed and still more occasions when the sound of this construction work intrudes on interior shots. The jackhammers consistently sound like machine-gun fire, so that, although there is no further bomb raid, the opening sound effects function as something of a leitmotif. The ruins that never seem to be restored further underscore a sense of things not fundamentally changing at one level, however much the signs of Economic Miracle prosperity are apparent in clothing, food, and the like. At the beginning of the film, sound swamps image; this is a point at which music frequently indicates a film's mood and theme, covering for the break in narrative as titles flash on the screen. Here in place of a melody that recurs we hear the sounds of battle, a baby's cry, and some elegiac bars of Beethoven, the Ninth Symphony. The baby never incarnates, and this cry remains the last sign of regeneration in the film—Maria does fall pregnant but bears no child. The music is undoubtedly a dirge for the destruction of the other Germany, the nation of poets and thinkers rather than of Hitler, for a tradition of humanism at whose pinnacle stands Beethoven's Ninth. It possibly stands too for the exclusivity of German preoccupation with the mind at the expense of political maturity throughout its history leading up to the point at which the film begins. There is a living-room scene in Grass's novel *The Tin Drum* in which a picture of Hitler and a bust of Beethoven glower at each other across young Oscar—his dual inheritance. With Fassbinder the same constellation is present at the outset, though significantly not in both cases through the camera. Instead we have a picture of Hitler fol-

lowed by the *music* of Beethoven, which modulates back to the world of Hitler via an air-raid siren that at first sounds like an instrument of the orchestra going off in a different key.

Fassbinder quotes Beethoven briefly as an elaborate cultural coding, as a swansong to those values destroyed before the film's opening and not recovered in the course of its action, which ends in 1954. Such a weighted musical reference is far from gratuitous and further still from the plundering of Beethoven in silent movies, in which, according to the *New Grove,* "various overtures" of his "were recommended as suitable for tree-felling, aeroplane dives and Red Indian chases."[12] The choice of music rather than a visual image to represent this cultural marker accords with Fassbinder's avoidance for the most part of concrete setting or plastic imagery. Its subsequent identification by a radio announcer reinforces the emphasis away from any notion of theme music in the direction of historical (and cultural) framing. He interrupts Beethoven's Ninth to read out a list of names of soldiers missing in the chaos of the immediate postwar period. Not heeded by the foregrounded actors, and untranslatable by single-stranded subtitles for non-German audiences, this intrusive voice generalises the fate of Maria's husband Hermann and lends a pretence of documented verification to the narrative framework.

Early in the film comes a scene in which Maria is seeking work as a bar girl in a nightclub run for the occupying American forces. As she speaks with her employer, the sound track has some vaguely exotic music to stress the off-limits nature of her future work, but this is surrounded by two snippets of classical music, the first an orchestral extract, the second a duet. They in fact both come from the opera *Der Rosenkavalier.* This opera's plot has the following complications: a youth, loved by an older noble woman, is sent by a dissolute baron as his emissary in winning the hand of a beautiful young girl. Octavian, the youth, presents the silver rose, entering to the strains of the first snippet in Fassbinder's film, and predictably he and Sophie, the girl he is meant to be wooing on another's behalf, fall in love. The older woman ultimately renounces her own feelings for Octavian and blesses the union of the young lovers, which is celebrated in the second Fassbinder quotation. In this duet Sophie sings: "Tis a dream, cannot be really true / that we two are together / together for all time and for eternity!"

Standard film music frequently uses late nineteenth-century harmonies and orchestral textures such as those of Richard Strauss for their overt emotional impact. These lend themselves well to use of the leit-

motif as in Wagner's operas, in which a musical fragment can identify a character or a theme of the plot; the applicability of this technique to film narrative is clear. This can easily deteriorate to an involuntarily comic effect, a *Pink Panther* theme run amok, and recall Debussy's barbed comment about Wagnerian heroes forever presenting their visiting cards in song.[13] A far subtler, artistically more effective possibility is that of narrative anticipation or disclosure, available to film either in its script or its visual symbolism, but in the example of *The Marriage of Maria Braun* conveyed solely by music.

In no sense can the references to Strauss's opera be understood as Maria's point of view, her only comment on art being that the works of Heinrich von Kleist would not burn well to keep out the cold of postwar privation. Instead, various overlaps between film plot and opera substitute in sound for the novel's convention of an omniscient narrator. Maria clings to her illusion of a marriage that lasted a whole night and half a day before she and Hermann were separated, first by his return to the front and then by his imprisonment on her behalf. Before they finally are reunited Hermann establishes himself as an apparent *Rosenkavalier*. Once freed from prison he goes into self-imposed exile, for reasons unclear at that stage of the film, and regularly sends a rose to Maria. As we learn at the end, he has in fact been bought out by Maria's lover, and his absence until the latter dies is a trade-off for being the only legatee in the lover's will apart from Maria.

The situation in Strauss's opera is then perversely inverted, and Maria's knight of the rose agrees in the interests of another *not* to woo. Out of the marriage of physical absence Maria spins a romantic construct akin to Strauss's opera, and this narrative strand is spelt out in the sound track but also most effectively camouflaged there by the accompanying visual images to which there is no immediately apparent connection. In terms of the cultural code explored with Beethoven's Ninth, it is worth pointing out that this opera glitters with Viennese nostalgia for a social class and a style of life swept away just three years after the premiere by the outbreak of World War I. The construction of Maria at this point of the film spins a musical fairy tale round a historical anachronism.

Conveying the construct through music creates the only break in the narrative's linear time. Via the music there are forays into the future at the inner level (Maria's dream of a dénouement that is denied her) and into the past at the outer level. This two-pronged reach captures the tension between the progression of the characters through narrated

time and the stasis or even regression of the historical forces blighting their lives, a tension underlying the whole film. In a book slanted to the classical Hollywood cinema of the 1930s and 1940s, Claudia Gorbman writes how significant action and dialogue are deferred during the performance of songs.[14] With Fassbinder, on the other hand, the significant dialogue is precisely that of the song lyrics, or opera libretto. Many of his films overlap with Gorbman's concerns, for she sees the classical Hollywood film as being fundamentally melodrama, Fassbinder's home territory. But the subtle musical aspect of the melodrama surrounding Maria Braun transcends any of the models offered by Gorbman's material. Music is not just an adjunct to the camera, opening up the linear representation of narrative time when it "accompanies montage and slow-motion sequences, imitates flashbacks, and so on."[15] In this Fassbinder example the music alone makes this leap in time, the visual level remaining linear throughout. A narrative thread that is later picked up visually is acoustically foretold here, at least for a significant proportion of his German art-film audience.

In the final scene of the film Hermann does return to claim his bride and his inheritance. Their coming together after surviving such an extended separation is shown in footage in which one of the two auditory levels again progressively takes precedence. In the foreground the couple engages in banal dialogue, and it becomes clear that, while he's no knight of the rose, she surely is a bartered bride. In the background, surviving the climax until the final sounds of the film, we hear an authentic radio commentary on the 1954 World Cup soccer final between West Germany and the favourites, Hungary. This completes the arch begun with the search for missing soldiers in the first excerpt, inasmuch as the radio announcer there ushered in a quest for missing identities in the wake of the severed link to the tradition of Beethoven's Ninth.

At the end a false national identity is found as underdog victors in the arena of the national sport. The commentator's voice rises in volume and fanaticism as the improbable victory is sealed, simultaneously with the defeat in the private realm of the lovers doomed to a melodramatic end rather than that of a romantic opera. The earlier promise held out by Hofmannsthal's libretto — "Tis a dream, cannot really be true / that we two are together, / together for all time and eternity" — becomes supremely ironic. The commentator's words "Aus! Aus!" ("It's all over") apply to Maria and Hermann, to the soccer final, and to any hopes Fassbinder might let the audience entertain of an uncompromised phoenix emerging from the ashes of history. For the commentator's ecstatic

"Deutschland ist wieder Weltmeister!" says it all: Germany, or at least West Germany, is indeed world champion, but in 1954 the literal meaning of "Weltmeister," "master of the world," can have one resonance only.

The Marriage of Maria Braun has been Fassbinder's most widely acclaimed film outside his own country, so that issues of cultural transference have not proved insurmountable. But the technical problems of the final sequence mean that a non-German audience gains a different slant. At the visual level the narrative is universal, but at the level of sound it is not, and when within the latter level two sounds compete and only one can be translated, then a crucial component of the narrative is missed. In terms of sound as narrative this means that a full richness of reception is available only to linguistic insiders. That in itself is a subtext of the narrative — the peculiarly German agonizing over an identity that remains an object of quest, all confined (in fully comprehending the film's narrative) to German speakers.

Fassbinder totally inverts the usual significance of the visual image in film. Throughout we never see the events mentioned on the radio, but these ultimately determine the fates of the characters. By the end we can barely hear the characters, and at no stage do they seem to register the political implications of what is broadcast. In this film the primacy of the visual is usurped by the auditory. Through the dislocation between what is seen and what is heard, the gap is established between historical message and individual consciousness. The montage of authentic radio broadcasts during the work furthermore bridges the gap between external reality and film's conscious representation of reality, its innate artificiality. And the reduction of *that* gap of course looks toward a more direct political statement. At one point in the film a "private" conversation is drowned out by a speech by Adenauer, the first postwar chancellor, denying any aspirations to rearm his state in the wake of World War II. But then toward the end of the film Adenauer retracts that claim. The Pandora's box of an armed German state is crucially positioned in narrative terms, immediately preceding an announcement of the soccer final against Hungary, a legitimised compensation for the same aggressive nationalism. Fassbinder clearly sees the two as linked forms of a latent chauvinism that has simply gone underground during the denazification of the postwar years and has learnt nothing.

Throughout the film Fassbinder's auditory narrative does not support the visual level, but undermines it. At the visual level too the narrative is cyclical. Supplementing the picture of Hitler at the beginning,

the film's final frames show an ancestral gallery of postwar chancellor portraits, with the omission of Willy Brandt, exempted from the historical reckoning of Fassbinder's coda. The ominous photo negatives have the same effect as the sound track, inverting the visual perception of the established exterior, the billboard portrait. The dissonant counterpoint of the sound track finally communicates to the visual level, and the viewer — not the characters — is shown directly the other side of the coin, the reverse of the photographic image. While all photographic images on the screen are two-dimensional, these photo negatives accentuate that quality and also of course the facelessness of the men portrayed. Theodor Adorno and Hanns Eisler claimed music restored spatial depth to this flatness, and it is technically telling that the negatives come right at the end, as if the sound track has to this point been propping up and filling out the hollowness of the material represented visually.

Helmut Schmidt, chancellor at the time when Fassbinder's film was made, alone is seen in photographically developed form, yet even he remains in the shadow of a black-and-white print. Passing review on postwar West German politics of course bursts the framework of the central narrative, which terminates in 1954, and represents a showing of his hand by the omniscient director akin to the *Rosenkavalier* example already discussed. The film's visual arch from Hitler to Schmidt also reinforces what is otherwise left to the auditory level, namely the framing of the events, their total circumscribing, by historical forces the fictitious figures never come to terms with.

The particular effect of this filmic narrative is a virtuosic use of simultaneous layers within the auditory level. Music itself has this twofold movement, horizontally through melody and rhythm, and vertically through harmony, through combinations of interrelated notes sounded together. Apart from the multiple resonances of individual words and images, this sort of simultaneity is largely closed to the novel, progressing in linear fashion in terms of reading time even when its narrative operates at different time levels. *The Marriage of Maria Braun* in fact saw the phenomenon, rare in German circles, of a serialised novel based on the film being released at the same time. Illustrated with stills from the film, it was criticised[16] for limiting the narrative to the love story of the protagonists and bypassing the social criticism discussed above. My analysis has aimed to show how a novelistic rendition of the film staying close to the scripted foreground cannot capture the narrative tensions, the political underpinning, and the virtuosic combination of the visual and auditory expressed in the film.

The spatial composition of film allows several statements to be made simultaneously, something without parallel in written language. A long description in a novel can be condensed into a single film frame. Simultaneity in spoken language is something usually confined to special effects, such as the rising cacophony at the end of Fassbinder's film, but in terms of narrative technique it's worth pointing out that the early reference to the duet at the end of *Der Rosenkavalier* also anticipates this, with the two singers singing different words. When the music harmonises we accept this dissonance in language. By the end of his film, Fassbinder has dispensed with the music, rewritten the operatic plot, and focussed obsessively on the dissonance in language and communication. The final penetrating sound effect is that of the phone off the hook, signalling dislocation even at the auditory level of communication.

Conclusion

Throughout his works Bakhtin pleaded for polyphony and dialogism in the novel as liberating forces overcoming the imposition of a single point of view. This narrowness he located in the law, both of social and aesthetic hierarchies. He championed a free play of voices against each other, allowing "an open system of relations rather than . . . a closed set of representations."[17] In Fassbinder's film this opening up occurs aesthetically. The auditory level, a corrective to that of superficial visual appearances, finally transforms its partner in counterpoint so that a historical pessimism emerges, a defusing of Bakhtin's carnivalistic challenge to authority. At the political level Fassbinder then exposes what he understood as a historically closed set of representations.

Bakhtin saw "dialogised heteroglossia" as "the exchange and interaction of two different languages," thriving "when foreign languages compete or when hierarchies break down."[18] Especially toward the end of the Fassbinder film visual and auditory languages compete, and their tacit hierarchy, apparently self-evident in this medium, is broken down. For all its richness in relation to the novel, Bakhtin's almost obsessive championing of this one genre blinds him to other instances of "this many-voicedness of the human historical world."[19] He continually plays off the novel as the ideal vehicle for heteroglossia against the epic and poetry, and this itself is questionable. But beyond that it is hard to imag-

ine better examples of "many-voicedness" than the stylistic montage in a Mahler symphony, or film fulfilling all the possibilities open to it. Not until film's auditory level is properly appreciated can Vaughan Williams's dream supersede Wagner's. Then the "potentialities for the combination of all the arts" may indeed be realised by film.

Notes

1. Alasdair MacIntyre, *After Virtue: A Study in Moral Theory* (Notre Dame, Ind., 1981), 201, 211.

2. Seymour Chatman, *Story and Discourse: Narrative Structure in Fiction and Film* (Ithaca, 1978), 236.

3. Robin Wood, *Hitchcock's Films* (New York, 1969), 37. Quoted in Chatman, *Story and Discourse*, 236.

4. Chatman, *Story and Discourse*, 237, n. 25.

5. Christopher Palmer, "Film Music," *The New Grove Dictionary of Music and Musicians*, ed. Stanley Sadie, v. 6 (London, 1980), 553.

6. Ralph Vaughan Williams, "Composing for the Films," in *National Music and Other Essays* (London, 1963), 162.

7. Roland Barthes, *Image Music Text*, trans. Stephen Heath (New York, 1977), 79.

8. Michael Ewans, "*Voss*: White, Malouf, Meale," *Meanjin* 3 (1989): 514.

9. Palmer, "Film Music," 550.

10. Ibid., 552.

11. Roger Manvell and John Huntley, *The Technique of Film Music* (Exeter, 1975), 5.

12. Palmer, "Film Music," 549.

13. Léon Vallas, *The Theories of Claude Debussy*, trans. Maire O'Brien (New York, 1967), 117.

14. Claudia Gorbman, *Unheard Melodies: Narrative Film Music* (Bloomington, Ind., 1987), 20.

15. Ibid., 55.

16. Anton Kaes, *Deutschlandbilder: Die Wiederkehr der Geschichte als Film* (Munich, 1987), 82, n. 17.

17. Kateryna Arthur, "Bakhtin, Kristeva and Carnival," in Sneja Gunew and Ian Reid, eds., *Not the Whole Story* (Sydney, 1984), 68.

18. Bruce Kochis and W. G. Regier, Review of M. M. Bakhtin, *The Dialogic Imagination: Four Essays*, ed. Michael Holquist, *Genre* 14 (1981): 532.

19. Sidney Monas, "'The Word with a Sidelong Glance': On Mikhail Bakhtin," *Encounter* 66, no. 5 (May 1986): 32.

10

Novel into Film

The Name of the Rose

GINO MOLITERNO

All the forgotten books that constitute those one remembers.
Elias Canetti, *The Secret Heart of the Clock*

Did he himself find on earth no reason for laughter? If so, he sought badly. Even a child could find reasons.
Nietzsche, *Thus Spoke Zarathustra*

The publication of *Il nome della rosa* in 1980 marked the apotheosis of a long and brilliant career that had seen Umberto Eco continually at the vanguard of literary and critical discussion in Italy from the early 1960s onward. Eco's first major work, *Opera aperta,* published in 1962, represented a milestone in Italian aesthetic criticism, ending decisively the Crocean regime and opening up a space for all the possibilities of structural and semiological analysis, a space that Eco went on not only to inhabit but largely to dominate for the next two decades with a steady stream of seminal scholarly publications. Then, after so much theory, and much to everyone's surprise, Eco published his first novel. The rest, as we all know, is history.[1]

The novel was an immediate success, winning the coveted Premio Strega in Italy in 1981 and, soon after, the Prix Médicis Étranger. It rose meteorically to the top of the bestseller list in Italy and remained there for 312 consecutive weeks. In 1983 Eco appended a series of reflections on the novel to the Italian paperback edition. In the same year

Secker and Warburg published an English translation in a hard-cover edition that went through five printings in 1983 alone. To date, in Italy, the novel has gone through twenty-four printings, sold two million copies, and become a new and indelible point of reference in the panorama of postwar writing. Worldwide, the novel has sold over nine million copies and has been translated into almost thirty languages including Russian, Chinese, Japanese, Korean, Albanian, Arabic, and Swahili.[2]

Swahili?! The mind gulps. Even at the risk of succumbing to a natural Eurocentrism here, one might still be surprised enough to ask: what would Eco's novel, originally written in inventive modern Italian, replete with long sections of liturgical, monastic, and learned Latin, dotted with scraps of ancient Greek, and completely founded on the Western culture of the book, what could this remarkable cento of European medieval culture look like when transposed into such an alien code as Swahili? Though I do not propose to attempt to provide any answer to this query here, the question itself is hardly otiose, for it brings up not only the issue of the fidelity of linguistic translation but the much wider question of appropriate strategies involved in the more complex process of a transcodification.

Leaving this question to one side for the moment, let us note that the success of the novel immediately ignited the interest of filmmakers. Marco Ferreri approached Eco for the film rights only three days after the book came out in Italy, and Michelangelo Antonioni followed only a few weeks later.[3] Eco apparently refused them both, and the dozen or so others who had also come forward, and eventually allowed his publishers to cede the rights to the RAI (Italian National Television), which immediately began to draw up plans for a TV mini-series. A young French filmmaker by the name of Annaud, a long-time worker in advertising and known only for his feature-length *Quest for Fire,* was also impressed by the novel's potential and apparently tried to contact Eco about the rights after having read only 200 pages of the proofs of the French translation. It took him a while but he did manage, finally, to wrest the rights from the RAI. It seems that his winning card with Eco was a school notebook in which Annaud had sketched and catalogued numerous medieval abbeys and monasteries as the result of a long obsession with the Middle Ages.[4]

Annaud's film took four years and a very large budget to make. The screenplay went through some fifteen different rewritings, and some big names were recruited for the task: Sean Connery and F. Murray Abraham were cast as William of Baskerville and Bernardo Gui respec-

tively, and the production was designed by Dante Ferretti and photographed by none less than Tonino Delli Colli. Then, amidst intense publicity and high expectations the film was finally released in late 1986, but it elicited only a lukewarm response and failed to make any real impact at the box office. It was relegated almost immediately to the overcrowded shelves of the video market as nothing more than "a whopping good tale, a medieval murder mystery."[5]

There was always a widespread belief that many more people bought the book than read it and there were probably many more people who enjoyed the film than the more astringent critics were willing to allow. Even allowing for this, however, the enormous disparity between the phenomenal success of the book and the abject failure of the film seems remarkable indeed. In fact, nothing would seem to better bear out the truth of the acute observation made many years before by George Bluestone in his *Novels into Film,* that "there is no necessary correspondence between the excellence of a novel and the quality of the film in which the novel is recorded."[6]

As Bluestone himself suggested, and as has by now been amply borne out by the many studies of film adaptation that have followed his seminal work, this has little to do with any inherent "inferiority" of the film medium with respect to literature but rather derives from the fact that cinematic codes and literary codes have very specific and very different modalities. Thus what comes to be involved in the cinematographic adaptation of a literary text is much more than a simple, if difficult, exercise in faithful translation. As Bluestone himself put it: "In the fullest sense of the word, the filmist becomes not a translator for an established author, but a new author in his own right."[7]

There can be little doubt that Annaud's film suffered harsh treatment precisely because it was so often and so insistently compared to the novel, but in this particular case such a comparison should have been regarded as quite inevitable. Given this inevitability, it would seem that the more fruitful question to ask is not whether the film could have avoided the fateful comparison but rather whether the film could not have adopted a more inventive strategy of adaptation, one that might, in fact, have made use of the comparison for its own purposes. In what follows I would like to examine briefly both the book and the film in order to try to gauge the adequacy of the film's adaptation of the novel. In the end, I will want to suggest, the film is a weak adaptation of the novel precisely because it fails to engage with the novel on any but the most superficial level of plot. The film translates the story of the book

but it fails to find a cinematic equivalent for its textual complexity, a complexity that is precisely what distinguishes *this* novel from other pot-boiler bestsellers.

The Novel

One begins to discuss the novel only with a sense of trepidation because as part of its extravagant popularity the book also spawned a virtual mini-industry in critical and exegetical studies.[8] Nevertheless, what seems to emerge insistently from most of these studies is the suggestion that the richness and the complexity of the novel are due largely to its masterly practice of allusion and intertextuality.

Although the term "intertextuality" is linked to the names of Kristeva, Barthes, Riffaterre, Bakhtin, and others and only dates from the 1960s, the phenomenon itself is probably as old as recorded human society and would appear to be inherent in any successful act of human communication. Briefly stated, the theory of intertextuality insists that a text simply cannot function as a closed and self-sufficient system. This is largely for two reasons, as Still and Worton point out:

> Firstly, the writer is a reader of texts (in the broadest sense) before s/he is a creator of texts, and therefore the work of art is inevitably shot through with references, quotations and influences of every kind. . . . Secondly, a text is available only through some process of reading; what is produced at the moment of reading is due to the cross-fertilisation of the packaged textual material (say, a book) by all the texts which a reader brings to it. A delicate allusion to a work unknown to the reader, which therefore goes unnoticed, will have a dormant existence in that reading. On the other hand, the reader's experience of some practice or theory unknown to the author may lead to a fresh interpretation.[9]

From this perspective, all texts would seem to be inherently intertextual though some texts — especially those we would regard as "literary" — dramatise their intertextuality more than others. The marker for such a process is the practice of quotation and of allusion in general, and *The Name of the Rose,* as has so often been pointed out, continually alludes to a myriad of other texts. Eco himself boasted on more than one occasion, perhaps with only slight hyperbole, that not a single word of the *Rose* was his own, and some of Eco's detractors immediately interpreted this as the admission of a lack of originality. Yet, given the social

and interactive nature of language, all texts, as Mikhail Bakhtin has suggested, are necessarily constructed as a mosaic of quotation, as all texts absorb and transform other texts.[10] This process is a sort of dialogue between books, as Adso himself discovers in the abbey library: "Until then I had thought that each book spoke of things, human or divine, that lie outside books. Now I realised that not infrequently books speak of books: it is as if they spoke amongst themselves."[11]

Intertextuality, then, is inherent in all texts, but, as has already been suggested, it is especially crucial to the function of literary texts. As G. B. Conte has pointed out in his study of allusion in the classical poets:

Intertextuality, far from being a matter of merely recognising the way in which specific texts echo each other, defines the condition of literary readability. Certainly the sense and structure of a work can be grasped only with reference to other models hewn from a long series of texts of which they are, in some way, the variant form. The literary text realises, transforms, or transposes in relation to these essential models. A literary work cannot exist outside this system; it can only be perceived if the reader is able to decipher literary language, and this ability presupposes familiarity with multiple texts.[12]

One of the most important mechanisms through which literary discourse engineers this intertextual play is the practice of allusion, and a closer look at the nature of allusion and Eco's masterful use of it in his novel definitely exonerates Eco from the charge of lack of originality whilst at the same time accounting for the novel's ability to work at a multiplicity of levels. Whilst the detractors of the novel objected to Eco's practice of allusion on the grounds that the author was here leading the reader by the nose, a more attentive look at this mechanism would suggest that it is no more, but certainly no less, than an invitation to a free and liberating hermeneutic dance.

As one of the few scholars who has attempted to define a poetics of literary allusion has observed, allusion is such a protean feature of ordinary language — and consequently of literature — that one often simply takes it for granted.[13] And, in fact, literary allusion can take a wide variety of forms: it can appear as a recalled title, a verbatim citation, or any of the many possible forms of periphrastic elaboration (commentary, summary, amplification, and so on). It is also present in parody, inversion, and other forms of *variatio*. In all of these manifestations certain features are common and are always present when the device is employed. In Ben-Porat's words,

These constants are the independence of both texts, the presence of a signal —
the directional marker — in the alluding text, the presence of elements in both
texts which can be linked together in unfixed, unpredictable textual patterns,
and the process of actualisation which reflects in all its stages the effort to re-
construct a fuller text.[14]

What should be noted here is the unpredictability, and the concomi-
tant indeterminacy and multiplicity, of the textual patterns that come to
be produced through this process, for the intertextual play thus insti-
tuted has all the characteristics of what another writer has called "a liber-
ating determinism."[15] The alluding text certainly obliges the reader, or
at least the attentive reader, to make a mnemonic detour to and through
other texts, but this journey is both liberating and productive since it
brings into play the reader's own interpretation of these other texts as
the important factor in the interpretation of this text. Allusion does not
prescribe and limit interpretation but rather prompts reinterpretation
through the reader's own recontextualisation. We glimpse here the im-
portant difference between creative allusion and slavish imitation, with
which it is often confused: imitation is mere formal repetition leading
to a return of the Same; allusion, on the other hand, is a force, a textual
dislocation, that utilises formal similarity only in order to transcend it
and thereby institute a reciprocal hermeneutic relationship that makes
possible not only a reinterpretation of the alluding text but of the al-
luded text as well. To take only the most obvious example: the continual
allusion to *The Odyssey* in Joyce's *Ulysses* not only invites the reader to
reinterpret the events of Bloom's day in Dublin in the light of the Ho-
meric text but may also lead the creative reader to a rereading and a
reinterpretation of the Homeric text itself. No such symmetry obtains
in the case of mere imitation, for here the role of the imitated text is
simply that of authorising and controlling its copy. Allusion thus does
not function to limit interpretation to a monotonous return of the Same
but rather dynamically returns the Same as always already different. By
engineering the multiple copresence of different texts in a new cultural
and historical context, allusion opens up the text to all the vicissitudes
of history and thus submits the entire tradition to a process of continual
reelaboration and reinterpretation.

Whilst traditionally the study of allusion in literature has been largely
confined to the analysis of poetry, it is clear that it is the novel, with its
generic and discursive largesse, with its capacity for incorporating all
sorts of heterogeneous texts, that provides the writer with the best op-
portunities for the exploitation of allusion to the fullest. The constant

and massive presence of allusion in classic novels such as *Don Quixote* and *Tristam Shandy* bears witness to this, and Eco's novel is firmly in their tradition. Moreover, closer examination of these novels has suggested that allusion is not used as ornament or even as a flag of erudition but rather functions as a structural principle of textual composition.[16] Clearly this is also the case with Eco's *Rose,* in which the allusions are not only to micro-units of others texts (words, images, lines, etc.) but to larger units such as narrative situations, entire books, and even more global units such as genres (the confessional novel, the historical chronicle, the *Bildungsroman,* the detective story, the horror tale, apocalyptic literature, and so on).

Such considerations help us to grasp some of the narrative complexity of Eco's novel, and in the light of such reflections *The Name of the Rose* can no longer appear as simply a fictionalised medieval chronicle bloated with learned quotes and bits of other books. On the contrary; since citation and allusion function as structural principles for the book, Eco's novel comes to be nothing less than a multiply stratified palimpsest (recall its very first words: "naturally, a manuscript"). This palimpsestic structure, deposited through layers of quotation and allusion, opens up a vertical intertextual space in which a dizzying multiplicity of heterogeneous texts is provided with a forum in which to dialogue (or polylogue), agree, disagree, and reinterpret each other in each other's light. The novel is thus both itself and all the other novels and texts it seeks to incorporate into its textual body. Fittingly apocalyptic, it attempts to be the book of books, the book-to-end-all-books, yet as such it merely manifests the essential but at the same time impossible, utopian, desire of every book to be *the* book, the book in which all preceding books are assimilated and find their fulfilment; to be, in a word, the Library. The *Rose* thus succeeds in reproducing within its own covers the aspect of the abbey library that Adso found so disturbing:

It was then the place of a long, centuries-old murmuring, an imperceptible dialogue between one parchment and another, a living thing, a receptacle of powers not to be ruled by a human mind, a treasure of secrets emanated by many minds, surviving the death of those who had produced them or been their conveyors. (286)

The massive presence and the structural function of allusion in the novel is thus the manifestation of literary megalomania, and in this Eco's detractors had probably been correct. Yet in the end this is merely an externalisation of the implicit desire of every novel and every author.

The great ingenuity of Eco's strategy, however, is to inscribe this desire of the text in the text itself, to dramatise this desire so that it becomes the story itself. The search for a book, for a book that *must* exist because it *should* exist, is placed at the very heart of the novel's *fabula*. The protagonists' quest for what comes to be a sort of "ultimate" book, *the* book whose discovery will bring with it the epiphany of enlightenment and meaning, takes place, at the level of plot, as a several-times interrupted journey through the labyrinthine abbey library, a library that, we should note, is itself structured as a book (verses from the *Apocalypse* above every door) and, in the last analysis, as the permutations of the Latin alphabet. What gradually becomes clear, then, to the attentive reader is that this search through the library is nothing less than a dramatised allegory of the process of both the composition and reading of this novel itself!

The simultaneous success *and* failure of the quest leads Adso to doubt, in the closing pages of the novel, whether anything that he has written has made any sense at all; does it contain, he wonders aloud, "some hidden meaning, or more than one, or many, or none at all" (501)? Since the text is allegorical, the ambivalent result of the quest at the level of the plot (the book *is* found but it is also destroyed in the process, along with the rest of the library) signals an analogous ambivalence regarding the novel's attempt to reconstruct the entire library through its practice of allusion. Adso's doubts about his own achievement in recounting the story imply a similar doubt about the novel's own success in becoming *the* book and thus raise the vexed and melancholy question: can *any* text, any book, ever really hope to be the ultimate one, the one that completes and seals the tradition, the last book in the Library? And this question, in turn, implies its correlative: can any reading, any single interpretation, ever hope to be fully exhaustive, complete, ultimate? The concluding epigram of Bernard of Morlay seems to supply the only possible answer: the complete meaning of the world and of things escapes us; we are only ever left with the words that name them.

Yet if on the one hand the palimpsestic structure of the novel and the practice of continual allusion has been an extravagant attempt to recall the entire library of tradition, to evoke the entirety of the already said and the already written in order to achieve some ultimate meaning (the "ultimate" book), on the other hand the riotous multiplicity and heterogeneity of the voices that have been summoned and allowed to speak in this intertextual space have undermined the gravity and seriousness of

such a project and have deconstructed in advance the pretensions to the monolithic truth at which it aims. In fact, through its obsessive practice of allusion the novel has managed to orchestrate such a raucous polyphony of voices that the terribly serious project of the Library of Babel of Borgesian memory has naturally and inevitably degenerated into a Rabelaisian carnival of babble: patristic authors have vied with nominalistic philosophers, heretics have cited the Gospels and been contradicted ad hoc, inquisitors have paraded a thorough knowledge of necromantic lore, and, at the head of it all, as in a *festa stultorum,* a pope has sought to redesign the Crucifix so that Christ can be shown with a purse in his hand, thus sanctioning worldly possessions. The comedy that erupts from all these incongruities is not only great fun, but it also signals that the battle between Jorge and William is played out both in the plot and at the level of allusion.

Jorge's great fear and his guiding motivation in the novel is that the discovery of Aristotle's lost book on comedy will legitimise laughter with the stamp of philosophic authority and will consequently inaugurate a generalised feast of fools. Jorge is the very spirit of monologism ("You are the devil," William says to him in the library). For Jorge *does* have the entire library in his head—in a sense he *is* the library—but when Jorge cites he merely seeks to repeat, he does not allude. For him, books do not speak to each other in an ongoing dialogue, but rather all together recite the Same. As he says in his last terrible sermon,

our work . . . is study, and the preservation of knowledge. Preservation of, I say, and not search for, because the property of knowledge as a divine thing, is that it is complete and has been defined from the beginning, in the perfection of the Word which expresses itself to itself. Preservation, I say, and not search, because it is a property of knowledge, as a human thing, that it has been defined and completed over the course of the centuries, from the preaching of the prophets to the interpretation of the fathers of the church. There is no progress, no revolution of ages, in the history of knowledge, but at most a continuous and sublime recapitulation. (399)

"Monologue," wrote Bakhtin, "pretends to be the *ultimate* word,"[17] and Jorge thus comes to be the very incarnation of the monological voice and of monological authority. Since the character of Jorge is so transparently modelled on the great Argentinian writer, Jorge Luis Borges, reading Jorge as the personification of the spirit of monologism helps us to unravel one of the great unsolved puzzles of the novel, namely why, given the overwhelming debt that the *Rose* seems to owe to Borges's writings, it should ultimately cast him as the villain of the piece.

Borges uses allusion extensively in his writings, yet one might argue that Borges, like Jorge, cites in the spirit of monologue. In his study of allusion in the works of Borges, significantly titled *The Narrow Act*, R. J. Christ writes that "Borges' technique destroys chronology and treats identical ideas as emanations of the same mind: to think the same is to be the same. To make allusions is to demonstrate the timeless universality of the human mind."[18]

So, for all its indebtedness to Borges and despite all its allusions to his writings, the *Rose* ultimately undermines his authority, for in the very same gesture that gives Borges a voice in the novel Eco's practice of allusion liberates the multiple forces of heteroglossia from the tyranny of monologism. In the *Rose* many voices come to speak, not in order to recite the same thing in timeless union but rather many things at many times and in many different ways. Thus Jorge's triumph over William as he snatches the book from him is a pyrrhic victory in more ways than one, for not only does Jorge die from ingesting the book of comedy that he takes so seriously but the gesture itself is glossed as a comic parody of the *Apocalypse* and, moreover, is inscribed in the Book of Laughter that continues to exist. That book is, needless to say, *The Name of the Rose* itself.

Inevitably, there remains a great deal more to be said about this remarkable novel. Yet perhaps even this brief and summary account may have served the purpose of suggesting how, in spite of its superficial affinities with, and allusions to, what have traditionally been regarded as the lighter and more entertaining forms of narrative (the detective story, the novel of intrigue, etc.), the real richness and ultimate strengths of Eco's book derive from the way in which the *Rose,* as a novel that is both itself and the many other novels to which it alludes, is nothing less than a riotous summation of the entire millenarian culture of the book. For it is "the book" as object of cultural veneration, as epistemological structure, as image, and as metaphor for the world itself that lies, in every way, at the very heart of the novel and that governs both the *fabula* and the strategies of its textual composition. The novel is, so to speak, a thoroughly *bookish* book: it functions by exploiting to the fullest the entire metaphorics of the book developed over two millenia of book culture as well as all the phenomenological aspects of reading and writing. By the masterful practice of the art of allusion Eco has been able to construct a multiply stratified polyphonic text, a palimpsest that succeeds in fact in being both literature and theory, both narrative and narratological self-reflection.

Any attempt to adapt such a novel for the cinema must thus seem to present almost insuperable difficulties. Not only would such an adaptation have to run the usual gauntlet of being compared with its literary pretext—and in this case, given the wide popularity of the novel, *this* problem would be all the more acute—but it would also have to face the added challenge of transposing into cinematic codes a textual ensemble that is essentially and self-consciously bibliocentric. At first sight, this might seem simply the old problem of adaptational fidelity twice over, but the intense textual self-reflexivity of the novel would appear to raise the problem to a sort of squared power. How did Annaud's film face up to this challenge?

The Film

Observers were sceptical about the film before it was released and either tepid, or downright hostile, in their reactions to viewing it. The comparison with the novel was quite inevitable (Eco's son, Stefano, had worked as an assistant on the film with Eco himself also involved as a sort of consultant), and the film never emerged in a positive light from the comparison. The film had clearly failed "to be" the book.

Still, as the ever-cautious Samuel Beckett once warned, the danger is in the neatness of identifications.[19] There has always been a temptation to try to identify a film with the novel from which it is drawn and to think of film adaptation on the model of literary translation from one national language into another. Yet the "dynamics of exchange" between film and literature, to use Keith Cohen's very apt phrase,[20] are much more complex than the process of linguistic translation precisely because, sooner or later, what they involve are the specific differences between the two media. Film adaptation is not translation but rather a process of complete *transcodification,* and thus any discussion of cinematographic adaptation seems to call forth the necessity of first defining the very nature of both cinema and literature, of their specific languages, codes, and rhetoric of communication. One way around this impasse, as Dudley Andrew has suggested, is to try to characterise different modes of adaptation according to the sort of relation that any particular film seems to set up between itself and its literary pretext. Andrew re-

duces the possible modes of this relation to three: borrowing, intersection, and transformation.[21]

In the borrowing mode a film simply "borrows" characters, plot, and situation from its literary source, though for aesthetic, cultural, and social exigencies that have little, if anything, to do with either the production or reception of the source text. Most filmic adaptations of Shakespeare would seem to be of this sort as well as many Hollywood films of famous European novels. In the second category, that of intersection, the film respects the uniqueness of its source text by keeping itself at a distance from it, intentionally leaving it unassimilated in adaptation. Some of Pasolini's films such as *Medea, Decameron,* and *The Canterbury Tales* function in this mode. They are, as it were, evoked and motivated by the source text, but they do not attempt to identify themselves with it. This tactic can legitimately permit the filmmaker to even alter "the letter" of the original, as in Godard's *Le Mépris,* or "the spirit" of its source, as in Bertolucci's film of Moravia's *The Conformist.*[22] This mode could quite accurately be described as dialogic insofar as the film does not attempt to reproduce the original but rather enters into an allusive dialogue with it. It is only in the third mode, that of complete transformation, that the thorny issue of fidelity comes to the fore. In this mode the film sets itself the task of translating both the letter and the spirit of its literary forebear into its own cinematic language, and thus its success or failure comes to depend on how well it manages to create a cinematic analogue of its literary source.

These categories are in no way absolute, but an attempt to focus on Annaud's film through the grid of Andrew's categories may allow us to shed some light on the reasons for the film's obvious failure to engage the novel more productively.

The film announces itself as "a palimpsest of Eco's novel," and this seems auspicious since, as we have seen, Eco's novel is itself one monstrous palimpsest. However, even a preliminary viewing of the film suggests that Annaud has fallen prey to the deviant force of catachresis. Yet what is in question here is not the legitimacy of using literary terms in cinematographic discourse — the films of directors such as Godard and Yvonne Rainer are often and very accurately described as palimpsests[23] — but rather that Annaud seems to make very little, if any, use of the intertextual techniques of allusion, polyphony, and multiple layering that one might reasonably expect to find in a cinematographic palimpsest. Film, of course, has no medieval form, but what is surprising is

that, outside the strict exigencies of the plot, Annaud makes no use of the visual iconography of the Middle Ages, which would have been one element available to him. Overall, then, and in spite of the intentions stated in its subtitle, the film appears to make no real effort to engage the polyphony and intertextuality of the novel so as to create a cinematographic palimpsest; rather, it settles for the much simpler option of borrowing from it what Joyce once called "the goahead plot." Even so, some characters are left out, and the plot itself is modified and streamlined so as to keep the story-line clear, simple and linear. The result seems to be a fairly straightforward whodunnit that just happens to be set in the Middle Ages so that, were it not for the name, Annaud's film would probably remind one less of Eco's novel and more of some of the medieval murder mysteries of Ellis Peters. In fact, as one caustic critic remarked: "Stripped of metaphysics, the central mystery story — a succession of bizarre and gruesome murders in a monastery — isn't very exciting: sub-Agatha Christie."[24] Thus one is forced to conclude that Annaud has misunderstood the sense of the term "palimpsest"; instead of the intertextual play of allusion, he has used the term merely to mean a reduction or summary of the novel.

A graphic confirmation of this occurs about halfway through the film where William (Sean Connery) attempts to draw the threads of his deductions together. In the novel William's conclusions are always provisional and hedged with caution. The film, however, has a flashback sequence through which William recounts the events not as they *might* have happened but quite definitely as they *did* happen, thus conferring what one critic has aptly called a *certificat d'authenticité* on the narration,[25] granting the status of objectivity and absoluteness to the connection of events as shown, which the novel was at such pains to avoid. The openness of the novel is thus closed in one stroke; the reader/viewer is no longer invited into a game of deduction and probable reasoning (Eco's model for both semiotic analysis and for the reading process itself) but is more simply and mechanically transported along a linear narrative with a clear and unambiguous solution. Tellingly, what gets lost in this process is not only the novel's openness but also its subtle, self-mocking humour. In the book Jorge's victory is a pyrrhic one; the final image of Jorge eating the poisoned book is grotesque, but ultimately, through its allusion to the old man in the *Apocalypse,* it is comic and subversive of the monologic spirit he personifies. In the film, however, Jorge seems to triumph both at the level of plot and at the level of technique, for the film seems to share his monologic vision of things.

In fact we might note that the betrayal of the book on the part of the film comes about as a sort of misguided obsession with fidelity, not unlike Jorge's own, for it becomes evident that the film, at least at one level, *does* attempt to be faithful to the novel, or at least to create what might be called a "fidelity" effect. Its major strategy here is its attempt to render the "authentic" medievalism of the novel through a choice of genuinely medieval locations, props, costumes, gestures, and so on. The noted medievalist Jacques Le Goff appears in the credits as a consultant, and from all reports Annaud was meticulous to the point of obsession in getting all the details right. Apparently he was accompanied constantly on the set by a team of separate experts on medieval sculpture, medieval objects, medieval heraldry, and so on.[26] All of this effort seems to have been to little avail, for, as many viewers of the film remarked, the "authentic medievalism" often appears as mere caricature. Had Annaud composed his shots with reference to the iconic imagery of the time instead of following the modern conventions of the mystery film, the effect might have been more successful. As it is, however, the film's attempt to mimetically and "realistically" reproduce the Middle Ages results in almost the opposite effect. Eco himself ventured to remark in one interview that it soon became clear to him that all the realistic effects after which Annaud was striving could have been better and more efficiently achieved in a studio. "Authenticity," he pointed out gnomically, "may be more readily achieved by faking."[27]

It becomes obvious, then, that much of the film's failure derives from the fact that it has chosen to adapt in the fidelity-of-transformation mode rather than intersecting with its pretext in a more playful and intertextual way. Annaud seems to have either misrecognized the novel's fundamental bibliocentricity or miscalculated the extent to which such a book about books could be effectively transformed into a film about the search for a particular book.

For consider how, in the novel, William's quest for the book and Jorge's obstruction of this aim quite clearly "work." The Middle Ages were obsessed with books and The Book, and they copied and conserved books with fanatic zeal. The period is also permeated with the attempt to integrate the newly recovered philosophical works of Aristotle with the Christian faith — Dante's *Commedia* and Aquinas's *Summae* being the two most successful attempts in this direction. Furthermore, Aristotle wrote a book on practically every subject — he is a sort of mini-library on his own — so the idea of putting the search for a known but lost manuscript by Aristotle at the centre of a medieval mur-

der mystery set in a famous abbey library is quite a brilliant literary *trouvaille*. The plot is not only coherent with its medieval setting, but it also has all the elements to operate the now familiar postmodern *mise en abyme*. All of this assures that, in the novel, "tout se tient," but these elements lose much of their force when transliterated, so to speak, into film. The film certainly can reproduce the bare bones of the plot (though not without running the risk of merely borrowing), but, as a medium with its own quite specific visual modalities, it doesn't come fitted with the metaphorics of the book or the stratagems of purely verbal self-referentiality that this novel embodies and that, naturally and effortlessly, permit it to be both historical symbol and self-reflexive allegory. Put simply: in the novel the battle for the book is rich with symbolic and self-referential possibilities; in the film these possibilities are immeasurably diminished by their irrelevance to the medium itself. The rose in Eco's title is one of the richest symbols in the literary tradition, but where in our century-old film culture could we find an equivalent symbol?

So far I have criticised the film for its inadequate adaptive strategy, but perhaps the time has come to ask: what might the film have looked like if it had chosen to actively intersect with the novel instead of trying to merely repeat it? Curiously enough, through what has been called the rebound effect whereby the "dynamics of exchange" between literature and cinema go both ways, the screenplay for just such a film already exists, outlined in a novel aptly titled *La rosa e il suo doppio* (*The Rose and Its Double*).[28] It comes from the pen of the established Italian crime fiction writer, Loriano Macchiavelli, and was published a year after the release of the film. By playful use of all the mechanisms and ruses of classic crime fiction writing, this novel carries on a very clever intertextual dialogue with both the film and the novel and thus provides some idea of how an intersecting film strategy might have worked.

The novel begins on the film set "five minutes after the end." Watching the smouldering remains of the abbey library and in the process of taking off his Franciscan habit for the last time, Connery/William confides to Adso that he is unsatisfied with the role that he has been made to play in the film and generally with the solutions that, as William, he has been obliged to present in both the film and the novel. His misgivings are augmented when he is interviewed by an enigmatic journalist who insinuates the idea of a cover-up. The journalist, however, disappears from the scene and thereafter becomes one of the keys to the "real" mystery that Connery/William now sets out to solve, the mystery of the

obfuscation that has been practised in both the book and the film by making the hapless Jorge figure as the culprit.

Tom Durrett, a Roman private detective with strong touches of Phillip Marlowe, is hired to track down the journalist while Connery, accompanied by an Adso who has become more rebellious and less pliable, sets out to find and question all the characters who have appeared in the film. By the end of the novel, through a series of movements that seem to roll together Conan Doyle, Agatha Christie, and a host of other crime writers, with a touch of Cluedo thrown in for good measure, Connery/William manages to reunite the entire cast at the Eberback abbey where the exteriors of the film were shot and where he now plans to hold a public press conference in order to announce to the world the real solution to the mysterious murders in the abbey. A complete film crew descends (again!) on the abbey in order to film the much publicised event, and professor Eco himself is cajoled into attending, though he sits mostly in silence, watching the proceedings with a slightly mischievous eye. Throughout the event he holds another book tightly in his hand (an allusion to *Foucault's Pendulum*?), and when he does speak in answer to questions he quotes himself from his innumerable published interviews.

However, there is a lot more action before the novel reaches this splendid and very funny climax. The producer of the film has heard of Connery's mad investigations and, fearful that there may be moves afoot to make another film that will compete with the original, hires the same private detective to track down Connery. When they finally meet, Connery obstinately refuses the producer's plea to abandon such a project unless the producer agrees to shoot an alternative ending based on more probable and more sound reasoning than that followed in the original film. Connery then goes on, in some of the most astute pages of this very clever novel, to point out to the producer and to his attendant scriptwriter all the deficiencies of the film with respect to the novel. In particular Connery accuses the film of reactionary politics, pointing out that the film has significantly elided one of the most political characters of the novel, the young revolutionary, Aymaro of Alexandria. In fact, in a magnificent *coup de scène,* the young journalist who had first incited Connery's doubts turns out to be a notorious Roman terrorist who identified with Aymaro and who interpreted Aymaro's exclusion from the film as evidence of an international reactionary conspiracy.

But the novel manages to engineer an even greater coup: in the final pages, as professor Eco tries surreptitiously to leave the abbey and the

press conference, which by this time has degenerated into mayhem, he is accosted by a cowled monk who forces him into the basement. Here he is pushed next to a helpless, bound Connery, and both of them are then subjected to a long lecture by the mysterious cowled figure who lays bare the flaws of their preferred solutions. The mysterious monk turns out to be none other than Adso, and, as he gleefully points out, *he* has been the killer all along. His motive was a deep resentment against William's condescending attitude to him throughout both the book and the film, and the murders were committed to teach him a lesson.

It is impossible to give any better summary of the twists and turns of this very clever novel, not so much because the plot is so complicated but rather because the novel is genuinely dialogical and intertextual, continually quoting and questioning both the book and the film, providing them with another place in which to dialogue. Macchiavelli's novel takes up seriously but with humour William's dictum that books are not meant to be believed but to be subjected to enquiry. Had William known about film, he would undoubtedly have included it in his adage, and Macchiavelli's strategy allows him to do it.

The questioning, dialogical attitude on the part of both novels allows them to play with the truth and, in the end, to fulfil Nietzsche's injunction to make truth laugh. This assuredly the film does not do, but rather, as a consequence of its deadly seriousness, it manages uncannily to thoroughly betray Eco's book. Macchiavelli's spirited little novel, however, gives us a glimpse of what the film might have been if it had not taken itself too seriously and if it had faced up to the challenge of adaptation with more verve and inventiveness.

Notes

I am particularly grateful to David Boyd for his response to this paper when it was first presented at the HRC Conference "Coming to Terms with the Photographic Image."

1. Eco's intellectual itinerary up to the time of publication of the novel is well documented by Teresa de Lauretis in her book *Umberto Eco* (Florence, 1981). The positive critical reaction to the novel is well represented in the Italian anthology *Saggi su il nome della rosa*, ed. Renato Giovannoli (Milan, 1985). Its counterpart in English is the anthology edited by M. Thomas Inge, *Naming the Rose: Essays on Eco's "The Name of the Rose"* (London, 1988). The best full-length

study of the novel remains Teresa Coletti, *Naming the Rose: Eco, Medieval Signs and Modern Theory* (Ithaca, 1988).

2. From figures reported in *Panorama* (31 July 1988), 116. More recent figures given in *L'espresso* (7 Jan. 1990) put worldwide sales at ten and a quarter million. The fact that the novel has been translated into Swahili is reported in the publishing trade journal *Millelibri* 11 (October 1988), 42.

3. See Fulvio De Nigris, "*Il nome della rosa* dall'illustrazione al film: Intervista a Umberto Eco," in *La rosa dipinta* (Milan, 1985), 12.

4. All details regarding Annaud's attempts to obtain film rights are reported in U. Volli, "I segreti della rosa," *Europeo* (11 Oct. 1986), 47–54.

5. David Ansen from *Newsweek*, quoted on the video-cassette cover, *The Name of the Rose* (Neue Constantin Film Production, 1986).

6. George Bluestone, *Novels into Film: The Metamorphosis of Fiction into Cinema* (Berkeley, 1968), 62.

7. Ibid.

8. To the studies already mentioned should be added: Werner Hullen, "Semiotics Narrated: Umberto Eco's *The Name of the Rose*," *Semiotica* 64, nos. 1–2 (1987): 41–57; Laurel Braswell, "Meta-Psychomachia in Eco's *The Name of the Rose*," *Mosaic* 20, no. 2 (Spring 1987): 1–11; Joann Cannon, "Semiotics and Conjecture in *Il nome della rosa*," *Italian Quarterly* 27, no. 103 (Winter 1986): 39–47; Christopher Palmer, "Ecosystems: *The Name of the Rose* and Semiosis," *Southern Review* 21, no. 1 (March 1988): 62–84; Rocco Capozzi, "Palimpsests and Laughter: The Dialogical Pleasure of Unlimited Intertextuality in *The Name of the Rose*," *Italica* 66, no. 4 (Winter 1989): 412–28.

9. Michael Worton and Judith Still, eds., *Intertextuality: Theories and Practices* (Manchester, 1990), 1–2. A thorough analysis of most of the recent discussions on intertextuality is provided by Thais Morgan in her excellent article "The Space of Intertextuality" in Patrick O'Donnell and R. Con Davis, eds., *Intertextuality and Contemporary American Fiction* (Baltimore, 1989), 239–79.

10. See Julia Kristeva, *Desire in Language: A Semiotic Approach to Literature and Art*, ed. L. S. Rondiez, trans. T. Gora, A. Jardine, and L. S. Rondiez (New York, 1980), 66.

11. Umberto Eco, *The Name of the Rose*, trans. William Weaver (London, 1983), 286. All further references will be to this edition, and page numbers will be given in the text.

12. Gian Biagio Conte, *The Rhetoric of Imitation: Genre and Poetic Memory in Virgil and Other Latin Poets*, ed. Charles Segal (London, 1986), 29.

13. Ziva Ben-Porat, "The Poetics of Literary Allusion," *PTL: A Journal for Descriptive Poetics and Theory of Literature* 1 (1976): 105. For an attempt at a typology of allusion see Carmela Perri, "On Alluding," *Poetics* 7 (1978): 289–307.

14. Ben-Porat, "Poetics of Literary Allusion," 162.

15. Vincent B. Leitch, *Deconstructive Criticism: An Advanced Introduction* (New York, 1983), 162.

16. See Herman Meyer, *The Poetics of Quotation in the European Novel*, trans. T. and Y. Ziolkowski (Princeton, 1968).

17. Mikhail Bakhtin, *Problems of Dostoievsky's Poetics,* ed. and trans. C. Emerson, Theory and History of Literature Series, vol. 8 (Minneapolis, 1984), 293; italics his.

18. Ronald J. Christ, *The Narrow Act: Borges' Art of Allusion* (New York, 1969), 34.

19. The opening line of Samuel Beckett's "Dante . . . Bruno. Vico . . . Joyce," in *Disjecta: Miscellaneous Writings and a Dramatic Fragment* (London, 1983), 19.

20. See Keith Cohen, *Film and Literature: The Dynamics of Exchange* (New Haven, 1979).

21. Dudley Andrew, *Concepts in Film Theory* (Oxford, 1984), 96ff.

22. See Aine O'Healy, "Re-Envisioning Moravia: Godard's *Le Mépris* and Bertolucci's *Il conformista," Annali d'Italianistica* 6 (1988): 148–62.

23. See, for example, Lucy Fischer's discussion of Yvonne Rainer's *The Man Who Envied Women* in her book *Shot/Countershot: Film Tradition and Women's Cinema* (Princeton, 1989), 301ff., and David Bordwell's characterisation of the early Godard films in his *Narration in the Fiction Film* (London, 1985), 311ff.

24. Margaret Walters, "Picture Predators," *The Listener* (29 Jan. 1987): 29.

25. Thierry Cazals, "Deus ex Machina," *Cahiers du Cinéma* (Jan. 1987): 52.

26. Volli, "I segreti della rosa," 51.

27. Umberto Eco, *"The Name of the Rose,"* interview with Gideon Bachmann, *Sight and Sound* 55, no. 2 (Spring 1986): 30.

28. Loriano Macchiavelli, *La rosa e il suo doppio* (Bologna, 1987). To the best of my knowledge, there exists no English translation of this charming novel as yet.

The Subject(ive) Voice

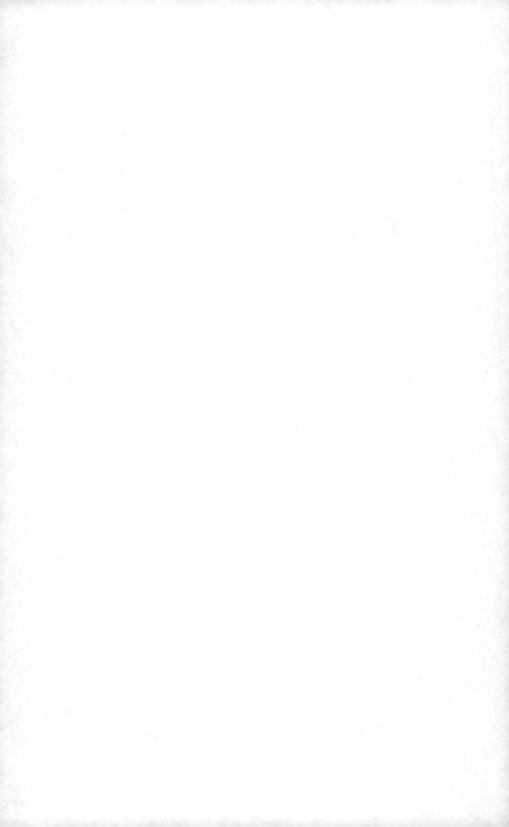

11

The Subjective Voice in Ethnographic Film

DAVID MACDOUGALL

The Problem of People

Throughout this century we have seen both anthropologists and critics periodically shift their attention between the competing claims of analytical and experiential knowledge. With written works this has often meant choosing between situating oneself outside the work as an interpreter or inside it as a reader. In anthropology it has meant seeing human cultures either from the viewpoint of the disinterested social scientist or the indigenous social actor. Anthropologists have taken to heart, sometimes concurrently, Malinowski's famous injunction to "grasp the native's point of view, his relation to life, to realise *his* vision of *his* world,"[1] and Lévi-Strauss's dictum: "Anthropology is the science of culture as seen from the outside."[2]

It is generally acknowledged that these perspectives are interdependent. We are taught that observation should precede analysis, that before one can interpret one must read. But critical theory and anthropology have often run aground on the problem of reconciling the analytical with the experiential, just as the mind balks at entertaining two readings of a visual pun or geometric figure at the same time.[3] The predicament of the critic has been put succinctly by Bill Nichols, with regard to film criticism, in the paradox: "If I am to analyse this film properly, I must not mistake it for reality; but if I do not mistake it for reality, I cannot analyse it properly."[4] For the anthropologist the paradox might go, "If

I am to understand this sociocultural system properly, I must not adopt the indigenous view; but if I do not adopt the indigenous view I cannot understand it properly."

In recent decades there has been a growing conviction that analytical and experiential perspectives are neither opposed nor hierarchical — that is, that experience is not just the messy prerequisite for knowledge. Rather, the two are complementary and of comparable importance. Nor should the experiential be viewed merely as uncritical emotion, devoid of its own analytical component. Finally, as counterpoised responses to the same historical phenomena, the two perspectives should be capable of reconciliation within a broader framework of knowledge. In the social sciences hermeneutic, narrative, autobiographical, multivocal, and descriptive methods now share the field with schematic analysis of a more traditional kind, and interpreters of written and other texts have attempted to enlarge structural and semiotic approaches with more subjective and socially contingent readings. The same insight that first applied a linguistic analogy to social patterns in terms of *langue* has now seemingly turned its attention to *parole*.

This sentiment appears to transcend alternations of academic fashion, where one tendency often seems to be simply the temporary corrective of another. I think this is because the focus has shifted to the problem of representation itself. In a sense, for the first time since the splintering of philosophy into separate disciplines, there is a current in the direction of a reintegration of knowledge, not by means of grand theory but by borrowings between disciplines and, more broadly, between the arts and the sciences. This process has been described as a blurring of genres.[5] I prefer to see it as an effort to heal what are increasingly regarded as ailing genres, flawed by reductionism and ethnocentric thinking. The willingness to borrow, to cut across the grain of human perspectives, has become a way of combating intellectual and moral tunnel vision. This sometimes creates a kind of vertigo as anthropologists and critics stand on the boundaries of their disciplines. They rightly fear losing their balance, but there is often, as well, a powerful urge to jump.

How to regard the individual and his or her experience has been a perennial and nagging problem in anthropology. At one time anthropologists viewed the experience of individual social actors, like the experience of individual readers of a text, as a suggestive but finally unreliable indicator of collective experience — although in practice the reliance they sometimes placed on a few informants dangerously compromised this view. Life histories gathered in fieldwork became part of the anthro-

pological data, to be merged for general conclusions and occasionally drawn upon for vivid examples. These histories were valued for the irreducible proofs that they contained and for the larger proof that a living subject actually underpinned the more abstract concerns of anthropology. Yet there was always an interest in subjective experience for its own sake, an interest that went beyond the mapping of a culture or the legitimation of the discipline. Anthropologists clearly desired, and often tried, to describe the special "feel" of living in another society, the distinctive world view of its inhabitants, a view delimited by language, physical setting, and the horizons of acceptable behaviour.

The problem is that these descriptions of the individual's world also tended toward the composite and eventually toward the comparison and classification of composites (as in Ruth Benedict's *Patterns of Culture*) in which the experiences of any actual person were useful only as illustration. In classical ethnographies the descriptions take the form "Posos believe . . ." or "If you are a Poso, you. . . ." Anthropological interest in subjective experience was thus channelled into holistic thinking that, crucially, promoted the reified notion of a single ethnographic reality, just as descriptions of social structure did. One odd hallmark of positivist social science has thus been its deep faith in a mystical object—a shared social experience that exists outside history and beyond the individual. In such an anthropology the individuality of the subject is preempted by the anthropologist's own individuality, a consciousness at one remove, to be shared with an individual still further removed, the reader.

Today, by contrast, the experiences of individual social actors are seen increasingly as vantage points within a society which, in the complex dynamics of their engagement, structure particular "readings" of social phenomena. The portrayal of subjective experience becomes a strategy for resituating anthropological understanding within the textual richness of a society. The goal is not simply to present the "indigenous view," nor to invade voyeuristically the consciousness of other individuals, but to see social behaviour, and indeed culture, as a continuous process of interpretation and reinvention.

What might be called the "problem of the person" in anthropology echoes a similar concern in documentary film. In Bill Nichols's view, "a central question posed by documentary is what to do with people"[6]— actual, living people as distinct from the imaginary people of fiction. Elsewhere he poses this question in somewhat different terms, as a question of magnitude. The documentary film gives us images that are in-

dexically linked to people who have lived; however, as in all cinema (like all ethnography) the people themselves are absent. Documentary is thus faced with the problem of "a body too few," the missing body, which must be reconstituted by the film. What relation does this figure bear, Nichols asks, to the historical person? How can the filmmaker hope to create a representation commensurate with the magnitude of what it describes?[7] Or, we might ask, how can any representation approximate the self that every self knows itself to be?

Both documentary and anthropology are faced with this problem, and perhaps also with a false issue. Full access to another consciousness cannot be achieved, and let us hope it never will be. But the attempt need not necessarily be viewed as either futile or reprehensible. Such an objective can still be approached and in that approach produce what Dai Vaughan has called an "unconsummated" understanding.[8] Representing the subjectivity of the historical person is a very different matter from attributing subjectivity to a fictional character. One may leave this task to the domain of imaginary art. Or alternatively one may try to incorporate in documentary and anthropology, first, the codes for communicating subjective experience used in everyday life and, second, the narrative systems that resituate the "reader" in circumstances different from his or her own. Documentary representation may finally produce a fiction, but (in Nichols's phrase) it is a fiction unlike any other.[9]

Ethnographic film, as a form of documentary, has often been regarded by cinéastes as obscure and by anthropologists, at least until recently, as lacking intellectual substance — at best, a sideline of anthropology, or an area of failed promise.[10] Occupying this marginal position, it seems also to have aroused deep suspicions — on the one hand, of extending anthropology's indecent appropriation of the voice of colonised peoples, on the other hand, of making anthropological claims that it, or its practitioners, have no intention of fulfilling. Of the explanations offered for this second view, one of the most common is that ethnographic filmmakers lack the methodological rigour and scientific perspective of anthropologists.[11] But I think more probably ethnographic film provokes such responses because its ambiguous intimacy with its subject sharpens and brings to the fore the anthropological problem of the person, exposing to view a contradiction that anthropological writing can more easily elide: that although the raw unit of anthropological study remains the individual, the individual must be left by the wayside on the road to the general principle. Yet this individual is the trouble-

some hitchhiker whom ethnographic filmmakers always seem to pick up and who is sometimes felt to claim altogether too much of their attention.

If this issue can be addressed more fully, I foresee the problems of documentary in dealing with the historical person, and those of anthropology in dealing with the individual social actor, converging to make the ethnographic film a focus of more serious interest and investigation. This in turn may offer a more precise role for film in anthropology and more intellectually productive directions for ethnographic film itself.

An Interior State

The value of the subjective voice, in anthropology and in the documentary film, is that it can give access to the crossing of different frames of reference in society—to what otherwise is contradictory, ambiguous, and paradoxical. One can plot these forces objectively, but it is arguable that one can only understand them experientially. As Nichols notes, the social forces that result in contradictions, and that in society may eventually work themselves out in historical terms, can be resolved in a film (and perhaps also in anthropological texts) through narrative strategies that allow us to experience them.[12] Building upon Bateson's and Lévi-Strauss's ideas, he has shown how fictional narratives are generated out of double binds.[13] In fact, these situations of irreconcilable imperatives, which in life and fiction produce aberrant behaviour—such as catatonia or putting your own eyes out—resemble those moments in intellectual life when the crossing of different disciplinary perspectives produces anger and bizarre behaviour among righteous academics.

The fiction film creates a multilevelled web in which its characters are contained and seen to struggle. The documentary film attempts to contain the historical person through a parallel set of strategies but also by allowing us to glimpse the ultimate failure of those strategies—by creating, as Nichols puts it, "the subjective experience of excess, the discovery . . . of a magnitude of existence beyond containment."[14] It thus perversely denies what it offers. This effect is partly produced by the recognized gulf between film images and their profilmic antecedents, but it is also achieved through evocative and ironic tactics that put the historical person in a dimension beyond that attainable by the film.

Thus is extended to the spectator an experience not unlike that of the characters of fiction, who suffer the consequences of a paradox even if they do not understand it.

Anthropologists become aware of a similar disjunction when reducing their fieldwork experiences to writing, and they may take lateral action to resolve it by writing outside the discipline.[15] Recent experimental ethnographies include formal signalling of experience exceeding containment,[16] but so do even many classical ethnographies. Writing of animal sacrifice among the Nuer, Evans-Pritchard says that it dramatises a spiritual experience, but "what this experience is the anthropologist cannot for certain say. . . . Though prayer and sacrifice are exterior actions, Nuer religion is ultimately an interior state."[17]

The ethnographic film, even as it aspires to the portrayal of the subjective, must make a similar disclaimer. The subjective voice is always mediated and fragmentary, however much it appears to be the independent voice of another person. In a strict sense, the only subjectivity in film-viewing is that of the spectator, the only subjective voice that of the filmmaker. Subjectivity is a product of the text and a quality that we assign to the text. The value of ethnographic films therefore lies in what a text can convey, always subject to verification and rereading.

In what follows I shall be concerned with the subjective voice as part of the construction of the subject rather than as the voice of the filmmaker. I shall hope to show how certain ethnographic films from a primarily Euro-American practice have attempted to give insight into the lived experiences of people in less familiar cultures and suggest the range of strategies that have been used for situating the viewer in different relations to the text. I do not propose here to judge the validity of particular interpretations, and in any case such judgements suggest a simple relation between sign (film) and signified (society), a relation that in fact may be far more complex. Films intend certain readings on the basis of prevailing cultural codes, and within a certain range one can say there are correct readings and misreadings. But it is an error, I think, to apply communications theory too literally to films by looking upon them as messages. A film is not ephemeral like a telephone call but remains to be reused and reread. It is perhaps less like a message than like a cultural artifact such as a table or chair, and like them it retains the grain of the materials from which it was made.

I shall be primarily concerned with the portrayal of experience across cultural boundaries rather than with cultural self-expression or reassertion, such as that of subcultures in the West, national cinema styles,

or the growing body of indigenous media production. Finally, I define ethnographic film here, as elsewhere, as a broader cultural category than films made within, and for, the discipline of anthropology.[18] Anthropologists had a hand in some of the films, but most are addressed to a wider public audience, although few have actually come from the mainstream of industrial cinema or television.

Frames of Reference

The subjective voice in films, as in literature, is often associated with first-person discourse or its double, the central character around whom the action develops. However, subjectivity in films is not simply a matter of identifying a speaker or seer. And although the modes of narration in literature and film sometimes run parallel, there are significant differences. It is not that film lacks a pronominal code but that the pronouns are often implicit or unstable. A film can involve the subjectivities of its subjects, the viewer, and the institutional or individual filmmaker in compound ways. From a textual point of view, each of these perspectives can become an "I" from which the other two are redefined as "you" or "they," just as kinship terms depend upon who is speaking. The perspective can oscillate between two or more focusses or assimilate both, as when we begin to associate our viewpoint in the film with a first-person speaker who has previously occupied a third-person category. This is the kind of shifting that occurs in Conrad's layering of speakers but that in film occurs in much less clearly marked ways.

Critics such as Nick Browne have shown that the conventions of filming and editing do not simply direct us to different visual points of view in a film but orchestrate a set of overlapping codes of position, narrative, metaphor, and moral attitude.[19] Subjectivity is therefore not merely a function of visual perspective. We are, in Browne's terms, "spectators-in-the-text." Our reading of a film, and our feelings about it, are at every moment the result of how we experience the complex fields this orchestration creates — partly dependent again upon who we are and what we bring to the film. This complexity extends to our relation to different modes of cinematic address.

One can get a sense of this in even quite early films in which cinematic rhetoric was still relatively undeveloped. *Living Hawthorn*, made

in 1906, addresses the viewer from a variety of stances and unintention-
ally provides an example of the transformation of the descriptive into
the subjective. The subjective effect is fleeting and depends not upon
the filmmakers' narrative agency but upon a form of direct address that
was soon to be largely excluded from the cinema.

The film was made in Australia by William Alfred Gibson and Millard
Johnson as a quick money-spinner. They would come to a town, film as
many people as possible, develop and print the film overnight, and then
hire a hall the next day and charge people admission to come and see
themselves. *Living Hawthorn* runs just twelve minutes but in that short
time manages to include shots of the streets from a moving vehicle, a
range of factory and shop fronts with their workers, a civic ceremony
with a marching band, the arrival of the mayor in a motor car, and
scenes inside the municipal swimming baths. In doing all this it deploys
a variety of strategies. Mounting a camera on a moving vehicle was a
trick known at the time to produce excitement. Some of the events are
clearly directed for the film, as in the appearance of the mayor, or when
the workers come filing out of their workplaces carrying the tools and
products of their trades. At the civic ceremony the filmmakers are given
a privileged vantage point. The final scenes in the municipal pool, on a
men's bathing day in an era of strictly segregated bathing, give the film
a touch of the sensational and play a parting trick upon the townspeople
of Hawthorn.

However, a number of street scenes in the film are shot in a more
observational style and seem intended to give a sense of ordinary life as
it is lived. This aim is often compromised by the tremendous public
interest in the presence of the camera. Children jump and dance in front
of it, wobble past on bicycles, push each other, and throw their hats in
the air. In these brief moments the coolly disengaged stance of the cam-
era—firmly established by this time in urban street photography—is
violated. As people look into the lens, the viewer suddenly has the sense
of being looked at, and looked at in this case with apparent delight.
Forget that this is not so, that the people looking so directly at the cam-
era are not seeing us; there is nevertheless the momentary sensation
even today of communion with people almost ninety years ago (fig. 12).

The glance into the camera evokes one of the primal experiences of
daily life—of look returned by look—through which we signal mutual
recognition and affirm the shared experience of the moment. It is the
look of exchange that says, "At this moment, we see ourselves through
one another." The encounter produces a phatic reversal of roles, in

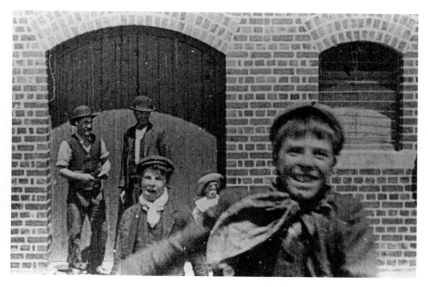

12. The look into the camera. *Living Hawthorn* (1906). William Alfred Gibson and Millard Johnson.

which the viewer seems to be regarding himself or herself with the eyes of the other. In a Lacanian sense, the self is reaffirmed and mirrored in these comparatively rare direct glances from the screen. In *Living Hawthorn* they have the effect of situating the audience in a psychological relation to the people on the screen. They also make clear that in films the usual narrative devices for creating identification with people need not always be present.

Subjective identification in ethnographic films occurs in both their narrative and nonnarrative forms. In character-centred films, as in the character narration of Hollywood, it can result from the imperatives of dramatic structure. This may require little more than a person wanting something, with obstacles placed in the way. Hitchcock tells us that if in a film a person is seen searching somebody's room as the owner comes up the stairs, "the public feels like warning him. Be careful, watch out. Someone's coming up the stairs. . . . Even if the snooper is not a likeable character, the audience will still feel anxiety for him."[20] A weak level of subjectivity could therefore be expected to arise from many comparable situations — from hunting scenes, for example, as Robert Flaherty no doubt realized.

On a closer textual level subjective identification with film characters

has often been attributed to manipulation of point of view, as it was developed in the "classical" Hollywood cinema. This was achieved largely through the technique of shot/countershot, tying the spectator's point of view to that of a character.[21] But it has been shown that literal point of view (in the visual sense) need not necessarily coincide with identification — that one can share the visual viewpoint of one character but identify subjectively with another, sometimes even with the person who is the object of the first character's gaze.[22] Nor are we usually asked to see from the literal perspective of a character but rather from a position in fictive space allied to theirs, as if we were looking over their shoulder. This implies that subjective identification too is more a matter of alliance than union: our emotional perspective requires a similar displacement. In ethnographic films this is subject to a further cultural displacement, which in the more successful examples lies somewhere between exoticism on the one hand and an all-engulfing humanist levelling on the other.

These conventions have implications for documentary which are largely irrelevant to fiction. Although our access to fictional characters is limited, how much more limited must be our access to the mind and body of a historical person? Further, our relation as spectators to the narrative agency of documentary is more complex than in fiction. Rather than dealing with products of the imagination, we are dealing with real human beings encountering a filmmaker who coexists with them historically. The question of the filmmaker's agency in representing them is thus implicitly pushed into the arena of the film. We are faced with a double task of interpretation. We interpret the perplexing exteriors of social actors in some ways as we interpret people in daily life, but we also perceive them through the narrative apparatus that the filmmaker has erected for us. On this epistemological level, at least, documentary confronts us with more complex forms than we are asked to deal with in fiction.

The different guises of subjectivity result from the different possible ways of combining three cinematic modes that I shall here call *narration* (including actual narrative storytelling, but also description), *address* (which may be direct or indirect), and *perspective* (which may focus on testimony, implication, or exposition). These variants could be said to occupy separate regions of potential within a notional triangle formed by the subject, the viewer, and the filmmaker.

Film technology has had a direct bearing on these choices. In the silent era titles provided the only medium for direct address by the filmmaker and the only medium for actors' dialogue. Titles were used

sparingly for a variety of reasons: because of the illiteracy of audiences, because reading too many titles proved wearisome, and because translating many of them made international versions more difficult to produce. If the technology had existed to superimpose titles rather than intersperse them, silent films might well have evolved differently. As it was, dialogue and direct address were minimised, and the emphasis was upon observation and enactment. With the coming of sound this emphasis was reversed. Commentary suddenly became almost continuous in the documentary, and spoken dialogue took over the fiction film to such an extent that the art of cinema was widely thought to have perished. One consequence of this history is that the subjective voice, with but few exceptions, was first developed visually, then later in commentary, and later still in synchronous dialogue.

The modes of *perspective* in film are sometimes difficult to disentangle because in narrative they need not conform to literal point of view and in description they can be confused with the filmmaker's first-person role as the source of the film's narration. Thus perspective is not a function of who is seeing or speaking but rather an indicator of a primary locus of expression. It can be most usefully understood as an emphasis placed variously upon first-person *testimony,* second-person *implication,* or third-person *exposition.* In this sense it is not inherent, but *assigned.* It represents the filmmaker's direction to the viewer to grasp the primary perspective of the narration. Does it lie in someone addressing the camera directly (the "I" of direct-address testimony)? Does it lie in the viewer being drawn into the film experientially, through such devices as shot/countershot (the "you" of implication)? Or does it lie in the activities of others studied from a certain distance (the "they" of exposition)? The varieties of perspective can be further delineated by how each communicates the subjective voice:

- *Testimony,* the first-person perspective, approaches subjectivity through the self-expression of the film subjects. It is found in films (or sequences) in which the primary source of experiential information is communicated to us by those who have had the experiences. It is typically the mode of interior monologue, confession, and interview.

- *Implication* is the mode that involves the viewer in the processes of lived experience. It is the method of much fictional narrative and of "classical" Hollywood film editing. It creates identification by allying the viewer to the perspectives of specific social actors, saying in effect, "You also are experiencing this."

• *Exposition* is the mode of third-person narration, by a third person displaying and explaining the behaviour of other third persons. It gives access to states of mind and feeling by describing them or demonstrating their exterior signs. It is a mode that tends to create empathy rather than identification—that is, it need not create the subjective experience of interiority. However, it can situate social actors quite powerfully in a social or narrative sense so that we ask ourselves how we would feel or behave in their place.

Approaches to Subjectivity

The portrayal of subjectivity in ethnographic film can be examined through films that introduced or significantly developed distinctive approaches. Although there is a rough chronology to these examples, it does not necessarily imply direct links between them but more often a common link to larger trends outside ethnographic film in the intellectual and methodological history of documentary. Ethnographic filmmaking has developed no major schools or genres of its own, and a particular approach is sometimes represented by the work of only one or two filmmakers.

Very early in its history the cinema bifurcated in two ways: into narrative and descriptive channels, on the one hand, and into fiction and nonfiction on the other. Narrative did not necessarily have to be fiction, any more than it does today. For example, the earliest narratives included a fiction film of a child stepping on the gardener's hose and then releasing the flow to squirt him in the face (*L'Arroseur arrosé* [*Watering the Gardener*], 1895) and a nonfiction film of *The Electrical Carriage Race from Paris to Bordeaux* (1897). The earliest ethnographic films, such as those of Félix-Louis Regnault, A. C. Haddon, and Walter Baldwin Spencer, tended to follow the descriptive and nonfictional modes, recording formalised events such as ritual dances and the techniques of pottery-making and fire-making. There was little room here for expressing subjectivity, and it would generally have been considered beside the point. Yet one often senses a gloomy forbearance on the part of the subjects as they perform what the filmmakers seem to have demanded of them. Scenes such as these were increasingly presented as spontaneous performances, making them a kind of documentary fiction.

After 1910 a few films about non-European societies appeared that suggested a dawning of interest in an indigenous point of view. These

were modelled roughly on fiction films, which by now dominated the commercial film industry. The best known today is perhaps Edward S. Curtis's *In the Land of the Head-Hunters* (1914), a love story filmed among the Kwakiutl of British Columbia. But there was also the missionary film *The Transformed Isle* made in the Solomon Islands between 1907 and 1915, in which narrative sequences of local warfare and European "blackbirding" are staged with considerable panache. At one point in the film a title actually invites us to "see what the native sees." Films such as these set the stage for the work of Flaherty and for a long-lasting approach best described as ethnographic narrative. These films take various forms, which can be grouped as exterior, interior, and narrated dramatisations.

Among exterior dramatisations Flaherty's *Nanook of the North* (1922) is far and away the most famous. It has been discussed variously for its authenticity, its fakery, its romanticism, and its formal qualities. Flaherty's cinematic approach may have been innocent of many of the narrative devices of point of view that had recently been pioneered by D. W. Griffith, but the film achieves considerable subjective effect in its overall framing of a family confronting adversity and in its treatment of intimate details in Inuit life. The film is a dramatisation in that its structure is of scenes that first develop the characters and their antagonist, the arctic environment, and that then build through various tests to the climax of a blizzard. To this end, Flaherty carefully staged many scenes with Nanook, based on their common knowledge of Inuit life.

Flaherty's signal technique was not to enfold the spectator in the actors' visual perspectives but to play upon dramatic tension and curiosity. He involves us in a good deal of waiting for things to happen, just as his subjects wait for things to happen. This third-person observation in long takes, celebrated by André Bazin as an alternative to seamless continuity editing, in fact operates structurally to achieve much the same results as continuity editing. Rather than being unco-opted witnesses of events unfolding in their own time (as for example when Nanook hunts the walrus), we are held as firmly by the dramatic logic of the scene as if we had been invited to identify with Nanook's visual point of view.

Similarly, Flaherty uses a technique of arousing curiosity and then satisfying it — a technique that has its analogue in the shot/countershot pattern of continuity editing. He will, for example, show us an unexplained activity such as cutting a block of ice, only to reveal later that it is to become the window of the igloo. Or, as in his next film, *Moana* (1926), he will show us part of an object, such as a palm tree, before he allows us to identify it in its entirety. By this technique Flaherty impli-

cates us in the process of decoding the film without resorting to a literally subjective viewpoint. The technique might be thought to distance us from Nanook's world, since Nanook is manifestly always one jump ahead of us in understanding, but the effect is curiously the opposite. As the ice window slides into position, we have a moment of elation at this ingenuity, as though we had thought of it ourselves. We find ourselves placed within the communal resonance of a small but satisfying achievement as though we were a participant in the event, much as we might join in the satisfaction of changing a tire without actually doing more than hold the tools. In Flaherty's later work this stance of third-person observation was only occasionally broken, despite the increasing sophistication of the cinematic techniques available to him.

Flaherty's subjective inflections of third-person narration were innovative, but in 1922 perhaps the most obvious new departure of *Nanook of the North* (although less obvious today) was its centring of an indigenous person as the hero of a film. *Nanook,* which appeared in the same year as Malinowski's *Argonauts of the Western Pacific,* was not the usual fanciful portrayal of noble savagery. Nanook was neither a fictional super-native, like a James Fenimore Cooper Indian, nor a native prodigy, like Bennelong, to be brought to Europe, dressed fashionably, and admired. By raising an unknown, living person from a so-called primitive society to the status of protagonist, the film confronted cultural stereotypes and suggested the possibility of identification with what was popularly viewed as an alien savage consciousness. Although the image of Nanook soon became a new stereotype, even as Nanook himself was dying of hunger, one can still glimpse in this effort of Robert and Frances Flaherty an early popularisation of cultural relativism and an implicit denial of social evolutionary theory.

Since Flaherty, ethnographic filmmakers have developed the various possibilities of exterior dramatisation, including further fictionalisation, as in Knut Rasmussen's *The Wedding of Palo* (1937); dramatic framing of discrete interactions, as in some of John Marshall's !Kung films and his *Three Domestics* (1970); and detailed recounting of the quests of individuals, as in *The Kawelka: Ongka's Big Moka* (1974) and Jean-Pierre Olivier de Sardan's *La Vieille et la pluie* (1974).

INTERIOR DRAMATISATION

It is interesting to compare Flaherty's work with a film that seems a precursor of Flaherty's own *Man of Aran* (1934) but in

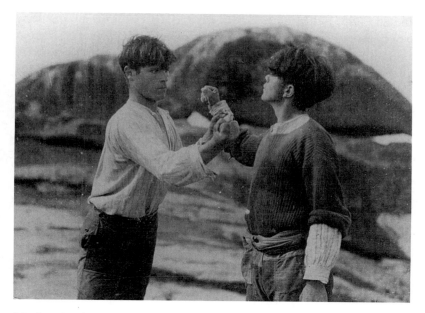

13. Interior dramatisation. *Finis terrae* (1929). Jean Epstein. British Film Institute still.

which the dramatisation is primarily concerned with evoking subjective experience. Today Jean Epstein's *Finis terrae* (1929) is all but forgotten, but in its time it was highly praised.[23] Like *Man of Aran* it is a fictionalised documentary, but set on remote islands off Brittany (in the *département* of Finistère) rather than off the Irish coast. Both films use local nonactors and deal with the theme of surviving in a harsh natural environment. But there the differences begin. Epstein's kelp gatherers are seen as members of a contemporary if remote community rather than as romantic anachronisms, and the film focusses on illness, the dangers of isolation, and the friction of personalities rather than on stoic heroism and idealised social relations. The film is primarily concerned to express the experience of a youth who contracts blood poisoning from a cut on his thumb while working with a companion and two older men on a waterless outer island. This story, by its very plainness and almost casual cruelty, seems meant to make a bourgeois audience aware of people for whom accidents and suffering are not always ameliorated by social institutions or happy endings (fig. 13).

Epstein's rough sea is often portrayed in slow motion, and the use

of wide angle rather than long lenses gives the landscape an unsettling emptiness rather different from Flaherty's heroic skylines. Throughout the film are shots evocative of human absence and irrational forces, such as a broken dish being gradually washed away by the tide. Early in the film, in the incident in which Ambroise cuts his thumb, a bottle of wine is broken and there is an argument between Ambroise and the other youth, Jean-Marie. This is edited in an abrupt fashion reminiscent of Soviet cinema and certain avant-garde and surrealist films of the period such as Buñuel's *Las Hurdes* [*Land Without Bread,* 1932]. Later, again in an avant-garde mode, Epstein creates a dreamlike montage of Ambroise's delirium in which he sees his own oddly extended arm.

Epstein's focus is upon his main characters' subjective experience of their isolation. Flaherty, by contrast, seems to have preferred to evoke the experience of people at a certain remove. This is consistent with the valedictory air that runs through all his films, and in the fishing scene in *Man of Aran,* or the extreme close-ups of faces he introduced in *Moana,* we remain spectators; in his last film, *Louisiana Story* (1948), the subjective experience of the Cajun boy is not so much created through the boy's eyes (except, notably, in the scene of the oil derrick) as through Flaherty's own detailed evocation of the swampland environment.

Throughout Epstein's film there are many instances of point-of-view editing that contrast with Flaherty's approach, but it is equally in the structures of third-person narration that Epstein, like Flaherty, effectively communicates the subjective experience of being in and of a place, as when Jean-Marie sculls his boat through the fog with Ambroise lying unconscious in the bottom. These scenes work by transference, as we project our own impressions upon the only character in the scene. In this sense *Finis terrae* seems to prefigure Antonioni's placing of figures in an environment—Monica Vitti on a rocky Mediterranean island thirty years later in *L'Avventura* (1960), or Steve Cochran in the foggy Po Valley of *Il Grido* (1957). Epstein also exploits the textures of objects and faces in close-ups in a way that links sight with the sense of touch, producing the strong synesthetic effect of feeling the objects as they might be felt by the characters in the film: the roughness of cloth, the coldness of rocks, the scab being scraped from Ambroise's thumb—possibilities similarly exploited in early Soviet cinema and by the surrealists.

With the coming of sound the dominant mode of documentary film became emphatically one of description and explanation. If the earlier confinement of text to screen titles was a barrier, this gave way to a flood of words. The emphasis was on the direct address of spoken commen-

tary, which had its origins in the lecture circuit and the emergent medium of radio. The resulting films bore the stamp of the institutional spokesman, the teacher, or, in the case of the strident American *March of Time* series, the voice of God, making assertions about other people with an assurance that left no room for their point of view.

This model continued into the 1950s, when it was transmogrified into television. The ethnographic version tended toward holistic descriptions of small-scale societies (*Mokil*, 1950, *The Land Dyaks of Borneo*, 1966); explications of ritual and technology (*Duminea: A Festival for the Water Spirits*, 1966, *Dani Houses*, 1974); and annotations of anthropologists' research footage, such as that of Gregory Bateson and Margaret Mead (*Childhood Rivalry in Bali and New Guinea*, 1952, *Bathing Babies in Three Cultures*, 1954). In one curious variant there were attempts to subjectivise the subject, seemingly because the films were aimed at children. The result was an endless stream of self-styled "educational" films with titles such as *Indian Boy of the Southwest* and *The Little Indian Weaver.* Occasionally a child's voice was used in the first person, usually with embarrassing results.

During this period the cost and difficulty of recording synchronous sound, or using post-synchronised dubbing, put the possibility of synchronous dialogue beyond the reach of most ethnographic filmmakers. British social documentary, however, gradually adopted it, so that by 1936 there were studio dialogue scenes in *Night Mail*, and by 1938 a film such as *North Sea* was made up almost entirely of scripted sequences, edited in fictional style, in which working people played themselves. There were also a few notable experiments in the testimonial mode using synchronous interviews: Arthur Elton's *Workers and Jobs* (1935) and the better-known *Housing Problems* (1935), which he co-directed with Edgar Anstey. One effect of the Great Depression and World War II seems to have been to turn the attention of European nations inward toward their own subcultures, producing a spurt of documentary dramatisations such as Georges Rouquier's *Farrebique* (1946) about farm life in France and Visconti's *La terra trema* (1948). This was a link backward to silent dramatic documentaries and forward to Italian Neorealism, which was to have important consequences for later observational ethnographic films. It established a model based on event-centred narrative rather than on explanation, and it implied that one could learn about other cultures through a combination of observation, empathy, and induction.

NARRATED DRAMATISATION

The strategy of *narrated dramatisation* seems to have arisen in the interval between the period of the "illustrated lecture" documentary and the advent of "direct cinema" and *cinéma vérité*, with their capacity to record natural sounds and synchronous dialogue at small cost and with small crews. In the early 1950s John Marshall began making film records of the San peoples of southwestern Africa. In 1956, when this material was archived at the Harvard Film Study Center, plans were made to produce five long films and fifteen or twenty shorter ones. The only long film completed was *The Hunters* (1958). A second, known informally as *Marryings*, was rough-cut but then taken apart and reintegrated into the rushes. *The Hunters* constructs the story of a thirteen-day giraffe hunt out of footage shot on various different occasions, in some cases even using shots of a different person to stand in for one of the main characters. Marshall narrates the story on the sound track, producing a hybrid of the traditional lecture film and the dramatised documentary. The camera tends to observe rather than draw the viewer into the scene, but the sound track develops an intimate and subjective, albeit third-person, perspective. This even extends to imputing thoughts to the characters. The film is notable for presenting itself implicitly as a cinematic version of a San hunter's tale, of a sort that might well be repeated and poetically embroidered around a campfire. In this respect, its form and semifictionalised construction, although later dismissed by Marshall as a Western overlay, may not necessarily be greatly at odds with San narrative practice, and the film to some extent parallels Jean Rouch's approach to indigenous storytelling and legend at about the same time (see below).

In 1961 Robert Gardner, who had been involved in the post-production of *The Hunters*, made the film *Dead Birds* about ritual warfare among the Dani highlanders of New Guinea. *Dead Birds* takes the narrated dramatisation of *The Hunters* a step further. Gardner knew pretty clearly in advance what sort of film he wanted to make, and he proceeded accordingly in his casting and filming. Unlike Marshall's camera work, much of Gardner's is in the second-person mode of shot/countershot. In keeping with the key metaphor of birds, one scene is even shot from the point of view of an owl. Sound is used to overlap discontinuous action, creating a suturing of time. There is considerable parallel montage, or intercutting of different actions so that they appear

to be happening simultaneously, as when the film cuts between men fighting and women getting salt from a brine pool.

Perhaps more significant than these specific narrative devices is the overall construction of the film. Gardner builds a story around certain characters who stand in an implied but only symbolic relationship to one another. Thus, out of the man Weyak and the boy Pua, Gardner creates a father-son archetype with a resonance for Western viewers and a utility for the plot that one suspects would not have borne the same significance for the Dani. In fact, Pua does not appear closely related to Weyak at all, and we are simply told that he "lives in a village close to Weyak's." The introduction of Weyak's wife Lakha completes the familiar circle of a nuclear family. The creation of these characters, their needs, and problems is consistent with the character-centred narration of much Western fiction.

Interestingly, Gardner elects to write most of his spoken text in the present tense, with certain archaic turns of phrase and, toward the end, a tendency toward iambic pentameter. We are introduced to Weyak in the following terms: "Among those who tell why men must die is Weyak." In part, the present tense serves the atmosphere of legend and the mythic metaphor through which Gardner wishes to explain Dani thought. It also imparts a further degree of intimacy, as when Weyak is looking out across the fields in the valley: "The sight never fails to please him, even when his thoughts concern the enemy and what they must be planning." There is an immediacy in such sentences as "Today Weyak is especially alert." Pua is characterised as a small swineherd, more timid than most, and we are told "Pua waits for manhood," giving him an objective in life to add to the welfare of his pigs.

The film is structured along the classical dramaturgical lines of exposition, conflict, rising action, reversal, climax, and resolution. This is a matter of framing events that occurred during the filming and that Gardner was either able to film or otherwise represent. The killing of the boy Weyakhé occurs unexpectedly, and in fiction the author would have been there, but of course Gardner was not, nor does he film the actual news of the death. What the film gives us instead is a freeze-frame as a man turns his head, with sudden background sounds of weeping; a shot of ducks taking off from the river; shots of empty watchtowers; and a stick floating down the river, which catches in the grass (signifying the stick of a boy swineherd).

The reversal of fortune represented by Weyakhé's death is centred by

the film as though it had happened to Pua, and from this point onward Weyakhé is Pua's surrogate self, just as Weyak is his surrogate father. To seal the relationship we are told, "Pua and Weyakhé were friends, being of similar age and disposition." The point at the river where Weyakhé was killed has been carefully set up earlier in the film as a place where Pua could be in danger, so that when the death occurs, we feel "It could have been Pua." In the events that follow, an enemy is killed, revenging the death, and the film moves swiftly toward its conclusion as Weyak's group celebrates in the gathering darkness.

I do not propose to discuss here the anthropological validity of Gardner's interpretation of Dani thought and culture. Some anthropologists have criticised it sharply, just as some have criticised the view of gender relations among the Hamar in *Rivers of Sand* (1975) and the portrayal of Hindu society in *Forest of Bliss* (1985). But I will point out several aspects of the film and Gardner's overall interests, which I believe are significant steps in the development of ethnographic film. Some of these are related to the attention he pays to subjective experience.

It is fair to say that Gardner is not particularly interested in the subjective experience of the Dani for its own sake, although there are moments in the film of intense personal sympathy. In fact, he has said that his interest in the Dani was secondary to his interest in what their experience might demonstrate about certain issues "of some human urgency."[24] The subjective view of ritual warfare in *Dead Birds* is therefore meant to make the viewer see warfare from another perspective, on its own premises, by a process of identification with people of a different society. Gardner wrote: "I wondered if a greater understanding of violence in men could be achieved if it was studied in a metaphysical context completely different from our own. I wanted to see the violence of war through altogether different eyes, and I dared hope that new thinking might follow from such an altered perception."[25] Writing four years before making the film, Gardner had compared human perception to the distorting eye of cinema. He suggested that film might produce reactions in the viewer affording "some approximation of the feelings of those to whom the experience actually belonged," or, failing this, it could at least make people "more deeply aware of the validity of what they witness."[26] This appears on one level to be merely a reaffirmation of the values of cultural relativism. Looked at more closely, it seems to me to be a link with recent efforts to position anthropological research in relation to seemingly puzzling behaviour in such a way as to understand it in the first instance as a dimension of emotional life[27] and per-

haps in the second instance as a function of how another society constructs personal identity.

There are several other points of interest. Gardner's use of a Dani myth represents an effort to incorporate textual material into ethnographic film as an explanation of behaviour, and at least it can be said that Gardner's use of the myth is not merely token but comprehensive. Gardner's interpretation of Dani experience through literary conventions is an instance of a filmmaker crossing generic lines in a way in which an anthropologist would usually not; yet in the present climate of experimentation, more than thirty years since Gardner's film, I would not be surprised to see it done convincingly. Works such as Michael Jackson's *Barawa and the Ways Birds Fly in the Sky*[28] may point the way for at least a few anthropologists. Last, Gardner's aim is the distinctly current one of turning the experience of other societies back upon his own as cultural critique.

In contrast to Gardner's rather utilitarian use of characters, a number of approaches in ethnographic film began to develop about the same time, approaches that took a much deeper interest in individual personality and its relation to society. It is perhaps significant that these approaches appear in films about societies in which changes are creating stress and ambiguity, and in films at the junctions between different cultures. These approaches can be roughly classed as psychodynamic — in their emphasis upon the conceptual and experiential worlds people inhabit and upon culture as it is reflected and re-created in the mind. Ethnographic films fitting this description have taken varied forms, ranging from psychodrama to cultural reexpression to ethnobiography.

PSYCHODRAMA

In 1953 Jean Rouch began shooting his film *Les Maîtres fous*, which portrayed secret rituals in which members of a Hauka cult in Ghana (then the Gold Coast) were possessed by the spirits of figures in the local British power structure, such as the governor, a doctor, and a general. The end of the film, where we see the members of the cult in their lowly jobs in Accra, forces a retrospective reading of the earlier material as a kind of psychological safety valve for their frustrations and loss of dignity under colonial rule.

It seems clear that in these events Rouch recognised the revelatory power of role-playing. In his next films he began to develop a form of ethnographic psychodrama. In *Jaguar*, filmed in 1954, he enlisted three

young men from the banks of the Niger to make a journey to the cities of the south in search of work and adventure. Their journey in fact followed a well-known labour migration route of the period. In making the film the three were also living out certain ambitions of their own, and Rouch later added a sound track in which they improvise dialogue, narrate the story, and comment on their own performances. The feeling of subjective experience in the film is vivid because it derives from several different sources: the character development on screen, the narrative flow that sweeps the viewer along as a participant, the redoubling of the actual upon the fictional, the spontaneous voices evoking places, encounters, desires, and memories. The film also operates on the level of legend, which Rouch was later to develop in his film *La Chasse au lion à l'arc* (*The Lion Hunters*, 1957–64).

In *Moi un noir*, filmed three years later, Rouch focusses more closely on fantasy in the lives of young men who are new arrivals to Treichville, a suburb of Abidjan in Côte d'Ivoire. Fiction and reality mingle as they adopt the movie gangster roles of Eddie Constantine and Edward G. Robinson in the back alleys and bars where they pass their time. But as the film makes clear, fiction is not simply fiction: it becomes reality in the formation of consciousness. And it is a significant feature of this liminal culture.

The following year, 1958, Rouch began *La Pyramide humaine*, a film that turned role-playing into a more conscious exercise of the participants, this time secondary school students in Abidjan. The film is posed as an experiment in race relations, in which the black and white students agree to increase their social interaction while at the same time inventing and acting out an interracial love story. The participants discuss their feelings about the experiment within the film, an approach that Rouch used again and extended in *Chronique d'un été* set in Paris two years later (fig. 14). From this Rouch produced his enigmatic dictum: "When people are being recorded, the reactions that they have are always infinitely more sincere than those they have when they are not being recorded."[29]

After *Chronique d'un été* Rouch gave up psychodrama, believing it to be too dangerous to the people involved.[30] But the method he had explored had opened up an approach in which testimony was transformed into narrative, an externalisation of interior space. Rouch's experiments took place in an atmosphere of political change and shifting cultural boundaries. In their effort to bring alive the experience of living through those times, they prepared, I believe, the way for Rouch's next

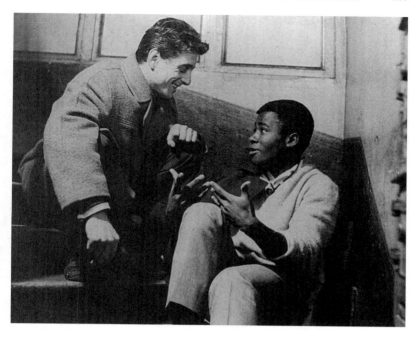

14. Psychodrama. *Chronique d'un été* (1961). Jean Rouch and Edgar Morin. British Film Institute still.

efforts, which involved speaking with his camera in a voice not unlike that of a spirit medium.

CULTURAL REEXPRESSION

Rouch's answer to his repudiation of psychodrama seems to have been to begin using himself rather than others as a primary subject. (In speaking of *La Chasse au lion à l'arc,* begun at about this same time, he said, "The film . . . is much less the lion hunt as it actually exists than myself in the face of this phenomenon.")[31] In the long series of *Sigui* films begun in 1966 with Germaine Dieterlen, he began recording a complex ritual cycle of the Dogon, performed only every sixty years. In the *Sigui* films, and in *Funerailles à Bongo: Le vieil Anai* (1972), he joins processions through the village while filming. One has the sense of being surrounded and of moving through spaces — not necessarily as a Dogon, but as Rouch possessed by the Dogon.

Tourou et Bitti, made in 1971, directly concerns spirit possession,

which can only occur upon the playing of two ancient drums, "Tourou" and "Bitti." The film is essentially a single sequence shot of ten minutes' duration. Afterwards, upon viewing the film, Rouch said he believed the camera acted as a "catalyst" for the trance and that while filming he himself had gone into what he called "cine-trance,"[32] an idea he was later to describe in the following terms: "I often compare it to the improvisation of the bullfighter in front of the bull. Here, as there, nothing is known in advance; the smoothness of a *faëna* is just like the harmony of a travelling shot that articulates perfectly with the movements of those being filmed. . . . It is this aspect of fieldwork that marks the uniqueness of the ethnographic filmmaker: instead of elaborating and editing his notes after returning from the field, he must, under penalty of failure, make his synthesis at the exact moment of observation."[33]

I interpret this notion of cine-trance both literally and metaphorically. There is no doubt that filming can induce a trancelike state in which the camera operator feels a profound communion with surrounding people and events and indeed feels possessed by a spirit emanating from them. In these curious ballets, one moves as though directed by other forces, and the use of the camera feels more than anything like playing a musical instrument. Nevertheless, I believe that what Rouch means to suggest by "cine-trance" is a more complex idea about ethnographic representation. The filmmaker can never duplicate another people's experiences, but, Rouch proposes, by internalising aspects of their life he or she can reproduce them in the first person through the camera. Cine-trance perhaps represents a form of ethnographic dialogue, or at least one half of such a dialogue, in which the ethnographer celebrates his or her own response to a cultural phenomenon. It seems to me in retrospect that most of Rouch's films have been such a celebration of his own sensibility in encountering another society.

There are a few other films that perhaps fit this description, of which I note specifically Basil Wright's *Song of Ceylon,* made in 1934, and Les Blank's films on music in the American South and Southwest. Wright's film, in particular, reflects an ecstatic experience, an epiphany. It was, Wright said, "the only film I've made that I really loved, and it was in fact a religious experience."[34]

ETHNOBIOGRAPHY

Jorge Preloran employs the term "ethnobiography" to describe his films portraying people in the marginalised folk cultures of

his native Argentina.[35] In its approach ethnobiography shares some of the testimonial qualities of Rouch's work, but it is more closely related to the "life history" genre of ethnography. Preloran began by making long journeys into remote parts of Argentina with only a tape recorder, gathering the material for his sound tracks before embarking on filming. His method was one of compiling extensive tape recordings of his subjects' reminiscences and opinions, which would then be drawn upon to form the voice-over sound tracks for the films about them, usually shot in short fragments with a spring-wind camera. He refined the technique in such films as *Imaginero* (1969), *Cochengo Miranda* (1974), and *Zerda's Children* (1978).

Preloran's films have always been collaborative, and this perhaps strikes us most forcefully in the English versions in which we hear both the original Spanish and Preloran's own voice translating it. However, this dimension is also partly suppressed, since we do not hear Preloran's eliciting questions. It is in fact in the images that Preloran provides both interpretation and contextualisation. The dialogue is here reestablished on the level of the intertextual play of the verbal and visual. These films also provide an opportunity, rarely given, for film subjects to express their own assessments of the effects of larger historical forces on their lives, and one senses that the framework that Preloran creates acts as a stimulus for such reflection. The style of filming is in itself unusual, in that it consists of layerings of details that situate the viewer, with a subjective implication, in the environment of the speaker (fig. 15).

Preloran's objective, he has said, is to see a culture through the eyes of one of its members, in order to give a voice to powerless and dispossessed groups in Argentine society.[36] Ethnobiography, whatever its aims as advocacy, attempts to create portraits of individuals of other cultures in some psychological and historical depth. While it is ostensibly a way of writing culture from the inside through an insider's perspective, it is framed by an outsider's concerns. In its doubling of subjectivities and its attempt to reconstitute the culturally different historical person it creates a conundrum, the charged space of an encounter. It differs from indigenous media production as all biography must differ from autobiography, in its strengths as well as in its weaknesses.

Preloran's films are similar in form to a genre of documentary exemplified by Roman Kroiter's *Paul Tomkowicz: Street-Railway Switch Man* (1954) and Richard Chen's *Liu Pi Chia* (1967). In these films the voice one hears does not speak for the subject but is, or purports to be, the subject speaking. But ethnobiography should be considered to extend

15. Ethnobiography. *Imaginero* (1969). Jorge Preloran.

beyond this formal strategy and to include other ethnographic films that concern the consciousness of individual social actors. These may use on-camera interviews and span a lifetime, as in *N!ai: The Story of a !Kung Woman* (1980), or attempt to portray a person at a particular juncture in his or her life, as in *The Spirit Possession of Alejandro Mamani* (1975), *Lorang's Way* (1979), *The House-Opening* (1980), and *Sophia's People* (1985).

A final cluster of approaches to subjectivity could be classed as contextual. These have produced ethnographic films that somewhat distance the social actors from the viewer and do not evoke the same level of identification as dramatisations and psychodynamic approaches. They permit an insight into subjective experience by allowing the viewer to interpret social actors' responses within a specific context, either elaborated by the film or defined by a particular context of interaction with the filmmaker. These approaches depend variously upon observation, interview, and interchange.

OBSERVATION

An alternative to the provocation employed in European *cinéma vérité* was the North American observational approach pioneered

by such filmmakers as Richard Leacock, Robert Drew, and the Maysles brothers in the United States and by Terence McCartney-Filgate, Michel Brault, and Roman Kroiter at the National Film Board of Canada. The ethnographic use of observational documentary style was first practised by John Marshall, who began shooting event-centred sequences of the life of !Kung people in southwestern Africa in the 1950s. Two other important bodies of work in this style are Timothy Asch's Yanomamö films and the Netsilik Eskimo series begun under the direction of Asen Balikci in 1963.

The aim of these films was to record events in long synchronous takes, without directorial or editorial intervention, so that the scenes, when properly contextualised, would reveal or demonstrate the cultural basis of interpersonal behaviour. They often give access to the emotional lives of people through their portrayals of characteristic social interactions, which are allowed to play out as much as possible in real time. The nuances of personality and discourse contained in such scenes, and their potential value for social analysis, can be seen in a film by John Marshall, filmed in 1957–58, called *A Joking Relationship* (1962), in which a young married girl, N!ai (the subject of Marshall's later biographical film), flirts with her great uncle, /Ti!kay. Such small dramas of self-presentation resemble scenes from earlier dramatised documentaries, but they are fundamentally different in their emphasis upon spontaneous events.

In the Netsilik Eskimo series the approach of one of the primary cinematographers, Robert Young, was central both to filming interpersonal behaviour unobtrusively and structuring it visually. The subjective effect — that is, the access given in this instance to perceived emotions — could be said to result from an "intimate" documentary camera style, which Young had already developed in the family scenes of *Cortile Cuscino*, made with Michael Roemer in 1961. In one of the Netsilik films about family life, shot inside a large igloo, the camera establishes one person, a young mother, as the person from whose point of view we tend to read the scene. It does this not by adopting her visual point of view but by making her the visual and metaphorical centre of attention. As in many fiction films, a special relationship is established with a character without employing the formal devices of character narration but rather through the structure of the scene itself.

Despite this sensitivity to individuals, the Netsilik films did not provide subtitled translations of spoken dialogue. The first ethnographic films that did — among them *The Feast* (1970), *Nawi* (1970), Marshall's early "sequence" films, and *Imbalu* (filmed 1968) — began to give access

16. Observation and subtitles. *To Live with Herds* (1972). David MacDougall.

not only to visible expressions of emotion but also to the intellectual lives of their subjects, including the feelings and accounts of personal experiences that might be expressed in the course of their conversations. The introduction of subtitled speech was in fact a crucial step in liberating the ethnographic film from the stranglehold of voice-over commentary (fig. 16). It also made possible a form of ethnographic narrative cinema that was no longer confined to nonverbal behaviour nor dependent upon voice-over narration — films such as *Naim and Jabar* (1973), *The Wedding Camels* (1977), and, more recently, *Joe Leahy's Neighbours* (1988).

INTERVIEW

One predictable consequence of subtitling synchronous speech was an increasing use of the interview in ethnographic films. The interview had emerged from journalism to become a key element in public affairs television and the documentaries of the 1960s. From an anthropological point of view, the interview was an obvious resource as one of the main information-gathering techniques of fieldwork.

Interviews in films not only convey spoken information but also unspoken information about the contexts in which they occur. They allow the speakers to describe their subjective experiences of past events, while simultaneously we interpret the emotions and constraints of the moment. The presence of a person talking on the screen can have a powerful effect upon us because of the resemblance of this situation to many of the situations in which we watch, and identify with, people in daily life. Interviews are perhaps the ideal medium for confession and self-revelation, but also equally for misinformation. In this respect, it is important to see interviews as representing limited perspectives and uneven mixtures of candour and self-justification. A film that demonstrates this is John Marshall's *N!ai*. As N!ai speaks, one has a sense of a performance addressed not only to Marshall, who has known her since childhood, but to others around her with whom she is shown to be in considerable friction. The film is eloquent of the emotional confusion of one individual in an uprooted indigenous society. By contrast, the private and confiding interviews with women in Melissa Llewelyn-Davies's films *The Women's Olamal* (1984) and *Memories and Dreams* (1993) are used to reveal women's attitudes generally toward disputes and gender relations. By including two or more women in the interviews the films allow a degree of consensus to emerge.

Films that include interviews with several people offer a more complex picture of enquiry and validation and some possibility of cross-checking responses. Unlike the results of sociological questionnaires, many judgements about reliability of testimony are left to the viewer. At its best, in such films as *Eskimos of Pond Inlet* (1975) and *Maragoli* (1977), this approach permits a kind of understanding that can incorporate multiple perspectives and transcend much apparently contradictory evidence. But interviews can also easily be used selectively, without the eliciting questions, and in fragments to support a particular argument, relying on the audience's assumption that the authority of the speakers validates the authority of the entire structure—a criticism legitimately levelled at many of the interview-based political documentaries of the 1970s and 1980s.

Although most interviews are employed to reveal personal attitudes and deliver information, the interviews in Roger Sandall's *Coniston Muster* (1972) are put to a somewhat different purpose. The film is first of all important for its foregrounding of individuals at a time when Australian Aboriginal people were still widely portrayed as anonymous social objects. It does this partly by eliciting stories. The effect upon the viewer

is of encountering an individual personality in all its forcefulness. But it is in the storytelling that the viewer also begins to read a distinctive cultural style and perceive another possible conceptual world.

There is a further form of testimony, which lies somewhere between the interview and storytelling. This is conversation with the filmmaker, freed from the formality of the question-and-answer format. It can produce a different kind of volunteered information (sometimes even turning questions back upon the filmmaker) and often includes the sort of low-key dialogue that consists of an accretion of comments, disagreements, and speculations. It can veer off to include other people who are nearby and move back and forth between them and the filmmaker, lessening the gap between formal filmmaking and first-person experiences familiar to most viewers. These situations resemble those of participant observation in which much ethnographic information is actually acquired. In this way they are capable of providing a commentary on the contingency and provisional nature of anthropological understanding, absent in films that purport to speak with absolute authority.

INTERCHANGE

In some films the context of interaction with the subjects tilts toward further involvement. The filmmaker intervenes increasingly in their lives or, often without intending to, becomes a major focus of their attention. Sometimes these films provide a catalyst for their actions and a mirror in which to see themselves. Their interchange with the filmmaker lies at the heart of the film, although not necessarily at the heart of all the behaviour that the film describes.

Rouch provoked the action of films such as *Jaguar*, but he was not *in* them. But in *Chronique d'un été* he and the co-director Edgar Moran emerge as major characters. Moran's scenes with the young Italian woman, Marilou, have the emotional intensity of psychiatric interviews. In documentary films such as *Home from the Hill* (1985) and *The Things I Cannot Change* (1966) filmmakers have been targeted behind the camera by lonely and talkative subjects, and the latter film, a study of a poor family in Montreal, becomes an extended monologue in which the father hijacks the film to explain his predicament and vent his feelings. Ethnographic films rarely reveal such occurrences, but relationships of dependency and the opening of new horizons created by the filmmaking have undoubtedly affected some film subjects deeply, for better or worse. Through ethnographic films, certain participants achieve a mea-

sure of fulfilment and prestige in their own communities. Frank Gurr-manamana of Kim McKenzie's *Waiting for Harry* (1980) is a clear example. But the father in *The Things I Cannot Change* is known to have suffered community ostracism when the film was televised, and James Blue described how the boy Peter Boru behaved at the end of filming *Kenya Boran* (1974): "He said, 'You have shown us a life we can never lead, and I don't want to be reminded of it.' And he walked off and wouldn't say good-bye after that."[37] In an effort to address such issues, Jorge and Mabel Preloran have made the consequences of filmmaking the focus of their film *Zulay Facing the Twenty-First Century* (1990), a study of one of their film subjects, Zulay Saravino.

In Gary Kildea's *Celso and Cora* (1983) the interchange of filmmaker and subject is not merely a feature of the encounter but is developed to explore the subjective world of the protagonists. Kildea's aim is to counter the Western conception of Third World poverty as a stereotyped "condition" that, to an outsider, reduces its members to an abstraction upon whom further injustices can more easily be practised. He wants to make it clear that although people like Celso and Cora are poor, they do not consider themselves to be primarily defined as human beings by their poverty. During the course of the filming both Celso and Cora talk separately to Kildea as well as include him in their own discussions. When eventually they quarrel and split up, Celso adopts Kildea as his companion and confidant.

Other ethnographic films emphasise such relationships more formally and aim at more specific areas of knowledge. In *Jero on Jero: A Balinese Trance Seance Observed* (1980) the main subject, a Balinese spirit medium and healer, watches a film made of her while she was in trance. As she follows her own image on a video monitor she grasps the anthropologist (Linda Connor) by the hand and provides an emotional commentary on her filmed behaviour, her ideas about spirit possession, her understanding of the supernatural world, and her reactions to seeing herself in trance.

THE SUBJECTIVE CAMERA

There is finally the possibility of a truly subjective camera. The use of a camera by the subject of an ethnographic film occurs briefly in a few films (*My Family and Me*, 1986; *A Wife among Wives*, 1981), but largely as an emblem of a personal exchange with the filmmakers. To my knowledge there are as yet no ethnographic films that integrate

long segments of indigenous filming with those by an outside film-maker, nor collaborations incorporating the different perspectives of several filmmakers. Some indigenous media production has specific ethnographic intentions, but this rarely extends to the conscious use of a "first-person" camera, although an exception is *Intrepid Shadows* (1970) by Al Clah, one of the Navajo participants in the Sol Worth-John Adair experimental Navajo film project. In a special category may be Marc Piault's *Akazama* (1984), an epistemologically complex film in which Piault uses the camera "in the first person" in a way quite unlike Rouch to reveal the problems of understanding and interpreting ritual during the enthronement of a West African king.

The Seen and the Unseen

Looking back on this history of efforts to encompass the subjective voice in ethnographic film, one can find few statements of the motives for doing so. There are several recurrent themes — "giving a voice" to others; seeing another culture through individual actors; engendering indigenous perspectives in the viewer — but these seem insufficient to explain a tendency that has been pursued with such persistence and ingenuity. We are left with a set of questions about the pursuit of the subjective voice. What are its motivations? Is it a means to an end or a fulfilment? What aspects of subjective experience are attainable in film? What place does the subjective voice occupy in filmmakers' conceptions of culture and society? Is the attempt to reveal the subjective an act of communion or merely of invasion?

The search in ethnographic films for analogues of subjective experience seems first of all to have been an effort to apply a corrective to increasingly abstract descriptions of colonised and marginalised peoples. It was seen to be within the powers of film to make the exotic and strange at least comprehensible if not familiar, and this accorded with liberal sentiments from early in the century. The fiction film provided a ready model and ideological framework for this at certain periods, particularly after 1910 with the emergence of new modes of filmic narration (in Griffith's work particularly) and after World War II with the advent of Italian Neorealism.

I consider a second part of the quest related to the perhaps perverse tendency among filmmakers to distrust visual representations and seek

to transcend them. There is an irony in the disjunction that has grown up steadily between anthropologists and filmmakers, in that anthropologists, by and large, have wished film to make increasingly accurate, complete, and verifiable descriptions of what can be seen—that is, of behaviour, ritual, and technology—whereas filmmakers have shown a growing interest in precisely those things that cannot be seen. It was never the physical body that was felt to be missing in ethnographic films. The body was constantly and often extravagantly before us in its diversity of faces, statures, costumes, and body decorations. It was all too easy to present such images with their accompanying exoticism. What was missing was not the body but the experience of existing in it.

There is thus in ethnographic filmmaking not only a journey of discovery from the abstract to the personal but from representation to evocation. I mean to suggest here something akin to Stephen Tyler's notion of replacing the scholarly or artistic object by a discourse which, because it evokes, need not represent.[38] In recent years one also sees a movement away from monologue toward—not even polysemic or polyvocal expression—but polythesis: an understanding that comes out of the interplay of voices rather than merely their co-presentation. Paul Willemen has noted the curious fact that while the tendency of radical cinema has been to reassert the importance of material and historical structures over the Western tradition of character narration centred in the individual, the movement of ethnographic film has been precisely the reverse, away from structures toward individual experience. In both cases the purpose can be seen as corrective. The dangers for ethnographic film lie in overcorrection, of exchanging one reductionism for another.

I have outlined three general strategies by which ethnographic films activate the subjective voice. Such distinctions are of course artificial, although they may help to characterise the emphasis of different films. The subjective voice is more often like an aerial image that forms only as a convergence of light waves. It is usually evoked in the intersection of what I have called testimony, implication, and exposition.

Toward the end of his essay "Questions of Magnitude," Bill Nichols writes of a necessary but unstable balance in which the person in documentary is held suspended, allowing the film to explore matters "that exceed any one logic or code, that are, among other things, magnitudes in excess of any discursive frame."[39] Evocation of the person for Nichols, following Frederic Jameson, seems to require a crossing of the trajectories of the historical, narrative, and mythic to overcome the closure of past structures of containment. I have put the problem in somewhat

different terms, but I believe the intersecting and contradictory frames of subjectivity lead to a similar conclusion. Testimony is what gives us the subjective voice of the historical person, yet we are implicated in the destiny of others through narrative; and the mythic attributes of social actors are heightened through the distancing created by exposition.

The interpenetration of these perspectives may be seen as a metaphor for the interpenetration of cultural perspectives that increasingly characterises human communities. Firm distinctions between self and other, East and West, North and South become less certain in the contemplation of almost every social arena. These changes have begun to undermine some of the assumptions upon which traditional critiques of power relations have been based, including those about disciplines such as anthropology. The changes now occurring should make clear that some of these critiques exhibit the same kind of reductionism that science itself has often embraced in linear representations that separate sign from signified, observer from object, analysis from experience. Such a realization may cause us to turn increasingly toward addressing the problems of interpreting multifaceted cultural relations.

The search for the subjective voice in ethnographic film often reflects, perhaps surprisingly, a repudiation of Western ideologies that celebrate the isolated individual consciousness as the only locus of understanding in a hostile but unquestioned (or supposedly "natural") social order. In many of the films I have discussed it is instead the means toward a more complex understanding of a cultural consciousness that consists in discourses between different subjectivities. In this sense it is an effort to construct a way of looking at the world that is intersubjective and, finally, communal.

Films cited

Akazama (1984). Marc Piault.

L'Arroseur arrosé (1895). Louis Lumière.

L'Avventura (1960). Michelangelo Antonioni.

Bathing Babies in Three Cultures (1954). Gregory Bateson and Margaret Mead. Filmed in the 1930s.

Celso and Cora (1983). Gary Kildea.

La Chasse au lion à l'arc [*The Lion Hunters*] (1964). Jean Rouch. Filmed 1957.

Childhood Rivalry in Bali and New Guinea (1952). Gregory Bateson and Margaret Mead. Filmed in the 1930s.

Chronique d'un été (1961). Jean Rouch and Edgar Morin.

Cochengo Miranda (1974). Jorge Preloran.

Coniston Muster (1972). Roger Sandall.

Cortile Cuscino (1961). Michael Roemer and Robert Young.

Dead Birds (1963). Robert Gardner.

Dani Houses (1974). Karl Heider.

Duminea: A Festival for the Water Spirits (1966). Francis Speed, filmmaker; Robert Horton, anthropologist.

The Electrical Carriage Race from Paris to Bordeaux (1897). Louis Lumière.

The Eskimos of Pond Inlet (1975). Michael Grigsby, filmmaker; Hugh Brody, anthropologist.

Farrebique (1946). Georges Rouquier.

The Feast (1970). Timothy Asch, filmmaker; Napoleon A. Chagnon, anthropologist.

Finis terrae (1929). Jean Epstein.

Forest of Bliss (1985). Robert Gardner.

Funerailles à Bongo: Le vieil Anai (1972). Jean Rouch.

Il Grido (1957). Michelangelo Antonioni.

Home from the Hill (1985). Molly Dineen.

The House-Opening (1980). Judith MacDougall. Filmed 1977.

Housing Problems (1935). Edgar Anstey and Arthur Elton.

The Hunters (1958). John Marshall.

Las Hurdes [*Land Without Bread*] (1932). Luis Buñuel.

Imaginero (1969). Jorge Preloran.

Imbalu: Ritual of Manhood of the Gisu of Uganda (1989). Richard Hawkins, filmmaker; Suzette Heald, anthropologist. Filmed 1968.

In the Land of the Head-Hunters (1914). Edward S. Curtis.

Intrepid Shadows (1970). Al Clah.

Jaguar (1967). Jean Rouch. Filmed 1954.

Jero on Jero: A Balinese Trance Seance Observed (1980). Patsy Asch and Timothy Asch, filmmakers; Linda Connor, anthropologist.

Joe Leahy's Neighbours (1988). Robin Anderson and Bob Connolly.

A Joking Relationship (1962). John Marshall. Filmed 1957–58.

The Kawelka: Ongka's Big Moka (1974). Charlie Nairn, filmmaker; Andrew and Marilyn Strathern, anthropologists.

Kenya Boran (1974). James Blue and David MacDougall, filmmakers; P. T. W. Baxter, anthropologist.

The Land Dyaks of Borneo (1966). William Geddes. Filmed 1961.

Liu Pi Chia (1967). Richard Chen.

Living Hawthorn (1906). William Alfred Gibson and Millard Johnson.

Lorang's Way (1979). David MacDougall and Judith MacDougall. Filmed 1973–74.

Louisiana Story (1948). Robert Flaherty.

Les Maîtres fous (1954). Jean Rouch.

Man of Aran (1934). Robert Flaherty.

Maragoli (1977). Sandra Nichols, filmmaker; Joseph Ssenyonga, anthropologist.

Memories and Dreams (1993). Melissa Llewelyn-Davies.

Moana (1926). Robert Flaherty.

Mokil (1950). Conrad Bentzen. Filmed 1947.

Moi un noir (1958). Jean Rouch. Filmed 1957.

My Family and Me (1986). Colette Piault.

N!ai: The Story of a !Kung Woman (1980). John Marshall.

Naim and Jabar (1973). David Hancock and Herb di Gioia, filmmakers; Louis Dupree, anthropologist.

Nanook of the North (1922). Robert Flaherty.

Nawi (1970). David MacDougall. Filmed 1968.

Netsilik Eskimo film series. Asen Balikci. Filmed 1963–65.

Night Mail (1936). Harry Watt and Basil Wright.

North Sea (1938). Harry Watt.

Paul Tomkowicz: Street-Railway Switch Man (1953). Roman Kroiter.

La Pyramide humaine (1961). Jean Rouch. Filmed 1958–59.

Rivers of Sand (1975). Robert Gardner.

Sigui film series. Jean Rouch and Gilbert Rouget, filmmakers; Germaine Dieterlen, anthropologist. Filmed 1967–74.

Song of Ceylon (1934). Basil Wright.

Sophia's People (1985). Peter Loïzos.

The Spirit Possession of Alejandro Mamani (1975). Hubert Smith.

La terra trema (1948). Luchino Visconti.

The Things I Cannot Change (1966). Tanya Ballantyne.

Three Domestics (1970). John Marshall.

To Live with Herds (1972). David MacDougall.

Tourou et Bitti (1971). Jean Rouch.

The Transformed Isle (1907–15). R. C. Nicholson.

La Vieille et la pluie (1974). Jean-Pierre Olivier de Sardan.

Yanomamö film series. Timothy Asch, filmmaker; Napoleon A. Chagnon, anthropologist. Filmed 1968 and 1971.

Waiting for Harry (1980). Kim McKenzie, filmmaker; Les Hiatt, anthropologist.

The Wedding Camels (1977). David MacDougall and Judith MacDougall. Filmed 1973–74.

The Wedding of Palo (1937). Knut Rasmussen.

A Wife among Wives (1981). David MacDougall and Judith MacDougall. Filmed 1973–74.

Workers and Jobs (1935). Arthur Elton.

The Women's Olamal (1984). Melissa Llewelyn-Davies.

Zerda's Children (1978). Jorge Preloran.

Zulay Facing the Twenty-First Century (1990). Jorge Preloran and Mabel Preloran.

Notes

1. Bronislaw Malinowski, *Argonauts of the Western Pacific* (London, 1922), 25.

2. Claude Lévi-Strauss, "Anthropology: Its Achievements and Future," *Current Anthropology* 7 (1966): 126.

3. E. H. Gombrich, *Art and Illusion* (Princeton, 1960), 5.

4. Bill Nichols, *Ideology and the Image* (Bloomington, Ind., 1981), 250.

5. Clifford Geertz, "Blurred Genres: The Refiguration of Social Thought," *American Scholar* 49 (1980): 165–79.

6. Nichols, *Ideology and the Image*, 231.

7. Bill Nichols, "Questions of Magnitude," in John Corner, ed., *Documentary and the Mass Media* (London, 1986), 231.

8. Dai Vaughan, *Television Documentary Usage* (London, 1976), 26.

9. Bill Nichols, *Representing Reality* (Bloomington, Ind., 1991), xv, 105–98.

10. David MacDougall, "Ethnographic Film: Failure and Promise," *Annual Review of Anthropology* 7 (1978): 405–25.

11. For example, Jay Ruby, "Is an Ethnographic Film a Filmic Ethnography?" *Studies in the Anthropology of Visual Communication* 2, no. 2 (1975): 104–11, and Jack A. Rollwagen, "The Role of Anthropological Theory in 'Ethnographic' Filmmaking," in Jack A. Rollwagen, ed., *Anthropological Filmmaking* (Chur, Switzerland, 1988), 287–315.

12. Nichols, "Questions of Magnitude," 110–11.

13. Nichols, *Ideology and the Image*, 96–100.

14. Ibid., 111.

15. For example, Claude Lévi-Strauss, *Tristes Tropiques* (New York, 1974), or Colin Turnbull, *The Mountain People* (London, 1973).

16. George Marcus and Michael M. J. Fischer, *Anthropology as Cultural Critique* (Chicago, 1986).

17. E. E. Evans-Pritchard, *Nuer Religion* (Oxford, 1956), 322.

18. David MacDougall, "A Need for Common Terms," *SAVICOM Newsletter* 9, no. 1 (1981): 5–6.

19. Nick Browne, "The Spectator-in-the-Text: The Rhetoric of *Stagecoach*," *Film Quarterly* 29, no. 2 (Winter 1975–76): 26–38.

20. François Truffaut, *Hitchcock* (New York, 1967), 51.

21. For example, Jean-Pierre Oudart, "La suture," *Cahiers du cinema* 211 (April 1969): 36–39, and "La suture (2)," *Cahiers du cinema* 212 (May 1969): 50–56, or Daniel Dayan, "The Tutor-Code of Classical Cinema," *Film Quarterly* 28, no. 1 (Fall 1974): 22–31, or Edward Branigan, *Point of View in the Cinema: A Theory of Narration and Subjectivity in Classical Film* (New York, 1984).

22. Browne, "The Spectator-in-the-Text," 33.

23. Richard Abel, *French Cinema: The First Wave, 1915–1929* (Princeton, 1984), 500.

24. Robert Gardner, "On the Making of *Dead Birds*," in Karl G. Heider, ed., *The Dani of West Irian,* Warner Modula Publication Module 2 (n.p., 1972), 31–33.

25. Robert Gardner and Karl G. Heider, *Gardens of War* (New York, 1968), xiii.

26. Robert Gardner, "Anthropology and Film," *Daedalus* 86 (1957): 347–48.

27. Michelle Z. Rosaldo, *Knowledge and Passion: Ilongot Notions of Self and Social Life* (New York, 1980).

28. Michael Jackson, *Barawa and the Way Birds Fly in the Sky* (Washington, 1986).

29. James Blue, "Jean Rouch in Conversation with James Blue," *Film Comment* 4, nos. 2–3 (1967): 84.

30. Ibid.

31. Jean Rouch, interview, in G. Roy Levin, *Documentary Explorations* (New York, 1971), 131–46.

32. Jean Rouch, interview with Enrico Fulchignoni, August 1980, in *Jean Rouch: Une retrospective* (Paris, 1981), 28–29.

33. Jean Rouch, "The Camera and the Man," *Studies in the Anthropology of Visual Communication* 1 (1974): 41.

34. Basil Wright, interview in G. Roy Levin, *Documentary Explorations,* 53.

35. Jorge Preloran, "Ethical and Aesthetic Concerns in Ethnographic Film," *Third World Affairs* (1987): 464–79.

36. Sharon R. Sherman, "Human Documents: Folklore and the Films of Jorge Preloran," *Southwest Folklore* 6, no. 1 (1985): 36.

37. James Blue and David MacDougall interviewed by Colin Young, 5 Jan. 1975 (typescript, 1987).

38. Stephen A. Tyler, *The Unspeakable* (Madison, Wis., 1987).

39. Bill Nichols, "Questions of Magnitude," 122.

12

Mediating Culture

Indigenous Media, Ethnographic Film, and the Production of Identity

FAYE GINSBURG

And tomorrow? . . . The dreams of Vertov and Flaherty will be combined into a mechanical "cine-eye-ear" which is such a "participant" camera that it will pass automatically into the hands of those who were, up to now, always in front of it. Then the anthropologist will no longer monopolise the observation of things.

Jean Rouch

Aboriginal communities are ensuring the continuity of their languages and cultures and representation of their views. By making their own films and videos, they speak for themselves, no longer aliens in an industry which for a century has used them for its own ends.

Michael Leigh

Many Aboriginal people have said, "let's have our own rights concerning TV. We must have equal time on air, showing our own people, our own culture and our own language. And it must be done in our own way!"

Central Australian Aboriginal Media Association

Over the last ten years, indigenous and minority people have been using a variety of media, including film and video, as new vehicles for internal and external communication, for self-determination, and for resistance to outside cultural domination. Yet the use of such visual media by indigenous people has also raised serious questions for them. Is it indeed possible to develop an alternative practice and aesthetic using forms so

identified with the political and economic imperatives of Western consumer culture and the institutions of mass society? In the most hopeful of interpretations, these new media forms are innovations in both filmic representation and social process, expressive of transformations in cultural and political identities.

Alternative "multicultural media" have become both fashionable and more visible since the mid-1980s: exhibitions and film festivals in the United States,[1] the Black Film workshop sector in the United Kingdom,[2] and a Special Broadcasting Service (SBS) in Australia are just a few examples of this increased interest.[3] Until quite recently,[4] support for and exhibition of such work focussed on productions by ethnic minorities rather than on the indigenous groups who have been dominated by encompassing settler states such as the United States, Canada, and Australia.

This essay will focus on what I am calling indigenous media — with a particular focus on Aboriginal Australians — as a distinct if problematic form of cultural activism and an emerging genre. To recognise indigenous media in this way acknowledges the fact that most indigenous people have a sense of how their political, historical, and cultural situation differs from that of ethnic minorities and how that difference might shape their use of media. As Rachel Perkins, the head of Australia's SBS Aboriginal Unit, explains, in relation to her work in developing Aboriginal television programming:

they [SBS management] would probably consider us another ethnic group . . . like the Italians, the Greeks, the Yugoslavs, etc., but . . . we've got a definitely different role than all the other people. . . . First of all, we have to educate the whole country about the history of the place and we've got to try and maintain our culture and also build an economic future for ourselves through employment in the television industry; we're not trying to assimilate as much as them, we're trying to promote our differences.[5]

Indigenous media also should be distinguished from the national and independent cinemas of non-Western Third World nations in Africa, Latin America, and Asia, which have developed under quite different historical and institutional conditions, and about which there is considerable scholarship.[6]

More positively, the term "indigenous media" respects the understandings of those Aboriginal producers who identify themselves as members of "First Nations" or "Fourth World People," categories that index the sense of common political struggle shared by indigenous

people around the globe. "Media," on the other hand, evokes the huge institutional structures of the television and film industries that tend to overwhelm local specificities and concerns for relatively small populations while privileging commercial interests that demand large audiences as a measure of success. Thus, to use the label "indigenous media" suggests the importance of contextualizing this work within broader movements for cultural autonomy and political self-determination. These movements exist in complex tension with the structures of the dominant culture. In a recent article on Aboriginal media, Philip Batty describes these social relations as a process of "negotiation" with the settler nation, a kind of intercultural bargaining that has shaped the emergence of such work.[7]

In general, efforts to produce indigenous media worldwide[8] have been relatively small-scale, low-budget, and locally based. Much of this work is shown in events organised for indigenous peoples, such as the Native American Film Festivals held regularly in San Francisco and New York City, the Pincher Creek World Festival of Aboriginal Motion Pictures (now known as Dreamspeakers) held every summer in Alberta, Canada, and the Inter American Film Festival of Indigenous Peoples held every two years in South America, most recently in Peru in 1992. For many indigenous producers, these festivals, as events that reinforce indigenous identities, are venues that are preferred over more "high profile" mainstream institutions such as the Museum of Modern Art in New York, which has made some effort at showcasing indigenous work.

There is very little written on these developments, and what exists comes mostly in the form of newsletters, reports, brochures, and catalogues that are useful but difficult to obtain. Only occasionally do such writings address broader theoretical questions regarding how indigenous media alter understandings of media, politics, and representation. It is particularly surprising that there is so little discussion of such phenomena in contemporary anthropological work, despite the fact that VCRs, video cameras, and mass media are now present in even the most remote locales. In part this is due to the fact that the theoretical foci anthropologists carry into the field have not, until very recently, expanded sufficiently to keep up with such changes.[9] The lack of analysis of such media as both cultural product and social process may also be due to our own culture's enduring positivist belief that the camera provides a "window" on reality, a simple expansion of our powers of observation, as opposed to a creative tool in the service of a new signifying practice.

My work is a preliminary effort to address what Aboriginal cultural activist Marcia Langton has identified as the "central problem" that has accompanied the development of Aboriginal media — that is, "the need to develop a body of knowledge and critical perspective to do with aesthetics and politics, whether written by Aboriginal or non-Aboriginal people, on representation of Aboriginal people and concerns in art, film, television, or other media."[10]

In order to open a new "discursive space" for indigenous media that respects and understands them on their own terms, it is important to attend to the *processes* of production and reception. Analysis needs to focus less on the formal qualities of film and video as text and more on the cultural *mediations* that occur through film and video works. This requires examining how indigenous media are situated in relevant discursive fields in order to understand how this work gets positioned by those practising it and by those in the dominant culture with some interest in it.

The initial section of this essay addresses at a general level how indigenous media might be positioned analytically in relation to ethnographic film as a form intended to mediate across cultural boundaries. The second section concerns the relationship of indigenous media to identity production among Fourth World peoples in the late twentieth century, examining claims for both its destructive and productive possibilities. The third section examines ideas about identity production in relation to recent developments in media production by Australian Aboriginal people. Specifically, I discuss several media groups in Central Australia that I have been following since 1988. These are the Warlpiri Media Association (WMA) in the Central Desert Aboriginal community of Yuendumu; CAAMA — the acronym for the Central Australian Aboriginal Media Association, located just outside the town of Alice Springs; and Imparja Television, based in Alice Springs but serving all of the Northern Territory and large parts of South Australia as well. I also will briefly discuss some of the efforts since the late 1980s to bring Aboriginal producers and production into national television.

It is difficult to consider indigenous media outside of some version of one of two dominant tropes, which I summarise as the Faustian contract or the global village. Each scenario has its virtues and shortcomings. The model of the Faustian contract, most clearly articulated in the work of the Frankfurt school, regards "traditional culture" as something good and authentic, as something that is irreversibly polluted by contact with the high technology and media produced by mass culture. This

view is very clear about what cultural domination can mean, but social actors are absolutely overdetermined; both kinds of societies are frozen into paradigmatic positions that essentialise features that distinguish them. By contrast, the model of the global village optimistically suggests that new media can bring together different cultures from all over the earth, re-creating a local sense of community associated with village life through progressive use of communications technologies. Here, social actors are active agents, and societies are recognised as constantly changing rather than determined by state, economic, and technological imperatives. However, the important, specific ways in which cultures differ and people experience political and economic inequality are erased in a modernist and ethnocentric utopian vision of an electronic democracy.

New discursive possibilities, I argue, might be found in models emerging from anthropology and cultural studies; these models call on metaphors of hybridity and self-consciously reject notions of "authenticity" and "pure culture" as ways of understanding contemporary identities. For example, Stuart Hall, a central figure in British cultural studies, argues that identity is a production that is never complete, always in process, and always constituted within, not outside, representation.[11] Accordingly, these studies tend to focus on the creative aspects of cultural production, where questions of representation are central.[12] Similarly, an area of primary concern for those concerned with indigenous identity is the mediation of politics and identity through the signifying practices of film and televisual forms; such practices cannot be considered apart from the political economies of the dominant cultures in which they are embedded. Ideally, from the point of view of indigenous producers, the capabilities of visual media to transcend boundaries of time, space, and even language can be used effectively to mediate historically produced social ruptures that link past and present. In so doing, producers are engaged in a powerful new process of constructing identities on their own terms but in ways that address the relationships between indigenous histories and cultures and the encompassing societies in which they live. As Stuart Hall expresses it, identities are the "names we give to the different ways we are positioned by, and position ourselves within, the narratives of the past."[13]

Genre Positions: Indigenous Media and Ethnographic Film

Ethnographic film was originally conceived of as a broad project of documenting on film the "disappearing" lifeworlds of those "others" — non-Western, small-scale, kinship-based societies — who had been the initial objects of anthropology as it developed in the early twentieth century. Whatever its colonial origins, the field of ethnographic film took on definition and shape as a genre during a critical period, the 1960s and 1970s, when efforts to "reinvent anthropology"[14] were produced by a variety of historical, intellectual, and political developments. Briefly stated, these include:

- the end of the colonial era with the assertions of self-determination by native peoples;

- the radicalisation of young scholars in the 1960s and the replacing of positivist models of knowledge with more interpretive and politically self-conscious approaches; and

- a reconceptualization of "the native voice" as one that should be in more direct dialogue with anthropological interpretation.

Some have called this constellation of events "a crisis in representation" for the field, a crisis that required new, experimental strategies for transmitting anthropological understandings.[15] It is not sufficiently appreciated that, in fact, many people working in ethnographic film already had responded to this "crisis." Often less constrained by the academy than those working in written ethnography, ethnographic filmmakers offered a variety of creative solutions. Following the experimental turns in the arts in general, they developed dialogical and reflexive strategies to mark the films as encounters contingent on the particulars of a historical moment. For example, questions of epistemology, ethics, and the position of the native interlocutor were being addressed in the 1950s by ethnographic filmmaker Jean Rouch in works such as *Les Maîtres fous* (1955), *Jaguar* (1955), and *Chronique d'un été* (*Chronicle of a Summer,* 1960). By the mid-1970s, the list included (to name a few) Tim Asch, David and Judith MacDougall, John Marshall, Gary Kildea, Barbara Myerhoff, and Jorge Preloran. A number of these people also articulated arguments in print for what David MacDougall has called more partici-

patory methods and styles of representation.[16] This increasingly collaborative approach to ethnographic filmmaking foreshadowed and encouraged the development of indigenous media.

An early effort to get the camera into native hands was carried out by Sol Worth and John Adair in the 1960s. Their project, discussed in the book *Through Navajo Eyes,* attempted to teach film technology to Navajos, without the conventions of Western production and editing, to see if their films would be based on a different film "grammar" based on a Navajo world view. However, the experiment focussed overmuch on the filmic rather than the social frame. Worth and Adair failed to consider seriously potential cultural differences in the social relations around image making and viewing, even though these concerns were brought up clearly in the initial negotiations with Sam Yazzie, a leading medicine man and elder.

Adair explained that he wanted to teach some Navajo to make movies. . . .
When Adair finished, Sam thought for a while and then . . . asked a lengthy question which was interpreted as, "Will making movies do sheep any harm?"
 Worth was happy to explain that as far as he knew, there was no chance that making movies would harm the sheep.
 Sam thought this over and then asked, "Will making movies do the sheep good?" Worth was forced to reply that as far as he knew making movies wouldn't do the sheep any good.
 Sam thought this over, then, looking around at us he said, "Then why make movies?"[17]

The lack of consideration for how movies might "do the sheep good" meant that the Navajo Eyes project was rather short-lived; in retrospect it is seen as a somewhat sterile and patronising experiment. Still, the notion of distinct indigenous concerns for cinematic and narrative representation was prescient.

By the 1970s, indigenous groups and some ethnographic filmmakers were questioning not only how conventions of representation are culture-bound; they also concerned themselves with central issues of power regarding who controls the production and distribution of imagery. Indigenous peoples who had been the exotic objects of many films were concerned increasingly with producing their own images, either by working with accomplished and sympathetic filmmakers[18] or by entering into film and video production themselves, for example Hopi artist Victor Masayesva, Jr., or Inuit producer/director Zacharias Kunuk.[19]

These developments were part of a more general decentralisation,

democratisation, and widespread penetration of media that emerged
with the growth of new technologies that simultaneously worked the
local and global fronts. On the one hand, inexpensive portable video
cameras and cable channels open to a spectrum of producers and viewers
gave new meaning to notions of access and multicultural expression.
On the other hand, the broad marketing of VCRs and the launching of
communications satellites over Canada in the 1970s and Australia in the
1980s suddenly brought the possibility or menace, depending on one's
point of view, of a mixture of minority/indigenous and mainstream
Western programming entering into the daily lives of people living in
remote settlements, especially those in the Canadian Arctic and central
Australian desert.

Given these developments, I would like to consider the position of
indigenous media in relation to ethnographic film. Some simply want
to abandon or declare "colonialist" any attempt to film "the other" since
indigenous media production makes it clear that "they" are capable of
representing themselves. For example, critiques coming out of some
branches of cultural studies, while raising important points about the
politics of representation, are so critical of all "gazes" at the so-called
other that, to follow the program set forth by some, we would all be
paralysed into an alienated universe, with no engagement across the
boundaries of difference that for better or worse exist.[20]

Underlying these responses, of course, is the idea that "we" and
"they" are separate, which in turn is built on the trope and mystique of
the noble savage living in a traditional, bounded world, for whom all
knowledge, objects, and values originating elsewhere are polluting of
some reified notion of culture and innocence. The movie *Crocodile Dun-
dee* presented a witty commentary on such misapprehension in an en-
counter between New York journalist Sue Charlton (Linda Kozlowski)
and Dundee's (Paul Hogan) Aboriginal friend Neville Bell (David Gul-
pilil). "Creeping through the bush, looking authentic but sounding up-
to-date, he is painted from the waist up but wears jeans and a watch.
Sue then wants to take his photo. He solemnly tells her she can't. She
wonders whether it is because it will steal his spirit. "No," he informs
her, 'the lens cap's on.'"[21]

Questions about the legitimacy of one's presence in a foreign setting
(especially in which power relations are unequal) as an outsider with a
camera should *always* be raised and generally have been in most success-
ful projects. The fact that the people one is dealing with also have cam-
eras and choose to represent themselves with them should not diminish

that concern. The making of images by "outsiders" is illegitimate when ethical and social rules have been violated in the process. Conversely, the fact that one is an "insider" does not guarantee an untroubled relationship with one's subject, as is dramatically clear in Navajo filmmaker Arlene Bowman's problematic encounter with her traditional grandmother in *Navajo Talking Pictures*. Filming others and filming one's own group are related but distinct parts of a larger project of reflecting upon the particulars of the human condition; each approach raises its own sets of issues regarding ethics, social relations, power, and rights to represent.

Another response considers indigenous production as an altogether separate category from ethnographic film, with different intentions and audiences. The sense of differences is exacerbated by the academic or media positions of one set of producers, as opposed to the community-based locations of the other, a point raised cogently by Marcia Langton regarding more academic anthropology.[22] One might, for example, view indigenous work as not intended to cross over so-called cultural boundaries but rather as made for intracultural consumption and therefore not satisfying some minimal definition of ethnographic film as images of some other, "B," taken by people identified as "A" and presented back to people "A." However, "ethnographic film" has never been bounded by its potential audience. To name only one prominent example, for nearly half a century Jean Rouch has argued that he considers the primary audience for his ethnographic films to be the people who are in them.[23] And recently, native groups all over the world have been reappropriating colonial photography and films for purposes of cultural revival and political reclamation.[24]

Clearly, indigenous media and ethnographic film are related but distinct projects. *Because* of the differences, I believe it is crucial that those interested in ethnographic film be informed and aware of developments in media being produced by those who might be their subjects. But beyond this ethical/political concern for an inclusive pedagogical frame, I would like to explore the basis for incorporating ethnographic film and indigenous media within the same analytical frame.

Mediating Culture

In considering what I call indigenous media, I use the word "media" not simply because it embraces video and television,

which play an ever-increasing role in these concerns, but also because of other meanings of the word. The *American College Dictionary* defines it as "an intervening substance, through which a force acts or an effect is produced; [2] an agency, means or instrument." It is related to mediate: "to act between parties to effect an understanding, compromise, reconciliation." Using these definitions, "indigenous media" as a term points to the common (and perhaps most significant) characteristic that the works I have been describing share with more conventional understandings of ethnographic film. They are all intended to communicate something about that social or collective identity we call "culture," in order to mediate (one hopes) across gaps of space, time, knowledge, and prejudice. The films most closely associated with the genre (ideally) work toward creating understanding between two groups separated by space and social practice, though increasingly they are calling attention to the difficulties of comprehension, as in Dennis O'Rourke's *Cannibal Tours*.

Work being produced by indigenous people about themselves is *also* concerned with mediating across boundaries, but they are directed to the mediation of ruptures of time and history. They work to heal disruptions in cultural knowledge, in historical memory, and in identity between generations occasioned by the tragic but familiar litany of assaults: the taking of lands, political violence, introduced diseases, expansion of capitalist interests and tourism, and unemployment coupled with loss of traditional bases of subsistence. Among some of the groups most actively engaged in media production—native North Americans (including Inuit), Indians of the Amazon Basin (especially Kayapo), and Aboriginal Australians—the initial activities with the camera are almost always both assertive and conservative of identity: documenting injustices and claiming reparations; making records of the lives and knowledge of elders whether through dramatising mythic stories, explaining traditional food gathering and healing practices, or re-creating historically traumatic events with those who witnessed the often violent destruction of life as they had known it.

What these works share with the current practices of ethnographic filmmakers such as David and Judith MacDougall, Gary Kildea, Dennis O'Rourke, and Jean Rouch is that they are not about re-creating a preexistent and untroubled cultural identity "out there." Rather they are about the *processes* of identity construction. They are not based on some retrieval of an idealised past but create and assert a position for the present that attempts to accommodate the inconsistencies and contradictions of contemporary life. For Aboriginal Australians, these encompass the powerful relationships to land, myth, and ritual, the fragmented his-

tory of contact with Europeans and continued threats to language, health, culture, and social life, and positive efforts in the present to deal with problems stemming from these assaults.

More generally, I am proposing that when other forms are no longer effective, indigenous media offers a possible means — social, cultural, and political — for reproducing and transforming cultural identity among people who have experienced massive political, geographic, and economic disruption. Yet, as in Worth's study with the Navajo, perhaps the real question remains, "Will it do the sheep good?" Or, in the case of satellites and VCRs, the question might be, "Can the sheep be kept alive?" As Rosemarie Kuptana of the Inuit Broadcasting Corporation succinctly phrased it: "As you know, the history of the Inuit people is a history of adaptation; to climatic change, to cultural threat, to technological innovation. Television had clearly arrived to stay; a way had to be found to turn this threat to our culture into a tool for its preservation."[25]

For some scholars of Third World broadcasting (following on the gloomy predictions of the Frankfurt school theorists), the Faustian contract is the discursive frame. They believe that people such as Rosemarie Kuptana are, at best, simply bargaining with Mephistopheles. They conclude that the content and hegemonic control of mass media irreversibly erode traditional languages and cultures, replacing them with alien social values and an attraction to Western consumer goods.[26] Others argue that the very *form* of Western narratives may undermine traditional modes but take this as a mandate for supporting more indigenous production. As David MacDougall recently pointed out,

The dominant conflict structure of Western fictional narratives, and the didacticism of much of Western documentary, may be at odds with traditional modes of discourse. The division into fiction and documentary may itself be subversive. Or differences may arise in the conventions of narrative and imagery. At a film conference in 1978, Wiyendji, an Aboriginal man from Roper River, argued against the Western preoccupation with close-ups and fast cutting, saying that Aborigines preferred to see whole bodies and whole events. This may not be borne out by Aboriginal preferences when viewing non-Aboriginal material, but it is a common complaint about films by outsiders which portray Aboriginal subjects. Such objections obviously cry out for more Aboriginal filmmaking.[27]

Last, and most significant, indigenous filmmakers, scholars, and policy makers have been advocating indigenous use of visual media as a new opportunity for influence and self-expression. In their view, these technologies offer unique potential for the expansion of community-

generated production and for the construction of viewing conditions and audiences shaped by indigenous interests and, ultimately, cultural regeneration.

Transmitting Identity: Aboriginal Media

In the following section I discuss particular instances of indigenous media production by Aboriginal Australians. I propose a preliminary analysis of how such work is engaged in the construction of contemporary Aboriginal identity in a way that attempts to integrate historical and contemporary lifeworlds for both Aborigines and the wider society.

The development of Aboriginal work in film and video is as diverse as the Aboriginal population itself, which includes both traditional groups and urban people who are relatively acculturated to Euro-Australian culture and whose history of contact may go back as far as 200 years. Urban Aborigines such as avant-garde filmmaker/photographer Tracey Moffatt may have been raised in a thoroughly assimilated manner and produce work comfortably within the structures of the dominant culture's independent film community, albeit addressing issues of Aboriginal identity, usually confronting problematic relations between Aborigines and the dominant culture.[28] At the other end of the spectrum are traditional people living in remote areas of central and western Australia whose contact history may be as brief as a decade and who have been experimenting with video production strategies to suit their own local concerns. While to Euro-Australians different "traditional" groups may seem indistinguishable, linguistic variation alone makes it clear that they are not a monolithic block; of the 200 Aboriginal languages originally spoken, approximately sixty are still in active use today.[29] Unfortunately, this diversity is frequently ignored by whites setting broadcast policy. As media scholar Helen Molnar points out: "This cultural diversity is important to stress as it can be ignored when discussing Aboriginal media and usually results in inappropriate planning. For Aboriginal programming to be effective, each community's requirements have to be addressed. A pan-Aboriginal solution is inappropriate."[30]

While Aboriginal media is barely a decade old, it is part of the ever-increasing involvement of Australian Aboriginal people in visual media

production over the last twenty years. Different aspects of this involve-
ment are summarised nicely in essays by film historian Michael Leigh,[31]
filmmaker David MacDougall,[32] as well as the late Eric Michaels[33] and
communications scholar Helen Molnar,[34] who reminds us that many
remote living Aborigines have been producing their own radio pro-
gramming since the 1970s, "leaping over the print generation to begin
recording their languages, stories, music and culture."[35] Underscoring
the connection of such indigenous media to political consciousness, Mi-
chael Leigh links the upsurge of collaborative productions with Austra-
lian Aboriginal people to the Labor government's liberal left policy
toward Aboriginal "self-determination" from 1972 to 1975.[36] For ex-
ample, since the early 1970s, at the Australian Institute for Aboriginal
and Torres Straits Islanders Studies Film Unit, new projects were based
increasingly on interest expressed by Aboriginal communities, resulting
in outstanding films such as *Waiting for Harry* (dir. McKenzie, 1980) or
Good-Bye Old Man (dir. MacDougall, 1977). Paralleling a similar shift in
ethnographic writing, these changes in ethnographic film practice that
accommodated indigenous interests were, according to David Mac-
Dougall, a shift away from "reconstruction of pre-contact situations to-
wards an examination of the realities of contemporary Aboriginal ex-
perience. Initially this took the form of supporting and documenting
Aboriginal moves for cultural reassertion."[37] In 1979 the institute began
taking on occasional Aboriginal trainees in film and video, such as
Wayne Barker, who is now an independent filmmaker. That same year
saw the debut of *My Survival as an Aboriginal,* the first film directed by
an Aboriginal woman, Essie Coffey of Brewarrina (made with Martha
Ansara and Alec Morgan of the Sydney Filmmakers Co-operative).

Indigenous Media at Yuendumu

In the early 1980s questions of Aboriginal involvement
in televisual media were raised in relation to the planned launching of
Australia's first communications satellite, AUSSAT.[38] With it would
come the possibility of the introduction of commercial television to re-
mote areas of the nation for the first time, including many Aboriginal
settlements and communities whose geographic isolation had protected
them from such intrusions. To assess the impact of majority culture me-
dia on Aboriginal viewers, the (then) Australian Institute of Aboriginal

Studies hired American researcher Eric Michaels in 1982 to conduct a long-term study in Central Australia.[39] He chose to work with Warlpiri-speaking Aboriginal people at the community of Yuendumu in the Central Desert, northwest of Alice Springs. He also helped train people from Yuendumu to produce videos based on Aboriginal concerns that might be programmed in place of the imagery of standard commercial television. The WMA grew out of this activity.[40]

The fifty tapes produced by Warlpiri videomakers between 1982 and 1984 demonstrated how media could be fashioned and used in ways appropriate to native social organisation, narrative conventions, and communicative strategies. Originally intended for use in their school, the works covered subjects ranging from traditional dances, to a piece memorialising a massacre of Warlpiri people by whites, to recording of local sports events. In April 1985, WMA established its own low-power TV station via a homemade transmitter, which pulled in the signal of the state television channel, the Australian Broadcasting Corporation (ABC) and also provided a broadcast outlet for locally produced tapes. (This and other similar operations, in a Kafkaesque twist of bureaucracy, are considered illegal because the state had not managed to authorise a new, appropriate licensing category.)[41]

By 1992, when I visited Yuendumu for the second time, the activities of WMA had expanded to include a new and very successful project, *Manyu-Wana*. Loosely translated as "just for fun," *Manyu-Wana* was initiated in 1989 by Aboriginal and white school teachers at Yuendumu to develop a kind of homegrown Aboriginal Sesame Street for Warlpiri-speaking communities. Made with local children for local use, the half-hour programs are intended to help Warlpiri youngsters learn about numbers and stories in their native language rather than in English, which is used in much formal schooling. The creative process is collaborative and improvisational; community members come up with ideas for the program and local children are the "stars" of the show. The show is shot and edited by David Batty (a veteran of CAAMA), who works with a wind-up Bolex 16 mm camera that allows for simple special effects such as fast forward, slow motion, and claymation. The result is a delightful kind of visual style in which cardboard toy cars magically become Toyota trucks or children's drawings become the background for animated versions of Warlpiri mythic stories.

As of April 1992, a new *Manyu-Wana* series is in production, funded by the National Aboriginal Languages Programme, with additional funding from the Australia Council and London's Central Television.

The six completed shows have become extremely popular not only for Warlpiri people, children and adults alike, but also for other Aboriginal and white audiences who are drawn to the quirky, local, and altogether charming sensibility of the work, despite the fact that it is all in Warlpiri language. In addition to its regular and frequent use at Yuendumu and other Warlpiri communities such as Lajamanu and Willowra, the work was broadcast on Imparja television and is scheduled to be aired on the national Special Broadcast Service.

Most recently, Yuendumu helped organise the Tanami Network, a video conferencing network that uses the satellite to link four Aboriginal communities in the Tanami area of the Northern Territory (Yuendumu, Lajamanu, Willowra, and Kintore) to each other and to Alice Springs, Darwin, and Sydney. The state-of-the-art compressed video technology that they are using allows groups of people to see and hear each other, what some have called a "space-age picture telephone." The communities jointly contributed over $350,000 in mining royalties and other community funds to establish this communication system, an indication of their view of its usefulness to them. Their sentiments were articulated at a communications workshop at Yuendumu in 1990 when the technology was first demonstrated to the community. At that meeting, two paintings by a Warlpiri woman, Jeannie Nungarrayi Egan, were used to show alternative models of communication. In one, Warlpiri communities depend for information on *kardiya* (white people's) centres such as Alice Springs, Katherine, or Darwin, a difficult and expensive situation; the other painting provides a decentralised, interactive model in which large white settlements are not privileged over smaller Aboriginal ones (fig. 17).

At a communications conference in March 1992, shortly after the network had been put in place, Peter Toyne, a former principal of the Yuendumu school who has been active in helping organise the network, put the network's goals in cultural and historical perspective from a Warlpiri point of view.

The establishment of the Tanami communities over the last fifty years severely disrupted the traditional network of information and personal contacts which existed amongst people in the area. The Aboriginal people have responded by attempting to reassemble the earlier network through the use of motor vehicles . . . outstations . . . and through such telephone and radio links as have escaped the restrictive control of non-Aboriginals in the communities. . . . Aboriginal community members have stated repeatedly that they want the links

to work out family things and help keep the traditions and Aboriginal law strong. . . . The Tanami Network is being developed in the belief that it offers a completely new line of approach to many of these problems by changing the basic dialogue through which the services are planned and delivered.[42]

The network has already been used for purposes as diverse as "sorry business" (funeral arrangements); driver's education; and long distance marketing of Aboriginal art. Other possible services include community-based secondary courses, enhanced adult education aimed at professional and semiprofessional employment for Aboriginal people; community detention as an alternative to jail; inservice support for agency employees; enhancing processes of consultation and representation; and secondary education.[43]

While some are sceptical of the expense and specialised nature of the technology at a time when so many basic needs — health, nutrition, shelter — are not adequately served, others find in the Tanami Network global-village possibilities. Consider the newspaper headlines that announced its debut: "Tribal business has gone space age in the outback" read the Alice Springs paper;[44] "Resourceful Aborigines use latest technology to preserve tribal life."[45] Whatever the outcome or relative utility of this experiment, what is clear is that there is an increasing self-consciousness and initiative on the part of remote living Aboriginal people to develop these media technologies in ways appropriate to traditional patterns of social organisation.

Other local media associations similar to Yuendumu have developed in a number of other remote areas, most notably at Ernabella, a Pitjantjatjara community in South Australia.[46] There, in 1983, local people began producing video programs reflecting their cultural practices and daily activities. The videos immediately became quite popular. By April 1985 Pitjantjatjara Yankunytjatjara Media Association established Ernabella Video Television (EVTV) when "EVTV commenced local broadcasting on the world's cheapest community television transmission system (less than $1,000 worth of equipment purchased from a 10 cent surcharge on cool drinks in the store)."[47]

Since then EVTV has produced over 100 hours of community television each year, which is strictly regulated by the local media committee in terms of both timing — so that it would not interfere with the social activities of the community — and substance. Rather than competing with traditional practices, EVTV's strong focus on recording the songs, dances, and ceremonies performed at the places associated with the

This model is a true network. It is just as easy for information to be shared between families and communities as it is between communities and government centres.

Lajamanu surrounded by its outstations

Willowra surrounded by its outstations

Pathways join all places together and are of equal importance

Yuendumu surrounded by its outstations

Alice Springs

17. Jeannie Nungarrayi Egan, two paintings of intercommunity communication (1990). Photographs: Yuendumu Community Education Centre

Figure 17 reproduces two large colour paintings made by Jeannie Nungarrayi Egan, a Warlpiri schoolteacher, painter, and activist, who painted them specifically for the October 1990 conference at Yuendumu, where the future of communication for Aboriginal people in the Tanami region was under discussion. As in her other painting, she used Warlpiri iconography that traditionally has been used in ceremonial settings to visualise stories about the relationship of mythic ancestors to the land in the "Dreamtime"; in this case, however, the meanings of some of the abstract signs have been transformed to indicate specific places that are linked through satellite information technologies in order to clarify the differences between *kardiya*

In this model information can travel easily to government centres but it is more expensive and indirect to contact your family in other communities.

Lajamanu with its kardiya (whitefella) and yapa (Warlpiri) inhabitants

Lajamanu outstations

Main communication routes (roads, telephones)

Kardiya towns (Darwin, Alice Springs, Katherine)

Willowra and its outstations yapa and kardiya inhabitants

Yuendumu and its outstations yapa and kardiya inhabitants

(whitefella) and *yapa* (Warlpiri) models of communication. These paintings demonstrate that the rethinking of Western media technology from an Aboriginal perspective is coming out of discussions and ideas in local Aboriginal communities such as Yuendumu that have successfully incorporated television and video on their own terms. I have used it here with the permission of the painter because it makes graphically clear (contrary to conspiracy models of media in which indigenous people are implicitly cast as innocent victims) that Aboriginal people are not only creating their own media, but are integrating it into their own theories and ideas about communication and information networks. The arguments in this article, for example, are drawn in large measure from those I heard articulated by a range of Aboriginal media activists, whom I have quoted and named throughout.

mythic *Tukurrpa* ("Dreaming Stories") for the area has had a revitalising effect on these beliefs and values—for example, generating traditional dance festivals at Ernabella and throughout Australia.[48]

EVTV and WMA became models for government efforts to introduce televisual technologies into other communities, in particular the Broadcasting for Remote Aboriginal Communities Scheme (BRACS). This plan was the government's response to the recommendations of *Out of the Silent Land,* the 1984 report of its Task Force on Aboriginal and Islanders Broadcasting. BRACS provides equipment for receiving and rebroadcasting the satellite signal as well as for producing video and radio programs to approximately eighty remote Aboriginal communities. It was conceived as a way to protect and promote local culture and languages against the intrusion of national or commercial television; the intention was to give Aboriginal communities the capacity to interrupt the satellite transmission with their own programming.[49] With a few exceptions, however, BRACS has not operated in that way for a number of reasons: there was almost no consultation with Aboriginal communities and no provision for maintenance, training, repairs, upgrades, suitable buildings, electricity, or cassettes. Also, the quality of the equipment is so poor that BRACS productions have very short life spans and limited circulation. Given these problems, it is not surprising that, for the most part, the only successful BRACS programs are those that are developed at communities that are already experienced in media production.[50] In comparing BRACS to the success of groups such as WMA and EVTV, Philip Batty suggests that the key to effective Aboriginal "resistance" to the imposition of television is not to ban it altogether but rather to figure out how to integrate it on their own terms.[51]

Aboriginal Media in Central Australia: CAAMA and Imparja

The Central Australian Aboriginal Media Association, or CAAMA, is one of the most successful of Aboriginally controlled media projects. Like many of the other Aboriginal media associations in Australia,[52] it started as an FM radio station. CAAMA was founded in 1980 by two Aboriginal people and one "whitefella," whose private record collection was the basis of most of the original programming. It quickly became one of the most popular radio stations for both blacks and

whites in the Northern Territory. Its format combines country western, Aboriginal rock, call-ins, and discussion of news of concern to Aborigines in six native languages and English for nearly fifteen hours a day. It later expanded to AM and shortwave broadcasts, a prize-winning educational show called *Bushfire*, and a recording studio for Aboriginal bands whose tapes are sold along with other Aboriginal art products in the CAAMA shop. In addition, a video unit was established in 1984; originally, it produced a series of one-hour video newsletters in English and other major Aboriginal languages to circulate to communities without radio access.

In 1985, when the Australian government launched AUSSAT and it became clear that, eventually, commercial TV was going to be available to the remote Aboriginal settlements in CAAMA's radio broadcast area, CAAMA's leaders were concerned about the destructive potential. Freda Glynn, the former director of CAAMA, made the argument clearly. As an Aboriginal woman who was taken from her family in childhood to be educated in Western schools, she is keenly aware of the impact of such interventions and sees TV as part of a continuum of assaults on Aboriginal life that must be dealt with in as positive a manner as possible.

TV is like an invasion. We have had grog, guns and diseases, but we have been really fortunate that people outside the major communities have had no communication like radio or TV. Language and culture have been protected by neglect. Now, they are not going to be. They need protection because TV will be going into those communities 24 hours a day in a foreign language — English. It only takes a few months and the kids start changing. We're trying to teach kids you can be Aboriginal and keep your language and still mix in the wider community and have English as well. At least they will be seeing black faces on the magic box that sits in the corner, instead of seeing white faces all day long.[53]

Out of this concern for mass media's impact on traditional Aboriginal languages and culture, CAAMA made a bid for the satellite's downlink licence to Central Australia as a symbolic assertion of the presence and concerns of that region's Aboriginal people. Much to their surprise, their proposal for taking on this multimillion dollar operation was taken seriously. In January 1987, after a prolonged battle against bigger commercial interests as well as opposition from the Northern Territory government, CAAMA won the Regional Commercial Television Services (RCTS) licence for the television downlink to the Central Australian "footprint" (so named because it describes the general shape of the sig-

nal patterns to earth given off by satellites). They were able to make the acquisition with financial assistance from a variety of government sources.[54] The private commercial station they now own, Imparja (which means "tracks" or "footprint" in the Central Australian language Arrernte), began broadcasting in January 1988, serving approximately 100,000 viewers in Central Australia, over a quarter of them Aboriginal (though some put that figure as high as 40 percent).[55]

Thus far, in addition to public service announcements, logos, wrap-arounds, and the like, which are directed to Aboriginal concerns such as bush foods or the Central Land Council, Imparja has been broadcasting regular Aboriginal programs produced by CAAMA. In 1988, they carried twenty-six thirty-minute current-affairs programs, broadcast twice a week in prime time: *Urrpye* (*Messenger*), an English language "magazine and current affairs style program helping to promote awareness about the concerns and issues of Aboriginal people" (cancelled in 1989); and *Nganampa — Anwernekenhe* (*Ours* in Pitjantjatjara/*Our Way of Culture* in Arrernte), a magazine show in different Aboriginal languages — Arrernte, Luritja, Pitjantjatjara, Warlpiri — with English subtitles, intended to help maintain and represent Aboriginal language and culture through art, music, stories, and dances. In 1989, Imparja broadcast a thirteen-part language series, an Aboriginal music program, and a late-night show featuring Aborigines talking in their own languages, telling their history, and "dreaming" stories.[56] In 1991, in addition to *Nganampa, Talking Strong*, a series of independent films by or about Aboriginal people was telecast over a seven-month period on Saturday nights. Currently, *Nganampa* continues to be produced and broadcast on Thursday nights at 8:00, and Aboriginal programs produced for other RCTS stations (programs such as *Milbindi*) are rebroadcast as well. As part of their support for Aboriginal health concerns, Imparja does not sell commercials for alcohol.

In its first two years, Imparja was viewed with great optimism. For example, writing in *Art in America* in 1989, cultural critics Tony Fry and Anne-Marie Willis presented Imparja optimistically as

a cultural space in which innovation is possible; it has a future. This is a new symbol of power in a culture dominated by the media. It doesn't override the effects of the damaged culture in which it functions, but creates a fissure in which a new set of perceptions can seep in. Such comments do not imply such an operation is free from either the reach of ethnocidal agency or of more direct effects of unequal exchange — it is not judged by authority as a mainstream commercial channel and is dependent on government funding. It is nei-

ther beyond nor lacking in criticism, especially over the nature and quantity of Aboriginal-made content.[57]

More recently there have been complaints, especially from other Aboriginal people, that two to three hours out of seventy hours a week, even at prime time, is insufficient Aboriginal programming. Others are concerned about Imparja's stress on "broadcast quality" — an elusive and problematic term, for somewhat arbitrary technical standards for productions used by television stations, that effectively keeps low-budget and unconventional work off the air. The result has been to limit Imparja's use of material produced by Yuendumu and other local Aboriginal media associations. It also restricts CAAMA's ability to produce programming for Imparja because of the costs involved in "broadcast quality" work. A thirty-minute piece could cost between $10,000 and $20,000, while imported American shows can be purchased inexpensively.[58]

The question of advertising also has an impact on programming content for any commercial TV outlet. Imparja, like the other Australian satellite downlinks, struggles to meet the $4.5 million satellite rental fee (rising at 12 percent a year) via advertising revenues, which will never grow significantly because the population numbers (and therefore potential consumers) are low. Aboriginal programming is particularly not lucrative because there is a dropoff in European viewers, and advertisers — most of whom are local business people — do not view Aboriginal people as consumers.

Finally, while Imparja is the only large-scale commercial television station owned by Australian Aboriginal people, only 10 percent of the television staff is Aboriginal. To help correct for this problem, in 1988 CAAMA and Imparja made a training agreement with the Department of Education, Employment and Training to train thirty-three Aboriginal people as videotape operators, editors, recording assistants, TV presenters, radio journalists and broadcasters, translators/interpreters, sales representatives, researchers, and bookkeepers. All trainees were supposed to be taken on as permanent employees by CAAMA and Imparja at the end of their training; the fact that this did not happen was in part responsible for a change in leadership at CAAMA in 1992 and ongoing criticism of Imparja.

Imparja, as the only indigenously owned commercial television station in the world, has received considerable attention by critics and supporters alike. However, to comprehend the significance of indigenous

media production, it is important to look at the *range* of media projects being carried out by Aboriginal Australians (of which this paper only touches on a few). Together, WMA, CAAMA, and Imparja (and others of course) might instruct us as to the costs and benefits of the introduction of media technologies in different settings. Small groups such as WMA, compared to CAAMA and Imparja, are fragile in economic terms *and* because they rely heavily on the unique talents of a few individuals. For example, WMA's central figure, Francis Jupurrurla Kelly, is able to juggle and use both Australian and traditional Aboriginal language and knowledge. Eric Michaels captured a sense of this in his description of Francis:

Jupurrurla, in his Bob Marley T-shirt and Adidas runners, armed with his video portapak, resists identification as a savage updating some archaic technology to produce curiosities of a primitive tradition for the jaded modern gaze. Jupurrurla is indisputably a sophisticated cultural broker who employs videotape and modern technology to express and resolve political, theological, and aesthetic contradictions that arise in uniquely contemporary circumstances.[59]

Such individuals, however, occupy a historically unique intergenerational position that is unlikely to be replicated unless a conscious effort is made to do so. So, the departure of just one of them is a serious blow to the operation of these small-scale media groups.

On the positive side, the local scale of WMA has allowed for community control over media both artistically and politically—for example, through the "illegal" satellite downlink into which they insert their own programming. More important, WMA has developed an innovative production style (in aesthetic matters and in work relations) that is embedded in local concerns and social organisation and traditions. Eric Michaels, in his report *The Aboriginal Invention of Television,* based on his work at Yuendumu, argued that the substance and formal qualities of the tapes have a distinctly Warlpiri sensibility, marked for example by an intense interest in the landscape as filled with specific meaning. In contrast to the free-floating signifiers that characterise televisual semiotics, traditional Aboriginal knowledge is made meaningful by associations with particular geographic locations. But, he went on to point out, of equal if not more importance is the social organisation of media production; the ways in which tapes are made, shown, and used reflect Warlpiri understandings of kinship and group responsibilities for display and access to traditional knowledge.[60]

The complex control of cultural information in Aboriginal society

has been of much interest to scholars of Aboriginal society. A number of ethnographic inquiries (e.g., Bell, Dyers, Sansom)[61] demonstrate how ceremonial and other kinds of knowledge ("law") critical to cultural identity are transmitted, and the power inherent in such social relations. Elders impart their knowledge at appropriate times over the life cycle, most dramatically through initiation rituals. Such knowledge transmission is organized not only by generation but by gender and kin classifications. Thus, in traditional communities, knowing, seeing, hearing, speaking, and performing certain kinds of information is highly regulated; violation of norms can meet with severe sanctions. Groups such as WMA, because they are locally based, are able to develop rules for video production and viewing appropriate to such community standards.

In contrast to the WMA, Imparja is a large multimillion dollar station in which information flows follow the imperatives of commercial television oriented toward mass audiences. The need for advertising always supersedes investment in programming for Aboriginal viewers. In keeping with the management's Euro-Australian orientation, Imparja's Aboriginal programs such as *Nganampa* use the conventions of television; yet Aboriginal people, news, and languages are heard and seen twice weekly on commercial television in Central Australia. The two other RCTS stations (satellite downlinks), though not owned by Aborigines, also offer programming for the Aboriginal populations in their areas. The Golden West Network in Western Australia (excluding Perth) produces *Milbindi*, a weekly current affairs magazine in prime time. The half-hour program, which is rebroadcast on Imparja, has Aboriginal presenters and stories stress positive aspects of Aboriginal life and culture. They also produce a twice-weekly news insert on Aboriginal issues, *Marnum*, and once a month screen an Aboriginal special as well as the government-produced *Aboriginal Australia*.[62] Queensland Satellite TV (QSTV) works with an Aboriginal and Torres Straits Islander program committee to provide about an hour a week of Aboriginal programming and also offers monthly broadcasts of *Aboriginal Australia*. Their thirteen-part Aboriginal affairs program, *My Place, My Land, My People,* about the various Aboriginal communities in the QSTV viewing area, was cancelled due to budget cuts in 1991.

Do the formal conventions of Western TV that these shows use turn off more traditional Aboriginal viewers, or do they seduce them into watching other non-Aboriginal programs? Are more European viewers inclined to attend to things Aboriginal when they appear in the "flow"

of broadcast? Indeed, in settings such as Central, Western, and Northern Australia, where different cultural models for communication intersect, questions about media reception are complex. As Helen Molnar points out:

> European mass media with its homogenised messages transmitted from a central source are at odds with Aboriginal information patterns. Aborigines see their local areas as the centre from which information emanates. Their information/communications model is completely the reverse of the European model which sees the urban cities as the centre and the remote communities as the periphery. The mass media not only ignores local boundaries (Aboriginal countries), it also makes information accessible to all viewers.[63]

However, the development of Aboriginal video production is significant not only to their own communities. "Aboriginal people, both individually and collectively, are turning to film, video and television as the media most likely to carry their messages to one another and into the consciousness of white Australia."[64] Given this situation, how can efforts to increase the visibility of Aboriginal people in the mass media also respect Aboriginal rules of representation — such as the taboo on viewing images of people who have recently died?

Over the last five years, a number of efforts have been initiated to meet the demand for more Aboriginal participation and visibility in television, not only for local access to video in remote areas of Australia, but also for more Aboriginal representation on mainstream national television. While the state-controlled and funded Australian Broadcasting Corporation (ABC) had been training Aborigines since 1980, by 1987 only seven Aborigines were employed there. That same year, the prime minister established the Aboriginal Employment and Development Policy (AEDP), which requires all industries to have 2 percent Aboriginal employment by 1991.[65] Consequently, the ABC set up an Aboriginal Programs Unit in 1987; their first Aboriginally produced and presented program, *Blackout,* began broadcasting in May 1989 on a Friday-evening time slot. Additionally, in 1991, the unit programmed a Thursday-night eight-part series of independent documentaries on Aboriginal topics, *The First Australians.*[66]

In April 1989, the Special Broadcast Service initiated a thirteen-part TV series devoted to Aboriginal issues. Called *First in Line,* it aired Tuesday nights at 7:30 p.m. The producers and crew were primarily Aboriginal and consulted with communities throughout Australia for items stressing the positive achievements of Aborigines.[67] Eventually, *First in*

Line was discontinued, and an Aboriginal Program Unit was established with Rachel Perkins (a former CAAMA trainee) at the head. For 1992– 1993, she is purchasing programming from groups such as WMA and CAAMA (Nganampa-Anwernekenhe), as well as commissioning four independent documentaries on different aspects of Aboriginal history and culture.[68]

Mediating Identities

The range of media generated with and by Australian Ab- origines since the 1980s operate at distinct levels of social, political, and economic organisation, yet increasingly they intersect. In some mea- sure, they correspond to the diverse social positions occupied by Ab- original Australians and the various ways they have attempted to gain visibility and cultural control over their own images. And it is important to remember that some remote Aboriginal communities still regard tele- vision as "the third invader" following Europeans and alcohol.[69] Yet the imposition of Euro-Australian televisual forms and technology on relatively intact traditional Aboriginal communities has also catalysed locally controlled, innovative, community-supported video production that has had a revitalising effect in some venues. It is important, then, to consider what distinguishes groups such as EVTV and WMA, who have maintained local control and creativity in developing television and video. As Philip Batty assesses it:

They had managed to establish their own local television service funded through their own local resources and became familiar with the basic processes of television production, long before the arrival of global television. . . . So when we talk about "resistance" to global television, it seems that this can only be accomplished in any effective way, by gaining an active if basic knowledge of television technology, and applying that knowledge in locally relevant and meaningful ways, and thereby be in a position to develop the confidence and the community consciousness to deal with global television on an equal footing.[70]

To return to Marcia Langton's argument, such work is necessary but not sufficient if it occurs in a vacuum of political and aesthetic sensibility toward Aboriginal cultural production.

The conflict between black and white in Australia about representations of "ab- originalities" cannot be resolved by demanding that Aboriginal people have

control of those representations. Self determination does not work at this level of social life. Rather the resolution is to be found in the development of a body of critical theory and knowledge about representations of Aboriginal peoples and concerns.[71]

The problematic placement of new forms of cultural expression has been noted by other scholars of Aboriginal Australia. It was the concern of Eric Michaels's later works on Aboriginal art and Warlpiri Media.[72] Recently, Fred Myers has written on the place of art criticism in the global circulation of Aboriginal acrylic paintings.[73] These works in Aboriginal studies have profited from an arena of discursive production in anthropology and cultural studies that has been emerging during the late 1980s, a discourse that transcends the static essentialism of the Faustian bargain and the cultural and political myopia of the global village. For example, in his essay on ethnic autobiography, Michael Fischer offers insights that also seem appropriate to understanding indigenous media (recognising that Aboriginal identity and ethnic identity are not to be equated with a depoliticised domain of multiculturalism):

What the newer works bring home forcefully, is, first, the paradoxical sense that ethnicity is something reinvented and reinterpreted in each generation. . . . The search or struggle for a sense of ethnic identity is a (re)invention and discovery of a vision, both ethical and future oriented. Whereas the search for coherence is grounded in a connection to the past, the meaning abstracted from that past, an important criteria of coherence, is an ethic workable for the future.[74]

With these insights in mind, what are we to make of MTV-inspired indigenous productions with well-known Aboriginal country western and rock groups that are so popular with a range of Aboriginal audiences? These are perhaps the metalanguage, the poetry of indigenous media, *performing* what is implicit in other kinds of productions that might follow more conventional lines. In one particularly popular segment featuring a band led by Aboriginal singer Ned Hargraves, the video-processed image, clearly a Western form, might be interpreted as contradicting the message of the song the group sings:

Look at us, look at the price we have paid.
Keep your culture, keep your land.
Will you stop before your ways are dead?

As the group performs against a dramatic desert background, visions of men doing traditional dances, images of desert animals and sites, fade

in and out. By the end of the piece, the lead singer, Ned Hargraves, falls down, apparently dead. It seems to be the fitting image to the end of the piece as the last line is repeated: "Will you stop before your ways are dead?" Then, suddenly, Ned revives with a wink and a "thumbs up" signal to the audience, suggesting a different perspective that inverts the usual jeremiad over cultural loss. Such unexpected bricolage, borrowing freely from a range of available expressive resources (rock music, video, Aboriginal language and landscape) is in the service of Aboriginal cultural assertion.

For Aboriginal producers, the goal of their media work is not simply to maintain existing cultural identities, what some Aborigines have called the "cultural refrigeration" approach.[75] The production of new media forms is also a means of cultural invention that refracts and recombines elements from both the dominant and minority societies. Art critics Fry and Willis try and capture that sense of "hybridity" in the language of postmodernism. They update Lévi-Strauss's image of bricolage with more contemporary metaphors, combining popular understandings of recombinant DNA and telecommunications.

Making a new culture which knowingly embraces the future is a more viable form of cultural bricolage (by this we mean the making of a culture by a process of the selection and assembly of combined and recombined cultural forms). Resistance to ethnocide is not seen as trying simply to defend an existent cultural identity but the forging of a new one which rejects the models sought to be imposed. Radio, television and video have become significant media in this cultural strategy. And what is particularly significant is that these media break the circuit of producing products for circulation and consumption within the culture of dominance (as opposed to works of art). Aboriginal radio, video and TV producers are producing ideas and images that circulate in their own cultures.[76]

Mass mediation of indigenous culture is certainly not a global village, as Imparja's subsuming of Aboriginal interests to commercial imperatives makes clear. Yet, when indigenous media is under local control, it seems to have a revitalising potential, suggesting a more positive model than the Faustian one. Young Aboriginal people who are or will be entering into production are not growing up in a pristine world, untouched by the dominant culture, nor do they want to assimilate to the dominant culture. They are juggling the multiple sets of experiences that make them contemporary Aboriginal Australians. Many want to engage in creating images and narratives about their present lives, which nonetheless connect them to their history, and direct them toward a future as

well. For this generation, Aboriginally produced stories and images about Aboriginal life in Australia are increasingly visible in the flow of images seen by *all* audiences.

At its best, indigenous media is expressive of transformations in indigenous consciousness rooted in social movements for Aboriginal empowerment, cultural autonomy, and claims to land. Many would argue that there is a continuum of activities for Aboriginal self-determination vis-à-vis the state that links land rights to air rights. Like the ethnic autobiographies that Fischer discusses, one can see in this work a new arena of cultural production in which specific historical and cultural ruptures are addressed and mediated, and reflections of "us" and "them" to each other are increasingly juxtaposed.

Interviews

Batty, Phillip, assistant director, CAAMA, Alice Springs, 5 July 1988.

Glynn, Freda, director, CAAMA; chair, Imparja, Alice Springs, 6 July 1988.

Perkins, Rachel, director, Aboriginal Programs Unit, SBS, Sydney, 29 April 1992.

Peters, Frances, Aboriginal Programs Unit, ABC, Sydney, 30 April 1992.

Sandy, David, Aboriginal Programs Unit, ABC, Sydney, 30 April 1992.

Filmography

BOWMAN, ARLENE
1986 *Navajo Talking Picture*

CAVADINI, ALESSANDRO, AND CAROLYN STRACHAN
1981 *Two Laws*

COFFEY, ESSIE, WITH MARTHA ANSARA AND ALEC MORGAN
1979 *My Survival as an Aboriginal*

ELDER, SARAH, AND LEONARD KAMERLING
1973 *At the Time of Whaling*
1973 *Tununeremiut*
1976 *From the First People*
1976 *On the Spring Ice*
1988 *The Drums of Winter*

KANUCK, ZACHARIAS
1977 *Goodbye Old Man*
1987 *From Inuit Point of View*
1989 *Quaggig*

MACDOUGALL, DAVID, AND JUDITH MACDOUGALL
1980 *Familiar Places*
1980 *Takeover*
1980 *The House Opening*

MASAYESVA, VICTOR
1984 *Itam Hakim, Hopiit*
1988 *Ritual Clowns*

MCKENZIE, KIM
1980 *Waiting for Harry*

MOFFATT, TRACEY
1987 *Nice Coloured Girls*
1990 *Night Cries: A Rural Tragedy*

OLIN, CHUCK
1983 *Box of Treasures*

O'ROURKE, DENNIS
1976 *Yumi Yet*
1978 *Ileksen*
1987 *Cannibal Tours*

ROUCH, JEAN
1954 *Les Maîtres fous*
1955 *Jaguar*
1960 *Chronicle of a Summer*

Notes

This essay is a revised version of an earlier article, "Indigenous Media: Faustian Contract or Global Village?" *Cultural Anthropology* 6, no. 1 (Feb. 1992), which was based on a paper delivered at the "Film and the Humanities" conference held in September 1989 at the Australian National University's Humanities Research Centre. For research support, I am grateful to the Research Challenge Fund of New York University (1988) and the John Simon Guggenheim Foundation (1991–92). I have made two research trips to Australia (five weeks in 1988; three weeks in 1992), which enabled me to visit and conduct interviews at CAAMA and Imparja in Alice Springs; EVTV in Ernabella; Warlpiri Media Association in Yuendumu; the ABC and SBS Aboriginal Program Units and the Australian Film and Television School in Sydney; and the library and film archive at the Institute for Aboriginal and Torres Strait Islanders Studies in Canberra.

This piece could not have been written without the help of Fred Myers in 1988 and Françoise Dussart in 1992, both of whom assisted me in the logistics and languages of Aboriginal research in the field and out. I would like to thank Leslie Devereaux and Roger Hillman, HRC conference organisers, for their editorial help; and George Marcus, Fred Myers, Jay Ruby, and Terry Turner for their helpful readings and encouragement of this project. I am also grateful to David Batty, Philip Batty, Freda Glynn, Annette Hamilton, Francis Jupurrurla Kelly, Ned Lander, Marcia Langton, Mary Laughren, Michael Leigh, Judith and David MacDougall, Michael Niblett, Rachel Perkins, Frances Peters, Nick Peterson, Tim Rowse, David Sandy, and Peter Toyne for their insights and assistance.

1. For example, in the summer of 1990, "The Decade Show: Frameworks of Identity in the 1980s" was hosted by a consortium of three New York City museums: the New Museum of Contemporary Art, the Studio Museum in Harlem, and the Museum of Contemporary Hispanic Art. The accompanying brochure to the show describes the issue uniting the diverse visual, video, and performing artists in the exhibition: "Through their examination of familiar issues — homelessness, gender, racism, sexism, AIDS, homophobia, media politics, the environment, and war — these artists demonstrate that identity is a hybrid and fluid notion that reflects the diversity of American society. . . . The work included in this exhibition may be seen as material evidence of alternate viewpoints. Many artists of color, for example, in their philosophical, aesthetic, and spiritual linkages to precolonial societies of Asia, Africa, and America, legitimize diversity, resist Eurocentric domination and create a foundation from which to analyze and explain contemporary social phenomena. Feminist, gay, and lesbian artists similarly affirm that there are other ways of seeing, ways equal to existing cultural dictates."

2. As part of a commitment to multicultural awareness, Britain's Channel 4 and the British Film Institute developed the Workshop Declaration of 1981, which gave nonprofit media-production units with four or more salaried mem-

bers the right to be franchised and eligible for nonprofit production and operation money. These workshops are expected to provide innovative media and educational programs in the communities where they are situated.

In the racially tense climate of Britain in the early 1980s, and especially after the 1981 Brixton riots, the Labour Party initiated progressive cultural policy through the establishment of a race relations unit and Ethnic Minorities Committee. Money was made available for film and video from the Greater London Council and local borough councils. Based on these funds, the future members of two influential and ground-breaking black film groups, Sankofa and Black Audio Film, financed their first works and organised workshops; see Coco Fusco, "A Black Avant-Garde? Notes on Black Audio Film Collective and Sankofa," in Coco Fusco, ed., *Young, British and Black* (Buffalo, N.Y., 1988), 7–22.

3. The Special Broadcast Service (SBS) in Australia was set up initially as an ethnic broadcasting service. Until 1989, it viewed Aboriginal people as outside its mandate because they are indigenous rather than ethnic minorities.

4. The following two examples illustrate the growing interest in indigenous media work in well-known "high culture" institutions. In the spring of 1990, the New Museum hosted "Satellite Cultures," a showcase of experimental and alternative video from Australia that included screenings of work by Tracey Moffatt, an urban Aboriginal filmmaker and artist who is relatively well known in art circles, as well as a reel of work by CAAMA, and a documentary on Aboriginal land rights, "Extinct but Going Home." Unfortunately, the video was poorly contextualized and badly exhibited. Lacking any background, most American observers watching the CAAMA programs seemed intrigued but bewildered.

In June 1992, the Association on American Indian Affairs, the National Museum of the American Indian, the American Indian Community House, the Learning Alliance, and the Film Society of Lincoln Center jointly sponsored "Wind and Glacier Voices: The Native American Film and Video Celebration." This was the first such festival ever held at the Walter Reade Theatre, part of New York City's prestigious "high culture" Lincoln Center.

5. Quoted in Philip Batty, "Singing the Electric: Aboriginal Television in Australia," in Tony Downmunt, ed., *Channels of Resistance* (London, 1993), 114.

6. For a recent comprehensive work, see Roy Armes, *Third World Film Making and the West* (Berkeley, 1987).

7. Batty, "Singing the Electric," 3.

8. The main centres of indigenous media production (besides Australia) are among the Indians of the Amazon Basin, especially the Kayapo, among Native North American Indians. See the following sources: Deborah Lee Murin, *Northern Native Broadcasting* (Runge Press [Canada], 1988); Terence Turner, "Visual Media, Cultural Politics and Anthropological Practice: Some Implications of Recent Uses of Film and Video among the Kayapo of Brazil," *Commission on Visual Anthropology Review* (Spring 1990): 8–13; Elizabeth Weatherford, ed., *Native Americans on Film and Video*, vol. 1 (New York, 1981); Elizabeth Weatherford and Emelia Seubert, eds., *Native Americans on Film and Video*, vol. 2 (New York, 1988).

9. This is beginning to change. For example, at the 1991 American Anthropological Association meetings in Chicago, there were two panels on Television and the Transformation of Culture that examined the social processes of production, distribution, and consumption/reception of television in Great Britain, Nigeria, Papua New Guinea, Nigeria, Indonesia, the United States, Colombia, China, and Japan.

10. Marcia Langton, *Well, I Heard It on the Radio and Saw It on the Television: An Essay for the Australian Film Commission on the Politics and Aesthetics of Filmmaking by and about Aboriginal People and Things* (Sydney, 1993), 6.

11. Stuart Hall, "Cultural Identity and Diaspora," in J. Rutherford, ed., *Identity, Community, Culture, Difference* (London, 1990), 222.

12. Some key figures in these discussions include Homi Bhabha, "The Other Question: Difference, Discrimination and the Discourse of Colonialism," in Russell Ferguson, Martha Lever, Trinh T. Minh-Ha, and Cornel West, eds., *Out There: Marginalisation and Contemporary Cultures* (Cambridge, 1990); Michael Fischer, "Ethnicity and the Post-Modern Arts of Memory" in James Clifford and George Marcus, eds., *Writing Culture: The Poetics and Politics of Ethnography* (Berkeley, 1986), 194–233; Hall, "Cultural Identity and Diaspora"; Stuart Hall, "Cultural Studies and Its Theoretical Legacies," in L. Grossberg, C. Nelson, and P. Treichler, eds., *Cultural Studies* (New York, 1992), 277–94; Lucy Lippard, *Mixed Blessings: New Art in Multicultural America* (New York, 1990).

13. Hall, "Cultural Studies and Its Theoretical Legacies," 285.

14. Dell Hymes, "The Use of Anthropology: Critical, Political, Personal," in Dell Hymes, ed., *Reinventing Anthropology* (New York, 1972), 3–79.

15. For example, George Marcus and Michael Fischer, *Anthropology as Cultural Critique: An Experimental Moment in the Human Sciences* (Chicago, 1986).

16. David MacDougall, "Beyond Observational Cinema," in Paul Hockings, ed., *Principles of Visual Anthropology* (Chicago, 1975), 109–24.

17. Sol Worth and John Adair, *Through Navajo Eyes* (Bloomington, Ind., 1972), 5.

18. These projects include works such as *Familiar Places* (1980), *Goodbye Old Man* (1977), *The House Opening* (1980), and *Takeover* (1980), by David and Judith MacDougall with various Aboriginal groups in Australia; *Two Laws* (1983), made by Carolyn Strachan and Alessandro Cavadini with Aboriginal people in Boroloola; *Ileksen* (1978) and *Yumi Yet* (1976), made by Dennis O'Rourke in New Guinea; and Sarah Elder and Leonard Kamerling's work with the Alaska Native Heritage Project, including *At the Time of Whaling* (1973), *From the First People* (1976), *On the Spring Ice* (1976), *Tununeremiut* (1973); and *The Drums of Winter* (1988).

19. Hopi video artist Victor Masayesva's works include *Itam Hakim Hopiit* (1984) and *Ritual Clowns* (1988); Inuit producer Zach Kanuck's work includes *From Inuit Point of View* (1987) and *Quaggig* (1989).

20. See, for example, Annette Hamilton's excellent discussion of this and related issues in her review of *Communication and Tradition: Essays after Eric Michaels* in *Canberra Anthropology* 14, no. 2 (1991): 112–14.

21. Peter Malone, *In Black and White and Colour: A Survey of Aborigines in Recent Feature Films* (Jabiru, Northern Territory, Australia, 1987), 114.

22. Marcia Langton, "Some Comments on Consultative Anthropology in Aboriginal Australia," paper presented at the Australian Anthropological Society meetings, Canberra, 1982.

23. What reason could we as anthropologists give for the glances we cast over the wall at others?

Without a doubt, this word of interrogation must be addressed to all anthropologists, but none of their books or articles has ever been questioned as much as have anthropological films. . . . Film is the only method I have to show another just how I see him. In other words, for me, my prime audience is . . . the other person, the one I am filming. Jean Rouch, "The Camera and the Man," in Hockings, ed., *Principles of Visual Anthropology,* 83–102.

24. For example, the film *Box of Treasures* (1983) shows how contemporary Kwakiutl Indians are utilising a number of resources—including colonial photography—to facilitate cultural revival.

25. Rosemarie Kuptana, "Inuit Broadcasting Corporation," *Commission on Visual Anthropology Newsletter* (May 1988): 39.

26. A recent example of this argument is Neil Postman's *Technology: The Surrender of Culture to Technology* (New York, 1992), in which he argues that we have surrendered our social institutions to the "sovereignty of technology" so that traditional culture has become invisible and irrelevant.

27. David MacDougall, "Media Friend or Media Foe," *Visual Anthropology* 1, no. 1 (1987): 58.

28. Anne Rutherford, "Changing Images: An Interview with Tracey Moffatt," in Anne Rutherford, ed., *Aboriginal Culture Today* (Canberra, 1988); Scott Murray, "Tracey Moffatt," *Cinema Papers* 79 (1990): 9–22.

29. P. Black, *Aboriginal Languages of the Northern Territory* (Darwin, 1983), 3.

30. Helen Molnar, "The Broadcasting for Remote Areas Community Scheme: Small vs. Big Media," *Media Information Australia* 58 (Nov. 1990): 148.

31. Michael Leigh, "Curiouser and Curiouser," in Scott Murray, ed., *Back of Beyond: Discovering Australian Film and Television* (Sydney, 1988), 78–89.

32. MacDougall, "Media Friend or Media Foe."

33. Eric Michaels, *The Aboriginal Invention of Television: Central Australia 1982–86* (Canberra, 1986).

34. Helen Molnar, "Aboriginal Broadcasting in Australia: Challenges and Promises," paper presented at the International Communication Association Conference, March 1989.

35. Molnar, "Broadcasting for Remote Areas Community Scheme," 148.

36. For anthropological analyses of Aboriginal "self-determination" and the production of Aboriginal identity in relation to the state, see "Aborigines and the State in Australia," a special issue of *Social Analysis* 24, edited by Jeremy Beckett.

37. MacDougall, "Media Friend or Media Foe," 55.

38. Molnar, "Broadcasting for Remote Areas Community Scheme," 149.

39. While Yuendumu and many other Aboriginal communities had not received the steady flow of broadcast television, it is important to point out that they were acquainted with Western filmmaking practice through community viewings of rented films, attending cinemas in towns, and, most recently,

through the circulation and viewing of materials through their own or resident whites' video cassette recorders.

40. Most of this information is compiled from my interviews with Philip Batty and Freda Glynn and from Eric Michaels' report *The Aboriginal Invention of Television* (Canberra, 1986).

41. Molnar, "Aboriginal Broadcasting in Australia," 34.

42. Peter Toyne, "The Tanami Network: New Uses for Communications in Support of Social Links and Service Delivery in the Remote Aboriginal Communities of the Tanami," paper presented to "Service Delivery and Communications in the 1990s" conference, Darwin, 1992.

43. Ibid.

44. Jenny O'Loughlin, "Tribal Business Has Gone Space Age in the Outback," *The Advocate* (8 March 1992): 12.

45. *Canberra Times,* 1992.

46. Molnar, "Aboriginal Broadcasting in Australia," 25ff.; Neil Turner, "Pitchat and Beyond," *Artlink* 10 (1990): 43–45.

47. Neil Turner, quoted in Philip Dutchak, "Black Screens," *Cinema Papers* 87 (March-April 1992): 48.

48. Batty, "Singing the Electric," 9.

49. Dutchak, "Black Screens," 49.

50. Molnar, "Broadcasting for Remote Areas Community Scheme," 149–53.

51. Batty, "Singing the Electric," 11.

52. In addition to CAAMA, there are now four large Aboriginal regional media organisations: WAAMA (Western Australia Aboriginal Media Association); TEABBA (Top End Aboriginal Bush Broadcasting Association); TAIMA (Townsville and Aboriginal Islander Media Association); TSIAMA (Torres Straits Islanders and Aboriginal Media Association). These organisations produce radio and in some instances video programs for broadcast in remote Aboriginal communities (Molnar, "Broadcasting for Remote Areas Community Scheme," 148).

53. Freda Glynn, interview with author, Alice Springs, 6 July 1988.

54. Imparja's initial funding came from the Australian Bicentennial Authority ($2.5 million), the Aboriginal Development Commission ($1.8 million), the National Aboriginal Education Commission ($1.5 million), and the South Australian Government ($1 million). Batty, "Singing the Electric," 121.

55. Cliff Goddard, "Imparja Gears up to Bring TV to the Bush," *Land Rights News* 2, no. 4 (1987): 12.

56. Molnar, "Aboriginal Broadcasting in Australia," 23.

57. Tony Fry and Anne-Marie Willis, "Aboriginal Art: Symptom or Success?" *Art in America* 77, no. 7 (Winter 1989): 163.

58. Molnar, "Aboriginal Broadcasting in Australia," 23.

59. Eric Michaels, *For a Cultural Future: Francis Jupurrurla Makes TV at Yuendumu,* Art and Criticism Monograph Series, vol. 3 (Melbourne, 1988), 26.

60. Michaels, *Aboriginal Invention of Television,* 30.

61. Diane Bell, *Daughters of the Dreaming* (Melbourne, 1983); Fred Myers, *Pintubi Country Pintubi Self: Sentiment, Place and Politics among Western Desert Aborigines* (Washington, D.C., 1986), and "The Politics of Representation: An-

thropological Discourse and Australian Aborigines," *American Ethnologist* 13 (1986): 138–53; Basil Sansom, *The Camp at Wallaby Cross* (Canberra, 1980).

62. Dutchak, "Black Screens," 50.

63. Molnar, "Broadcasting for Remote Areas Community Scheme," 8.

64. MacDougall, "Media Friend or Media Foe," 58.

65. Molnar, "Broadcasting for Remote Areas Community Scheme," 36–38.

66. Francis Peters and David Sandy, Aboriginal Programs Unit, Australian Broadcasting Corporation; interviews with the author, Sydney, 30 April 1992.

67. Molnar, "Broadcasting for Remote Areas Community Scheme," 38–39.

68. Rachel Perkins, director, Aboriginal Programs Unit, Special Broadcasting Service; interview with the author, Sydney, 29 April 1992.

69. Alexander McGregor, "Black and White Television," *Rolling Stone* 415 (1988): 35ff.

70. Batty, "Singing the Electric," 11.

71. Langton, *Well, I Heard It on the Radio*, 6.

72. Eric Michaels, "Bad Aboriginal Art," *Art and Text* 28 (1988): 59–73, and *For a Cultural Future*.

73. "Representing Culture: The Production of Discourse(s) for Aboriginal Acrylic Painting," *Cultural Anthropology* 6, no. 1 (February 1991): 26–40.

74. Fischer, "Ethnicity and the Post-Modern Arts of Memory," 195, 196.

75. Molnar, "Aboriginal Broadcasting in Australia," 151.

76. Fry and Willis, "Aboriginal Art: Symptom or Success?" 160.

13

The Pressure of the Unconscious upon the Image

The Subjective Voice in Documentary

SUSAN DERMODY

On "Brooding"

Rather than comply with the usual demands of scholarship I want to remain sketchy and open — "brooding" is the word that keeps coming to mind at the moment. An interestingly feminine term for thought. Perhaps at the end of brooding — a very inward kind of process — some *thing* emerges into the world. But if so, the thing is likely to get up on its wobbly legs and run off in any direction when it does. And soon start hatching out its own new schemes.

Of course there's a danger, if we pursue this analogy too far, of ending up with a chicken and egg problem. And of remembering a short piece of writing by Judith Brett called "The Chook in the Australian Unconscious." She argues that there is a secret identification in most Australians' hearts between themselves and the chook, that peculiarly Australian, mongrel form of poultry.

Brett's position is that "the chook symbolises the forces, both inner and outer, which we fear we have not conquered, and it does so by being a uniquely comic figure."[1] Flightless birds are vulnerable, hierarchical, and therefore prone to being comical. They resonate with our own, perhaps ridiculous, vulnerability and intractability. The essay notes, "The pecking order, closely observed, is not a lovely institution; nor is the chook pen under threat an image of an ordered social world."[2] And it goes on to note that it's the chicken's vulnerability that lets it slip

so deep into the unconscious and qualify for comic distancing, as in the very word "chook." If you've ever seen a headless chook in flight — "an image of panic not even death can stop"[3] — or noted that distinct resemblance, played on by so many films, urban legends, and jokes, between a plucked, trussed chicken and a newborn baby, you'll understand the rich territory of the chook in the unconscious very well.

You could go further, perhaps too far, with this invitation to fancy. For example, think about that particular genre of Australian men, especially the two generations who went to war and who are represented iconically by actors such as Tal Ordell, Chips Rafferty, the young Peter Finch, and, carrying on the tradition, Bryan Brown. These are actors with a particular beakiness and stringiness — actually a far more appealing configuration than it sounds in these words — and an astringent, humorous courage. Recognise the organising figure from the unconscious?

But getting back to "brooding." It is a state of receptiveness very close to the viewing mode that some documentaries, some less than strict "documentaries," induce in the audience. If you are "brooding," you are sitting with something, suspending thought, and letting something not really in your grasp come to its time. Actually, I'd go further: you have no choice but to do this. Perhaps this is where the connotation of sullenness comes from in the word "brooding." Writing is a brooding process, a suspended "thinking toward," and it often eludes the active will. By which I mean it is painful to begin and riddled with insecurity and procrastination. Scholarly writing seems to me to be considerably less demanding of this difficult kind of unconditional patience. As is any kind of writing that is "commissioned," to some extent, from the outside world. The muscular ego rises to the occasion, takes up the task, produces something good enough in the relevant genre.

But a writing process that is entirely uncommissioned, undemanded by the world, or the workplace, adding nothing obviously useful to the Current Account figures — that requires all the self-collapsed posture, doubt, and forced inactivity of the unverifiable, inward process of brooding. To borrow a distinction Christa Wolf makes about her own kind of writing, it is a "thinking toward" (*nachdenken über*) rather than an act, precisely, of thinking. A hovering of thought that keeps the self always present, in a constant process of movement between memory, reflection, dream, and narrative. Scholarly writing either maintains a rhetoric that keeps the self officially absent, or at bay, or brings it in more decisively by yet another rhetorical strategy that acknowledges the

convention in refusing it. Unnecessary, uncommissioned, unknown acts of writing are cast in a speaking voice that makes the self as complexly present to the reader as the subject of the writing is to the speaker, the writing self.

I can't make an absolute distinction here, of course; I'm well aware of how complexly present the self is in acts of scholarly writing. And I know about postmodernism and the dissolution of the boundaries between criticism and any other kind of speech act. But I think that there is a strong enough sense of difference in the way the self is posed and proposed in the two kinds of writing. That it is more present, in order to be more undefended, in the kind of writing that brooding is or leads to. And that you can extrapolate from this notion in writing to something similar in film, to think about subjectivity and the unconscious in the film image and the film voice, which is an especially interesting question for documentary or, as Bill Nichols has called it, expository film, in distinction to narrative film.

Associative Montage and "Voice"

I'd like to start by considering a short segment at the start of Dovzhenko's 1929 film, *Arsenal*. I'm not making a historical case, here, particularly; I just wish to see what a series of "documentary" images look like when organised associatively and obliquely, with sparse use of speech — in this case, silent intertitles.

The static, then exploding landscape is used again in the opening of Dovzhenko's 1932 film, *Ivan;* it announces the emotional configuration of the next two sequences, which are variations on a single theme, of stress at breaking point, bursting point. It leads into the first of the desperately frozen poses of the women in the village, relieved by the shot on the top of the moving train, the sleeping soldiers, then, taking over again, almost a short "narrative" about a village sleepwalking in grief and privation. The speech of the film is bare bones: "There was a woman who had three sons" (fig. 18). "There was a war." Then the grim joke from the diary of Tsar Nicholas: "Today I shot a crow" (fig. 19). The sense being established by now of language almost stopped up is strengthened by the way Nicholas manages to think of one last thing for his diary entry for that day in the middle of a terrible war. "Splendid weather, Nikky." Intercut with this sequence are the shots of the old

18. "There was a woman who had three sons." *Arsenal* (1929).
Alexander Dovzhenko.

19. "Today I shot a crow." *Arsenal* (1929). Alexander Dovzhenko.

woman collapsing in the field (as if shot for a crow) (fig. 20), and a
cripple trying to plough with a starved old nag. The sequence as a whole
builds to the frustrated violence of a woman beating a baby (figs. 21
and 22), the man kicking his horse, and the horse's reply. Fifty years
later, in a Kluge film, *The Patriot,* the kneebone of a dead corporal will
discourse about war and history, about the strategy of history from

20. The old woman collapsing in a field (as if shot for a crow). *Arsenal* (1929). Alexander Dovzhenko.

below, and the importance of connections between ideas. "You are wasting your time, old man," says the horse. "I'm not what you need to strike at."

Then a second short, and very complex montage sequence from the battlefield is organised around the same devices — of frozen, catatonic poses, this time organised around the paralysis of the front and the grim irony of laughing gas (fig. 23). Movement in this sequence has the jerky, spasmodic, convulsive rhythm of agonised, hysterical laughter, the *danse macabre* of the front. The only things that flow are the rivers of faceless troops. The figure here is irony, again, tautened one or two more painful notches — irony at the point of self-laceration.

It is impossible not to talk of sequences, of associative relationships between shots, and yet the cutting has the effect of isolating each shot, giving it its own weight and unity, and not restricting the associative process to the relationships between immediately neighbouring shots. Because each shot sinks into the memory, the possibility for association, for waiting, for letting things happen, is an extended, unproscribed one. It is a different experience from Eisenstein's montage varieties of the same time — say, in *October*. And one of the differences is the sense of time in the shot, to which I would like to come back in my conclusion.

Where the film speaks, in this excerpt, it speaks in a most refined, limited, and powerful way. Like a fairy tale. Ordinary, direct speech,

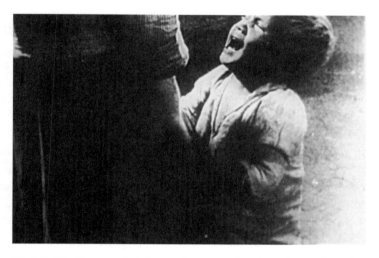

21–22. The frustrated violence of a woman beating a baby. *Arsenal* (1929). Alexander Dovzhenko.

with no implied position above or outside of the viewer. The voice seems to speak inside your head. It does not instruct. The only posture in it is the momentary one of irony, of absurd pleasantry, when it comments in the laughing-gas sequence, "These gases — some of them make the heart gay." But again, it speaks from the midst of what's happening, not completely from above it. And even here, it avoids what Ursula le

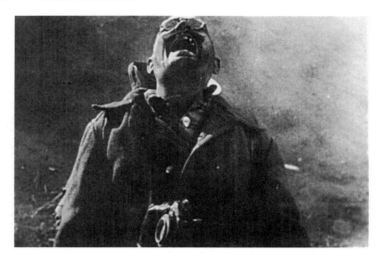

23. The grim irony of laughing gas. *Arsenal* (1929). Alexander Dov-zhenko.

Guin has called "the father tongue,"[4] which organises the narration of the majority of documentaries.

One purpose of this paper is to try to identify something about a mode of film that is not quite documentary nor yet quite fiction, not essay, not poetry, not anything yet satisfyingly described by a single word. I am interested in trying to tease some of these things out, because I'm in the midst of trying to write a film like this, to get it right.

It is a mode that may use images collected or created from the real world, "documentary" evidence from the real world, but is free to use them to speak of something other than primarily their "factual" referents as documentary tends to do. It uses its images to be truthful rather than necessarily factual; and sometimes to be truthful toward private rather than necessarily public realities. But all of this is in one way or another in service of an engagement with reality, a communal sharing of reality, a *communitas* such as the best documentaries always provide at some level.

The films may blur the already soft lines between direct and fictional proposals about the world. They may mix genres of representation to the point where generic expectation is defeated (though it must be noted that all genre involves a play with the idea of genre, but some players are just hams and others can take you completely off guard).

Whatever other rhythms may become manifest, it is possible also to

make out an oracular, meditative, irregular, unpredictable, and essentially discontinuous rhythm emerging from the coincidences of conscious and unconscious associations. The associative rhythm seems to retain a connection with dream corresponding to the drama's connection with ritual. In these films, the drama is subdued, constantly broken off, and the dream, "dreamwork," is uppermost.

And what emerges in all of the films I would see as engaging partly or wholly with this mode is a "voice" in the film that addresses the inner voice of the viewer. And that helps to release the imagery from a strictly referential function, to the point where a line is crossed and we are reading the image and sound track from the perspective of the unconscious.

"Tongue"

I've mentioned the notion of "the father tongue" and would like to elaborate le Guin's idea quite a bit further, here. It is extremely useful, to me, for trying to get at the distinction between kinds of narration that I've already started to draw.

The father tongue is the language of social power, the one that is learnt at university and exercised in academic gatherings. It is the public discourse, and one dialect of it is speechmaking, another is much documentary narration. It is generally a written form; even when spoken dialects are involved, the traces of written speech are felt. "It doesn't speak itself," le Guin says.

It lectures. It began to develop when printing made written language common rather than rare, five hundred years ago or so, and with electronic processing and copying it continues to develop and proliferate so powerfully, so dominatingly, that many believe this dialect — the expository and particularly the scientific discourse — is the highest form of language, the true language, of which all other uses of words are primitive vestiges.[5]

She then makes a crucial distinction: it is the language of thought that seeks objectivity — a gap, a space between the subject or self and the object or other. That is not quite the same as calling it the language of rational thought. "Reason," she points out, "is a faculty far larger than mere objective thought." And "the essential gesture of the father tongue is not reasoning but distancing."[6] She goes on to argue that the forcing and rending of this gap between Man and world has generated enor-

mous energy that fuels the continuous growth of technology and science, an interesting argument that can't be pursued here. But the fact remains that those who don't or won't speak the empowering language are silent, or silenced, or unheard. The father tongue is a forked tongue: "it speaks dichotomy, valuing the positive and devaluing the negative in each redivision: subject/object; self/other; mind/body; dominant/submissive; active/passive; man/nature; man/woman, and so on."[7]

The murderous "who did what to whom." It doesn't have to be murderous — it has great use in the service of justice and clarity. It is when it claims a privileged relationship to reality that it becomes dangerous. "It describes with exquisite accuracy the continuing destruction of the planet's ecosystem by its speakers," le Guin remarks, with superb economy. And "ecosystem" itself is, of course, a word entrapped in a discourse that objectifies to a possible logical endpoint of terminal irresponsibility.[8]

This tongue is nobody's native tongue (although we've all met people who have mastered the art of talking in perfectly printed sentences). As le Guin says, "You didn't even hear the father tongue your first few years, except on the radio or TV, and then you didn't listen, and neither did your little brother. . . . You had another kind of tongue to learn. You were learning your mother tongue."[9] The tongue we learn from our mothers and speak to our kids. And it is the language stories are told in.

This is the other, inferior tongue, in father-tongue terms. Primitive, inaccurate, unclear, coarse, limited, trivial, banal. Repetitive, vulgar, common speech. It expects an answer, unlike the father tongue. It is essentially conversation, connecting language. "Its power is not in dividing but in binding. . . . It flies from the mouth on the breath that is our life and is gone, like the outbreath, utterly gone, and yet returning . . . and we all know it by heart."[10] Have you got your umbrella? Joan dear, did you feed the sheep, don't just stand around mooning. My heart is breaking. Touch me here, touch me again. God damn you to hell. Oh shit. Go to sleep now, go to sleep. You are wasting your time, old man. There was a woman who had three sons.

It is the tongue that offers experience as truth rather than claiming anything. It offers. And experience, as such, cannot be denied, negated, disproved. The mother tongue reintroduces the sense that people can't contradict each other, only words can, when they are separated from experience and sent in to battle to expose and exploit the object while disguising and defending the subject. As le Guin says, "People crave

objectivity because to be subjective is to be embodied, to be a body, violable, vulnerable."[11]

Finally, she distinguishes a third tongue, a native tongue, which you spend your life trying to know and master. It is unlearned language, some kind of child of the father and mother tongue both. It is for clarity, but from the heart, "the marriage of the public discourse and the private experience, making a true discourse of reason. This is the wedding and welding back together of the alienated consciousness (of) the father tongue, and the undifferentiated engagement (of) the mother tongue."[12] It has intimacy and clarity at once, hallmarks of the inhabited, inner kinds of voice-over that I'd like to select from two further film examples before I finish.

But first I'd like to establish another aspect of the way such a voice may be organised.

"Nachdenken über"

Christa Wolf calls her novel *Nachdenken über Christa T.,* which we know as *The Quest for Christa T.*[13] The meaning of the phrase falls somewhere between "thinking over," "thinking toward," "thinking in accordance with." The novel develops an interestingly ambiguous and open-ended relationship to its subject of recollection, an undefended manner, which does not serve the end of self-justification. Similarly, in her *Cassandra: A Novel and Four Essays,* she develops a noncoercive, heterogeneous kind of mode or series of modes of talking, that, like the phrase "nachdenken über," contains both the active intentionality of a subject's appropriation of an other *and* the receptive surrender of the subject to the other.[14] I especially like the way that Wolf can shift, in a single paragraph, and sometimes a single sentence, among oracular speech, meditative essay, private memory, journal entry, a description of a meal, a recounting of a conversation, a dream. It is a self-interrupting form of conversation or storytelling that is naturally predisposed toward heterogeneity (and, with one more step taken, bricolage). And it is, of course, an absorption of process into product.

But what particularly interests me are not these postmodern virtues but the way this flexibility opens up moments for speaking or hearing the inner voice, the unconscious voice. And the way it removes all space in which the heroic posture can be struck.

I'll have to come back to le Guin again, who, fortunately or not, I happened to delight upon as I was struggling to write this paper and be a scholar again. In a 1986 essay, she announces a new theory of fiction, "the carrier-bag theory of fiction."[15]

The title caught my eye like a flash from an important dream, and I quickly remembered why. Do you recall, in the nightmarish few days of the crushing of the prodemocracy demonstrations in Tiananmen Square, that image on the news, shot from a hotel balcony, perhaps, of a small man with a shopping bag in his hand, who stepped off the curb and stood in front of the first of a column of tanks as they chewed their way up the street? He stood his ground in front of the lead tank, and it came to rest a few feet from him. Then it veered to one side, to get around him. He stepped to that side. It veered to the other side. He blocked it again, and again, while a whole street of snarling tanks were made to wait. A bull fight in reverse. And in his hand, a shopping bag, the kind of painfully ordinary detail that sears into your mind, like the holes in the socks of a man about to be executed, and the way he tries to find a dry spot on the ground to put down his coat that in a moment he won't be needing ever again. It was a simple "no," enacted without a single overtone of heroism. The camera angle was hidden, candid. There were no apparent spectators on the street. And he never put down his shopping bag.

The carrier-bag theory of fiction holds (a most appropriate term) that it is hard to tell a gripping tale of how you wrested a wild-oat seed from its husk, and then another one, and the three-year-old said something funny, and then we went to the creek and had a drink and watched the waterskimmers for a while, and then you found another patch of wild oats and. . . . On the other hand, it is marvellously compelling to tell of how you thrust a spear into the titanic flank of a hairy mammoth, and how the other three were crushed or impaled while you shot your unerring arrow straight through eye to brain. You can make a killing with a story like that. It is easy to see how story was pressed into service of the tale of the hero.

So the Hero has decreed through his mouthpieces the Lawgivers, first, that the proper shape of the narrative is that of the arrow or spear, starting *here* and going straight *there* and THOK! hitting its mark (which drops dead); second, that the central concern of narrative, including the novel, is conflict; and third, that the story isn't any good if he isn't in it.[16]

Instead, le Guin offers the view that the natural, proper, fitting shape of the novel might be that of a sack, a bag, a shopping or carrier bag.

"A book holds words. Words hold things. . . . A novel is a medicine bundle, holding things in a powerful, particular relation to one another and to us."[17] Now substitute "film," especially documentary, for "novel," and you begin to have, I think, a great working definition of a non-authoritarian expository film, with an intimate, inner, undefended, storytelling kind of approach.

Time in the Image

There's one more aspect of the image under pressure of the unconscious that I wish to try to establish. And here I'm drawing on Tarkovsky, whose films I could have easily made the centrepiece of this paper. In his *Sculpting in Time: Reflections on the Cinema*, Tarkovsky argues that "time in its moral implication is in fact turned back. Time cannot vanish without trace for it is a subjective, spiritual category; and the time we have lived settles in our soul as an experience placed within time."[18]

From this he builds a marvellously simple and obvious case. Film is the taking of an impression of time, a print of time; the other forms that have time at their heart are different; music, for example, "materialises moment by moment on the brink of its own total disappearance." So, "Why do people go to the cinema? . . . I think that what a person normally goes to the cinema for is *time:* for time lost or spent or not yet had."[19] Cinema concentrates the experience of time and so enhances experience, makes it significantly longer, more invested, more typical, more memorable. This diffusion of idea and feeling into time is nothing much to do with screen time, with the clock time of the image on the screen. It is to do with duration, the experience of time, a kind of memory happening now.

Tarkovsky's sense of the time within the shot, and of a vast variety of kinds of such time, is best examined by looking at his films, of course. But it runs also right throughout these notes of his on cinema and is especially interesting when he talks about editing. He throws out the conventional wisdom that time is manipulated primarily in the cuts between shots and that rhythm arises from the rhythm of the screen time of shots cut into sequence, faster, slower, choppy, and so on. He forces attention back to the psychological experience of time within each shot. "Rhythm, then, is not the metrical sequence of pieces; what makes it is the time-thrust within the frames. And I am convinced that it is rhythm,

and not editing, as people tend to think, that is the main formative element of cinema."[20]

I think that it is time to end like a magician, with a demonstration of some of the tricks I've been talking about.

The sequence I shall describe from Marker's 1982 film *Sunless* (starting seven minutes past the front title and lasting nearly eleven minutes) must be understood in the context of a kind of travelogue into the unconscious levels of several cultures, especially Japan, posed as a woman recounting and perhaps quoting directly from letters sent back to her by a photographer friend. That provides a lovely motivation for a voice track that can shift between all of the registers with great flexibility and be in a mode of intimacy even when it is reaching toward oracular pitch and aphoristic clarity. I am interested in seeing what happens, in concert with this voice, to the experience of the image as an inner image, with the palpable pressure of the unconscious coming to bear and to alter the sense of time in the image.[21]

- A street parade in Japan, at night—dancing figures (mainly women), with lots of attention to repetitive hand movements, against the neon street signs and subjects always in oscillating motion.

- Shots approaching Tokyo by road. The voice-over refers to a list "of all those things that quicken the heart," with images as various as wrecked cars propped on old tree stumps, the scaffolding of a fun park against the sky, buildings like fairy castles. The driver's white-gloved hands on the wheel.

- The voice-over recalls the story of a man from Nagoya whose wife died. He went on to work extra hard, in the Japanese style, even made an important discovery in electronics. Then he killed himself. It was said that he couldn't stand hearing the word "spring."

- The "reunion with Tokyo" sequence. Twelve million anonymous inhabitants, their cats, rituals, totems, icons, supply a sense of home. Endless trains. "Tokyo, a city criss-crossed by trains. Tied together by electric wire, she shows her veins."

- Comic-book graphics sequence. Hordes of readers, in bookshops, streets. The sad fate of the comic-strip heroines. Cruelty, ubiquity. Huge street-mural reappearances of the few that make their escape from their fates. "The entire city is comic strip. It's planet Mongo." Dalek-shaped buildings brooding down into the camera. Images,

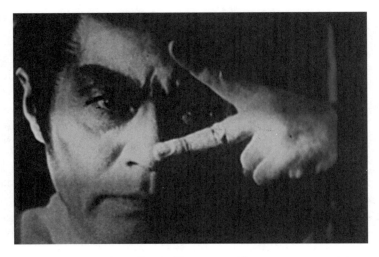

24. "You must make a friend of horror. . . . The more you watch it, the more you feel it's watching you." *Sans soleil* (1982). Chris Marker. Produced by Argos Films (Paris).

especially faces, everywhere on walls, graphics, electronics, liquid crystal — "voyeurizing the voyeurs."

- At nightfall, the megalopolis reverts into a thousand villages. The bar in Shinjuku. The "action-painter" cook, with "the essence of style" as he scoops food into a pile on the hot plate and squirts the character for "the end" on the top.

- A sequence that journeys for a day and a night into Tokyo television, "that memory box." Commercials, "like haiku to the eye," a documentary on Gérard de Nerval, including a lingering close-up of the grave of Jean-Jacques Rousseau, strangely pertinent in this plethora of images that now substitute for nature, for the wild. Childlike paintings about the Khmer Rouge atrocities. Quoted from *Apocalypse Now* (in Brando's voice), "You must make a friend of horror. . . . The more you watch it, the more you feel it's watching you" (fig. 24).

- An earthquake interrupts briefly, spilling things onto the floor, reminding the commentary that poetry is born of insecurity. Samurai films, in black and white. Cats in hats. Late night, a nude beauty contest, with bobbing lights masking the genitals of the contestants,

making "censorship the show," and, like religion, pointing to the absolute by hiding it.

- Another image around town right now, huge poster displays of the Pope, whose visit is accompanied by a display of some of the Vatican treasures on the seventh floor of a department store. We visit it, watch fascinated Japanese absorbing the spectacle, stooping down to get its exact measure. "I imagine them bringing out in two years time a more efficient and less expensive version of Catholicism."

And the sequence (starting at three minutes beyond the opening credits and lasting nearly seven minutes) from Kluge's *The Patriot* (1979) comes from a film that is a series of propositions about history, German history, wartime experience, and the proper way to dig back out the history-from-below, not the history of the administered sphere,[22] of public life, but the history in the millions of heads down onto which the bombs dropped. Even the history, and meditations on history, that can be recovered from a fragment of the dead, like the knee-bone of a German officer at the battle of Stalingrad. For we all know that if time can be imprinted on film, the dead can speak.[23] Again, the voice is effortlessly intimate in its address. However, this time it may have more to do with the exact pitch of the performance — by Kluge himself — of the voice track and the coincidence of aphoristic statements bathed in a kind of nostalgic and ironic empathy with intensely private landscapes. The camera explores its live and still spaces with a kind of private search for meaning. Time is only sometimes in something like accordance with screen time — the filmed bits of dialogue, for instance, or the scenes that insert a fictional character, Gabi Teichert, into "real" party political conferences, and so on. Otherwise, it is inner time, cupped in a soft iris mask of darkness, or in the arms of the abruptly edited stretches of music.

Let's see.

- A pan of treetops from a stone tower. Corporal Wieland's "knee" is speaking: "I must clear up one error: That we dead are quiet. We're full of protest and energy. Who wants to die?" (fig. 25).

- As the knee starts to speak, we are in black-and-white World War II newsreel footage of the German retreat from Russia, suffering soldiers in the snow.

- Gabi Teichert prepares to leave her bathroom and go out into the

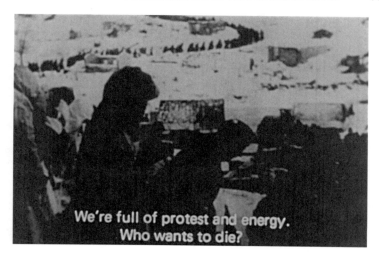

We're full of protest and energy.
Who wants to die?

25. "We're full of protest and energy. Who wants to die?" *The Patriot* (1979). Alexander Kluge.

night to dig up German history with a spade. (Footage repeated from Kluge's contribution to the 1979 collective film, *Germany in Autumn*.)

- Lights in the dark. Gabi at work. A plane heard, overhead.
- Right-to-left tracking shot following an astronomical telescope to its eye piece, where we find Gabi looking. "Reverse shots" of what she sees — a slim new moon that fades to dark, factory rooftops that fade to dark.
- An image, pulsing in light, of "the high-rise of Salmi," as the voice-over identifies it. "One night, it burned down," and we see a fire at night. Black-and-white birth film footage, silent, a girl is born, then laid into a shallow bath.
- A puddle, rain drops falling into it (fig. 26). We are told, "A puddle has a history of three days." Music starts (Sibelius, *Swan of Tuonela*).
- Time-lapse photography of a city skyline, clouds racing, day turning to night, lights racing in the dark.
- Green-tinted black-and-white, slightly fast-motion footage of windmills turning on the far side of a river.
- Tanks tacking through autumnal woods on a manoeuvre. Music stops abruptly at some point.

26. A puddle, raindrops falling into it. *The Patriot* (1979). Alexander Kluge.

27. The bomb disposal men discuss defusing Allied bombs: "Standard left threads? No . . ." *The Patriot* (1979). Alexander Kluge.

- A series of five (female?) faces explored in extreme close-up, tinted black-and-white footage. One lights a cigarette. One laughs a little.
- Wartime footage: bombers in formation against clouds.
- Aerial shots of bombs falling into a city.
- Enacted sequence, titled "The Bomb Disposal Men in a Cellar." Four men discuss ways of defusing unexploded English and Ameri-

We're full of protest and energy.
Who wants to die?

25. "We're full of protest and energy. Who wants to die?" *The Patriot* (1979). Alexander Kluge.

night to dig up German history with a spade. (Footage repeated from Kluge's contribution to the 1979 collective film, *Germany in Autumn*.)

- Lights in the dark. Gabi at work. A plane heard, overhead.

- Right-to-left tracking shot following an astronomical telescope to its eye piece, where we find Gabi looking. "Reverse shots" of what she sees — a slim new moon that fades to dark, factory rooftops that fade to dark.

- An image, pulsing in light, of "the high-rise of Salmi," as the voice-over identifies it. "One night, it burned down," and we see a fire at night. Black-and-white birth film footage, silent, a girl is born, then laid into a shallow bath.

- A puddle, rain drops falling into it (fig. 26). We are told, "A puddle has a history of three days." Music starts (Sibelius, *Swan of Tuonela*).

- Time-lapse photography of a city skyline, clouds racing, day turning to night, lights racing in the dark.

- Green-tinted black-and-white, slightly fast-motion footage of windmills turning on the far side of a river.

- Tanks tacking through autumnal woods on a manoeuvre. Music stops abruptly at some point.

26. A puddle, raindrops falling into it. *The Patriot* (1979). Alexander Kluge.

27. The bomb disposal men discuss defusing Allied bombs: "Standard left threads? No . . ." *The Patriot* (1979). Alexander Kluge.

- A series of five (female?) faces explored in extreme close-up, tinted black-and-white footage. One lights a cigarette. One laughs a little.
- Wartime footage: bombers in formation against clouds.
- Aerial shots of bombs falling into a city.
- Enacted sequence, titled "The Bomb Disposal Men in a Cellar." Four men discuss ways of defusing unexploded English and Ameri-

can bombs (fig. 27). "Standard left threads? No." A bombing run continues overhead. The light fails a few times, dust and mortar rain down.

• Green-tinted black-and-white shot of a figure at a distance on a horizon line halfway up the circular, masked image — like a gun sight. He lights a cigarette that flares in the strange darkness. The voice-over says, "Documentary. A man with cigarette at 800 metres. Night. (Pause.) His story I can't know." Camera pans left to find a rise, up to a clump of trees. A crow caws. It then pans right again, back to the man. The flare of the cigarette, magnified by darkness. Fade to dark.

Notes

1. Judith Brett, "The Chook in the Australian Unconscious," *Meanjin* 46 (June 1986), 246.
2. Ibid., 247.
3. Ibid., 248.
4. Ursula K. le Guin, "Bryn Mawr Commencement Address (1986)," in *Dancing at the Edge of the World: Thoughts on Words, Women, Places* (London, 1989), 147.
5. Ibid., 148.
6. Ibid.
7. Ibid., 149.
8. Ibid.
9. Ibid.
10. Ibid., 150.
11. Ibid., 151.
12. Ibid., 152.
13. Christa Wolf, *The Quest for Christa T.* (London, 1970).
14. See Myra Love, "Christa Wolf and Feminism: Breaking the Patriarchal Connection," *New German Critique* 16 (1979): 31–53, for a discussion of this novel and the meanings of the phrase "nachdenken über," especially page 35.
15. Ursula le Guin, "The Carrier Bag Theory of Fiction," in *Dancing* (1989): 165–70.
16. Ibid., 169.
17. Ibid., 169.
18. Andrey Tarkovsky, *Sculpting in Time: Reflections on the Cinema,* trans. Kitty Hunter-Blair (London, 1986), 58.
19. Ibid., 63.
20. Ibid., 119.
21. Both this and the excerpt from *The Patriot* are far too detailed in mon-

tage of sounds and images to "list" briefly in any rounded way; the commentaries are to be seen as maps to the territory covered.

22. The "administered sphere," in Kluge's terms, is that increasingly abstract, incomprehensible, uncanny public discourse, drained of emotion, inscrutable of motive.

23. What the knee hunts out is the tissue of history from below — facts and wishes, documentary and desire. For Kluge establishes that the human abilities to both bear facts and form wishes are poles of the same need, and, within that need, reality and imagination cannot be unravelled from one another. Hence the nostalgia and irony of Kluge's mode of historic empathy.

14

Robert Gardner's *Rivers of Sand*

Toward a Reappraisal

PETER LOIZOS

The chief aim of this paper is to discuss a film by Robert Gardner, an American documentarist who has worked at Harvard University for over thirty years. The issues raised are questions about how to read a documentary film text, the importance of identifying an author's intentions, and the question of how far an intellectual from one culture may legitimately raise questions about the human condition through representations of another culture whose language he does not speak. A further question, raised only implicitly, is whether social scientists have a more privileged right to represent others than do intellectuals who do not use the styles of argument and analysis associated with scientific realism? Finally, the paper is concerned with the meeting ground (or is it a missing ground?) between artistic representations and those of the social sciences.

Had the question "Who is the best-known living American anthropological filmmaker?" been asked fifteen years ago, many people might have replied, "Robert Gardner, hélas!" But in recent years his films have drawn a lot of fire, so I rehearse below the main criticisms. It is often said by anthropologists that Gardner's films are "too subjective" and that, since Gardner sees himself as an artist rather than a social scientist, any further discussion of the value of his films is more or less pointless. It is put most rigorously by Craig Mishler in his analysis of *Dead Birds*, a film about fighting, death, and much else among the Dani people of Highlands West Irian (Irianjaya): "My judgement is that *Dead Birds* has been coloured by so many subtle fictional pretensions and artistic orna-

mentations that it has surrendered most of its usefulness as a socially scientific document."[1] He then goes on to give a very well-argued listing of the film's defects. He would have preferred a film in real time about real events, with no interpretive statements that were not fully supported by the specifics of Dani views or faithful to them. The criticisms of two anthropologists, Ivo Strecker and his wife, Jean Lydall, about the film *Rivers of Sand* are similar in tone and in content. They argue that Gardner misread certain crucial facts of the ethnography of the Hamar (a pastoral people in southwest Ethiopia) and produced "an ethnographic farce."[2]

More recent criticisms have taken slightly different tacks. Alexander Moore has denounced *Forest of Bliss*, Gardner's film about Benares, as "imagist" and a throwback to the days of silent films, which is intellectually and morally confused.[3] And the anthropologist Jonathan Parry, who has studied the city and its culture intensively, has suggested that Gardner's views of Benares are distorting and liable to support a prejudice that Hindu culture is beyond rational comprehension.[4] The word "orientalist" is not actually used, but that is the thrust of Parry's judgement. And, for good measure, Parry invokes Leni Riefenstahl, a documentarist who made two films to celebrate the success of the National Socialist movement in Hitler's Germany. Riefenstahl is for European socialists a versatile hobgoblin, and Parry mentions her example in order to remind us that films celebrating dubious philosophies have been defended for their aesthetic power in a way that ignored the septic political values behind them. Parry's review also contains hard words for filmmakers who do not use context-elucidating commentary. He rightly insists that rituals do not explain themselves.

But there are reasons for not getting too worried by the alleged deficiencies of the films. First, Gardner's *intentions:* from early on in his career, he has signalled that he was not working to make films of record. He does this signalling in his titles, in his signature, in various stylistic ways, and in what he says and writes about film. The titles of mainstream ethnographic documentation films sound like journal articles: *Walbiri Ritual at Ngama, The Iron Smelters of Eremi,* or *Life Chances: Four Families in a Changing Cypriot Village.* Gardner's films usually have eye-catching literary titles, *Dead Birds, Deep Hearts, Rivers of Sand,* which do not suggest the intentions of a scientific recording angel but someone altogether more ambitious.

After the main title Gardner adds "A film by Robert Gardner." This is like a painter's signature, taking *personal* authorial responsibility for

what follows. Anthropologists are usually relegated to a distinctly minor position in Gardner's credits.

The reduction of descriptive or explanatory commentary to a minimum in most of his middle and late films is also a deliberate distancing from the genre of the film of record. Gardner wants his audiences to be transported at least as much as informed.

Beyond the question of intentions, the second reason for remaining open to Gardner's films is oblique, and analogous to the first. It involves the proposal that written ethnography is a matter of composition and that the resulting text is composite, aggregative, and in no sense a literal record of events observed. Written ethnography may use some conventions of realist narrative, but it is almost never a document describing in real time a single flow of events with no interruptions. The only near exception to this I know of is Dwyer's *Moroccan Dialogue,* which is an edited transcription of a series of dialogues between an anthropologist and a single key informant.

More generally, a monograph is a distillation of a period of fieldwork, and it synthesises hundreds if not thousands of encounters, events, and conversations in order to produce a coherent summary. Malinowski never actually went on a kula expedition but wrote it up as if he had witnessed one. Written ethnography has to be synthetic and composite; it has to transpose, to decontextualise, and reaggregate. Otherwise, a monograph would have to be a series of field notes pasted together plus a "commentary." One or two authors have tried this out—Leach's *Pul Eliya* is one example, and Riviere's *Trio Marriage* is another. But these attempts have not been widely emulated, because we very sensibly prefer more reader-friendly books to these experiments in dishing up practically raw data, which needs a lot of treatment to be digestible.

The third reason for remaining open to Gardner's films arises from taking a holistic, scholarly approach to the man and his work. That is to say, we need to see any Gardner film in the context of his creative life. In two words: people experiment. The reviewers Moore and Parry, each picking away at a single Gardner film without regard for the body of his work, wrench the film from the context of the man and the meaning of his life. This might not matter had that life not been spent in doing something of at least passing interest to anthropologists professionally—that is, making representations of other cultures. Parry would never allow himself to take intellectual shortcuts when dealing with the citizens of Benares. Why apply to a Gardner film less rigorous contextualising criteria than to a necrophagous ascetic or a funeral priest?

I would suggest that in some of his films Gardner is best understood as a painter with a film camera, one who happens to have been able to add in sound effects. The second film he directed was in fact a portrait of an American painter called Mark Tobey. This film, completed in 1951, is characterised by some extraordinary visual effects, both surreal and allusive, and by some fast cutting effects that are notable. Gardner's voice on the sound track says things about the nature of the artist and his vision, some of which now embarrass him, but the film has a curious power.

Gardner's first film is, in a way, equally predictive of his later work, in two senses. It is called *Blunden Harbour*, written and directed by Gardner, and is in fact about a small community of Pacific Northwest coast Native Americans who are fishers and gatherers. It is marked by its nonrealist, nondescriptive narrative style. First, Indian mythic poems are recited as a significant part of the sound track. They are for me fairly hard to pick up on, sonorous, portentous, and about the passed days of greatness and integrity, but they are very evocative. There are sequences of people in production activities, but Gardner clearly betrays no desire to tell us about how people work, nor to instruct us. The style of shooting and of sound incantation using an old text is reminiscent of the dramatised lyricism and painterly composition of Basil Wright's *Song of Ceylon,* a film that Gardner greatly admired.[5] There is also a sequence of a performed ritual, whether as deliberate reenactment for the camera or on a more routine basis it is not possible to tell from the film. But the cinematography again has an unusual quality, the camera coming up very close to frightening animal masks, while the sound track carries chants and tambourine-like music of the performers. After the ritual, the film returns to the seashore and to the slightly dispirited daily round. The film succeeds in conjuring up a past that was different from the present, on lines similar to Rouch's *Les Maîtres fous* although with much less sensational material.

Ivo Strecker used the word "surreal" several times about Gardner, in order to claim that Gardner is not a good surrealist.[6] Although I grant Gardner has sometimes used shock effects in a manner reminiscent of surrealism, I do not see that the word is appropriate and later on will suggest other sources for his film aesthetics. At this point in his career, though, we could probably use in preference the terms "nonliteral" or "experimental" to suggest his approach.

Perhaps this is the place to say that Gardner was an admirer in his youth of the experimental filmmaker Maya Deren, who made a two-

hour film on voodoo in Haiti in the 1950s, a film that contains many slow-motion sequences, particularly concerning dance and sacrifice. And in correspondence he has insisted that

> my favourite ethnographic films include *Modern Times, The Rules of the Game, Zéro de conduite* (to mention only three). I have said this because I felt then and I feel now that the sheer observational power that illuminates these films contributes more to an understanding of the human condition than the great majority of all other motion picture documents, with the emphatic inclusion of nearly all those that are referred to as "ethnographic."[7]

All three of the films he mentions are technically "works of fiction." "Observational power" is not about the indexical real-time observation of observational documentaries. It is about insight and illumination, observing the human condition manifested by people in their natural habitats, an activity for which Flaherty was justly famous. It is about making the familiar into the extraordinary by stylistic experiments that force the viewer to look more consciously.[8] In most respects he has been fairly consistent in his practices.

Now at this point I would like to suggest that there is a query implicit in Gardner's career as a documentarist, a query that I would sum up as "How to film the exotic without anthropologists." I do not mean entirely without, but I do mean without ceding creative control to them. Gardner seems, retrospectively, pretty clear on wanting full creative control. He invites assistance, which he usually pays for, but he does not usually invite 50–50 collaborative partnerships. If Gardner wishes to make films that are equivalent to visual essays, with a stress on the word "visual," why should he cede control to realist ethnographers? I suspect the reason so many anthropologists feel he should have done so has a good deal to do with the protection of a professional monopoly, the right to speak for another people, or the claim to speak more responsibly of them. If Gardner had set himself up as a maker of films of ethnographic record (like, for instance, Timothy Asch), then the quality of his cooperation with the relevant ethnographer would be paramount. But this is not his usual or recent intention.

It is quite clear that Gardner has not been able to learn the language or to spend the equivalent of a full field-work period in the places where he has normally filmed. He has thus depended on anthropologists for some minimum guidance, for translations, for all kinds of enablements. But this has only rarely turned into a fully collaborative relationship. This is the area of his basic vulnerability, and it is here, I would argue,

that he made an early decision not to work in the terrain of the ethno-graphic. That is a matter of the strength of the creative ego, the ability to take risks, and to survive, perhaps thrive, on a certain kind of criticism from a profession in which he studied for two years, completing his graduate examinations, before deciding on a film career rather than one as an academic anthropologist.

I wish now to look at one particular film and suggest how to read it and what kind of value it may have for anthropologists. First, here is Gardner himself on his intentions:

> My first choice as a title for *Rivers of Sand* was *Creatures of Pain.* Though it evoked most aptly the central theme of the work, I was persuaded by friends not to use it. They felt, no doubt correctly, that it was too sombre, too suscep-tible to a wrong interpretation. . . . But what I heard in those words is what I felt as I made the film: an ordeal and a process in which men and women ac-commodate to each other in the midst of the tension and conflict caused by their fidelity to social roles. . . . Part of that tradition was the open, even flam-boyant, acknowledgement of male supremacy. . . . Hamar men are masters and their women are servants. The film is an attempt to disclose not only the activi-ties of the Hamar, but also the effect on mood and behaviour of a life gov-erned by sexual inequality.[9]

Gardner's film may be understood as a string of dramatised questions about the nature of gender relations among the Hamar and, by implica-tion, more widely. They include: the nature of the sexual division of labour; the nature and meaning of pain, and how human beings endure pain voluntarily for personal adornment or social promotion (both in conformity to custom); and how they endure other forms of pain in order to consolidate a marriage or provide for a child.

The Streckers seemed to have been hoping for a conventional de-scriptive-analytic ethnographic film, which allows a good deal of infor-mation to be offered through the commentary. Such a film tends to define and specify, to reduce uncertainty, and is a *relatively closed text* to which the viewer need not bring a great deal except a willingness to be informed. In contrast, *Rivers of Sand* and other films that rely on mon-tage and allusion may not specify or define much conceptual informa-tion, although they may illustrate a great deal of cultural behaviour. In-stead of instructing, they offer us puzzles, contexts for reflection, and add to the list of questions we might have about human natures and human cultures. For those viewers who are willing to learn but do not "know the answers" (that is, do not know all they need to know about

either the general issues or the cultural particularities of the film), such a film functions as a *relatively open text,* a text that can be productive of questions.

I do not suggest that open is "good" and closed is "bad." We need both kinds of texts. If people need rapid orientation to another culture and are busy, they might prefer a good "closed" film, one that tells them quickly what they think they need to know. In situations in which there is plenty of time, and viewers are free to explore issues without immediate pressures to act, a more "open" film might offer more stimulation.

Since the late 1960s one orthodoxy in ethnographic film has been based on observational real-time filming and has been very hostile to montage-based films. *Rivers of Sand* is flamboyantly a montage film. There is no real time, no narrative. The structure is that of Gardner's thematic preoccupations.

The review by Bender, the Streckers' letter, and the Royal Anthropological Institute catalogue all treat *Rivers of Sand* as a stick of rock candy that has a simple message (such as "kiss me quick" or "a souvenir from Southsea") inscribed in it, the message being the same from one end to the other, and they all write as if the film contains a definite representation of Hamar gender relations. Mishler notes that Gardner thinks of each of his films as being organised around "a kind of extended metaphor" and if we take that suggestion as seriously as we are meant to, we cannot look quite so readily for a paraphrasable "message."

The film has two voices. One is Gardner's, who has titled it, superimposed a few written statements, and two major paragraphs of commentary, one at the beginning and one at the end. The other voice is that of a mature, married Hamar woman, Omalle-inda.[10] The first words that Omalle-inda addresses to us are these:

A TIME COMES WHEN A HAMAR WOMAN LEAVES HER FATHER'S HOUSE TO LIVE WITH HER HUSBAND. IT'S LIKE SMOOTHING A GRINDSTONE WITH A PIECE OF QUARTZ. THE QUARTZ IS HIS HAND, HIS WHIP, AND YOU ARE BEATEN AND BEATEN. YOU RUN FOR TOBACCO AND WATER. WHILE YOU RUN, HE ONLY SITS. FOR A LONG TIME YOU STAND THERE. AT LAST HE TAKES THE WATER AND DRINKS THEN HE TAKES SOME TOBACCO AND CHEWS IT. YOU GO BACK INTO THE HOUSE WITH THE REMAINING TOBACCO. AFTER THIS YOU MAKE COFFEE AND HE DRINKS IT. THEN YOU COOK FOOD AND SERVE IT TO HIM — THAT'S HOW IT IS — THAT'S YOUR NEWNESS — YOU ARE AFRAID OF HIM. YOU ASK, WHEN WILL HE BEAT ME, AND YOU ASK, WHY NOT? HE IS BEATING YOU EVEN WHEN HE IS NOT. YOU ARE AFRAID OF HIM, AFRAID.

LATER YOU GO TO ACCEPT GIFTS FROM RELATIVES, YOU GO TOGETHER, YOU
GET USED TO HIM, YOU BECOME ONE OF HIS PEOPLE, YOU BECOME RECON-
CILED TO STAY. THAT IS THAT. AND THAT IS THAT.

Then the main title comes up:

Rivers of Sand
A film by Robert Gardner

Subtitles explain that the film is about a people in southwest Ethiopia,
how they live in their semiarid environment, and the nature of gender
relations among them. We then see a series of short sequences of
women working and men taking their ease, and we hear, over dawn
sequences of a cattle camp, the sonorous voice of Gardner:

> A day begins in the dark for the Hamar. Children milk cows and women be-
> gin their long hours of servitude. They submit with considerable grace to the
> plentiful demands of their men. Merriment more than rancour defines their
> mood. A woman's life is purposeful, and essential, but it is also tinged with a
> certain sorrow which stems from their familiarity with both physical and psy-
> chic abuse. Men are also afflicted through their tyranny with wasted energies,
> idle spirits, and self-doubt.

Major statements complement the somewhat startling account of newly
married wives being fearful and beaten. The strongly evocative words
"servitude," "abuse," "tyranny," and "wasted . . . idle . . . self-doubt" are
all both descriptive and judgemental and not the normal currency of
ethnographic discourse. The commitment of anthropologists to under-
standing a culture from within its own values has stopped many aca-
demics from making such statements, but the impact of feminism put
such traditional relativism into question, and in the early 1970s a num-
ber of collections of papers by American feminist anthropologists used
equally judgemental terms. Gardner never clarifies what he means by
speaking of the men's wasted energies, idle spirits, and self-doubt, and
I am not persuaded he had good grounds for the suggestions.

 This is the first editorial statement Gardner makes in the film, and it
fits the pretitle sequence. It is modified by his closing remarks and, I
shall argue, by a good deal of the remainder of the film. While at the
start of the film Gardner appears to present the oppression of Hamar
women as a straightforward matter of political fact, by the end of the
film the whole matter appears to be more complex, puzzling, and part of
some universal problem of relations between men and women. Gardner
wishes us to leave the film not thinking that Hamar men are especially

awful but rather that *in any culture* gender relations are especially diffi-
cult to understand. I would propose that his "extended metaphor" in
this film is of a youth whipping a girl who smiles lovingly at him after
the whipstroke. The girl has been made beautiful with hundreds of
small razor cuts and her front teeth being cut out with a knife, and the
boy dreams of possessing a rifle, killing animals for food, and owning
many cows.

The first images in the film seem to reinforce Gardner's early state-
ment. We see women working and men resting or playing. In the first
ten minutes we are treated to disturbing images—a flash-shot of a
woman being struck with a whip, another of a leg burdened with ankle
irons. These images seem to emphasise the themes of beating and servi-
tude. But the first fifteen minutes of the film, like the pretitle sequence,
are there to get us involved, worried, and watching carefully, to ask our-
selves, "What is going on here? What is this all about?"

In the first minutes of the film women work and men rest, but gradu-
ally we start to see men in productive roles—drawing water for cattle
and herding cattle; hunting and carrying meat home; young men and
boys scaring birds off the ripening sorghum. We do not see men per-
form the "heavy" male task of breaking the ground for planting, but
presumably that is because most of the film was shot in the harvest pe-
riod and such material was missed. The film's time frame seems to be a
few consecutive weeks. Nor do we see men in warfare, although
Omalle-inda mentions the importance of raiding as a male activity. We
also see men doing the "heavy work" of burying a woman who has died.
So the early picture of male idleness is strongly modified. The problem
of elders performing blessings has been mentioned. Blessing within the
logic of Hamar cultural ideology is undoubtedly crucial "productive
work."

These sequences are cross-cut by sequences of women doing things
that are not work: decorating the body and cutting cicatrices; playing a
melodious phrase on a flute in the afternoon heat, out in the sorghum;
and, most significant, dancing for pleasure in the boys' maturation cere-
mony. Now although these sequences constitute a kind of "shading" of
the preceding black-and-white male-female contrasts, there is no sugges-
tion of *balance* because throughout the film there are many images
of women grinding sorghum, now singly, now in pairs. The camera
watches this act from numerous angles. The women are very often smil-
ing and singing, and we may recall Gardner's early references to their
good humour and grace. (Notably, fifteen years later, when Jean Lydall

made with Joanna Head her first film on Hamar women, they called it *The Women Who Smile*.) We may be led to reflect that although on the technical level of labour expended this work is laborious, drudgery from which men are free, the women show no signs of fatigue or resentment. Gardner is perhaps inviting us to think about how productive work for one's family may have a "non-alienated" character in a precapitalist society. "Women grinding sorghum," repeated as often as it is, becomes a running metaphor for the gendered division of labour, for the integration of person in direct production, for bodily grace confirming lived-in acceptance of a gender role, and for the drudgery that is the lot of women in a male-dominated culture. Within the context of the film, there are three recurring images of men that we might stack up against it: men blowing out liquid spray in a blessing; men stroking rifles; and men with whips striking at women, livestock, or simply the air.

Gardner's treatment of hunting needs comment. It is a male monopoly, which he treats both lyrically and enigmatically. The film is seeded with shots of men caressing, cleaning, or operating the bolt action of rifles, the weapons that above all underwrite their identities as men. We see two men stalk an ostrich, shoot it, skin it, dismember it. The open carcass fills up with blood, and one hunter lowers his face to this pool and drinks from it, an arresting image to those of us used only to seeing bloodless meat dressed in supermarket packets. Then we see that the men have stripped entirely and are consuming marrow from the roasted ostrich bones. It's a feast, a celebration of success in the hunt. As one man finishes eating he blows a long stream of water from his mouth onto his hands to cleanse them. Civility, the deliberateness of cultural (as opposed to natural) humanity, is conveyed in that gesture.

The use of sound in this sequence is lyrical, in the literal sense that from the kill to the end of the cutting up, cooking, and eating we hear Hamar men's voices singing in what to my ear is a melodious counterpoint. It is ethnographically enigmatic since no translation allows us to know the sense of their words. The effect of this use of music is to heighten those aspects of the hunt, the kill, and the eating that stress the sense in which the act is celebratory, ceremonial, and expressive of Hamar manhood. Instead of the sequence remaining technical and pragmatic, we are made to think about hunting in its symbolic, role-confirming sense. I would say it helps us "see" hunting more clearly.[11]

If Gardner can be said to have heightened the expressive aspects of hunting through his contrapuntal sound editing, the blessing process really needs no editing assistance to produce similar effects, for the pro-

cess is inherently a theatrical piece of ritual. Indeed, it makes abundantly clear in practise (even though nothing is "said" at the level of explicit commentary) the extent to which certain rituals are *performances*, and it enables us to put certain debates about the nature of ritual into a setting of social action.[12] One man's voice "leads" with a phrase that identifies the person or thing to be blessed, and the men's group responds with emphatic assent. Gardner translates this incantatory speech for us in subtitles. Otherwise, throughout the film hardly any speech from men is translated. Our only comprehensible Hamar voice is that of the woman Omalle-inda.

Problem of Beatings

As already noted, the film opened with the statement that a new young wife is fearful of being beaten by her husband. But later in the film we come to see that this is a feature of the new young bride, because once she has had a child, Omalle-inda tells us, a Hamar husband will say to his wife: "A child has come between us. Shall I continue to beat you for ever?" The clear implication is that he will *stop* beating her.

The Streckers' letter[13] mentioned indignantly that Gardner's narrator Omalle-inda had herself in fact never been beaten in her life and was a "model" Hamar wife. They suggested that the film is nothing more than a sometimes misleading local informant's model joined to an even more misleading outsider's model, a combination that produces a thoroughly unsatisfactory whole. This was repeated by Ivo Strecker:

> Omalle-inda's account of wifely subordination would, in fact, appear to be at variance with her own experience. The relationship between men and women in Hamar is clearly more complex than Omalle-inda's theory. Bob, however, preferred to edit his material to fit her theory and his own ideas about male domination, rather than to explore actual relationships between real men and women. Part of his footage included scenes of girls being whipped. That the whipping was ritualised and initiated by the girls themselves is not made clear in the film.
>
> Like Omalle-inda's account, the ritual whipping belongs to the realm of the ideal, rather than everyday reality. There is undoubtedly a strong interconnection between the two, but to present the ideal as if it were reality is, quite simply, to distort the truth.[14]

In my view, the ritual character of the ritual whipping is quite clear, although not stated in words. It is filmicly clear. It is not clear to

Strecker, and it is clear to me. What more can be said? The communicative indeterminacy of film (particularly a montage film, and one keeping commentary to a minimum) is a taut wire stretched across the chasm of our two mutually exclusive interpretations, which also includes, of course, Strecker's preference for the explicitness normal in science and my unwillingness to treat the film as science, whether good or bad science. The reader must decide for herself. But to learn that Omalle-inda has never herself been beaten puts both her statements and Gardner's film in a different light. Had the film been posing as a factual film of record, it might have been a worrisome fact. Lévi-Strauss warned us that the distance between individual facts and structural models is informative, yet the Streckers did not ask in either of their critical articles why Omalle-inda in her account should stress beatings. Gardner could have replied that the substantive picture was true and that it would have been blurred by the admission *in a film* of a rare exception.

But thanks to the Streckers' comments we are now in a position to see that Omalle-inda is giving us an account of "Hamar marriage from the woman's point of view" and that it is an ideal-typical account, not a personal reminiscence. In this respect it resembles the normative statements made by the wives in *Maasai Women* and by the moran in *Maasai Manhood*. Omalle-inda does not offer us a subjective or testimonial narrative of what happened to her. She does not say "Then I was taken to my husband's people . . . then he beat me." Consider the effect on our view of the complexities of gender and narratives if, during her statements, a subtitle appeared under her words saying "in other discussions with the ethnographers Omalle-inda insisted that she herself had never actually been beaten at all." It would have made the film no less thought provoking, and even more interesting, and it is perhaps a pity from the realist viewpoint that such a statement was not made. But Gardner was not offering a realist, observational account.

Not that wife beating is so unusual that Gardner is doing anything very odd by putting it in the foreground of *Rivers of Sand*. In a personal communication to me Melissa Llewelyn-Davies has said that virtually every Maasai wife she knew well had at some point in her marriage been severely beaten by her husband to make sure that his authority was unquestioned. Jean Strecker edited a film on Hamar women, *The Women Who Smile* (1991), a major prizewinner at the Royal Anthropological Institute International Festival of Ethnographic Film. In this film unmarried girls discuss beating within marriage as an inevitable fact of life arising out of the patrilocal marriage rule, but they mention it with-

out much rancour, laugh about it, and treat it as a taken-for-granted fact of women's lives. They suggest that their husbands will take the place of their fathers, their brothers, and even their mothers, and they also describe marriage as a total transition, meaning that they become the property of their husbands. Marriages are arranged between seniors in Hamar, and girls marry the man of their parents' choice.

In his article about working with Gardner Ivo Strecker stresses that his own relationship with his Hamar informants is that of a friend. This is the way anthropologists today often describe field research. But I am led to ask if it is not the very character of that friendship that leads many anthropologists to relativise those features of the cultures they study that appear problematic to other eyes? Is it not hard to judge one's "friends"? Perhaps there is something to be said for the existence of a more distanced kind of observer, one who raises questions that become harder to discuss the more one likes and understands one's informants?

In my view, *Rivers of Sand* is Gardner's last film that is even in a secondary sense "for anthropology," and from then on his films were made for a wider audience, particularly one that is concerned with "the visual arts." The London-based Institute of Contemporary Arts would provide an almost ideal forum for the later Gardner films.

The latest films, *Deep Hearts, Forest of Bliss,* and *Ika Hands* are works that invite the viewers to suspend their conceptual/abstract faculties and surrender to their sight. The sound track will offer them mostly song, incantation, and sound "effects" — that is, natural location sounds. *Deep Hearts* has a spare commentary. It transports us to a single ritual and gives us a spectator's seat at a beauty competition between young Wodaabe men. It offers us spectacle, and although Gardner casually throws in thoughts about the Wodaabe male idea of the self, and how it must be hidden from envy, the power of the film lies in the images of the men adorning themselves and then dancing in the heat of the day. It is a film that might help break down some crude gender stereotypes, and one can imagine it starting fairly heated classroom debates in several directions, but it is primarily a celebration of the peacock pride of the human male and the vagaries of culture. Culture as surprise, perhaps.

Rivers of Sand was Gardner's only major engagement with a speaking subject. After this film, he turned away from even the restricted conceptual character of Omalle-inda's discourses. It seems plausible to suggest that he found his mature style through montage and through turning his back on conceptual statement. Poet, painter, provocateur — he can be all of these. Certainly not a "social scientist," but a filmmaker who

can set a roomful of scholars arguing heatedly. That, for me, is a singular talent, and one that many scholars do not possess.

Notes

My thanks to Patsy Asch for incisive comments on my first attempt to write about Gardner's films, to Roger Just and the Melbourne University Department of Classical and Modern Greek Studies for an invitation to sojourn among them, even though my research had no links to their normal interests. Thanks also to David MacDougall, Leslie Devereaux, and Roger Hillman for their invitation to participate in the film programme and conferences that led to this volume and to both the editors for their comments and continued support. My particular thanks to the entire staff of the Humanities Research Centre of the Australian National University. The Centre generously funded my visits, and the staff could not have made research more friendly and painless.

An earlier version of this essay was published by Trickster Verlag, in German. It is handsomely illustrated with high-quality photographs by Gardner and others, and I commend it to the reader: R. Kapfer, W. Petermann, and R. Thoms, eds., *Rituale von Leben und Tod: Robert Gardner und seine Film* (1989).

My thanks not least to Robert Gardner, who guided my first film reading, put a 16 mm camera and stock into my hands, and was forbearing in his criticisms of the results. He was equally helpful nearly thirty years later when in prodigal fashion I returned to Harvard to view his films, having been out of touch for half a lifetime. This essay is dedicated to him in gratitude for starting me filmmaking, but the flaws in the article (and my films) are mine alone.

1. Craig Mishler, "Narrativity and Metaphor in Ethnographic Film: A Critique of Robert Gardner's *Dead Birds*," *American Anthropologist* 87 (1985): 669.

2. Jean Lydall and Ivo Strecker, "A Critique of Lionel Bender's Review of *Rivers of Sand*," *American Anthropologist* 80 (1978): 945.

3. Alexander Moore, "The Limitations of Imagist Documentary: A Review of Robert Gardner's *Forest of Bliss*," *Society for Visual Anthropology Newsletter* 4, no. 2 (Fall 1988): 1–3.

4. Jonathan Parry, "Comment on Robert Gardner's *Forest of Bliss*," *Society for Visual Anthropology Newsletter* 4, no. 2 (Fall 1988): 4–7.

5. Robert Gardner, personal communication, 1988.

6. Ivo Strecker, "Filming among the Hamar," *Visual Anthropology* 1 (1988): 369–78.

7. Gardner, personal communication.

8. Sigfried Kracauer, *Theory of Film: The Redemption of Physical Reality* (New York, 1960), 54–57.

9. Robert Gardner, "*Rivers of Sand*," *The Harvard Magazine* (Oct. 1974): 44–53 (includes a discussion of the film by Octavio Paz).

10. I shall follow the spelling used by Jean Lydall in her article on the mak-

ing of two television documentaries about Hamar women, "Filming *The Women Who Smile*," in P. I. Crawford and J. K. Simonsen, eds., *Ethnographic Film Aesthetics and Narrative Traditions,* (Aarhus, Denmark, 1992): 141–58.

11. The hunting and blood-drinking sequence could of course shock people whose only experience of dead meat is the wrapped packets and dressed cuts they buy in supermarkets. Martinez has made it clear that showing certain ethnographic films without any preparation or contextualisation to Californian students tended to increase their tendency to react negatively to the people in the film. It is not my purpose here to analyse the reactions of such audiences to *Rivers of Sand,* but the issue is worthwhile. See W. Martinez, "Critical Studies and Visual Anthropology: Aberrant vs. Anticipated Readings of Ethnographic Films," *Commission on Visual Anthropology [CVA] Review* (Spring 1990): 34–47.

12. I am thinking of the use of Austin's notion of performatives by Maurice Bloch, "Symbols, Song, Dance and Features of Articulation," *European Journal of Sociology* 15 (1974): 55–81, reprinted in Maurice Bloch, *Ritual, History and Power: Selected Papers in Anthropology,* London School of Economics Monographs on Social Anthropology, no. 58 (London, 1989); and also by S. J. Tambiah, "A Performative Approach to Ritual," *Proceedings of the British Academy* 65 (1979): 113–69.

13. Lydall and Strecker, "Critique of Lionel Bender's Review of *Rivers of Sand,*" 945.

14. Strecker, "Filming among the Hamar," 373.

A Last Word

15

Cultures, Disciplines, Cinemas

LESLIE DEVEREAUX

When disciplinary boundaries grow permeable, there is the possibility of looking again, with new questions in mind. As movement across disciplinary boundaries becomes as routine as movement between cultures has been this century, new considerations are needed of the very notion of culture itself. Work on the form and politics of culture, which has informed literary and film theory in this century, has underlying relationships with the approaches to culture in the more realist social sciences, relationships that are perhaps more visible in the area of visual representation than in any other. The conundrums that have arisen in the use of documentary film and photography in anthropology, history, and sociology more clearly point to their kinship with cultural studies than do other aspects of work in those disciplines.

Film, by its seeming closeness to or identity with what we see with our own eyes, by its nature as simulacrum, is in fact highly specific. When it records an image, it is an image of *this* rock, *that* person, *those particular* insects. And yet, by film's embeddedness in the histories and fields of composed images it can easily set that specificity in such a way that it stands for, typifies, an entire category devised not "in reality" but in our collective cultural discourses: king of the beasts, man of the land, fallen woman. In other ways, too, film both is and is not the same as that which it depicts. It has a transparently referential quality that asks us to mistake it for reality. Indeed, if we do not in some sense mistake it for reality we cannot really understand a film properly, as Nichols has reminded us.

Perhaps the most extreme case of film as simulacrum is the nature film. The creature under view stands for the life of its entire species in the undisturbed depths of nature, while it has in fact been trapped, manipulated, surrounded by equipment, and finally edited into a replica of what it might have been and done, but didn't, or at least not in that order. Its image has been trapped, possessed, and, by our imagination, fertilised into a whole new organism of meaning. Film and photographic images are altered, recomposed, and transformed in many ways and yet still retain the sharpness of form and detail, the whiff of actuality, that allows us to continue in our happy pleasures of mistaking it for reality.

Trinh Minh-Ha, whose films challenge both ethnographic and documentary conventions in representing difference, has recently made the point that documentary is a genre that is at once "authored" and a conveyor of "the real." Documentary film acknowledges that the filmmaker's perspective may be personal; the effect of documentary relies on the sincerity of the filmmaker not to fake it but to show us "what really happened." The objective quality of what the film records and what we see goes unchallenged. Documentary harnesses the power of the film to capture what is "really 'out there' for us."[1]

The ethics of documentary photography and of ethnographic film hang on observing and recording events and circumstances that, with the exception of interviews and portraits, would largely happen in any case whether the photographer or ethnographer had been present or not. Of course, the presence of both has significant effects, but the aim is that such presence not create or determine the course of events. This is wholly different from the conditions of fictional cinema, where precisely everything in an image is constructed entirely for the purpose of making that image and would never have occurred except for the vast and fantastic imagination, technology, and investment of time and trouble by the many makers of the image. Nonetheless, documentary film cannot help participating in the codes and conventions of fictional cinema, even as it signals its genre differences. Documentary film takes place within the (maternal) body of fictional cinema, which is itself involved in a dance with European conventions of how to tell stories and what stories there are to tell. By the devices of narrativity in documentary or ethnographic film, the social reality of others is rendered into an ideal of transparency through which we imagine we understand them. The laws of naturalism in film and the techniques of invisible assemblage work to produce a fullness of meaning that obscures what is left out. Kluge's

three cameras — the technical camera, the eye of the filmmaker, and the patterns of film representation founded in the (culturally trained) expectations of the viewers — each operate a schema of selection by which *all remaining possible facts and factual contents are excluded.*[2] This is what produces the pleasure of the finished story. We have a complex set of recognitions by which we identify ourselves and reality in stories on film.

Social science is in the process of taking into its theoretical body the swarm of propositions about the highly indirect relationship of the written, imaged, or even thought representation to any "reality." This indirect relationship is triangulated through the "self," the historically and discursively constructed melange of responses and perceptions through which any one of us experiences life as a member of some social or cultural collectivity. Well in advance of representation in writing, documentary and ethnographic film have been aware of the difficulties involved in representing other peoples' worlds through the medium of images and story forms particular to Euro-American culture.

In the past decade critics have been considering the nature of the post-Enlightenment self as it is visible in poetry and autobiography as well as other forms of expressivity. This self is a coherent, unified, self-aware agency, constructed both by the Christian discourses on the disembodied nature of the spirit and by the Cartesian ego that knows itself by its own act of thought. This thinking self is the product of a historically male, for the most part leisured, European bourgeoisie free from the bodily necessities of self-support and the deprivations of hunger or poverty. Thus, it has enjoyed the luxury of an imagined transcendence, mind detached from body and unencumbered by the particularities of circumstance, geography, and time. This is the self of the agents of colonialism as well as the self of the romantic travellers who sought worldly paradises and the ground of self-discovery through the rigours of hardship and the encounter with the other. All these men produced the exotifying discourses on the other races and cultures sought and subdued by the militarised commerce of the outward push of European domination. The forebears of ethnography are the trappers, the recording explorers — rugged Renaissance men of letters — and the meticulous clerks and magistrates of the colonial legalistic bureaucracies who attempted to bring into congruence their understandings of local process with the mechanisms of justice and the markets exported from Europe. Ancestral, too, are journal-keeping travellers, painters, and poets who defined and refined their souls in the arms of the subjects of empire.

Writing about Victor Segalen's travels in Tahiti and China, emblematic of a moment in Western culture, James Clifford noted that by the end of his life Segalen had lost faith "in the possibility of sharing other lives, of erotically possessing the other, of shedding a given identity."[3] Erotic possession. Penetration. Knowing the other. Intellectual and carnal knowledge. This universe of eroticism is suffused with power: taking possession, doing something to someone else. The (male) European subjectivity in search of the boundaries of itself.

My own experience of eroticism is closer to Eros. It is replete with difference, full of Yes. In touching I am touched, suffused by touch, and in the mutual movement toward each other I come to a place of *no* boundaries. I experience my self as the other; *there is no possession in it.*

In the movement of desire, in knowing, can there be the mutual experience of no boundaries? What can we know? For what is the pursuit of knowing? To know the other without knowing the self, without opening the self to being known, is truly an act of taking possession. The colonial legacy of lands and peoples *taken possession of* has fortified the boundaries — the heavily policed borders of the nation-state. These borders separate tribal and peasant villages, canonically the destination of anthropological study, from the postmodern urban subcultures that produce the film and written texts that cultural studies critically analyse.

In the section of *Minima Moralia* titled "Keeping One's Distance," Adorno cautioned that critical "distance is not a safety-zone, but a field of tension," and this tension cannot be relaxed by a posture of relativity. Relativism, that "modesty" that is content to stay within whatever boundaries have been set for it, cannot, indeed, experience its own limits, cannot truly acknowledge all the many distances that attend knowing. Relativism ramifies boundaries by holding truths within them, while only the stance that clasps untruth to itself can "lead to the threshold of truth in its concrete awareness of the conditionality of all human knowledge."[4]

If all knowledge, all sedimented concept of human history, is conditioned, then that very history is our only guide, say the cultural critics, looking back to the immediate intellectual past and finding there, under the mask of universal and transcendent truth, the self-interested, (over)-determined, and limited point of view of someone on their way to becoming us. The development toward progress appears unidirectional. This is, of course, a crippling view. It condemns us to regard ourselves as the perpetual apex of history, and it makes it very hard to imagine difference in a nonhierarchical formation.

Critiques of rationalist philosophical discourse that have been in train within linguistics, literary theory, and parts of philosophy itself are shifting the cornerstone of Western epistemology from *identity* to *difference*. This is potentially far more than a paradigm shift. Epistemology is at once a theory of mind and of evolution, contained in seed form, from which root and also branch will, with their circumstantial peculiarities, both grow. Among the humanities, anthropology has long specialised in the nonidentical, working the edge of cultural difference, but like the rest of European thought it has done this largely within an epistemology of identity. To be sure it has been a discipline embedded in colonial architectures of domination that have themselves helped to define the hierarchical relation of the modern European rational self to the other as the archaic survival of a human past to be harnessed to the engines of world progress. Some aspects of these relations have been brought clearly into view in recent writing.

In the era of decolonisation anthropology came to recognise that the objects of anthropological study were part of history. We did not, however, immediately take on board the more easily evident possibility that we ourselves, our own subjectivities, too, were part of history. Our recognition of this today is still only partial. Drawn by our interest in semiotics to begin to acknowledge the burden of sedimented semiosis on our own textual practices, we have started to look for the residues of our colonial heritage in our own writings.[5] Rooting out the implicit racism and the many manifestations of orientalism in a Eurocentric anthropology, as much as other intellectual traditions, we have grown self-conscious about our focus on the other as the object of our researches. Postures of self-declaration of our positionings in European bourgeois endeavours hope to forestall at least the critique that we are unaware of our writing position. We have still to begin a serious investigation of how it is that we are constituted as knowers.

Deeper good may unfold even from the superficial critique of overtly textual practice, as this brings forth a recognition that we are members (both by default and by practice) in our own cultural formations, at once produced by and actively engaging in not only our chosen theoretical devices but in the larger, less conscious, and ubiquitous intellectual traditions that form our psycho-philosophical relationship to ourselves and the other. That is, it has taken the work of cultural criticism carried out in other disciplines to reveal to us that our own subjectivity is the product of cultural history. The romantic realism of our texts is not, or not so simply, an aspect of form, to be discovered and redressed by

formalist techniques of representation; our very selves — individualised, interiorised, and unitary — may well be the expression of the epoch of modernism. If we now bring our subjectivity into critical view around the moment of knowing, as well as of speaking, we may return attention to the encounter with the other, which is the basis of anthropology in its best sense. Understanding this encounter freed of the teleological view of ourselves as inheritors of a uniquely rational apex of intellectual evolution may provide the grounds for an epistemology of wonder and respect for the other in the other's own entanglements with history.

In working this edge of cultural difference, anthropological practice has specialised in encountering the unfamiliar as the as-yet-to-be-known: how can one discover for oneself meanings in an unfamiliar culture, meanings that bear some relationship to the meanings for the members of that culture, for whom it is wholly familiar? The gap between what foreign investigators come to know, or believe, and the nature of local knowledge is variously constructed as ignorance, ours or theirs. How culture mystifies itself for its own members has thus been a question in anthropology. But unlike critical theorists such as Foucault, or perhaps not so unlike him, we have assumed that it is our outsider's eye, properly educated by universalising theory, that allows us to know something about a culture, something its own members do not see. That is, like other heirs of rationality we lean on the border between inside and outside to gain a critical distance. The distinction between critical distance and transcendent knowledge is still a fine one in our intellectual tradition. In the outrage of the once colonised at the "knowledge" about them produced by universalising discourses there is often a denial of the validity of an external perspective; this critique sets our universalising theory in its historical conditions and shows it to be a product of its own perspective. When colonial mastery crumbles, the power to enforce the truth games of European knowledge is also eroded.

Here is where culture (as in theirs) and culture (as in ours) come together. Raymond Williams, disentangling the knots of this most complex word, remarked:

Thus there is some practical convergence between (i) the anthropological and sociological sense of culture as a distinct "whole way of life," within which, now, a distinctive "signifying system" is seen not only as essential but as essentially involved in all forms of social activity, and (ii) the more specialised if also more common sense of culture as "artistic and intellectual activities," though

these, because of the emphasis on a generalised signifying system, are now much more broadly defined.[6]

But for all intellectuals in the world of our times it is necessary to break down the false generality of the notion of "a whole way of life" and be more discriminating.

The root of the European dichotomy between tradition and modernism lies in the liberal, and imperialist, claim to have introduced reason. In European accounts of itself the Enlightenment began the social and intellectual processes of the modern present; elsewhere in the world, colonialism differentially introduced these processes into "traditional" societies. Tradition dichotomised with the modern in Europe in terms of temporality: before/now, allowing a certain field of play with contemporary European peasants "caught in the past."

Writers all around the world have had to demolish this dichotomy by pointing out that in colonised societies what is identified as modernism never *is*. In Latin America, in India (as we know from cultural historians such as Ranajit Guha, Geeta Kapoor, Eduardo Galeano, and even Octavio Paz, for example), the first generations of intellectuals and officials, educated in Western modes to serve as the governing elites of the colonies, practiced in their home lives the most orthodox traditionalism, precisely in order to differentiate themselves from the colonialists.

Thus in these places the dichotomy of traditional and modern is constituted from the beginning as a slippage that goes on amending the meanings of these terms in a field governed by the antinomies between the concept of "the folk" and the ideal of the rational, and by the political differences between the sense of cultural continuity and cultural survival. A survival is a reminder of what could have continued but did not. Thus, once colonialism has intervened, the traditional is something new; likewise, the rational modern is not simply the Enlightenment of the West, hung about with indigenous contaminations.[7] There is a new field of cultural play with new valences of difference. Thus in cultural terms we are drawn away from seeing things as polarities; instead, we begin to see things as elements always in a shifting field.

However, the awareness of the other as the condition of any anthropological knowledge at least sets this undertaking apart from cultural critique in a context of membership. The shifting field of identity and difference can be oversimplified, but it cannot be ignored. In an epistemology of identity, where the other is constituted hierarchically against

the self, constructed as not-A, anthropological inquiry (at least since Malinowski) has had the one virtue of proposing a description of the other in something like its own terms. This has not been rendered *entirely* futile by the conventions of writing within which it has made its representations.

However, a profound question that looms at us asks, Is it possible to produce an image that is not stereotype? Can we encounter the other as alterity, existing in its own right, and not for us?

Regarding the "A equals A" logic of identity, the feminist project within philosophy has been to investigate the conditions under which woman as the other has no autonomous position but is merely the negation of man. In Derridean thought such a negation is revealed to be not the absence of A, or of man, but the very condition upon which A's, man's, existence in discourse is founded.

The feminist project in anthropology has been to inquire whether woman everywhere, as Lévi-Strauss would imply, lives as not-A, as the coin of a male regimen of exchange upon which society was founded. This question is the source of feminist resistance to binarism seen as the constituting quality of human thought. If we analyse binarism historically as the logocentrism of our own intellectual tradition, must we then also extend it, assume it, find it in the rest of humanity?

We could with some justification regard anthropology as one arm of the incorporation into Western discourse of all that lay without it, as the intellectual act of subduing under logocentric oppositions the thought worlds of humanity, universalising our own pattern and putting all other modes of existence, being, and doing into an ordered place within our own. We could say that anthropology has no alternative, since we apprehend the world with the intellectual tools of our cultural selves. But there is always room for new information. Is there the possibility in this meeting with the eternally constituted other of unsettling this discourse of incorporation?

One clear realm of possibility lies in self-representation, as specified by Paul Willemen's essay. The subalternity of the non-European intellectual lies in the fact that she is obliged to know European thought, while the European has had little need to know much about the histories and thought of the rest of the world. Can such intellectuals render Europe one amongst many, "parochialise it"?[8] This is not a reversal of the centre-periphery paradigm but a refusal of it in favour of a multicentred world.

Richard Rorty, speaking around the notion of "vocabularies," which

is a less freighted handle on the idea of discourse in its looser sense, pro-
poses:

Since there is nothing beyond vocabularies which serves as a criterion of
choice between them, criticism is a matter of looking on this picture and on
that, not of comparing both pictures with the original. Nothing can serve as
a criticism of a person save another person, or of a culture save an alternative
culture — for persons and cultures are, for us [ironists, as opposed to metaphy-
sicians], incarnated vocabularies. So our doubts about our own characters or
our own culture can be resolved or assuaged only by enlarging our acquain-
tance. . . . Ironists are afraid that they will get stuck in the vocabulary in which
they were brought up if they only know the people in their own neighbor-
hood, so they try to get acquainted with strange people, . . . strange families,
. . . and strange communities.[9]

Rorty is more comfortable with his vocabulary and his neighbour-
hood than I am. It may well be that the anthropological ironist under-
takes such broad acquaintance that her vocabulary becomes too polyglot
to cohere into sentences, but I am inclined to feel that Rorty's sense of
himself, and the person, is a more separate(d) sense than mine. None-
theless, he gracefully locates the anthropological impulse in a context
that, denying nothing of differential power relations in the world, speci-
fies that attitude of coming to the other with astonishment and an open-
ness to its implications for the self. There is room here for the subject
to be evoked by the other, called to responsibility by the prior existence
of the other.

Now what happens when film has in fact ridden out, seized, and
possessed the other and brought it back to us to regard in the comfort
of our own living rooms (since most documentary film funding stands
or falls on TV sales)? Does cinema, with its love of disguised repetition,
render us incapable of broader acquaintance? Do the conventions of
cinematic narrativity doom us to perceive the other only as stereotype
of disowned aspects of ourselves? Does the projection of the cinematic
aspect inscribe us with our own projected shadows in the mistaken form
of the other?

A broadened acquaintance has more appeal than a trapped and pos-
sessed other. In this the phenomenology of Emmanuel Levinas, a bright
vein in the bedrock of much Derridean and feminist critical work, may
bring the crisis of representation, which is simultaneously the crisis of
anthropology, to a moment of greater clarity. Levinas bases the encoun-
ter of self with other in a priority of the other. The self is in fact evoked
and called forth by the other, whose alterity is thus not a subordinate

term in an A, not-A logic but preexists in a semiotic field that constitutes subjectivity, variably, within it.

Under these epistemological conditions of alterity neither subject nor object can be fixed in a final totalising analysis. Alterity exceeds the capacity of the subject to grasp it in its entirety. Seizure and possession are transformed into awareness, excess, and movement. Conversation becomes the model for knowing in place of penetration or dismemberment.

This is a dialogism much more fundamental than that of the text. This is a philosophical orientation to social living that keeps us always in relationship, an orientation broaching on the contingent and permeable and quite far removed from the "egotistical sublime," as Keats referred to the autonomous Cartesian self expressed in Wordsworth's poetry.[10] This orientation underlies the claims for equal voice, for self-representation, for which subordinated and indigenous cultures are calling in this age of satellite transmitted imagery.

While the economics of such highly technological media of representation as film and television suggest that the control of cultural images is likely to remain firmly in the hands of the First World, it is also likely to be the case that as these technologies become cheaper, visual imagery, especially on videotape, will follow the music and sound technologies of cassette recording, and self-representations by local groups will come to exist in burgeoning and diverse forms. Just as over the past ten years the categories of non-Western musics available locally and globally have expanded enormously, the time may not be very distant when metropolitan video libraries also contain the stories and self-accounts of peoples currently excluded from self-representation in the visual mainstream of the contemporary West. These stories will, like the musics of non-Western musicians, then be subject to appropriation and homogenisation, via the cinema industry and its search for cultural vitalisation — an outcome perhaps like Paul Simon's *Graceland* album, unacknowledged and unrewarded use of other peoples' cultural innovation and tradition.

Notes

1. Trinh Minh-Ha, "Documentary Is/Not a Name," *October* 52 (1990): 76–98.

2. Alexander Kluge, in *Alexander Kluge: A Retrospective* (New York, 1988), 4 (cited in Trinh Minh-Ha, "Documentary Is/Not a Name," 88).

3. James Clifford, *The Predicament of Culture: Twentieth Century Ethnography, Literature and Art* (Cambridge, Mass., 1988), 159.

4. Theodor Adorno, *Minima Moralia: Reflections from a Damaged Life* (London, 1974), 128.

5. A great deal of recent writing in anthropology has taken up this issue. James Clifford and George Marcus, eds., *Writing Culture: The Poetics and Politics of Ethnography* (Berkeley, 1986), was an early and influential collection, especially the paper by Mary Louise Pratt.

6. Raymond Williams, *Culture* (London, 1981), 70.

7. Much of my thinking here has its articulated origins in Ranajit Guha, over many personal communications.

8. I am grateful to Dipesh Chakrabarty for this idea, which he is developing in the context of Indian and other subaltern histories.

9. Richard Rorty, *Contingency, Irony and Solidarity* (Cambridge, 1989), 89.

10. I am indebted for this to Anne K. Mellor's comparison of the self-writing in William Wordsworth's *Prelude* and Dorothy Wordsworth's *Journals*, in *Romanticism and Gender* (London, 1992).

Contributors

BARBARA CREED lectures in film at La Trobe University, Melbourne. She has spoken and published widely in the area of feminist approaches to the cinema. She is coauthor of *Don't Shoot Darling! Women's Independent Filmmaking in Australia* (1987) and author of *The Monstrous-Feminine* (1993).

SUSAN DERMODY lectures in film at the University of Technology, Sydney. She is coeditor of *The Imaginary Industry: Australian Film in the Late '80s* (1988), and of the two-volume *The Screening of Australia* (1987–88). She is also an independent filmmaker, her first feature being *Breathing under Water*.

LESLIE DEVEREAUX has been engaged in anthropological fieldwork in Chiapas, Mexico, since 1967 and in Cape York, Australia, since 1971. Her interest in film began at Harvard and matured over many years of conversations with ethnographic filmmakers in Canberra, especially Timothy and Patsy Asch. She teaches anthropology at the Australian National University.

FAYE GINSBURG is an associate professor in the anthropology department at New York University, where she directs the Program in Ethnographic Film and Video. Her books include *Contested Lives: The Abortion Debate in an American Community* (1989), and an edited collection, *Uncertain Terms: Negotiating Gender in American Culture* (1991). Her essay for this book is part of a larger project investigating the use

of media by Fourth World peoples. She currently holds a Macarthur award.

ROGER HILLMAN is coordinator of the new Film Studies program at the Australian National University and he teaches German and contemporary Europe units in the department of modern European languages. He is currently investigating the use of classical music in European cinema, a project supported by the renewal of a Humboldt Fellowship and a small Australia Research Council grant.

BERND HÜPPAUF taught German at the universities of Regensburg and New South Wales before taking up a professorship in the department of Germanic languages and literature at New York University. Alongside many publications on literary themes, he has been involved in a longstanding project on photography and World War I.

PETER LOIZOS is reader in social anthropology at the London School of Economics. He has made fifteen documentary films and written several books, including *Contested Identities: Gender and Kinship in Modern Greece* (with E. Papataxiarchis, 1991) and *From Innocence to Self-Consciousness: Innovation in Ethnographic Films, 1955–1985* (1993).

DAVID MACDOUGALL has made some twenty films, primarily in Africa and Australia, many codirected with his wife, Judith MacDougall. From 1975 to 1991 he was director of the film unit of the Australian Institute of Aboriginal Studies. He writes regularly on documentary and ethnographic film.

GEORGE E. MARCUS is professor and chair of the department of anthropology at Rice University. He is coauthor of *Anthropology as Cultural Critique,* coeditor of *Writing Culture,* and founding editor of the journal *Cultural Anthropology.* He has inaugurated a series entitled *Late Editions,* of which the most recent volume is *Connected: Engagements with Media at the End of the Century.*

GINO MOLITERNO teaches Italian, film, drama, and contemporary Europe units in the department of European languages at the Australian National University. He also teaches film courses, including Cinema and Literature in Postwar Italy and (with Roger Hillman) Postwar European Cinema.

GAYLYN STUDLAR is associate professor of film studies at Emory University. Her books include *Reflections in a Male Eye: John Huston and*

the American Experience; *In the Realm of Pleasure: Von Sternberg, Dietrich, and the Masochistic Aesthetic*; and two forthcoming volumes, *This Mad Masquerade: Stardom and Masculinity in the Jazz Age* and *East of Suez: Orientalism in Film*.

PAUL WILLEMEN was a member of the editorial board of *Screen* in the 1970s and editor of *Framework* in the 1980s. He is the author of *Looks and Frictions* (1994) and coauthor of *The Encyclopaedia of Indian Cinema* (1994).

ANNE-MARIE WILLIS teaches Australian studies at the University of New South Wales. She is the author of *Picturing Australia: A History of Photography* (1988) and *Illusions of Identity: The Art of a Nation* (1992).

Index

Index: Donna Kaiser
Composition: Graphic Composition, Inc.
Text: 10/13 Galliard
Display: Galliard
Printing and binding: BookCrafters

WITHDRAWN